ART AND THE HIGHER LIFE

KATHLEEN PYNE

Art *and the* Higher Life

Painting and

Evolutionary Thought in

Late Nineteenth-Century America

University of Texas Press

Austin

This publication is made possible in part by support from the Institute for Scholarship in the Liberal Arts, College of Arts and Letters, University of Notre Dame.

LIBRARY OF CONGRESS CATALOGING-IN-PUBLICATION DATA

Pyne, Kathleen A., 1949–

 Art and the higher life : painting and evolutionary thought in late nineteenth-century America / Kathleen Pyne. — 1st ed.

 p. cm.

 Includes bibliographical references and index.

 ISBN 0-292-76571-1 (cloth : alk. paper).

 1. Painting, American. 2. Painting, Modern—19th century—United States.

3. Evolution (Biology)—Philosophy. I. Title.

ND210.P96 1996 95-43964

759.13'09'034—dc20

For

PAUL GREGORY JOHNSON

and

NICHOLAS PYNE JOHNSON

CONTENTS

ILLUSTRATIONS

ACKNOWLEDGMENTS

THIS BOOK HAS BEEN WRITTEN and rewritten over a period of ten years. I would like to acknowledge here the many debts of intellectual and personal support I incurred over this period of work. First and foremost among these is my gratitude to my husband, Paul Johnson, and my sister, Nanette Pyne, who read through several versions of the manuscript and in innumerable ways helped to refine my thinking about this historical moment in American culture. My brother-in-law, Robert Wenke, was always ready to clarify points of evolutionary theory for me, and Joyce Pyne and Jeffrey Pyne gave their unflagging encouragement.

During the nascent phase of this project at the University of Michigan, my interchanges with David Huntington, David Hollinger, and Joel Isaacson were instrumental in framing the questions that this study addresses. The research for the book was considerably enhanced by my work in 1990–1991 as a Smithsonian Institution postdoctoral fellow at the National Museum of American Art and the Freer Gallery of Art, where Linda Merrill, Elizabeth Broun, William Truettner, and Lois Fink gave generously of their assistance and raised interesting issues for my study. In the later stages of the writing, Linda Merrill perceptively criticized the chapter on Whistler, Hilary Radner greatly enriched my understanding of the representation of the feminine, and Thomas Schlereth offered many useful suggestions for the entire project, as did Sarah Burns and Wanda Corn.

I wish to express my warm appreciation for the tireless efforts extended

on my behalf by the staff of the Archive Library at the Freer Gallerery of Art, in particular, Colleen Hennessey, Lily Kecskes, Reiko Yoshimura, and Kathryn Phillips. At the Library of the National Museum of American Art and the National Portrait Gallery, I thank Pat Lynagh and Martin Kalfatovic. Many private collectors and scholars also kindly assisted me in obtaining photographic materials. They are: Thomas Colville, John Dryfhout, Elizabeth Gunter, Willard G. Clark, Stephen D. Rubin, Peter Terian, David Nisinson, N. Robert Cestone, Steven V. DeLange, Sona Johnston, and Laura Fuderer.

At the University of Texas Press it was a pleasure to work with Elizabeth Williams, Joanna Hitchcock, Tayron Tolley Cutter, and Lois Rankin. Kerri Cox provided excellent guidance in copyediting the manuscript. The illustrations for the book were funded by the Institute for Scholarship in the Liberal Arts, College of Arts and Letters, at the University of Notre Dame.

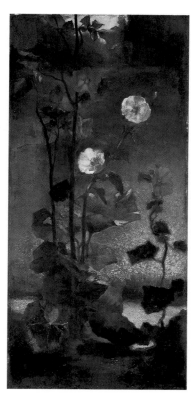

PLATE 1.
John La Farge,
Hollyhocks, c. 1863.
Private collection.
Photograph courtesy of
Thomas Colville Fine Art.

PLATE 2.
Henry Hobson Richardson
with John La Farge,
Trinity Church, Boston,
1877. Interior view,
looking toward the
chancel. Photograph
courtesy of John Woolf.

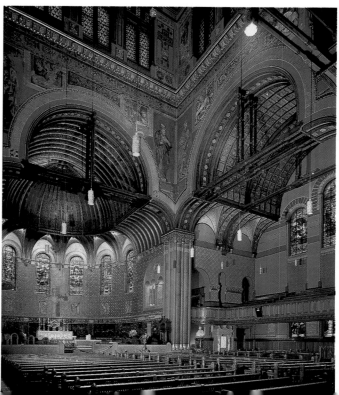

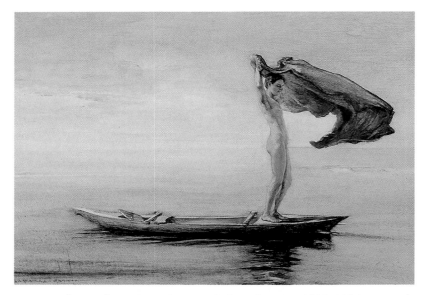

PLATE 3. *above: John La Farge,* Samoan Girl in a Canoe, *c. 1890–1895. Watercolor. The Corcoran Gallery of Art, Museum Purchase.*

PLATE 4. *right: James McNeill Whistler,* Symphony in White, No. 2: The Little White Girl, *1864. Tate Gallery, London.*

PLATE 5. *below: James McNeill Whistler,* Nocturne in Blue and Silver: Cremorne Lights, *1872. Tate Gallery, London.*

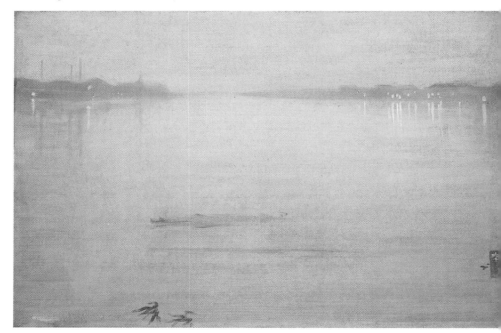

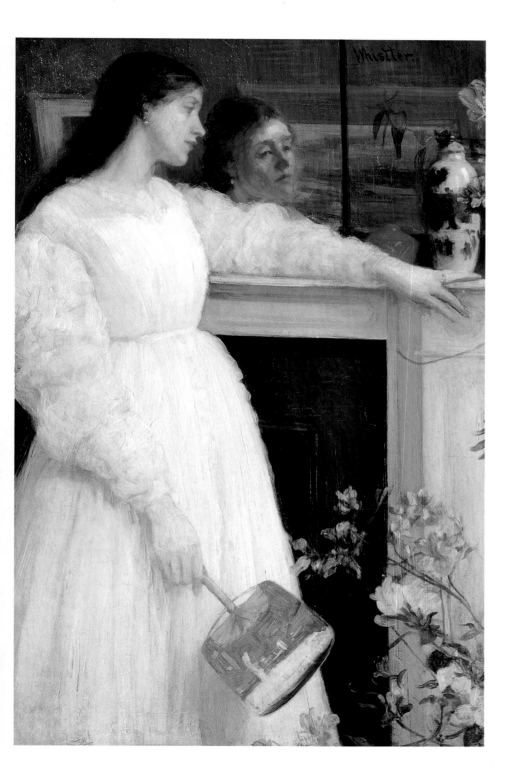

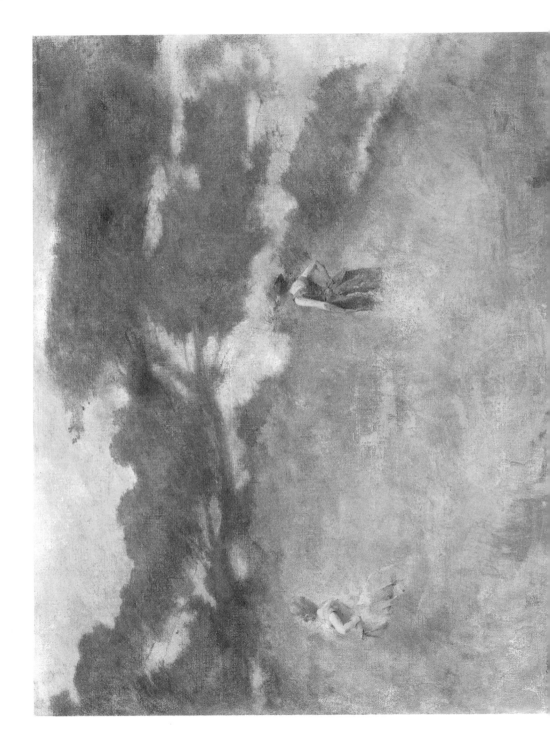

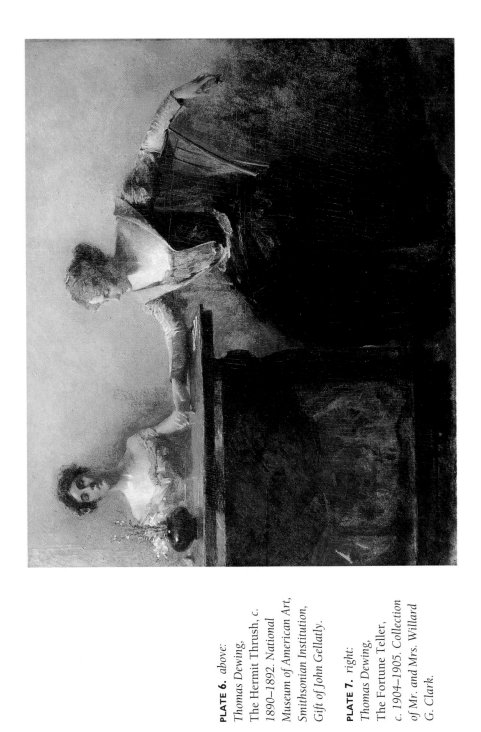

PLATE 6. *above:*
Thomas Dewing,
The Hermit Thrush, c.
1890–1892. National
Museum of American Art,
Smithsonian Institution,
Gift of John Gellatly.

PLATE 7. *right:*
Thomas Dewing,
The Fortune Teller,
c. 1904–1905. Collection
of Mr. and Mrs. Willard
G. Clark.

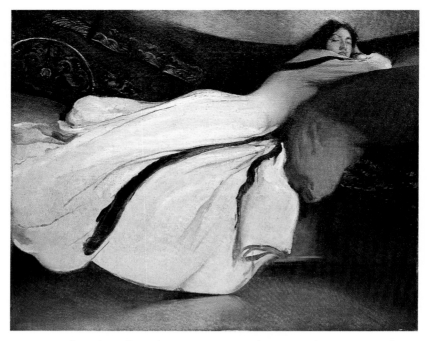

PLATE 8. *John White Alexander,* Repose, *1895. The Metropolitan Museum of Art, New York, Anonymous Gift, 1980.*

PLATE 9. *John Twachtman,* On the Terrace, *1890s. National Museum of American Art, Smithsonian Institution, Gift of John Gellatly.*

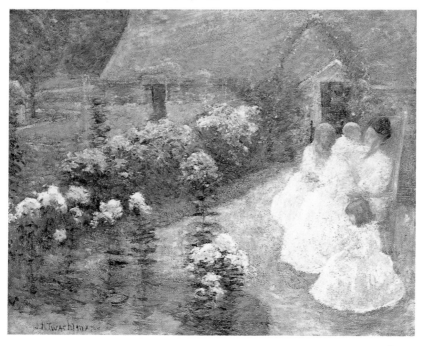

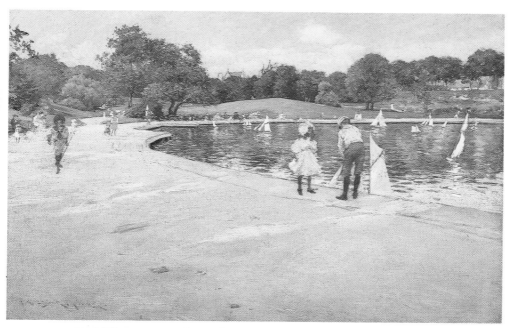

PLATE 10. *William Merritt Chase,* The Lake for Miniature Yachts, *c. 1890. Peter G. Terian, New York.*

PLATE 11. *Willard Metcalf,* October Morning, Deerfield, Massachusetts, *1917. Freer Gallery of Art, Smithsonian Institution.*

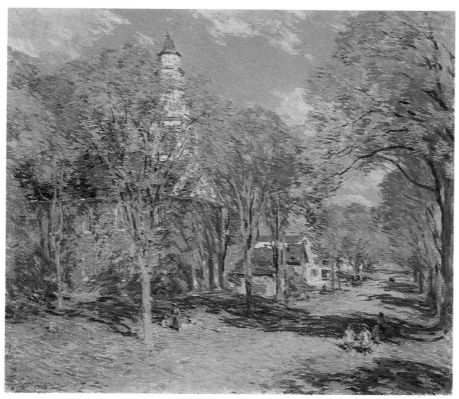

PLATE 12.
J. Alden Weir,
Upland Pasture, c. 1905.
National Museum of American
Art, Smithsonian Institution,
Gift of William T. Evans.

INTRODUCTION

HOW MUCH OF JOY and life one has who is really in keen sympathy with beauty. It seems a pleasure almost too fine for this sphere and differentiates any one who possesses it from the common humanity. I cannot imagine a higher life than the rare moments when one is attuned to a really great art work; it seems to me to contain the essence of all religions and comes the nearest to true spiritual manifestations that are known.

—*Letter dated July 21, 1907, from Dwight Tryon to Charles Lang Freer*[1]

Reasoning from one thing to the other and about the hopelessness of trying to fathom what it all means, I reached this: that we know nothing, . . . but a deep conviction came over me like a flash that at the bottom of it all, whatever it is, the mystery must be beneficent. . . . After all, we are like lots of microscopical microbes on this infinitesimal ball in space. . . . I suppose that every earnest effort toward great sincerity or honesty or beauty in one's production is a drop added to the ocean of evolution, to the Something higher that . . . we are rising slowly (d___d slowly) to. . . .

The principal thought in my life is that we are on a planet going no one knows where, probably to something higher (on the Darwinian principle of evolution); that whatever it is, the passage is terribly sad and tragic, and to bear up at times against what seems to be the

Great Power that is over us, the practice of love, charity, and courage
are the great things.

<div align="right">

—*Letters dated February 17, 1897; September 2, 1898;*
and September 23, 1898, from Augustus Saint-Gaudens
to Rose Standish Nichols[2]

</div>

In the decade following the Civil War Darwin's theories shook the founda-
tions of America's self-identity as God's chosen people. Indeed, scholars of
American intellectual history have well established that evolutionary thought
provided a new governing paradigm for the philosophical structures of
science and religion in the late nineteenth century. Charles Darwin brought
the scrutiny of positivist science to bear on biological issues, while Herbert
Spencer translated evolution into a philosophy of human progress. Spencer's
evolutionary discourse in particular had a tremendous impact in the
United States because it reconciled the new science with America's tradi-
tional image of itself as a nation guided by providential dispensation. Just
as important, Spencer's philosophy preserved the belief in both the special
spiritual nature of humankind and the existence of a spiritual realm where
the soul lived on after death. The purposefulness of human life on earth
thus was upheld, in contrast to Darwin's negation of any human unique-
ness. Thus, as Gillian Beer has pointed out, evolutionary science abounded
in metaphors and contradictory elements: it could be read as both an ascent
and a descent of man.[3] The term *evolution* in itself connoted a trajectory of
development and energy, and it became in the late nineteenth century,
specifically in America, synonymous with the idea of progress.

In recent literature on late nineteenth-century American art, scholars
have largely omitted intellectual and social considerations in their discus-
sions of the artist's approach to picturing the world. While Wanda Corn's
study of tonalism and Charles Eldredge's survey of symbolist tendencies at
the end of the nineteenth century are pioneering attempts to contextualize
American painting in this period, formalist accounts of the tonalist and
impressionist modes of painting have dominated the discourse. In con-
trast, although my study does take into account Americans' acute aware-
ness of European artistic developments, its chief objective is to describe
late nineteenth-century American visual culture as a response to the prob-
lematic conditions of American life at a point when the nation transformed
itself from a devoutly Calvinist, provincial, and agrarian society to a
modern, urban, industrial, and more agnostic culture.

In this book I argue that the generation to which the American tonalists
and impressionists belonged was traumatized by the Civil War; by the

theories of Darwin, which challenged both traditional views of human supremacy over nature and also traditional Christian ideas about the spiritual afterlife; and by an influx of foreign immigrants who challenged the supremacy of the old Anglo-Saxon elite. In reaction, the postwar generation found comfort in the theories of Herbert Spencer, who interpreted evolution as a teleological process of ascent: that is, human society inevitably developed toward higher and more spiritual forms. The artists accorded the greatest approbation in this period were those who offered art forms that spoke to the Anglo-Saxon, New England elite of a transcendent realm and of social refinement and that defended the embattled position of the elite of which these artists were members.

Spencer's social theory was also propitious for that historical moment, since it seemed to provide scientific guidance as to how recently arrived masses of immigrants might be incorporated into American society without undue struggle. According to Spencer, environment, not natural selection, shaped character. Thus the human environment came to be regarded as the key factor that would reshape foreign peoples in the mold of ideal types, patterned after Anglo-Saxon Protestants. American society in this period was faced with overcoming the hurdles not only of vast immigrations but also of massive industrialization, a more aggressive corporate climate, and the attendant social and labor disruptions following in the wake of these developments. The cultural environment, especially the visual arts and architecture, was weighted with the responsibility of effecting this transition to a harmonious society that could embrace diversity in its unity. Despite the often-voiced rhetoric of "art for art's sake," the function of the visual arts in this period was implicitly acknowledged by artists and critics alike as one of assisting the evolutionary progress of American society.

The culture of the 1890s, then, was a contested terrain in which the Anglo-American establishment held out an ideology seemingly liberal enough to encompass the interests of a number of groups. The evolutionary thought of Darwin and Spencer, of descent and ascent, became the dominant paradigm that directed and justified the production of the dominant culture. The notions that humankind was evolving to a higher state of being and that the fruits of evolution in terms of a new world culture would first arise in the United States played upon the traditional millennial aspirations of the nation and, at least rhetorically, included the broader range of constituencies that were coming to compose American society. As in T. J. Jackson Lears's observation on the hegemonic function of law, the Darwinian and Spencerian construction of evolutionary law operated as a

"powerful hegemonic instrument but also a fund of beliefs and values from which the less powerful could draw sustenance" and which "could be contested by conflicting social groups. Law promised a reign of universal norms with utopian implications."[4] The fracturing within the evolutionary ideology is witnessed in the way it promoted a utopian project on the one hand while on the other it proposed a racist hierarchy of cultures through which "progressive" Anglo-American society could identify itself as ascending by virtue of its difference from the other, "lower," groups.

The project of this book, however, is not simply to engage in "unmasking" the failures and mystifications of the late nineteenth-century Anglo-American elite but also to reconstruct and understand the "utopian promise" that persuaded Americans to believe in the evolutionary program.[5] In the medium of painting Anglo-American artists constructed a symbolic universe that served their own constituency well in situating themselves as the exemplars of evolutionary progress. To comprehend that painted universe as it was inherently received by its audience, we must revisit those images in the context of the belief in the evolutionary progress of civilization. For complete surveys of American tonalism and American impressionism, as well as standard biographies of the artists discussed here, I would refer the reader to the many excellent volumes of this type already available.[6]

The approach here, however, has been to investigate a number of subtle ways in which the evolutionary paradigm assisted Anglo-Americans in the Northeast, as opposed to the South or the Midwest, in reproducing their hegemony through the proliferation of cultural forms. My focus has therefore been a selective one, in which certain artists have been examined for the salient ability of their works to articulate some permutation of the evolutionary ideologies that were popularized in the 1880s and 1890s. Paintings and sculptures in this discussion are confronted both from within the language of the evolutionary paradigm—from within this culture that was seduced by the utopian promise of beauty (though aestheticism implicitly fostered a number of insidious biases)—and from without, from the distance of a late twentieth-century perspective that is sensitive to issues of race, class, and gender. In setting out the paradigm and its resonances in particular examples, I hope that this study will be suggestive for a continuing discourse on American artists and ideology, in terms of the resistances to, and reinforcements of, the social doctrines that spread in the wake of Darwin and Spencer.

The methodology employed throughout locates the cultural meaning of objects in the social construction of art. Because his ideas seemed to

reinforce a dynamic I had already observed in my research, I have drawn on the sociological theories of Pierre Bourdieu in certain instances to amplify the complicity of artists in defending the Anglo-American establishment against the potential threat posed to its dominance by the newly arrived immigrants. Bourdieu has proposed a theory of cultural capital in which "widely shared, high status cultural signals (attitudes, preferences, formal knowledge, behaviors, goods and credentials)" are employed by a dominant class to control and perpetuate its version of legitimate culture and stake out social boundaries. In contrast to Thorstein Veblen's ideas, this theory more attractively describes these signals as being activated unconsciously because they are perpetuated through family socialization.[7] Studying the Boston elite in the nineteenth century, Paul DiMaggio has applied Bourdieu's concept of cultural capital, defining it in that milieu as an appreciation of music and the fine arts; I have concurred in this definition.[8]

Bourdieu's writings further stimulated my consideration of how in the period leading up to World War I Anglo-Americans marshaled their traditional cultural practices and symbols as forms of cultural capital in order to buttress their position as the dominant group; and in turn how they employed Spencerian thought to avoid a struggle for survival and to reify traditional religious beliefs. The movers and shakers within the dominant class are regarded here not as the mythical merchant princes and robber barons or new-money capitalists, but as a group of middle-class intellectuals, academicians, writers, editors, and artists who controlled the social and educational institutions responsible for shaping discourse and reproducing social hierarchies. While cultural and social boundaries between classes in the United States today may be more fluid than those in other countries, in the late nineteenth century the perimeters that cordoned off a fairly homogeneous Anglo-Saxon Protestant culture in the Northeast from the ethnic diversity of foreign Catholic and Jewish cultures were well marked. In response to traditional American concerns about the determinism of theories such as Bourdieu's, I have provided ample room for the agency of free will and have given much scrutiny to the ways in which social ideologies were inflected by the personal needs and experiences of artists.

Linking the separate, and sometimes disparate, discussions of artists that make up this book is the identification of the central visual tropes, or rhetorical devices, that register the special complaints and solutions Americans posed to the dilemmas presented by Darwin's writings. My understanding of these tropes, as they were established in literary texts of the period, is especially indebted to Jackson Lears's study of the philosophical

and religious malaise that afflicted late nineteenth-century Americans, as well as to the authoritative works of David A. Hollinger, James R. Moore, Robert C. Bannister, Carl N. Degler, James Turner, Bruce Kuklick, William R. Hutchison, and Cynthia Eagle Russett on the varied American responses to those who were received on these shores as the primary evolutionary scientists.[9]

The paintings and the cultural practices of John La Farge, James McNeill Whistler, Thomas Dewing, and their colleagues in the 1890s are threaded throughout with these tropes. Some are directed toward private solutions to the dilemmas upper-middle-class Anglo-Americans perceived in the teachings of evolutionary science. In this respect, images of individual self-culture, in which the moment of contemplating the transcendent work of art or the beauty of nature is portrayed, served to generate reassurances of harmony with the world and the existence of a spiritual realm in which human beings could share. The production of a huge number of images of a beautiful woman apprehended in a quiet interlude, sometimes meditating on an art object, proposes a link between the feminine and the spiritual, a typology that survived well into the early twentieth century. It also, however, reflects the widespread embrace of self-refinement, earlier promoted by the Unitarian elite, as a progressive, evolutionary cultural practice. In the quotations that introduce this preface, Saint-Gaudens adumbrated this practice as a "drop added to the ocean of evolution, to the Something higher that . . . we are rising slowly . . . to" while for Tryon it figured as *the* "higher life"—the singular experience that offered the "essence of all religions."

Another category of visual tropes constitutes a response to the threat posed to the unity of the social state by the spectre of evolutionary struggle. These images are concerned with the progress of the American people as evidenced by signs of order and power in the urban scene. In images of the rural New England landscape, such tropes propose that the earlier Anglo-American culture of the small town was still intact and vital in the period leading up to World War I. The morphology of the New England landscape that is inventoried in these canvases seeks to freeze for all time an antiquarian world that denies the actual changes wrought upon the countryside, its demographics, and Anglo-American dominance there in the last half of the nineteenth century.

But it would be a mistake to see the artists of this period as entirely univocal: like other Americans, artists subscribed to evolutionary doctrines to varying degrees, and some not at all. Painters such as Sargent and Cassatt—who developed outside the evolutionary ethos of progress that

dominated the Northeast and who worked primarily for an English or Continental clientele—had little use for these tropes. Others, such as Homer and Eakins, went against the grain of the dominant ethos and resisted the tropes of progress. Eakins was regarded even in his own time as a cynical agnostic, while Homer's imagery of death and brutality in nature presented a Darwinian vision of struggle that was difficult for many of his contemporaries to accept. But both were lauded by twentieth-century modernists for just these reasons—that is, their difference from the genteel tradition that was reviled by the generation of the 1920s and 1930s.[10] In place of the modernist account of the 1890s, I offer here a resituating and reinstatement of that tradition within its historical context, a social and philosophical context that has been lost because of our myopic focus on those painters who prefigured the modern tradition.

I begin this book with a sketch of the Protestant responses to Darwin and Spencer in America in the religiophilosophical and the socio-economic spheres, in order to provide the background necessary for understanding the translation of the evolutionary paradigm into cultural and artistic terms. Sections of chapter 1 address the perceived differences between Darwin's and Spencer's versions of evolution, as well as William James's critique of evolutionary theory. The discussion then moves to the question of American social evolution and the problems posed to Anglo-American dominance by increasing social diversification and stratification. The first chapter concludes with an account of how Spencer's social theory was translated into cultural theory. The World's Columbian Exposition of 1893 and Frank Lloyd Wright's houses are posed as examples of designed environments that have their origins in the evolutionary ethos and that offered Americans an avenue toward the "higher life."

The four chapters that follow demonstrate the forms and methods through which certain leading American painters expressed their sensitivities to the tensions and hopes created by the new evolutionary worldview. This evolutionary content might have been consciously constructed by the artist or subconsciously presumed simply as a given in the spontaneous cultural ideology of the moment. As early as the 1860s, John La Farge in America and James McNeill Whistler in England began to produce paintings that grew out of a radical aesthetic of sensuousness and simplicity. It is important to realize the ways in which their works proposed models of how the cultural artifact might assist the Spencerian scheme of evolution in which society was seen as progressing toward a utopian state. La Farge's statements on his intended purpose for his oil paintings and stained glass bear out this contention, as does the American reception of Whistler's art.

Chapters 2 and 3 thus examine the aspects of their lives and careers that demonstrate their fashioning and promotion of the visual tropes that in America would become central to the rhetoric of evolutionary progress. How La Farge and Whistler exploited nineteenth-century gender typology, in using the feminine object to carry off the "higher," refining purposes of their art, serves as a major connecting theme throughout the discussion of their works.

My discussion of La Farge (chapter 2) begins with his early development of a mystical visual language and its possible origins in his Catholic upbringing. His leadership in the movement toward sensuous religious environments for his Anglo-Saxon Protestant patrons is situated in the religious crisis Protestants experienced in the wake of Darwin, when aestheticizing the sacred space became a strategy to sustain their belea- guered faith. La Farge's search for mystical experience in Japan is seen as culminating in the implicitly agnostic expression of Saint-Gaudens's *Adams Memorial*. Commissioned by Henry Adams, this monument is emblematic of the fears the Protestant elite harbored for the survival of the soul after death.

My study of Whistler (chapter 3) reconstructs his development of a utopian imagery of self and environment that Americans would find useful in articulating an evolutionary nationality that evaded social reality in the 1890s. The discrepancies between the images Whistler created in the "nocturnes" and the real sites he observed along the Thames are examined to reveal his elitist position in surveying the public spectacle of London, a view which was first projected unconsciously but which later in his career became a conscious means of presenting himself as an elect member of a spiritual order. Whistler's actual spiritualist practices and identification with his mother are also explored as the formative conditions that led him to construct his mature portraits and public persona as highly refined, spiritual manifestations—and thus feminine in gender. In order to evoke the social uses of his images, Whistler's relation to his patron Charles Lang Freer (founder of the Freer Gallery of Art, Smithsonian Institution) is reviewed, as are the interpretations of historians and critics such as Ernest Fenollosa and Charles Caffin who read Whistler's work in the light of social evolution.

Of the generation of American painters who matured in the 1890s and built on the practices and theories of Whistler and La Farge, Thomas Dewing offers the consummate example of a late nineteenth-century American artist who embraced in his work the idea of the evolutionary purpose of culture via an Emersonian reading of Spencer (chapter 4).

Dewing's leadership in the Cornish (New Hampshire) art colony provides a moment that reveals how aestheticism in the 1890s could serve for Anglo-Americans as an agnostic philosophy of life, for the Cornish colony constituted a utopian experiment in the "higher life." Focusing on Cornish provides a glimpse of how Americans, who were neither old money nor new money but a middle-class intelligentsia, seized on aestheticism as a framework through which they articulated their group identity as an elect that stood at the pinnacle of the evolutionary trajectory of history. A major portion of this chapter on Dewing is given over to examinations of how his landscapes and paintings of women—in other words, imagery that was gendered feminine—were used by male patrons such as Charles Freer as sources of psychic and spiritual therapy. Because the archival sources on Freer's life and preferences are so rich, he presents a unique opportunity to consider the ways in which the male collector made use of such feminine imagery. The modern Anglo-American female type that figures largely in Dewing's work is also placed in the context of contemporary evolutionary theories of feminine sexuality and cultural modes. An interrogation of Thorstein Veblen's often-invoked censure of the "genteel tradition"—particularly in terms of its feminine culture—is demanded here, especially with regard to the fitness of Veblen's *Theory of the Leisure Class*[11] to stand as a critique of the works of Dewing and the related images of the Boston school in this period.

The last chapter provides an ideological analysis of the complex American response to French impressionism. A review of the late nineteenth-century literature makes it evident that these Americans appreciated and comprehended Monet's contribution to the science of vision. Their objections, however, were premised on both religious and political grounds, as much as on the basis of aesthetics. They castigated the impressionists' positivist worldview, just as they rejected the impressionists' lower-class subjects. As such, the literary critique compellingly voiced the American fears of an impending social apocalypse in which the laboring and immigrant classes would displace the intelligentsia and reconstruct the social order as a socialistic, Godless world. In the minds of the old northeastern elite, late nineteenth-century tonalist painting in the style of Whistler and La Farge, then, in contrast to French impressionism, seemed to speak affirmatively to the pressing social and philosophical dilemmas of that period.

After surveying the critical literature on impressionism in America, the ensuing sections of chapter 5 discuss the ways in which the works of artists who dominated American painting from 1890 to 1915 offer visual critiques

and reconstructions of French impressionism, along the lines of current Anglo-American social ideologies. In particular, these artists include Theodore Robinson and the painters who exhibited together as members of "the Ten"—the patriciate of the American art scene at the turn of the century. When their images are viewed again through the lens of popular evolutionary thought, as they were in the late nineteenth century, the reasons why these painters chose not to adopt pure impressionist modes become clear. Their modifications of French models instead suggest the extent to which they individually conceived their works to conform with the progressive role that culture was expected to play in the American arena in assisting society toward a utopian state. Moreover, their subject matter functioned to reify the conservative reaction against the demographic changes taking place in the urban, industrial Northeast. Here my reading of how the Ten selectively presented the topography of New York and New England is informed by recent sociogeographical studies of the North American landscape, particularly those of D. W. Meinig and Yi-Fu Tuan.[12] David Schuyler's and Peter Hales's discussions of the design and photographic framing of urban spaces in late nineteenth-century America have also contributed to my perceptions of the American impressionist representations of New York City.[13] The urban prospects these painters created are thus described as celebrating the progress of American civilization, while their images of the countryside are seen as constituting reverent homages to an Anglo-American past that had already disappeared.

From our vantage point at another fin de siècle, we see that we too have entered another crisis of belief, impelled this time by the paradigm shift to postmodernism. As our philosophical foundations are now being questioned, our response has been to turn to domestic comforts and personal therapies in a manner that is not so different from the strategies of self-culture Anglo-Americans adopted in the 1890s. A warning against seeing our own image reflected in that of the post-Darwinian generation, however, is in order here, because the nineteenth-century crisis involved the undermining of a totally religious worldview, in contrast to the secular presumptions of our culture. The discussion that follows this preface constitutes an effort to understand the uniqueness of that cultural moment.

The American Response *to* Darwinism

ALTHOUGH *The Origin of Species,* by Charles Darwin (1809–1882), was published in 1859 on the eve of the Civil War, it was not until the postwar period of the 1870s that serious opposition to its findings was mounted in America. Some disgruntled rumblings about the threat of science to religion had surfaced in the 1860s, but in the presence of the more imminent threat of biblical criticism, American Protestants did not perceive the specifics of Darwin's study as a menace that required an immediate response. Only at the international meetings of the Evangelical Alliance, convened in New York in 1873 to discuss the progress theologians were making against the forces of skepticism in America, did the issue of evolution finally surface. Amid the clergy's resounding self-congratulations on their success in disarming the arguments of biblical criticism, Charles Hodge, a leading Presbyterian theologian from Princeton, rose to disturb their tenuous air of complacency. While evolution and natural selection, he said, were not new concepts, Darwin's version of natural selection was. Darwin had proposed a scheme in which nature was ruled by chance, a world in which there was no design and no evidence of mind, purpose, or deity. Darwinism, he concluded, was atheism.[1]

After Hodge's declaration, a legion of Protestant ministers and philosophers hurried to condemn Darwin's vision of life on earth. Borden P. Bowne, a professor of philosophy at Boston University, for example, gave voice in 1878 to a characteristic interpretation of Darwin's study:

Life without meaning; death without meaning; and the universe without meaning. A race tortured to no purpose, and with no hope but annihilation. The dead only blessed; the living standing like beasts at bay, and shrieking half in defiance and half in fright.[2]

For Americans, Darwin's later study of human evolution, *The Descent of Man* (1871), seemed only to intensify the attack of science on faith. His hypothesis in this volume overturned the commonly held belief that humankind was a semidivine creation for whom the universe was expressly designed. "The difference in mind between man and the higher animals . . . ," Darwin stated, "is one of degree and not of kind." Moreover, man's evolution, he maintained, had entailed the same struggle for existence as that of the other animals.[3] To deny humankind its special qualities of mind, intelligence, and especially soul proved to be "Darwin's greatest sin against American beliefs."[4] Battle lines were now clearly drawn to defend the inherited beliefs at stake in the conflict between science and religion: the belief in design and purpose in the universe; the belief in a Designer or Creator; and the belief in the existence of the human soul. Indeed, the existence of the entire higher metaphysical realm—which crucially involved the belief in life after death—was in question.

The most serious problem for most Americans in coming to grips with Darwin concerned the meaning of death. For the last quarter of the century this question plagued America's ruling class, the upper-middle-class Anglo-Saxon Protestants of the Northeast, laymen, professional philosophers, and theologians alike. If human beings were not unique and there was no human soul, then the existence of life after death was obviously jeopardized too. Of such paramount importance was this issue for America's elite that the Cambridge philosophers Charles S. Peirce, Josiah Royce, and William James focused all their energies over the course of their long careers on solving this one dilemma—how to refute the doubts raised by the mechanistic universes of Charles Darwin and Herbert Spencer.[5]

For James, this dilemma was not just an abstract theoretical issue but a matter that had deep personal reverberations. As a young man, he had suffered an emotional collapse after being tortured by the implications of Darwinian science. Faith in a higher realm and scientific doubt battled in James's mind during the winter of 1870, and he fought off his suicidal impulses only by reading Emerson, Fechner, and Plato. His despair finally lifted when he learned of Charles Renouvier's ideas of free will, which allowed him to find the solution he would continue to promote energetically in the 1880s and after. While he admired the empiricism of Darwin

and the positivist methodologies of other scientists, at the same time James argued to convince men and women that science was impotent in disproving their right to believe in a higher metaphysical realm. As one historian of American thought has remarked, for James, "as for all his generation who explored Darwinian science, a belief in spiritual powers essential to the being of the universe was necessary to make life significant."[6]

The educated public was no less attuned to the evolutionary controversy than scientists, theologians, and philosophers. Like James, some were driven to thoughts of suicide by the implications of Darwin's discoveries. That the cosmos must now be construed as a place that was totally unresponsive to human longings for purposeful life on earth and immortality afterward was intolerable. Marion Hooper Adams, the wife of the historian Henry Adams, for example, took her own life by drinking chemicals for developing photographs in 1885. This occurred after a period of depression following the death of her father, on whom she had been extremely dependent emotionally. When forced to confront the riddle of existence, her doubts about a life after death had brought her to despair. In his *roman à clef, Esther* (1884), Henry Adams had uncannily forecast his wife's religious crisis. Thinly disguised as the skeptical Esther, she is revealed in the novel as a woman who could not be persuaded by the arguments of either science or religion. Marion Adams too failed to reconcile the contradictions of science with faith. During the last year of her life she ironically insisted that the Christian symbol of a cross be placed in the facade of the house being constructed for the Adamses in Washington by H. H. Richardson. Since Marion Adams had earlier referred to Richardson's Romanesque-style architecture as a "Neo-Agnostic" style because of its somber color and gravity, the fabric of this house in which she died may be viewed as a metaphor for her own crisis of faith.

When Henry Adams in turn was forced to interpret his wife's death, he begged the question entirely: in his autobiography, *The Education of Henry Adams*, where he never mentions her name or their marriage; and in the visual form of the monument he commissioned for her grave in Rock Creek Cemetery (1886–1892, Rock Creek Cemetery, Washington, D.C.). Adams told the sculptor Augustus Saint-Gaudens that he should think of the Buddhist Kannon in Nirvana when conceiving the figure. Personifying a state which is beyond all human pain and suffering, the hooded and silent figure thus offers no consolation on the question of a Christian afterlife.[7]

Near the end of his life Saint-Gaudens himself often mused on the problem of what evolutionary theory permitted us to know about human destiny. At one point in his contemplations he decided that there was a

"hopelessness of trying to fathom what it all means . . . We know nothing, (of course) but . . . at the bottom of it all, whatever it is, the mystery must be beneficent." A year later he concluded that

> we are on a planet going no one knows where, probably to something higher (on the Darwinian principle of Evolution); that whatever it is, the passage is terribly sad and tragic, and to bear up at times against what seems to be the Great Power that is over us, the practice of love, charity, and courage are the great things. . . . The thing is to try and do good, and any serious and earnest effort in almost any direction seems to me to be a drop in the ocean of evolution to something better.[8]

Saint-Gaudens's sentiments recall William James's arguments for belief in "The Will to Believe" and "Is Life Worth Living?" As James had concluded, Saint-Gaudens decided that in the face of no evidence either for or against an afterlife, he would believe that "the mystery" is "beneficent" and that human destiny must be inexorably progressing to a higher life. Though he equated this view with the general public conception of Darwinism, it did not originate with Darwin's writings; rather, it reflects the popularized views of the British philosopher Herbert Spencer (1820–1903), whose evolutionary thought in America was widely confused with Darwin's.

THE AMERICAN RESPONSE TO CHARLES DARWIN

When Americans finally began to pay close attention to Darwin's *Origin of Species* in the 1870s, the response to his studies approached the dimensions of a hysteria, because it was sensed that Darwin had effectively and deliberately destroyed previous justifications for the idea of nature as designed.[9] During the first three-quarters of the century clergymen who doubled as scientists, such as William Paley (*Natural Theology*, 1802), had convinced both the scientific community and the lay public in America that God created new species by directly intervening in the natural order through miracles or mysterious natural processes. The geological record, they taught, proved that the earth was a product of a grand cosmic design: nature was a reflection of Divine Mind and purpose. During the 1850s, however, positivist science, which was limited to describing observable phenomena in the natural world, was winning more converts in England, where Darwin was only one of many practitioners of this new empiricism. Hodge noted that natural selection had been a feature of the scientific

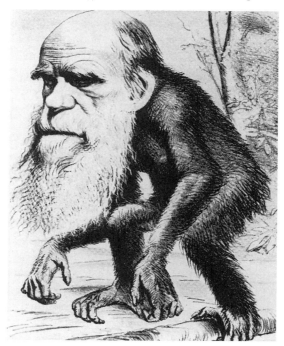

FIG. 1.1. *Cartoon of Charles Darwin as an ape. From* The Hornet *(March 22, 1861).*

discourse for some time but that Darwin's version of natural selection, with its attendant violence and randomness, forced people to choose either the orthodox view of creationism or the new positivism of Darwin. Such a description of nature, "red in tooth and claw," could not be a reflection of the Divine Mind. The hostility Darwin encountered in America largely emanated from the overlap of the new positivist paradigm with the old creationist worldview (see fig. 1.1).

The cardinal tenet of creationism centered on the idea of purpose in nature, the idea that the world was moving toward a predetermined end. Darwin countered this model by describing the evolution of nature as a process of natural selection marked by random and purposeless variations. Though he was persuaded that the world was governed by natural law, as opposed to the catastrophe, miracle, or caprice of a Creator, he also made room in his theory for evolution through chance variations and adaptations in nature and even "a leap from structure to structure" in the evolutionary chain. During his journey to South America (1831–1836) on the

H.M.S. *Beagle* Darwin had recorded mismatches between species and their environments: for instance, web-footed geese that live on land instead of in water and woodpeckers that inhabit treeless terrains. He also found innumerable habits of animal behavior wasteful: for example, the overproduction of eggs. It seemed impossible, then, to maintain that organisms were harmoniously adapted to their environment, in consonance with a designed world, as the creationists avowed.[10]

More loathsome yet to liberal Protestant Americans was Darwin's insistence on delineating evolution as a process in which nature was laid waste by a brutal struggle for existence. Not only did his dysteleology arouse fears that in the plenitude and superfecundity of nature, mutation, miscegenation, randomness, and ugliness formed the basis of natural law, but the distinct possibility of an extinction of species Darwin described excited a philosophical and religious ferment that is "hard to overestimate." Darwin's theory of natural selection held that within the randomly distributed variations of any species, those organisms that win the struggle and reproduce are those who are best adapted to the environment. In arriving at his "principle of preservation," he had interpreted the animal world through the English social paradigms of middle-class domesticity and social strife, drawing particularly on the novels of Charles Dickens and the essays of Thomas Malthus.[11]

The social economist Malthus had observed that human population growth continually tends to outstrip the food supply, a situation which then results in power struggle, or famine and disease, which in turn limits the size of the population. Darwin made certain that no reader could go away from the *Origin* without a sense that power struggles and carnage in nature were indisputable features of the law of life. One such page of *Origin* that "distills the essence of Darwinism," for example, refers in six separate places to the struggle for life and the extinction of species. Privately ruminating on the appalling—even seemingly diabolical—scheme he had laid out, Darwin himself reflected, "What a book a devil's chaplain might write on the clumsy, wasteful, blundering, low, and horribly cruel works of nature!"[12] His nineteenth-century American reader agreed. Charles Eliot Norton responded in kind: "In a large sense the moral law prevails in the long run, and man, perhaps, slowly improves, but 'how blundering, wasteful and horribly cruel' seems the process!"[13] The tension Darwin created was between the natural world, whose laws he had revealed to be based on bloody, purposeless struggle, and the traditional idealist belief in a beneficent God, whose goodness was manifest in the order and beauty of nature and humankind.

Darwin was one of a number of British scientists who labored at midcentury to get the "parsons" out of science, as T. H. Huxley remarked, and to keep God out of the workings of nature. Neal Gillespie has shown that Darwin's belief changed over the course of his life: his orthodoxy began to wane in the 1830s and then was subsumed into agnosticism in the 1860s, as he became increasingly committed to pursuing positivist science and establishing the purely natural causes of evolution. In fact, Darwin characterized his own beliefs as "hopelessly muddled" and "constantly shifting" between doubt and faith in the existence of a personal God. Darwin was not an atheist, as Hodge accused him of being, but his early Calvinist beliefs allowed him to think of God as a remote Deity who was separate from nature, rather than identical with and immanent in the world. In the *Origin* Darwin related that nature moved as a result of the laws "impressed on matter by the Creator." For Darwin, God was beyond trifling with the material minutiae of nature and was absolved of creating cruelty and waste in the world, but then, consequently, was bereft of omniscience. It was only in this manner that Darwin was able to acknowledge the terrible workings of natural selection and at the same time to see God's goodness as unimpaired by the apparent evil in nature.[14]

HERBERT SPENCER IN AMERICA

Within ten years of the publication of the *Origin*, the irreconcilability of Darwin's vision of nature with beliefs common to nineteenth-century Protestants contributed to the rise of an anti-Darwinian school of evolutionary thought. In the post-Darwinian controversies, one set of personal anxieties centered on the question of death, the human soul, and the afterlife, while another, more public, issue involved the national self-identity. Americans sought an accommodation between religion and science because their definition of themselves as a nation hinged on the self-image of a religious people elected by God to do his work in the world.[15] The philosophy of science developed by Herbert Spencer provided that accommodation. For those whose view of the world was darkened by Darwin, Spencer's theories provided the lens through which the world could again be viewed brightly. Where Darwin's work was limited in scope to a biological theory, Spencer's monumental ten-volume *System of Synthetic Philosophy* (1862–1896) expounded on an audacious array of topics, applying evolution to subjects as diverse as fossil life, linguistics, manners, morals, fashion, child rearing, the rights of women, psychological phenomena, education, political history, architecture and the fine arts, and

everything in between. Though his observation of biological law was directed by English social paradigms, Darwin confined the *Origin* to countering creationism in science. In contrast, Spencer's opus had the immense attraction of moderating the horrors of natural selection by emphasizing the more promising evolutionary mechanism of peaceful adaptation to the environment. In public, however, Darwin repeatedly professed great admiration for Spencer's work and dubbed Spencer "the great expounder of the principle of Evolution" because Spencer had assaulted creationism in expositions on natural selection and environmental adaptation even before Darwin's *Origin*. At the same time Darwin complained in private that Spencer's discussions were of no use to him.[16]

Spencer not only differed immensely in methodology from Darwin but he also derived his system from another school of evolutionary thought altogether—not from Paley's but from Lamarck's. American scientists were so won over by Lamarckian evolution, in fact, that Lamarckianism was known as the American school of evolutionary thought. Jean-Baptiste Pierre Antoine de Monet, Chevalier de Lamarck (1744–1829), had formulated an evolutionary system in which environmental adaptation was the primary mechanism of change. In Lamarck's science change within a species occurred as organisms adapted to their environment. This newly adaptive behavior became habitual, then instinctive, and in the course of a single life span was finally passed on to the next generation. Lamarck thus privileged habit, memory, inheritance, and mind. Lamarckian evolution was largely a chronicle of the evolution of the mind, which preserved the all-important elements of will and intentionality. Most crucial for American scientists was the way in which Lamarck preserved the eighteenth-century sense of providential progress in the world, for he determined that the forces that propelled animals from lower forms to higher, and then culminated in humans, were innate and imbued with divine powers, set into motion by God. As opposed to Darwin's orthodoxy, which kept God separate from nature, Lamarck's science mandated an inherent pantheism in the movement of nature.

American Lamarckian scientists such as Joseph Le Conte and George Cope regarded Darwin's principle of natural selection as wasteful and cruel, which for them made Darwin's theory of evolution an inadequate description of the way in which their immanent God manifested his goodness in natural law.[17] As one of a number of scientists dedicated to the task of ridding science of religion, Spencer did not intentionally pander to such overtly religious thinking; however, the reconciliation of evolution with religion occupied a considerable portion of space in his *System of*

Synthetic Philosophy, First Principles (1862). Spencer's single organizing principle allowed order, harmony, and unity to be discerned in nature, and in Lamarckian and Spencerian evolution natural selection played a subordinate role to the extent that it became almost entirely inoperative in the development of civilized human societies—a point on which Darwin concurred.[18]

Spencer arrived at his comprehensive law of evolution by deduction from Lamarckian assumptions and from Karl Ernst von Baer's biology, in which animals were graded from simpler lower forms to complex higher forms in keeping with the Great Chain of Being.[19] Spencer recorded the essence of his theory:

> Evolution is an integration of matter and concomitant dissipation of motion; during which the matter passes from an indefinite, incoherent homogeneity to a definite, coherent heterogeneity; and during which the retained motion undergoes a parallel transformation.[20]

Such pronouncements were derided by Spencer's British contemporaries as nonsense. Darwin, for example, had rejected Lamarck's idea of progression, as well as any hierarchical movement that placed humankind at the apex. Yet Spencer's thought remained attractive to Americans because it was so generalized that it could be applied to any form of development, physical or social.

While he was rejected by some American theologians and academics, Spencer won an impressive number of followers through his influential popularizers, for example, Henry Ward Beecher and John Fiske. In the decades following its publication, the American sales of *Synthetic Philosophy* rose to five hundred thousand volumes (including unauthorized editions). Although Darwin's notoriety was greater and his name became popularly attached to the notion of evolutionary science—even to Spencer's ideas—he continued to evoke odious associations for orthodox believers while he was reverenced by those agnostics who valued the most rigorous scientific truth. Because Lamarckian and Spencerian theories were acceptable to their liberal religious beliefs, however, most Americans, including the major evolutionary scientists, accepted Lamarckian—in other words, non-Darwinian—forms of evolution via Spencer.[21] So profound was Spencer's impact on late nineteenth-century Americans that John Dewey remarked that "even non-Spencerians must talk in his [Spencer's] terms and adapt their problems to his statements."[22]

Spencer's main attraction for Americans was the allure of religious

coherence buttressed by the authority of scientific truth. Spencer intended his science to be a new natural religion of evolution that would supplant orthodox Christianity.[23] If this posture seems to be sheer arrogance on Spencer's part, it nevertheless reflects the evangelical zeal and purpose with which he set into the enormous task of interpreting evolutionary process as a saga of the perfectibility of human life. In adapting evolution to religion, a vague and flexible use of language proved to be enormously efficacious. The very beginning of *First Principles* introduced his method, as he promoted a brand of agnosticism in which "in its ultimate essence nothing can be known," neither the reality of religion nor the reality of science. Spencer wrote, "the Power which the Universe manifests to us is utterly inscrutable." Spencer's vague terminology thus left the discourse open to theological speculation, and Americans easily substituted the word *God* for his Unknowable.[24]

In terms of its implied social and political ideology, the *Synthetic Philosophy* received a meager appreciation in England. Again, its most enthusiastic admirers were to be located in the conservative American middle-class, who saw Spencer's principles (heterogeneity and liberty) as giving scientific validity to the claims of individualism and *laissez-faire* economics as progressive tendencies.[25] Since heterogeneity was a sign of evolutionary progress, America's policies of free enterprise—individuality and competition in business, numerous religious groups, social diversity and democratic political system, and pacifistic industrial development—all seemed to mark the nation as the exemplar of Spencer's most highly evolved societies.[26] Americans were so receptive to Spencer's evolution then because his thought buttressed the inherited ideology of the Northeast, in both its socioeconomic aspects and its religiophilosophical aspects.

In the Northeast the Unitarians and Transcendentalists basically adumbrated Spencer's liberal Protestant beliefs, since the thought of both Spencer and these American elites sprang from the same roots in Kant's and Hegel's idealism. At least three decades before the Civil War, Unitarians began to broaden Protestantism, opening up religion to the demands of contemporary life. They addressed current scientific and philosophic issues, as well as the basic problems of secular life, in their sermons. Rejecting the rigorous intellectualism of theology and a cataclysmic view of history, Unitarian ministers such as William Ellery Channing called for a religion of feeling and a religious mode that was more passive and dependent on mind rather than activist and militaristic.[27] Ann Douglas has connected the investment of passive, intuitive modes of knowledge with religious authority to the early nineteenth-century stereotyping of women

as godly. Examining this process, she discerned that a newly "feminized" American culture had displaced the old masculine ethos, the hard-mindedness of Calvinism.[28]

But if the assault positivist science and biblical criticism were making on orthodox Christianity is added to Douglas's picture of liberalization, it becomes obvious that Protestant ministers were maneuvering defensively, attempting to get religion out of the line of fire by removing it from the intellectual sphere to the affective realm of art and poetry. Christian apologists set the trend for the rest of the century by availing themselves of Schleiermacher's definition of religion as mystery and feeling. Just as William James would later argue, religion and science were held to be equal but separate endeavors, and religion was thus protected from the rational analysis of science. Believers could take shelter from the cruel world of Darwin in the vagueness of Spencer and the religion of feeling. Protestant religious figures such as Horace Bushnell, Henry Ward Beecher, and Ralph Waldo Emerson took active roles in this transformation, in serving as authorities on evolution and culture and in reconciling America's traditional ideological investments with the new science.[29]

SPENCER'S AMERICANIZATION

The decade of the 1880s brought an accommodation of traditional American beliefs with Spencer's evolution. According to James Turner, earlier in the century Emerson's radical doctrines of divine immanence in humankind and nature were accepted in their entirety by very few outside of Boston. By the end of the Civil War, however, Americans had incorporated Transcendentalism into Protestant evangelicalism. Emerson's humanism intrigued confirmed believers as well as dissenters. The agnostic Charles Eliot Norton, for example, declared in 1866 that he could find no American writer whose work he valued more than Emerson's.[30] From the late 1870s onward the major American literary periodicals *Scribner's Monthly* and *The Century Magazine* featured a series of reverent articles on the Concord seer.[31] And when Emerson died in 1882, the nation was in the throes of a full-fledged revival of Emerson's philosophy. After his death the outpouring of praise for him reached a crescendo matched only at the centennial of his birth in 1903.[32] In that year Charles William Eliot, the president of Harvard College, recounted that though Emerson's thought had seemed meaningless to him when he was young, it had grown richer for Eliot as he matured. Eliot asserted that this was due primarily to the fact that during the last few decades of the century Emerson's philosophy had gained

support from developments in other fields, namely religion and social theory.[33]

Eliot might have cited evolutionary theory as well, for Emerson's pantheism seemed to converge with Spencer's natural religion of evolution. This convergence had its roots in Emerson's embrace of Lamarckianism as early as 1844, when he wrote in his poem "The Poet" that "within the form of every creature is a force impelling it to ascend into a higher form."[34] Retreating to an awestruck position of passive observation in the face of divine forces and evolutionary processes he deemed providential, in his writings after 1840 Emerson anticipated Spencer's hopeful yet deterministic spiral of progress. The transition from Emerson's cosmos—unified, harmonious, and ever in flux—to Spencer's fluid world of energy was effortless for Americans who favored religious pantheism. Spencer's nature, moving in a harmonious manner toward a higher, more complex form of life, plainly seemed to offer a welcome, scientifically confirmed version of Emerson's familiar world of unity-in-diversity. Thus did Emerson's Oversoul find its late nineteenth-century correspondence in Spencer's Unknowable, the supreme power or absolute existence that can be sensed in consciousness.[35]

The alliance of Spencer's evolution with Emerson's pantheism was most successfully preached and popularized by John Fiske. Endorsed by Spencer himself as his American mouthpiece, from the 1870s onward Fiske was the most important conduit for Spencer's evolution to the upper-middle-class, Anglo-American populace of the Northeast, the socioeconomic group that still dominated America's cultural enterprise. A resident of Cambridge, Massachusetts, from 1860 until his death in 1901, Fiske first came to terms with the Scottish empiricists, Comte, Darwin, and Spencer in the meetings of the Cambridge Metaphysical Club in the 1870s, which counted among its members William James, Chauncey Wright, and Charles S. Peirce. Though Fiske never won a place on the faculty at Harvard, his importance to the history of this period derives from the particular meaning of evolution that he gave to America's most influential class. Fiske's success on the lecture circuit had no match in the nineteenth century perhaps, except for Emerson, whom he followed as the nation's foremost popular philosopher. His lectures on the evolutionary support for traditional Protestant theology drew thousands, and his several influential books disseminated the same message in a more permanent form.

Fiske was almost single-handedly responsible for the shift of focus in the evolutionary discourse during the last quarter of the nineteenth century, when Americans turned their sights away from the origin of species toward

the progress of civilization. To agree with Spencer that humans were different in kind from animals was to subordinate issues of biology to issues of culture. More was at stake in the potential glories of human destiny than in the certain savagery of the animal kingdom. From the *Outlines of a Cosmic Philosophy* (1874) to *The Destiny of Man Viewed in the Light of His Origin* (1884) and *The Idea of God* (1885), Fiske's publications chart his mellowing from a confrontational positivist viewpoint to a liberal Spencerian position. At first he stridently called on Christians to depersonalize God, in line with his commitment to a rationalized "pure religion." After 1882, however, Fiske described Spencer's evolutionary scheme in traditional Christian terminology, and finally, after 1885, reasserted that the perfection of humankind in America was the final outcome of universal evolution.[36] For Fiske, the Supreme Power was immanent and yet transcendent, manifest in all forms of the universe and yet greater than the universe, and so unknowable. Since he identified God's presence with nature, Fiske rationalized the problem of evil (pain, suffering, and death) in the world as a function of the evolutionary struggle, a small but necessary part of the process by which the undesirable elements would be purged from existence as humankind slowly evolved toward perfection. God worked, then, through natural selection, ensuring that the best and the good survived. As Fiske realized, this reasoning came very close to the sentiments of Emerson.[37]

Predictably, the human soul was the central concern in Fiske's theological evolutionary program, as it was in Emerson's writings, in contrast to Darwin's universe, in which the human presence was marginalized. In *The Destiny of Man* (1884) Fiske concluded that "the dominant aspect of evolution was to be not the genesis of species, but the progress of Civilization" and that "Man" is "the consummate fruition of creative energy, and the chief object of Divine care."

> The creation of Man is still the goal toward which Nature tended from the beginning. Not the production of any higher creature, but the perfecting of Humanity, is to be the glorious consummation of Nature's long and tedious work. . . . In the deadly struggle for existence which has raged throughout countless aeons of time, the whole creation has been groaning and travailing together in order to bring forth that last consummate specimen of God's handiwork, the Human Soul.[38]

Soul, mind, psyche, and consciousness all had divine connotations in Fiske's interpretation of Spencer, and these terms became somewhat inter-

changeable in late nineteenth-century usage. Determined that the nature of the universe must be understood in psychical, and hence religious, terms, Fiske persuaded Spencer to agree with him on the distinction between *psyche,* a word not yet bereft of spiritual connotation for Fiske, and *nerve,* which he wanted to be understood in a completely physiological sense.[39] Derived from the laws of thermodynamics, Spencer's term *energy* described the underlying principle of unity in the universe, while *force* referred to a concentration of that energy. Fiske gave these terms a more religious cast. In his writings they became a "spiritual force" and a "divine psychical energy" that according to him pervaded all things in the universe but welled up and was concentrated only in humankind, conferring upon it a semi-divine status.[40] Fiske wrote,

> The conscious soul is not the product of a collocation of material particles, but is in the deepest sense a divine effluence. According to Mr. Spencer, the divine energy which is manifested throughout the knowable universe is the same energy that wells up in us as consciousness.[41]

The development of refined, civilized human beings could also be explained by the physiological processes of adaptation—specifically, the constant exercising of intellectual faculties so that the cerebral surface had vastly increased. Fiske combined Spencer's ideas on the growth of human intelligence with Alfred Russel Wallace's supernatural evolution toward spirit by declaring that the level of human intelligence was multiplying at a constant rate from generation to generation, in the process of the human organism's adjustment of its inner self to its outer environment. This increase in turn promoted greater imaginative powers and sympathetic feelings in individuals. Higher, more complex societies were not competitive but cooperative and altruistic, not militaristic but peace loving. The progress of civilization thus rested on the close connection between man's physical and moral natures.[42]

In *The Idea of God as Affected by Modern Knowledge* (1885) Fiske identified the nineteenth century as the era in which the perfection of the human soul would occur. In making this assertion Fiske invoked the authority of science. Evolution simply reconfirmed what Americans wanted to continue to believe: the received millennial mission of American Protestantism in which the New World had been divinely ordained to fulfill Christian history. Yet Protestantism had been recast by evolutionary thought into scientific language with its attendant authority. Man's "appearance

upon the earth marked the beginning of the final stage in the process of development, the last act in the great drama of creation." The influence of natural selection on humans was soon "coming to an end," so that humankind's refinement would be accomplished solely through the growth of the mind—"the ever increasing predominance of the life of the soul over the life of the body."[43]

WILLIAM JAMES'S CRITIQUE OF SPENCER AND DARWIN

Some sense of the American dissent from the materialistic and mechanical universes of Spencer and Darwin and the idealism of Fiske and the Transcendentalists can be gained from the writings of William James (1842–1910). James deplored determinism in any philosophic guise, whether it was the positivist science of Darwin, the mechanistic philosophy of Spencer, or the monotheism of the idealists. Even as he sought to formulate an alternative, however, his critique was conditioned by that idealism, which reveals in turn how nearly impossible it was for Americans in this period to define the evolutionary controversy outside the paradigm established by Spencer and Fiske.[44] James's problem with the popular forms of idealism encountered in Spencer's work, for example, centered on their inability to come to terms with evil in nature and in civilization. His articulation of this problem clarifies the crisis of faith evolutionary thought precipitated in Anglo-Americans, and by extension the social crisis and the proposed remedies to it that were supported by evolutionary arguments.

Evil had little or no place both in Spencer's vision of higher civilizations and in Emerson's Oversoul, in which the natural and human orders were unified. A belief common to these idealists was that individual minds are partial manifestations of the one absolute Divine Mind that encompassed the universe. The Transcendentalists saw nature as inherently good and humankind as perfectible, largely ignoring the presence of evil in the world.[45] Spencer had similarly minimized the reality of pernicious tendencies in nature and in 1865 proposed that "all evil results from the non-adaptation of constitution to conditions." Evil amounted to disharmony, as he said, a "want of congruity between the faculties and their spheres of action," while imperfection was merely a lack of fit between the organism and its "conditions of existence."[46] In the last quarter of the nineteenth century liberal Protestants and progressive evolutionists echoed his devaluation and rationalization of evil as maladjustment, seeing misadaptation to the environment as a result of wrong habit or action that was capable of being corrected by education and socialization.[47]

For the better part of his career James pitted himself against the unitary view of the cosmos, just as he and his pragmatist colleagues in Cambridge during the 1870s focused on the existence of the unseen world as their central problem in rejecting Spencer's materialistic philosophy.[48] The great inadequacy in such philosophic theisms as Royce's influential Absolute Idealism, he stated, was their "tendency to become pantheistic and monistic, and to consider the world as one unit of absolute fact." James decided that the root of the Protestant religious despair of the 1880s and 1890s resided in the inability to reconcile the evil, now revealed by Darwin's science, with traditional pantheistic beliefs in God as "All-in-All" and in nature as deity and absolute good. As a result statistics told the tragic story, he said, of thousands of suicides committed in recent years. Absolute Idealists only perpetuated the dilemma: in a manner recalling the ill will Lamarckian evolutionists expressed toward natural selection, they treated evil as "an alien unreality, a waste element to be sloughed off and negated, . . . if possible, wiped out and forgotten."[49]

In contrast, James urged Americans to conceive of the universe as pluralistic, a world in which evil was recognized as an aspect of reality that must be strenuously combatted.[50] The model of a multidimensional, pluralistic universe appeared to offer a solution to the determinism of the pantheists, whose Emersonian world of unity-in-diversity precluded the existence of evil as well as the possibility of an open-ended universe. Pluralism evaded the relegation of humans to miniscule parts of a solitary godly consciousness, and it admitted the possibility that the cosmos could still harbor worlds unknown to human consciousness. The shape of the universe, then, James concluded, might be polymorphous *and* pantheistic. Though at the end of his life James more and more approached Royce in the belief that "God was a consciousness greater than ours," he continued to dissent from Royce's idealism in refusing to see this consciousness as "all-embracing."[51] And although James remained an agnostic until his death, he never stopped hoping to find proof for a transcendent spiritual realm beyond that of normal existence. Thus James devoted a significant part of his career to investigating the legitimacy of spiritualist mediums, because it seemed to him that those who professed mystical religious experiences held the greatest promise of determining if the unconscious mind, as the seat of these experiences, was the conduit for divine influx from that higher realm.[52]

If James was dissatisfied with the metaphysical limitations of idealism, he was, however, in agreement with Spencer, Fiske, and Royce on the

preeminent place of the active mind within the scope of the individual life. The vitality of the mind, they concurred, played a critical role in the success or failure of the individual's adaptation to the environment. James made the "will to believe" (or the right to believe) a central cause in the lectures he addressed to the educated lay public and the essays he published in mainstream literary journals. Empirical proof for a higher realm or for life after death is irrelevant, James said, if belief in that realm helps us to live better. Living well—or our successful adjustment to our environment— was proof enough. Fiske had come to a similar conclusion in 1889, that belief in God must be true if it assists human progress.[53]

Spencer not only offered balm to the psyche plagued by doubt but also gave advice on practical ways in which modern life could be perfected. These admonitions were delivered at Delmonico's restaurant in New York after his northeastern tour in 1882. Drawing on his version of evolution in which nurture predominated over nature, the British philosopher ob- served that the quandaries confronting Americans resulted from their misadaptation to the environment in the form of bad habits—primarily overwork, an abundance of nervousness, and unrest. Spencer held that Americans could avert the struggle for existence, in which the fittest, but not necessarily the best, survived, if only they would allow progress to unfold by living a complete, full life, balancing body with mind, work with pleasure, discipline with relaxation. Addressing his remarks to America's upper classes, he preached a "gospel of relaxation" and warned that "Na- ture quietly suppresses those who treat thus disrespectfully one of her highest products, and leaves the world to be peopled by the descendants of those who are not so foolish." "Damaged constitutions reappear in children," and competitors would take advantage of their weakness. Spen- cer ended on a more optimistic note, ensuring that progress was inevitable, if Americans would only cultivate strength through rest, and thus preserve and pass on the best characteristics of the race.[54]

The notion of self-culture as a means of individual and social perfection had a long history in the United States before Spencer. The Puritans' belief in life as a course of spiritual refinement is reflected in the host of diaries and journals that speak of their obsession with inventorying and guiding the soul toward spiritual grace. The Unitarians not only kept this tradition alive, but ministers such as the formidable William Ellery Channing also encouraged the use of art and literature as forms of self-refinement, adapt- ing secular culture to religious ends. Emerson, for whom the experience of art provided a moment of self-culture, devoted himself to the same cause

and pushed this Unitarian program to its logical extreme by calling for the endless evolution of the soul toward perfection.[55] His students, such as James Freeman Clarke, continued to address this program in the 1870s, with a series of lectures published as *Self-Culture: Physical, Intellectual, Moral, and Spiritual* (1880).[56] What was primarily a religious process for Emerson, however, became for William James a therapeutic prescription for the psyche.

Although James rejected much of Spencer's thought, his interest in psychological therapy led him to draw on Spencer's perception of American ills as the result of overwork. Shortly before Spencer's tour of New York and New England the physician George M. Beard published his analysis of America's psychic unrest, *American Nervousness*. Beard's diagnosis of modern problems as a result of overwork and the frenzied, mechanical rhythms of urban life prefigure Spencer's observations, but his treatment of ruined nervous systems differed in its prescription of enforced passivity rather than moderation. James too found an "absence of repose," a "lack of inner harmony," and a "bottled lightning quality in us Americans" to be symptoms of distress, and, recalling Spencer's "gospel," he endorsed the power of relaxation, whether perceived as leisure activity or the experience of divine influx, to revitalize men and women.[57]

The mind-cure movement offered one popular method of fighting nerves and depression through relaxation, and James enthusiastically threw his weight behind it both publicly and personally. Describing this therapy as the religion of the future because—according to James—"it worked," at least at three different times in his life James himself went through the process of mind cure for the relief of his recurring neurasthenia. Called New Thought after the turn of the century, mind cure brought together prevalent concerns with the unconscious and evolutionary naturalism, with ideas drawn from Berkeleyan idealism, Eastern religions, Christianity, and Emerson. As it ministered to the psychological distress and the religious needs of American Protestants, the spread of this fledgling form of psychotherapy widely throughout the Northeast and Midwest was enabled through the proliferation of a literature in the form of small, inexpensive pamphlets. One of the earliest and best known of these booklets was Prentice Mulford's series *Your Forces, and How to Use Them*, published in the late 1880s in New York. Mulford's version of mind cure typically taught relaxation through meditational techniques, through "holding" a reassuring thought, or even through losing oneself in a soothing visual image, real or imaginary. If self-practice proved to be ineffective, the

sufferer could always employ the assistance of a mind curist (who was sometimes a Christian Scientist), as James did. In theory, the mind curist instructed the initiate to relax and let go of conscious control, at the same time yielding the ego to the flux of unseen energy forces.[58]

It is obvious that an army of savants in the fields of evolution, philosophy, social science, and literature were teaching late nineteenth-century Americans to think of the mind as an instrument of social adaptation and individual self-perfection. But, in addition, mind curists were promoting the idea of the unconscious as the link to the mysterious unseen world James was seeking as well as to the higher, infinite realm of the idealists. Thus meditational experience presumably utilized the unconscious mind to tap into the larger unconscious life of nature and the cosmos. Through meditating one could get "in tune with the infinite" and experience a personal renewal that was simultaneously psychological, spiritual, and physical.

Mind cure was just one of a variety of panaceas through which Spencer's paradigm of mental and physical "relaxation" or "repose" entered the mainstream of American liberal culture in the 1880s and 1890s. Repose became a buzzword for the educated classes, who were harassed by the competition of the marketplace and constricted by social conventions. As a regular practice, it might take the form of active relaxation through outdoor exercise such as bicycling, golfing, or eugenic dance, or assume the form of inward, passive revitalization such as pleasure in aesthetic experience or meditational exercise.[59]

James's endorsement of mind cure as a therapeutic and religious program was obviously aimed at his middle-class peers. Affirming the capacity of the mind to act, rather than to remain passively subordinate to natural processes, was James's response to the spectre of a deterministic and godless universe that confronted Americans in the wake of Darwin. But if mind cure was effective in ministering to the neuroses of his social group, it was impotent in the face of the larger social problems that confronted the country in the last quarter of the century. Rooted in the liberal Protestant ethos of the northeastern community, this therapy could have little relevance to the lives of the underprivileged groups newly created by patterns of immigration and industrialization. When it came to considering the injustices that were meted out to immigrants and laborers, both James and Royce showed themselves to be either naive or not very critical of the status quo, though the Progressives of the next generation seized on the implications of their pragmatism in recommending social action.[60]

THE QUESTION OF SOCIAL EVOLUTION

Like most American philosophers and scientists of their era, James and Royce saw it as their duty to explain to the public the implications of evolution for the meaning of human existence. But as members of the northeastern intelligentsia, they also acted effectively to console Anglo-Americans and reinforce the social and religious discourses inherited from their New England forebears.[61] As Gillian Beer has noted, evolutionary scientists thought of themselves as speaking not only to each other but also to the educated lay public, as they endeavored to discern the significance of their findings for civilization.[62] Their discourse was rooted in the language of other disciplines, such as literature, history, and philosophy, and its metaphors and paradigms fed other fields throughout the late nineteenth and early twentieth centuries. As we will see shortly, Spencer's and Darwin's paradigms had profound repercussions for the visual arts and architecture, as artists and architects were called on to help direct the course of American social evolution.

In the 1880s, when the cities seemed to have become Darwinian environments overnight, James's audience sorely needed reinforcement and required even more reassurances about the meaning of evolution for social progress. With a trepidation equal to their fears of natural selection, Anglo-Americans suddenly found themselves facing a staggering influx of non-WASP immigrants. In the Northeast and Midwest Catholic and Jewish peasants from the south and east of Europe threatened soon to overwhelm the descendants of the original Anglo-Saxon settlers. From 1860 to 1900 a full one-third of the population was comprised of immigrants. Some eleven million entered America during this period, with the result that by the end of the century 60 to 80 percent of urban dwellers in America's largest twelve cities were foreign-born or of foreign parentage. The large urban industrial centers were now sites where the Darwinian principle of "survival of the fittest" took on real meaning in human terms.[63]

With these events the loss of the Anglo-American hegemony loomed as one of the most worrisome issues pressing on northeasterners. Intensifying their sense of investment in the old order were their Puritan beliefs, particularly that of their self-identity as divinely ordained architects of world progress—beliefs that had been inculcated through literary and religious traditions. Darwin, for example, was in 1872 merely the latest in a long line of historians, ministers, and scientists to give the doctrine of America as an elect nation a foundation that was now "scientific." The "wonderful progress of the United States, as well as the character of the

people, are the results of natural selection," Darwin stated, the culling out of the most energetic and bravest. Drawing on the observations of a contemporary Anglican minister, he went on to assert that the history of the Western world, beginning with the " 'culture of mind in Greece' " and ending with " 'the great stream of Anglo-Saxon emigration to the west,' " demonstrated the advance of civilization.[64] Anglo-Americans also prided themselves on being the caretakers of the democratic form of government, which in Spencer's terms was the most highly evolved political form. During his trip to New York, ten years after Darwin's statement, Spencer predicted that the United States would achieve a "civilization grander than any the world has known" and that "the allied varieties of the Aryan race forming the population will produce a finer type of man than has hitherto existed," if Americans could eliminate the stresses damaging to successful adaptation.[65] The most significant exponent of these ideas, however, was again John Fiske, who promoted American history as the agent of evolutionary progress.

Beginning in his lectures in the early 1880s, Fiske presented a new version of the earlier nineteenth-century millennial dream. The identification of the American mission with the coming of God originated with the Puritans' arrival in the New World; the Revolutionary War renewed this conviction, which was again reinvigorated by the Northern victory in the Civil War and the ensuing decade of material prosperity. In one sense, Fiske merely brought these traditional assumptions up-to-date, advancing them with new evidence gleaned from recent histories of political and social organization. Drawing on the ideas of Edward Augustus Freeman, as well as those of other historians, Fiske framed Freeman's notion of the Anglo-Teutonic ascent of the free, self-governing political state in terms of Spencer's conception of evolutionary history—the universal progress toward a peaceful world state.[66]

The demand for his evolutionary history of the Anglo-American community was so great that Fiske repeated his most popular lecture, "Manifest Destiny," fifty times in England and America in 1879–1880, including seven times in Boston alone, and published a series of articles on this theme in mainstream American and English literary periodicals.[67] The fifth and most important article of the series, again titled "Manifest Destiny," as it appeared in *Harper's New Monthly Magazine* in 1885, clearly laid out the process by which the non–Anglo-Protestant immigrant masses would be assimilated through cultural adaptation into the peaceful and freedom-loving English-speaking races.[68] As Fiske's biographer, Milton Berman, has observed, Fiske justified America's renewal of the doctrine of Manifest

Destiny, which had been temporarily jettisoned during the Civil War, on a global scale at the turn of the century, underwriting the surge of nationalism that would culminate in Teddy Roosevelt's admonition to Anglo-American men to complete the evolution of civilization through a Darwinian struggle of races.[69]

Fiske directed his message to the descendants of the Puritans—primarily upper-middle-class Unitarians, Congregationalists, Presbyterians, and Episcopalians—who still held control of American cultural and political institutions firmly within their grasp. Reassuring the northeastern elite of their superior place in world history, he claimed that the future was theirs. "The conquest of the North American continent by men of English race was unquestionably the most prodigious event in the political annals of mankind," he asserted. Ominously portending America's imperialist policies in the early twentieth century, Fiske declared that the day was not far off when the whole world would be "English in its language, in its religion, in its political habits and traditions, and to a predominant extent in the blood of its people."[70] Providential evolution had reached its ultimate goal with the settlement of the peaceful homesteads of the Northeast. Like the highest forms of Spencer's evolutionary process, the democratic federation of the United States was unified yet heterogeneous, peaceful yet complex.[71]

Fiske thus delivered to his audience exactly what it needed to hear at this hour. The heads of the leading northeastern cultural institutions joined him in his antiforeign, filiopietistic invective. Charles Eliot Norton, dean of Anglo-American culture at Harvard in these years, for example, feared the growing political strength of Catholic immigrants and those he deemed "destitute of ideas and the power of initiative action."[72] Until the last quarter of the nineteenth century the country had been culturally homogeneous, since it was composed of an "allied mixture of the Aryan races," as Spencer put it in 1882. With the subsequent emergence of a social and religious plurality in this period, Spencer's followers translated the idea of natural selection into social terms as both a "competition of races" and a "conflict of cultures." It was this potential catastrophe that would be averted, Fiske reassured his audience, through the adaptation of foreigners to the American environment and their assimilation into the fabric of traditional American culture.

The problem of assimilation hinged on the debate over the primacy of nature or nurture: that is, whether human character was limited by "racial" inheritance or was formed by the environment. That "men were made by their environment" had been a tenet of the Enlightenment philosophy

deployed by the English middle class and Dissenters in their bid to depose the hereditary rights of the aristocracy. Spencer's sociology, which was rooted in this tradition, suggested that the strife and competition endemic to the lower orders of civilization could be avoided by controlling the quality of the environment, since organisms, in their adaptation to the environment, were impressed with its character.

Only in the presence of a "fit environment"—namely, the educational processes lacking in the "primitive cultures"—could the "higher intellectual faculties" be produced which in turn fostered altruistic and peaceful behavior. Spencer had in mind here that individuals in complex societies adapted to the environment through the agency of cultural practice, which meant that primitive man was limited in cultural growth not only by his lack of a fit environment but also by his lack of "capacities that only progress could bring." To be a social scientist in America from 1890 until 1910 by and large meant to be a student of mental evolution within the discourse established by Spencer's *First Principles,* which held that the history of human culture was a correlate of the growth of human brain size. In this tradition that "hardened into dogma" human evolution was constructed as a pyramid that progressed upward from culture grade to culture grade, from the state of savagery, to barbarism, to civilization, pushed along by Aryan and Semitic families until the Aryans alone ascended to the top, their mental "superiority" both a "cause and a product of their ascent." As George Stocking recounts, "their large brains . . . were products of their cultural evolution; but their cultural evolution was at the same time conditioned by environmentally acquired racial characteristics." Thus a "raciocultural hierarchy" was assumed in which "civilized men, the highest products of social evolution, were large-brained white men, and only large-brained white men, the highest products of organic evolution, were fully civilized." Moreover, the hallmark of the most civilized society was a democratic governmental structure, which as Fiske asserted placed the Teutonic/Anglo-Saxons at the top—the United States representing the apogee of this evolution.[73]

This idea that cultural characteristics and social behavior were shaped through adaptation to the environment was given added weight in America by Lamarckian sociologists such as Lester Frank Ward, who followed Spencer and his English colleagues in confusing biology and socialization and assumed that cultural traits were transmitted physically from one generation to another. Thus for Fiske the world was destined to become English not simply through cultural mechanisms but "in the blood of its

people." The assumption that racial heredity was produced by social and environmental forces permitted a shuttling between these two points of reference, biology and culture, depending on what was more ideologically useful at the moment. Immigrants, then, were thought to become "Americanized, liberated, and fused into a mixed race" as they confronted the frontier—whether in the city or the wilderness. The environment, Ward wrote, "resists the upward pressure of the life-force and holds all nature down," while the mind was being impelled "toward some exalted goal." The solution was to transform the deadly environment into a nurturing and acculturating landscape.[74]

Such was the confident rhetoric of American Anglo-Saxonism, when underlying fears of thinning Anglo-Saxon bloodlines and possible racial extinction were being more persistently voiced in literary periodicals. *Harper's New Monthly Magazine* asked in 1886, "Does the Puritan Still Survive?" while the *Atlantic Monthly* almost a decade later was still querying the "Survival of the American [i.e., Anglo-Saxon Protestant] Type."[75] Conventional wisdom held that the stronger Anglo-Saxon culture would absorb the weaker European races. The inflammatory prose of Josiah Strong's infamous polemic, *Our Country: Its Possible Future and Its Present Crisis* (1885), on the one hand promised that this comforting belief would still hold true, even while on the other it hysterically decried the anarchistic strain harbored by the new immigrants. That WASPs were losing their nerve as they contemplated their possible loss of social control is painfully obvious in the legal efforts of patrician New Englanders such as Fiske and Henry Cabot Lodge to keep non–Anglo-Saxon foreigners out of the country. Just at the point when immigration was at an all-time high, Fiske and Lodge formed the Immigration Restriction League, a group that in 1906 attempted to limit immigration by requiring literacy tests for all newcomers.[76]

Fueling the WASP panic was the argument that Anglo-American culture and its values of individualism, intellectual and physical strenuosity, and self-perfection would all be lost in a future dominated by peoples who were indifferent to this ethos. This potent issue was firmly entrenched in immediate social reality: in settling into their new environment, the immigrants seemed stubbornly to resist assimilation into Anglo-American culture.[77] Moreover, in the decade following the Civil War profound changes in the American workplace and the great social upheaval they produced intertwined with immigration. The economy shifted from small owner-operated businesses to impersonal, elephantine corporations, and large urban

centers absorbed what had been America's predominantly agrarian popu-
lation, displacing farmers from rural homesites to the crowded tenements
of the city. The industrial work force itself grew phenomenally and amounted
to more than one-third of the population by the end of the century.

The statistics describing the distribution of wealth in the period before
unionization confirm the actuality of a seemingly unbridgeable chasm
between social classes. The 1890 census revealed that the richest 1 percent
of Americans were commanding more in wages than the poorest 50 percent
of the population and possessed more capital than the other 99 percent.
The gross inequality in the distribution of wealth, the abominable treat-
ment of the worker, and the frightening condition of the workplace re-
sulted in a series of volatile events when labor and corporate management
clashed. As the unions struggled into formation, the strike emerged as
labor's most forceful weapon, primarily in the cause of the eight-hour day.
In 1886 alone, the year historians have designated the Great Upheaval,
nearly seven hundred thousand people went out on strike in industrial
sectors, while the number of work stoppages mounted to almost ten
thousand over the course of the 1880s.[78]

In addition to imposing low wages, the industrial workplace also proved
to be dangerous: in a survey solely of the railroad industry from 1890 to
1917, fatalities number as many as 230,000. Blue-collar families were also
victims of high unemployment rates (as high as 16 percent) during the
recessions of the mid-1870s and 1880s precipitated by the boom or bust
cycles of the economy. But even during periods of steady employment
workers were required to put in ten- to twelve-hour days and were miser-
ably recompensed for their efforts. Earning on the average $1.50 per day,
45 percent were living just above the poverty line of $500 per year by the
late 1880s, while 40 percent lived below.[79]

The 1890s witnessed continuing large-scale agitation, which was made
all the more frightening by the economic depression of that decade. After
steelworkers in 1892 battled Andrew Carnegie's Pinkerton agents in Pitts-
burgh, an assassination attempt was made on the life of Henry Clay Frick,
Carnegie's most trusted executive officer. At the Pullman strike in Chicago
two years later fourteen thousand federal troops were called out, thirteen
people killed, and thousands of dollars in railroad property destroyed. The
depression that lingered from 1893 to 1897 precipitated the failure of 800
banks and many railroads, as well as the decline of wages and an increase
in unemployment to an average of as high as 20 percent.[80]

When discussing the philosophy of American industrialists, we are

tempted to label these conditions as the product of "social Darwinism," as Richard Hofstadter and other historians did in the era following World War II. Since Spencer's writings advocated *laissez-faire* as the highest economic order, they were identified as the basis for the philosophy of the robber barons. In accordance with the language of natural selection, these capitalists invoked the "survival of the fittest" to justify their exploitation of the weak as an appropriate measure to weed out and strengthen the race. Spencer's biographer, J. D. Y. Peel, however, has disputed the notion that this was a central tenet of Spencer's social philosophy. Peel emphasizes two essential points: one, that Spencer promoted cooperation, not competition and struggle, as the rule in more complex and highly developed societies; and two, that Spencer argued that natural selection was operative only in "primitive" groups, an opinion with which Darwin concurred. Peel also observed that when Spencer did invoke the notion of a struggle of survival he did not mean the combat of humans against one another but rather their struggle against the hard conditions of the environment. Darwin's complicity in the spread of social Darwinism has also been argued by historians because Darwin accepted a hierarchy of races, thus leaving his studies open to racist interpretations.[81]

The accuracy of this traditional account of American industrialists as endorsing the ethos of the jungle has also been significantly called into question by Irvin G. Wyllie, who suggested that this brutal attitude is borne out by the histories of only a handful of capitalists, for example, Andrew Carnegie and H. O. Havemeyer.[82] Rather, the "survival of the fittest" was not really the spontaneous social philosophy among businessmen in the last half of the century as much as it was a highly successful metaphor for the business world. This expression had its origins in the simple observation of the capitalist system and in the economic theory of competition and strife in Malthus's essay, which both Darwin and Spencer appropriated to describe animal and human behavior. Wyllie maintained that the guiding thought of American businessmen in this period was still that of Christian moralism and self-improvement and particularly that they bought into the positive philosophy of New Thought, which held that there was plenty for all in America if one could rise up to grasp the opportunity that lay waiting.

If the workers were failing to seize these opportunities for improvement, these businessmen rationalized, then individual character must be faulted. The stereotypical worker in this period was the immigrant who inherently lacked control and discipline, in contrast to the Anglo-American's love of order and self-restraint. In reality, the friction between laborers and capitalists cut across cultural boundaries involving WASP workers as much as

immigrants, but the resurgence of nativism in this period lent an implicit cast of foreignness to the despised categories of revolutionary, socialist, communist, and anarchist.[83]

By the early 1890s the fears of "foreign anarchists" had proliferated to the extent that the attorney general of the United States, Richard Olney, claimed that America was at "the ragged edge of anarchy." During the railroad violence of 1877 the newspaper headlines had screamed "Civil War," "Horrid Social Convulsion," and "Red War," and the press was unrelenting in its sensationalism well into the 1890s (fig. 1.2). In response to the forecast for national catastrophe, publishing houses also disgorged a host of novels dedicated to utopian visions of American society, the most famous being Edward Bellamy's *Looking Backward* (1888). But the fact that disaster novels such as Joaquin Miller's *The Destruction of Gotham* (1886), in which New York City goes up in flames, or Ignatius Donnelly's *Caesar's*

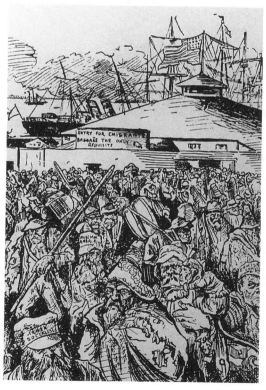

FIG. 1.2. *Grant Hamilton, "The Evils of Unrestricted Immigration." From* Judge *(March 28, 1891).*

Column (1891), which fantasized an urban armageddon, also sold well serves to evoke the contemporary apprehension that American society was headed toward either utopia or apocalypse.[84] As the calls for socioeconomic reform voiced by theorists such as Henry George, William Graham Sumner, and Ward assumed an increasingly strident pitch in the last quarter of the century, the means by which the American people could be spared another devastating national conflict—this time an internal war between classes—emerged as the question of the hour.

THE URBAN ENVIRONMENT AND THE PROGRESS OF AMERICAN CIVILIZATION

To combat the threat of social anarchy in the cities the establishment essentially marshaled two strategies: one was the overtly moralistic, old-fashioned "purification" campaign, set on repressing vice and coercively instituting Anglo-American civic values; and the other was to improve the physical environment by way of raising the moral atmosphere.[85] Nurturing cultural environments, it was held, directly conditioned social behavior and, most important, could assist in the harmonious interaction of different groups, helping a subculture to assimilate the habits of the dominant group. In connecting the cultural environment with the education of the individual and the overall improvement of the "race," then, reformers also realized that the human-made environment functioned as an instrument of education. Moreover, the developmental constraints inherent in strict biological evolution were overcome in the Lamarckian stress on environment. Men and women were free to create and improve themselves, intellectually, socially, and economically. Culture, then, had a "crucially determining role" in the progress of a society and humankind's moral evolution.[86]

The affirmative use of the environment to direct social development proved to be the most potent strain of the movement aimed at improving the squalid existence and the presumedly low moral character of the poor in the 1890s.[87] Most of these efforts, however, were directed at providing slum dwellers not with the better living quarters and occupations that would have required bold political commitments and enormous expenditures of public funds but with a wholesome alternative in the form of pleasurable or uplifting recreational activity. The municipal officials of New York and Boston opted for the latter remedy. The erection of new parks, playgrounds, gymnasiums, swimming pools, and public baths, they thought, would build

strong bodies and a sense of communal responsibility, while structures for concerts and lectures would create opportunities to elevate the mind. Especially targeted for character building through this type of leisure activity were children, whose habits were still being formed, while their parents were already set in unalterable and perhaps undesirable ways.[88]

Frederick Law Olmsted thought that pleasurable viewing of park scenery would "tranquilize" the viewer as well as refresh the individual who was bombarded daily with the friction and discord of street life in the metropolitan environment. Even before the great waves of immigration, Olmsted had the minimization of social differences in mind in the design of his parks, and he counted on the natural landscape, placed in the heart of the city, to function as a great social leveler. When removed from the oppressive density, the noise and filth of the ghetto to the fresh air, green grass, and sunlight of Central Park, the economically disadvantaged, it was hoped, would adopt the social norm of responsible, rule-observing Anglo-Saxon behavior. The democratic ethos of the park would unify the community and instill consciousness of the social polity. Before Central Park opened, the New York *Herald* had expressed concern that the expansive green space would function as "a great beer-garden for the lowest denizens of the city." After the park opened, however, the polite behavior of the lower classes observed there only reproved such chauvinism and encouraged Olmsted's theory that the structured environment had its social utility in teaching social mores.[89]

In the absence of large-scale government sponsored programs, the socialization of hyphenated Americans assumed diverse forms in the scattershot efforts sponsored by both the public and private sectors. Middle-class Protestant reforms such as charities, missions, and settlement houses mounted energetic but uncoordinated campaigns aimed at assimilating foreigners by teaching WASP moral and civic values. Colonial Revival themes in the fine arts and in advertising for commercial products were rampant in this period, functioning not simply as a reflection of WASP nostalgia for its seemingly disappearing heritage but also as an effort to integrate immigrants into the fabric of Anglo-American culture.[90] The Americanization of foreigners was attempted through less didactic forms as well, such as the sensuous impressions made on the unconscious by an aestheticized environment. Charles Eliot Norton, for one, believed in the reform of American society through appreciation of the fine arts. "The concern for beauty, as the highest end of work, and as the noblest expression of life," he determined,

hardly exists among us, and forms no part of our character as a nation. The fact is lamentable, for it is in the expression of its ideals by means of the arts which render those ideals in the forms of beauty, that the position of a people in the advance of civilization is ultimately determined.[91]

At the Centennial celebration of 1876 a display of decorative arts from around the world inspired American artists to turn to mundane objects in the domestic environment as a source of transcendent beauty and moral uplift. Encompassing the United States and Canada on a lecture tour in 1882, Oscar Wilde imported from England the gospel of the beautiful and gave a more definitive public articulation to what became known as the Aesthetic Movement. Pieced together from the ideas of Walter Pater, William Morris, and James McNeill Whistler, Wilde's doctrine expounded the beauty of the commonplace, especially in the "house beautiful." In the aftermath erupted a craze for Morris wallpapers, furniture, and fabrics in the Northeast, which was capitalized on by decorating firms such as Herter Brothers, who catered to an elite clientele.[92] Within this artistic ferment stained glass and decorating firms such as those headed by John La Farge and Louis Comfort Tiffany also produced lavish schemes for both public and private settings of the upper classes, as the taste for the sensuous, unified environment promoted in London by Whistler reached these shores to materialize as a new form of cultural capital. A whole generation of fledgling New York and Boston artists in the 1880s in fact found employment executing decorative works, whether they were book designs or painted ceilings. Thomas Dewing, for example, did friezes and murals in this period for the projects of a friend, the prominent New York architect Stanford White, while Augustus Saint-Gaudens carried out sculptural projects for both La Farge and White. Later in the 1890s the ameliorative possibilities of the unified therapeutic environment would become a lasting principle in Dewing's formulation of his many murals and painted screens.

The 1890s also brought the popularization of the Aesthetic Movement among upper-middle-class and professional elites in the form of the Arts and Crafts Movement, which in England and America was the child of William Morris. The belief in the aestheticized environment as a "powerful weapon against class conflict and social ills" is reflected in the pronouncement of Candace Wheeler, a one-time associate of Tiffany and matriarch of the Aesthetic Movement, that "good surroundings are potent civilizers." As Eileen Boris has pointed out, the "missionaries of the beautiful . . . presented

the dominant culture through housekeeping courses and home decorating guides; they would Americanize by design, sanitize through the arts and crafts." These reformers operated on the basic assumption of progressive environmentalism, that "good taste" was a mark of civilization that could be learned through socialization in an aestheticized environment.[93]

While the strong Arts and Crafts societies of Boston and Chicago originally organized to improve the lives of the lower classes and workers through the production of handicrafts, both societies eventually drifted toward facilitating the desires of middle-class consumers and amateur producers. The Chicago organization in particular had been backed by wealthy women and crusading social scientists from the University of Chicago who wished to confront the disastrous social conditions of immigrants in that city. Yet the social vision dimmed, the focus became handicrafts as a form of cultural capital or leisurely therapy for both progressive-minded men and women, and the society found itself speaking primarily to the converted.[94] One of the more positive ramifications of the movement, however, was that it did absorb men into the domestic sphere, which had previously been viewed as the preserve of women and children. But even as earlier gender codes began to break down and what had been rigid roles now overlapped to a certain extent in the mutual interest in domestic aesthetic matters, crafts activities were segregated according to gender, with men taking over furniture-making and metal-crafting activities and women maintaining textile and pottery production.[95]

Arts and Crafts societies also played an instrumental role in establishing art training programs in the public schools, in order to produce a "finer and finer humanity." Through art training Arts and Crafts missionaries believed that immigrant children would learn a craft vocation that would prepare the child for adult life in a capitalist milieu, but it was also thought that contact with beautiful objects would teach Anglo-American mores and children would bring these influences back to the home, so that the poorest homes could be aestheticized through techniques learned at school. In Chicago the founders of the Arts and Crafts Movement's most famous settlement project, Hull House, involved immigrants in reading circles, art print lending collections, art classes and lectures, and theatrical performances, and the clubwomen of the Chicago Public School Art Society, like public schools elsewhere around the country, hung art prints of the *Sistine Madonna* (to pacify "rough boys") and patriotic subjects in classrooms. Prints of Chicago's "White City" were another of these popular decorations.[96]

The World's Columbian Exposition of 1893 was undoubtedly the most outstanding example of the aestheticized pedagogic environment constructed before the turn of the century. The Chicago architect Daniel Burnham, assisted by a small militia of architects, engineers, artists, craftsmen, and workers, had transformed a swamp on the shores of Lake Michigan into a glittering White City of neoclassical structures (fig. 1.3). The Court of Honor at the Chicago fair impressed all—even the skeptical Henry Adams—as a possible model of social and aesthetic unity.[97] For the reformer Henry Demarest Lloyd as well as others, the uniformity of the exhibition buildings at Chicago spoke of the "possibilities of social beauty, utility and harmony." The order and discipline of the White City served as an explicit rebuke to the American city in its social and philosophical chaos.

Average fair-goers similarly perceived the classical structures around the Court of Honor as lessons in behavior that recalled Spencer's descrip-

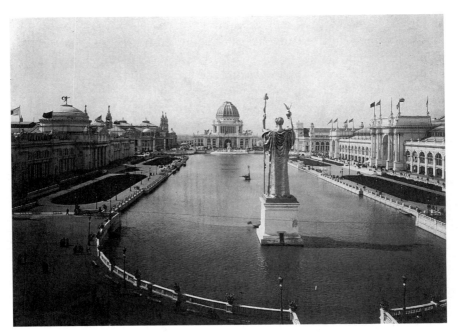

FIG. 1.3. *Charles Dudley Arnold,* Basin Seen from Peristyle, Court of Honor, World's Columbian Exposition, Chicago, *1893. Platinum print. Chicago Historical Society.*

tion of the most highly civilized societies. The overall effect taught coop-
eration, discipline, and sympathy with one's fellow humans, and subordi-
nation of individuals to the highest good, just as the designers sacrificed
their individual personalities to the expression of communal unity here. In
its ideology and corresponding physical structure, the White City in fact
struck a sympathetic chord with the utopian cities of William Dean
Howells's Altrurian traveler and Bellamy's Boston in A.D. 2000 in his novel
Looking Backward. Illuminated at night by the glow of electric lights or
during the day by the play of iridescent light over water, the classical
structures, with their lagoons, fountains, sculptures, and exotic foliage,
reminded middle-class Americans of the splendors that they could ima-
gine existed before the fair only in Venice, a fairyland, or in the celestial
city.[98]

The fair buildings were laid out so that the achievements of the Western
nations were represented in the exposition buildings around the Court of
Honor and the cultures of the third-world countries were displayed in the
honky-tonk atmosphere of the Midway—a scheme that resonated with
Spencer's ideas on the progress of civilizations, from simple, primitive
forms to complex, highly advanced forms. The hierarchy of spaces at the
fair provided a symbolic "sliding scale of humanity": the "primitive"
nations were situated farthest from the White City, while American pro-
ductivity was given pride of place as the final efflorescence of world
civilization.[99] The opening day ceremonies resounded with platitudes that
linked Columbus's discovery of the New World with the birth of Jesus
Christ as the two most significant events of world history. Even for social
critics such as William T. Stead, the fair was a great lesson in reforming
the present into an Arnoldean civilization: this White City "led citizens to
be transformed according to the best thought of the world's greatest
thinkers."[100]

Directed at the ills of American society, the fair prescribed a solution of
unity and harmony that emanated from Burnham's faith in "the possibility
of order and the usefulness of beauty." Its implied ideology—the "recon-
ciliation of contrasts" through disciplined subordination to a corporate
state—coincided in a timely manner with the Republican efforts to insti-
tute stabilizing measures in the economy. Burnham went on to spearhead
the new science of urban planning at the turn of the century; his City
Beautiful movement promulgated the same goals of stabilization and rec-
onciliation through tactics similar to those he had advanced at Chicago in
1893. As the United States instituted its imperialist policies of establishing
order and Christian morality in the trouble spots of the world, the moment

had arrived when the rhetoric of order found its usefulness in international politics and social ideology.[101]

That the doctrine of the progressive environment was a pervasive and widely embraced remedy by the end of the century for the ills of American life can be observed in the way this evolutionary belief in the power of the environment to shape human character manifests itself in the domestic philosophy of the greatest American architect of the twentieth century, Frank Lloyd Wright.[102] Wright's debt to this school of thought, as well as his roots in Transcendentalism and the Arts and Crafts Movement, also reveal Wright as "the greatest architect of the nineteenth century," as Philip Johnson has dubbed him. Wright was involved in Jane Addams's Hull House and the Chicago Society of Arts and Crafts at a formative moment in his career, and in both his buildings and his writings Wright showed himself to be acutely aware of the shaping power of the environment on the individual. He conceived of architecture in the therapeutic terms of the 1890s, as "a benefactor of tired nerves and jaded souls, an educator in the higher ideals and better purposes of yesterday, to-day, and to-morrow" (see fig. 1.4).[103]

Especially when it came to the environment of children, whose characters were so malleable, he advised parents to create harmonious conditions, "an atmosphere that contributes to serenity and well-being and to the consciousness of those things which are more excellent, in childhood." His design of his own children's playroom serves as a model of how to impress children early with all that is excellent—music, theater, literature, and nature. Wright elaborated on the relationship between human character and the designed environment:

> Whether people are fully conscious of this or not, they actually derive countenance and sustenance from the "atmosphere" of the things they live in or with. They are rooted in them just as a plant is in the soil in which it is planted. . . .
>
> We all know the feeling we have when we are well-dressed and like the consciousness that results from it. It affects our conduct, and you should have the same feeling regarding the home you live in. It has a salutary effect morally, to put it on a lower plane than it deserves, but there are higher results above that sure one.

Wright's idea of organic architecture predicated a structure in which form and function, as well as house, nature, and inhabitant, were wedded

to one another in perfect harmony. The sources of this philosophy have been traced to Ruskin and Viollet-le-Duc, to the pre-Darwinian era of creationist thinking in which the design of God's world provided his creatures with order and right relationships to one another. Wright's declaration that his organicism had ushered in "a higher *order* of the spirit . . . for modern life," however, was informed also by the late nineteenth-century idea that the progress of civilization rested upon the progress of the human-made environment.[104] For Wright, the architectural environment was so ultimately *the* factor in determining the quality of human life that the architect was given a central authoritative role in Wright's ideal social scheme, the Broadacre City designs of the 1930s. In Wright's dictation of every interior and exterior detail of the structure, including all furnishings and landscaping, his Prairie School houses had earlier suggested the architect's right to assume autocratic powers over the lives of the

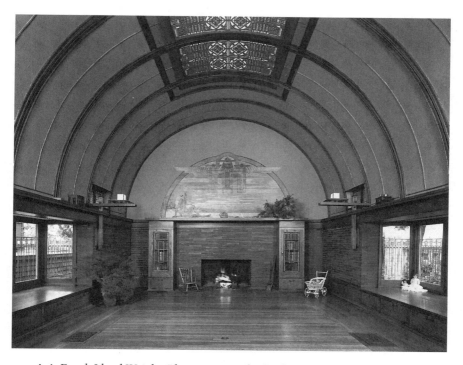

FIG. 1.4. *Frank Lloyd Wright, Playroom, Frank Lloyd Wright Home and Studio, Oak Park, Illinois, restored to the year 1909. Photograph: Jon Miller, Hedrich-Blessing. Courtesy of the Frank Lloyd Wright Home and Studio Foundation.*

inhabitants. The delegation of executive power to the county architect in the Broadacre plan was emblematic of his opposition to centralized government. Conceived as a philosopher-ruler, the architect not only designed the form of the environment and social interaction in the city but he also was empowered to banish anything that threatened the "harmony of the whole."[105]

With the advent of progressive environmentalism, then, design was regarded as an agent of human progress. Spencer taught that the evolution of life moved by some great unknowable power toward some higher goal. Spencer's popularizers convinced Americans that they could still direct their evolution toward that higher goal of civilization, that their history could be a *progress* if they controlled the human and the natural environments. Cultural artifacts created in this ethos therefore shared this implicit moral purpose, to contribute to the upward spiraling of human life. Evolutionary thought functioned as a paradigm in this period, in the manner that Thomas Kuhn has described as the performance of scientific paradigms directed by social ideologies: the evolutionary paradigm at the end of the nineteenth century served as a matrix of consensual beliefs that defined and guided cultural practices.[106] Social problems were apprehended in the terms of evolution—as a struggle for survival—while solutions to problems were equally posed in the evolutionary terms of adapting to and shaping the environment. Evolutionary thought lent the power of ordinance to cultural forms as these forms were called on to explain and clarify the confusion that reigned in the American environment, to bind the country together, and to justify the nation's defensive strategies to itself.

Whether artists overtly acknowledged this social purpose of culture—that of shaping the environment in an advantageous manner and explaining the actions of the establishment to solve social problems—or whether they remained silent on the issue or even mouthed the elitist rhetoric of "art for art's sake," the evolutionary paradigm provided the context in which their works were created, received, criticized, and praised. Architects and planners who were directly responsible for the larger urban environment in America at the end of the century looked on that responsibility with the utmost seriousness—they were charged with creating aesthetic order, and implicitly with social order as well. Large urban centers impressed with the country's grand millennial aspirations reaffirmed the faith of architects and their peers in the power of the aestheticized environment to shape indi-

vidual experience and social mores. By clothing their architectural projects in the classical idiom, Charles McKim, Stanford White, and Daniel Burnham also employed aesthetic unity to banish thoughts of social disorder, while at the same time they gave form to the promise of an imminent golden age in the United States. Similarly, artists in the 1880s and 1890s working in "Darwinian" urban environments turned to the holistic design as an aesthetic corrective to the problems modernity had foisted on the individual. In doing so they confronted the philosophical threat Darwinism posed to the singularity of the human soul and shored up investments in the Anglo-American tradition of self-culture, a tradition that was now inflected with the rhetoric of evolutionary progress.

John La Farge *and the* Sensuous Environment

JOHN LA FARGE'S relation to evolutionary discourse and the issue of social development in America rests in his socially minded approach to his artistic projects. His professed purpose in his later decorative work was to educate the taste of the public by creating a finer and more sensuous environment. This agenda corresponded with the thought of contemporary sociologists and reformers under the sway of evolutionary theorists who stressed the importance of physical and cultural environments in shaping the course of history. A Roman Catholic who made a mark on American Protestant culture in a period of rabid anti-Romanism, La Farge (1835–1910) appeared in the eyes of his friends as a Renaissance priest who lived a solitary life in search of sensuous mystery. In his novel *Esther* (1884) Henry Adams evoked La Farge's character in the mural painter Wharton, a capricious and cryptic man whose brilliance periodically surfaced from the depths of his mind.

> He was apt to be silent until his shyness wore off, when he became a rapid, nervous talker, full of theories and schemes, which he changed from one day to another, but which were always quite complete and convincing for the moment. At times he had long fits of moodiness and would not open his mouth for days. At other times he sought society and sat up all night talking, planning, discussing, drinking, smoking, living on bread and cheese or whatever happened to be within reach, and sleeping whenever he happened to feel in the

humor for it. Rule or method he had none, and his friends had for years given up the attempt to control him.[1]

Through Wharton Adams also caricatured La Farge's obsession with grandiose epochal projects in which art would remake the world:

> Wharton always had on hand some scheme which was to make an epoch in the history of art. Just now it was a question of a new academy of music which was to be the completest product of architecture, and to combine all the senses in delight. The Grand Opera in Paris was to be tame beside it. Here he was to be tied down by no such restraints as the church imposed on him; he was to have beauty for its own sake and to create the thought of a coming world.[2]

The cynical Adams had no faith in such utopian schemes. But it was La Farge's engagement with the socially redeeming function of art—with the use of the useless, as La Farge phrased it—that defined his self-appointed mission to Americans in the last quarter of the nineteenth century.

The appearance of La Farge's flower paintings and landscapes in the 1860s and 1870s presented a new sensuousness in American painting that emanated not just from a painterly handling of the medium but also from the painter's meditative approach to his subject. Paralleling the career of William Morris, he left oil painting behind later in the 1880s in order to originate a business venture that specialized in stained glass, decorative painting, and murals, as well as embroidered hangings. It is in these works that the social purpose of his sensuous art emerges. Exchanging the private world of the small easel paintings for the more public arena of interior design, La Farge confessed that the social purpose of his decorating activity was the improvement of the environment through beauty and consequently a transformation of public taste. For him, however, the visual arts were "not the best form of explanation and development of a moral and metaphysical notion." But while the plastic arts could not perform the didactic function of the literary arts, he thought, they were superior in another respect: they could affect the individual consciousness even more successfully and deeply than the written word through their direct impact on the senses. Through sensuousness art could instill the individual with a love of beauty and harmony, then promoted as socially useful traits.

Social theorists had popularized the idea that education of the moral and aesthetic senses could refine humankind from egotistic, warring creatures to altruistic, pacifistic individuals, allowing society to move toward the

glittering spectre of the higher life that beckoned at the apex of civilization. This was the evolutionary rhetoric La Farge adopted to justify his focus on the production of stained glass—commonly considered a lesser art form—as the principal project of his mature years.[3]

La Farge's transformation from the private easel painter to the public decorator need not be ascribed only to a nationalistic evolutionary motive, however. The never-ending crises of his personal finances, as well as his fascination with colored light, no doubt played some part in this shift from easel painting to a more lucrative career in design. Nevertheless, his decision would not have been so lucrative had not a widespread realization already arisen in the Anglo-American elite that beauty in the environment could be useful. La Farge's career spans the period between the early nineteenth-century paradigm, governed by Creationist mythology, to the late nineteenth-century evolutionary paradigm, focused on environment as the agent of progress. The pressures to reform the environment in accordance with social evolution came into play in the 1880s just as La Farge was attempting to get his fledgling business off the ground. The public La Farge served by no means resembled the underprivileged group targeted by reformers as in need of education and assimilation into the mainstream of WASP culture. La Farge, like the social theorists of his time, however, regarded the work of art as offering a means of self-refinement, a cultural practice viable for individuals of all classes. The enlightenment gained by acts of self-culture, he hoped, would lead to a golden age when the "doors of the kingdom" would open once again.[4]

In the 1860s La Farge's painting and decoration, like James McNeill Whistler's, forecast the late nineteenth-century transformation of American art from an aesthetic that was descriptive, narrative, and intellectual to a mode that was sensuous, simplified, and integrated. Both La Farge and Whistler had a profound impact on the younger American artists who were to mature in the 1890s. While this group learned of Whistler's aesthetics and artworks from afar, by reading stories in the press of his suit against Ruskin and examining his paintings at exhibitions, they found La Farge personally accessible in New York. Both Whistler's and La Farge's activities, however, promoted a faith in the power of art to enhance the quality of life by aestheticizing the environment, especially when that aesthetic derived from a synthesis of East and West.

The overriding question that emerges from a consideration of La Farge's career is: why was John La Farge the first in America to turn to the form of the private, sensuous oil painting and the sensuous environment as instru-

ments of societal advancement? La Farge's distance from his contemporaries during the Civil War years may be succinctly demonstrated by comparing two paintings from the early 1860s, his *Hollyhocks* (pl. 1; fig. 2.1) and Frederic Church's *Cotopaxi* (fig. 2.2). Nature in Church's painting is sanctified, typifying the contemporary submissive posture Protestants assumed in the face of God's creation. Each blade of grass, tree leaf, and rock formation is rendered with an empirical fidelity so that it is the Creator's omniscient vision of the earth that is advanced, while the painter's presence and subjectivity in viewing the scene are allegedly effaced.

La Farge's intimate flowerscape shows a world apart from his Protestant peers. Though some measure of empirical observation is asserted through the rhetorical construct of the "natural" (that is, the flowers are observed *in situ*), the aureole of light filtering through and around the plant life intimates that the scene is strongly mediated by the artist's vision. Linear description is sacrificed for nuances of soft colors and textures. La Farge has no use for Church's public narrative of national or natural history; his concern instead is with fashioning a private reverie of how the flower feels and smells to the painter, the fragility of its structure and the delicacy of its perfume. La Farge was here exploring a self-centered, sensuous mode that was inflected with his Catholic humanistic beliefs.[5] In a word, it was La Farge's Catholicism that permitted and even encouraged him to pursue a line of inquiry about the act of seeing that was independent from that of other New York painters in the 1860s.

THE DEVELOPMENT OF A SENSUOUS MODE

A clear attraction to a sensuous, naturalistic form of representation is evident from the beginning of La Farge's career. His preference from the first was for an artistic approach that imposed the artist's mood on nature in the cause of unifying the self with the world. Like George Inness and Winslow Homer, La Farge was drawn to the poetic landscapes of the French Barbizon painters, commenting that he himself was "largely made" by the Barbizon men whose lithographs he collected in the 1850s.[6]

During his first trip to Europe in 1856–1857, he became entranced with Rubens, Rembrandt, and Delacroix—the masters of highly charged color and atmosphere. Having read Michel Eugène Chevreul's theories on color before leaving for Europe, he had already familiarized himself with the problems of the optical relationships between color and light. His understanding of the expressive possibilities of colored light continued to

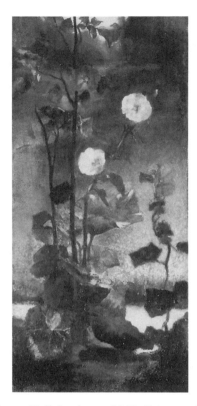

FIG. **2.1.** *John La Farge,* Hollyhocks, *c. 1863. Private collection. Photograph courtesy of Thomas Colville Fine Art.*

FIG. **2.2.** *Frederic Church,* Cotopaxi, *1862. The Detroit Institute of Arts, Founders Society Purchase with funds from Mr. and Mrs. Richard A. Manoogian, Robert H. Tannahill Foundation Fund, Gibbs-Williams Fund, Dexter M. Ferry, Jr. Fund, Merrill Fund, and Beatrice W. Rogers Fund.*

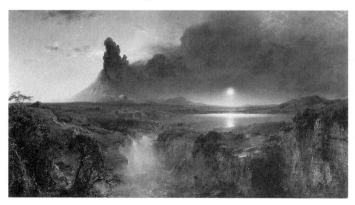

expand in England as he perused medieval stained glass windows and the paintings of the Pre-Raphaelites. La Farge also had the opportunity to become acquainted with the major figures of the emerging French realist and naturalist movements while in Paris, through the introductions of his cousin, the art and literary critic Paul de Saint-Victor. Though he returned to America unconverted to any single artistic style, the trip fed his characteristic "habit of mind," an ever-searching, restless intellect that eventually led him to the psychology of perception and a philosophy of art.[7]

In 1859 La Farge moved to Newport to study with the roughly contemporary but more seasoned William Morris Hunt, whose taste for Barbizon painting corresponded with La Farge's. It was over the next several summers that La Farge located the means of suggesting an experience of the world that was at once quasi-mystical and quasi-naturalistic through the potential expressiveness of color-light masses in nature. Ostensibly these flower paintings and landscapes were made as technical studies for a group of religious figure paintings that he was executing at the time.[8]

Noticeably absent from La Farge's nature studies was the fine draftsmanship that was considered so integral to academic figure painting. But the accurate delineation of form, in which the object's precise contours and limits are described, was not what he was after, and he seems to have taken no notice of those who criticized his figure drawing.[9] La Farge's later writings, in fact, vent his disapproval of a linear, graphic approach to painting. Line, he said, separated and divided figure from background, creating an abstraction, while imitation "petrified and crystallized [nature], in some shape far from her fluid readiness to change."[10]

While painting the landscape around Newport during this time, he discovered that the transfiguring lens of the artist's vision enabled "each work of art" to restore "nature to what she should be." The primary function of the artist, he concluded, was to transform nature according to a personal way of seeing.[11] La Farge accorded color-light relationships the greatest value in his approach to the art of painting because to him reconstructing the world in terms of colored light signaled the actual dynamic reciprocity between physical object and the artist's subjective feelings. Reality was perceived through the action of the individual mind on external nature, investing "ordinary objects with beauty by mere direct observation," as La Farge himself stated it.[12]

While painting plein air landscapes, probably in the summer of 1865, La Farge realized that the self-centeredness of the artist's vision inevitably imposed itself on the canvas as an active filtering agent of the observed object.[13] Even in his earlier works, however, the artist obviously went

beyond casually recording the physical interaction of atmospheric elements. In paintings such as *Hollyhocks*, c. 1863, a concerted attempt to record natural law according to Chevreul's color-light theories is evident in the juxtaposition of complementary reds and greens and in the subtle tonal gradations. La Farge seems to have duly observed every possible variation of light in the glowing masses of blossoms, including half-lights, cross-lights, and back lighting. But the unusual proportions of the composition also register La Farge's manipulation of the subject and its framing, and on closer examination it becomes apparent that contrasts of light and dark are heightened, color is highly saturated or tonally uniform, and subtle light effects have been selected to provide a mood of intimacy.[14]

In *Magnolia Grandiflora* (fig. 2.3) La Farge further exploited the silky texture of oil paint to suggest different physical qualities—the softness and delicacy of white petals, the slippery hardness of dark green leaves, the rough, blurred, iridescent patch of light in the window behind, and so on. The magnified form of the magnolia, enlarged in scale to fill the frame, forces the viewer into intimate rapport with the heavy white blossom—a strategy that prefigures the enlarged floral forms Georgia O'Keeffe would produce a half-century later.

The dual processes of observation and stylization evident in La Farge's *Hollyhocks* recall the saturated colors and outdoor settings of the English Pre-Raphaelites William Holman Hunt and John Everett Millais, while the self-conscious artifice in the long, narrow format brings to mind a Japanese *kakemono*. La Farge's interest in the Pre-Raphaelites' naturalism and jewel-like color dated from his European trip of 1857, but his fascination with Asian art extended back even further to his schoolboy days of 1853. He probably purchased Japanese prints in Paris in 1856–1857, and by 1864 he was exploring Japanese design principles in his paintings, making him one of the earliest, if not the first, to realize the expressive potential of *japoniste* composition.[15] The allure of the Japanese print for La Farge lay in the way the print offered novel and strange points of view to the Western eye, which was conditioned by the norm of one-point perspective. Distortion of space and form could render the image more decorative and also imbue it with more obviously personal and metaphorical meaning. *Japonisme* taught Western painters a more "flexible realism," in which the sensuous use of color and form could evoke both natural phenomena and individual psyche; it could reconstruct the unifying experience of the self with the non-self. For this reason, La Farge seemed to have preferred the naturalist modes of Japanese, Barbizon, and Pre-Raphaelite painters.[16]

FIG. 2.3. *John La Farge,* Magnolia Grandiflora, *1870. Williams College Museum of Art, Gift of Mrs. John W. Field in memory of her husband.*

LA FARGE AND ROMAN CATHOLICISM

The situating of La Farge's early work within the category of nineteenth-century naturalism, however, must be qualified in comparison with the more secular and positivistic outlook of the French naturalists, for overdetermining his investigations in phenomenology and perception, as well as his religious paintings, was his education in Catholic teleology. While La Farge later publicly aired his views on the importance of a religious frame of mind in approaching nature, in the 1860s this belief remained only visually implied in his work.

In the period leading up to his marriage in 1860 he was involved in persuading his fiancée, Margaret Perry, to convert to his faith by arguing the superiority of Roman Catholicism over Protestantism. "Most Protestant sects," he cajoled her, functioned like social clubs, while the Catholic

Church required of its members the commitment of a "full faith."[17] In his cause La Farge enlisted the assistance of Father Isaac Hecker. A Methodist who had himself converted to Catholicism, Hecker had just founded the Paulist order in New York in 1859 with the mission to convert dissatisfied Protestants to Catholicism. At this moment La Farge would have been acutely aware of the differences between the two faiths, as well as his own position as an outsider in mainstream American culture, by the fact that traditional anti-Romanism in America had recently been raised to a new pitch in response to the large Catholic immigration in the decade of the 1850s.[18]

Although La Farge's view of nature in his flower studies has been termed "Darwinian," this description is accurate only insofar as La Farge, like Darwin, maintained a belief, in accordance with the orthodox Christian beliefs of Roman Catholics and Calvinists, in a personal Creator who was separate from His creation. Opposed to the orthodox view of a transcendent God was the concept of an immanent God working His will in the world through providential progress, a belief that was embraced by liberal Protestants such as the Transcendentalists and Henry Ward Beecher and incorporated into American popularizations of evolutionary thought by Spencer's followers, such as John Fiske. Contemporary critics determined that La Farge never accorded nature a sense of divinity, but neither did he depict nature as afflicted by Darwinian struggle, cruelty, and evil. A pacifist by nature, La Farge was, in fact, personally known to abhor violence and any incidence of struggle or conflict. In his emphasis on the human mind as distinct in kind and quality (rather than in degree) from the rest of creation, La Farge sided with Spencer rather than Darwin.[19]

To Royal Cortissoz, it was obvious that La Farge in his flower paintings had acted as a "scientific enquirer and the experimentalist in technique," but it was equally apparent that La Farge "could not shake off the glamour of things unseen but felt." La Farge confirmed the supra-empirical dimension of these early works, commenting that in certain of his flower paintings he "tried to give something more than a study or a handsome arrangement." The hold of the water lily on his imagination, for example, La Farge explained as "a mysterious appeal such as comes to us from certain arrangements of notes of music." And what clearly attracted La Farge in nature was the usefulness of its beauty to humans; "human consciousness," in acting on nature, made "her mysteries" come to life. In effect, nature, to La Farge, revealed "something of himself" through its subjectification. Its mysteries and loveliness simply reflected back and

reinforced the soulfulness of his own self-image.[20] Later in his career La Farge would even transpose his sense of the unconscious life of nature into a human figure—for example in *Spirit of the Water Lily* (fig. 2.4) or *The Centauress* (1887, Brooklyn Museum).

In essence, the philosophy of art directing La Farge's natural studies of the 1860s was religious and moral rather than positivistic. If an artist would only assume a religious attitude, La Farge maintained, the mind would be in harmony with these universal laws, enhancing the ability to perceive this order in nature.[21] His later lectures relate his awareness of the metaphorical quality of visual language, as well as his sense of the analogy between the laws of visual art (color, light, and perspective) and the laws of nature, which were "known to the Creator Himself," he said. Universal geometry governed all visual laws, like the laws of music, and formal artistic qualities—lines and colors—determined by ideal laws had intrinsic affective properties that provoked a corresponding emotional response in the viewer.[22]

The impression La Farge made on his friends was also that of a decidedly religious and mysterious personality. Throughout his hagiographic volume on La Farge's life and work, biographer Royal Cortissoz as much as sanctified La Farge in a descriptive litany that distinguished the artist as erudite, secretive, aristocratic, autocratic, mystical, and exotic. Drawing on the recollections of the artist's closest friends and associates, Cortissoz set

FIG. 2.4. *John La Farge,* Spirit of the Water Lily, *c. 1883. Watercolor. Isabella Stewart Gardner Museum, Boston.*

down a picture of La Farge as a man who projected "a tremendous intellectual and spiritual activity" and who was possessed of a "complex, rich nature . . . the very texture of his soul with a strange self-centered calm, his habit meditative." The nervous, thin, secretive, and meticulously attired La Farge resembled a "majestic dignitary musing in the obscure recesses of an Oriental temple," or he could be imagined as an old Italian priest or a cardinal of the Renaissance.[23] Contemporary critics had responded to his nature studies in a manner similar to this later evocation of La Farge's personal character. In the myth of La Farge they established, the man was thoroughly identified with his work. The sense of mystery and beauty in his works simply suggested the painter's "strong tendency to seek for the religious aspect of life and nature."[24] George Lathrop, for example, wrote in 1881 that La Farge expressed a "mystical sentiment" through a complex use of "latent color" and translated "aspects of the life of unconscious nature into some higher conscious meaning."[25]

The critic James Jackson Jarves, even earlier than Lathrop, had discerned a non-pantheistic nature in La Farge's flower paintings and landscapes. Jarves characterized La Farge as an artist of "deep religious feeling," who endowed nature not with divine spirit itself but with "a portion of his inmost life" and with "an almost superhuman consciousness." This description was penned as a response to La Farge's self-image as well as the mystical project of his paintings. "He evokes the essences of things," Jarves said, and "draws out their soul-life."[26] In the flower paintings in particular, Jarves found that La Farge used "color not as fact, but as moods of feeling and imagination."[27] La Farge's work was deserving of notice, he thought, not only because the artist's non-pantheistic philosophy was unique in the Protestant Northeast of the 1860s but because Jarves also sensed that La Farge was working in a coloristic mode of expression that at this historical moment was nearly peerless in American art: this mode was radically different from the tight, dry, linear surfaces of the luminist paintings Jarves admired, and even more extravagant than the coloristic flourishes of Sanford Gifford.[28]

La Farge's exploitation of color and texture to engage the viewer immediately and intuitively was later translated into a different medium when he explored the opulent possibilities of stained glass. His reasons for reorienting his career, however, are complex. While the nature studies of the early 1860s allowed La Farge to explore color and light in nature, subjectivity in the work of art, and sensuous mystery in the feminized natural object, by 1878 he had failed to sell a single painting from an exhibition and was in constant financial distress.[29] Finding new mediums

and markets for his interests in the fields of floral watercolor, stained glass, and decoration during the last quarter of the century, La Farge would put sensuousness to a public and nationalistic purpose.

LA FARGE, CATHOLIC RITUAL, AND THE DESIGNED ENVIRONMENT

In the early 1870s La Farge turned away from the small private easel painting to the task of aestheticizing the public environment. Twice he traveled across the Pacific Ocean to remote cultures he would admire for their preservation of holistic integration. Back in America he continued his search for a "oneness of mind and feeling" through the production of a social environment of mystery and beauty. La Farge wrote that the "meaning of our struggle" was "to open to us the doors of the kingdom."[30] In these crypto-biblical terms La Farge was not insinuating his intentions to create a hedonistic paradise of "art for art's sake"; rather, he was announcing that his art would be directed at realizing the higher life predicted by evolutionists such as John Fiske: in other words, a social condition that would transpire through educational efforts and nurturing strategies. La Farge's pronouncements on the reformative powers of art commonly invoked the romantic dream of returning to a childlike state of awe and wonder at the beauty of the world. La Farge's own childhood, therefore, should be the starting point of this effort to locate the source of his ideal nurturing environment.

La Farge's father, Jean-Frédéric de la Farge, had fled from France to America during the Napoleonic Wars, while his mother, Louisa Josephine Binsse de Saint-Victor, was a first-generation American of upper-middle-class French parentage. Jean-Frédéric made a small fortune from shipping and real estate investments and settled his family on Washington Square in New York when it was still more or less the exclusive province of Anglo-American families of means. Surrounded by his well-educated maternal grandparents and their emigré friends, La Farge was taught the classics of Western European literature and philosophy, and he eavesdropped on the gossip about political and literary figures the family had known in Paris. The ambience of the Washington Square home in itself provided an aesthetic education for the young La Farge. Decorated with Old Master pictures, recent French paintings, French Empire furnishings, and gilded Italianate ornament, the elegance of the La Farge residence was rare, even exotic, for that time in America.[31] Alongside these influences, the familiar ritual of the Catholic Mass, with its appeal to religious emotion through

sound, sight, and scent, must also have had a considerable impact on him.

Some sense as to how rarefied the experience of Catholic ritual appeared to American Protestants in this period can be gained by briefly examining Robert Weir's *Taking the Veil* (fig. 2.5). Executed in 1863, the painting anticipates the Protestant movement toward Catholic ritual and the aestheticized sanctuary witnessed in the last two decades of the century. A convert to the Episcopal church, Weir was careful to describe every possible sensuous and theatrical aspect of the Mass, from the burning incense to the rose petals, the colored light of stained glass, the sculpture, the music of the choir and the organ, and the immensity of vaulted space. In commenting on this painting, art critic Henry Tuckerman gave voice to popular conceptions of how Protestantism and Catholicism exemplified the antipodes of Christian faith. "Puritanism" (i.e., Calvinist Protestantism), he wrote, "addresses the intellect," while "Catholicism . . . the feelings and the imagination."[32]

FIG. 2.5. *Robert Weir,* Taking the Veil, *1863. Yale University Art Gallery, New Haven, Connecticut.*

During the last quarter of the nineteenth century Protestants of all denominations were lured to Roman Catholicism, not simply because of the beauty of the Mass but also because Catholicism seemed to have retained the propensity of a "full faith," as La Farge put it, that Protestantism had lost in the wake of the higher biblical criticism and the attacks of Darwinian science. As American Protestantism accommodated evolutionary thought and the modern demands of secular life, Roman Catholicism resisted modern thought and upheld orthodox Christian doctrines.[33] The certainty of Catholicism's age-old beliefs contrasted starkly with the Protestant tendency to blur the boundaries between sacred and secular and thus diminish the transcendence and supernatural power of God. La Farge had precisely this contrast in mind when he advised his fiancée, just before her conversion to Catholicism, that the Catholic Church could not be entered "without full faith." "It is *not* . . . ," he emphasized, "a charitable and religious association to which one can belong as well as to half a dozen others—like most Protestant sects."[34] These strong convictions were recognized as giving shape to La Farge's religious paintings. One critic, for example, described his works as full of "a pre-Raphaelistic fervour and sincerity" in contrast to "the modern, lukewarm, casuistic fashion" of Protestant faith.[35]

With High Church Episcopalianism appearing to be the next best alternative to complete defection from the Protestant fold, conversion to Anglo-Catholicism became a commonplace phenomenon at the end of the century. Earlier in the 1840s and 1850s the Oxford and Cambridge movements in the Anglican Church had sought a rapprochement with Roman Catholic doctrine and ritual. The American Episcopalian church had experienced phenomenal growth in the 1850s, when New York became the center of the movement toward ritual. The numerous Gothic Revival churches Richard Upjohn built in New York during this period were the most obvious by-products of the Episcopalian ferment.[36] As Anglo-Catholicism intensified within the Episcopalian church in the 1880s and 1890s, the religious experience of its sanctuaries was transformed by newly constructed scenery. While the idea of adopting Catholic sensuousness as a mode of religious experience inspired fears in some Protestants because of its blurring of denominational lines, an upper-middle-class majority welcomed the infusion of ritual and aestheticism as a healthy antidote to Calvinism's tendency toward morbid self-accounting and guilt.[37] The decision of Episcopalian and Congregational churches to initiate more public rituals and to decorate their traditionally unadorned walls was not just a political strategy to keep the faithful from defecting from the ranks. Rather,

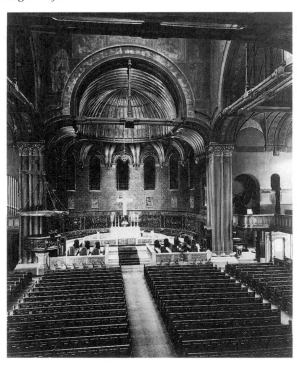

FIG. 2.6. *Henry Hobson Richardson, Trinity Church, Boston; Interior decoration by John La Farge, 1877. View, looking toward the chancel. Photograph courtesy of Trinity Church.*

the aesthetic reordering of the place of religious worship was also symptomatic of the liberals' efforts to reform their faith by using secular culture affirmatively.[38]

To a great extent La Farge was aware that through his decorating firm he was bringing Catholic traditions to Protestant churches. When working on the decorations for the Episcopalian Church of St. Thomas in New York, for example, he told Saint-Gaudens that "there is no such thing as the Protestant in art."[39] La Farge found himself at the spearhead of the Protestant convergence with Catholic forms of worship—not solely because he was Catholic, but also because he had been responsible for the interior decoration of Henry Hobson Richardson's ground-breaking Trinity Church, Boston (1876–1878), whose rector, Phillips Brooks, was one of the most influential spokesmen for upper-crust Anglo-Americans. Trinity's polychromed and gilded design by Brooks and La Farge (pl. 2; fig. 2.6)

made it the first of the Protestant (and Episcopalian) churches to regenerate its practice of worship into an affair of the heart more than the mind.

After the commission at Trinity was completed, La Farge continued to occupy a leading position in the movement to decorate Episcopalian, Congregational, and Presbyterian churches.[40] Orchestrating mural painting, embroideries, stained glass windows, and often mosaics and sculpture into a rich ambience, he set the example for churches and designers after him, so much so that in *Esther* Henry Adams broadly sketched Brooks and La Farge as two theatrical producers striving to make an aesthetic environment worthy of the aspirations of the upper-class parishioners who wished to have a suitable Sunday morning setting for their finery. Looking around the interior of Adams's thinly disguised version of Trinity just after its completion, the fictional geologist George Strong wryly notes that the church is "a stage, like any other. . . . [where] there should be an *entre-acte* and drop-scene," perhaps with an appropriate Last Judgment, while his companion, Esther, is made to remark that the church prompts her to feel "like a butterfly in a tulip bed." Adams's narrative centers around the dilemma of Esther, a typical member of the northeastern urban elite, who after experiencing the death of her father struggles to believe in the consolatory faith offered by the church (personified by the minister, Hazard) in the face of the arguments of science (Strong) against such belief. Adams implies that aestheticizing the sanctuary, as a form of persuasion to believe, is essentially a gesture of misplaced idealism, an "ecclesiastical idyl" far removed from the "realities of life" that exist outside the hermetic enclave of the church.[41]

After reinvesting his self-identity with the program of public decoration in the 1880s, La Farge served up a strong opinion that such an engagement in public projects placed the artist at the center of the advancement of society. This statement was made roughly at the same time that evolutionists and social reformers were redefining the evolutionary controversy as an issue of cultural progress rather than biological transmutation. La Farge's experience at Trinity Church and his discussions there with Brooks stood behind his rethinking of the social utility of the aestheticized environment. A charismatic preacher, Brooks was well known and popular among upper-class Protestants of the Northeast. During the period of planning for Trinity Church, he was deeply troubled by the relation between evolutionary thought and religion, and especially concerned to answer the questions parishioners brought forth about orthodox Christian beliefs in the light of the new science. These concerns are vaguely impli-

cated in the subjects of two of the murals La Farge painted at Trinity, *Christ and the Woman of Samaria* and *The Visit of Nicodemus to Christ* (fig. 2.7). Both depict Christ ministering to human needs, a theme that reflects Brooks's own preoccupation with the problems of his parishioners, in assuaging their doubts and bolstering their faith. But Brooks was not a confirmed High Churchman, and the new aestheticized environment of Trinity seemed to pique Brooks's conscience and require some justification—as if he feared it might offer more to the well-to-do than the poor parishioner, for during the building of Trinity he preached a sermon on physical beauty as a spiritual force in human life.[42] Brooks's apologia for the sensuous appeal of the church was to resurface in the rationale La Farge adopted for the career in decorative work he was about to pursue.

In the decade following the Trinity commission, La Farge devoted all his energies to mural painting and stained glass production for both ecclesiastical and domestic interiors (see fig. 2.8). He set up his own glass studio for the manufacture of windows in 1879 in New York, and during the follow-

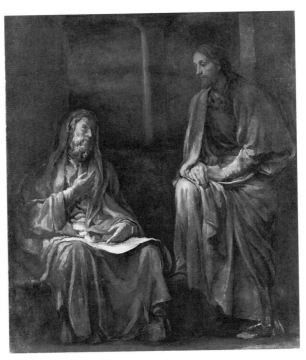

FIG. 2.7. *John La Farge,* The Visit of Nicodemus to Christ, *c. 1880. National Museum of American Art, Smithsonian Institution, Gift of William T. Evans.*

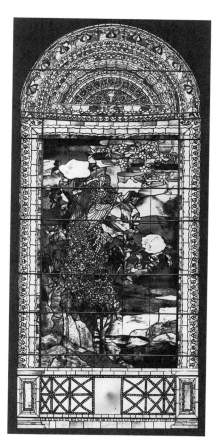

FIG. 2.8. *John La Farge,* Peacocks and Peony *(one of a pair of windows from the Frederick Ames house, Boston), 1882. Stained glass and lead. National Museum of American Art, Smithsonian Institution, Gift of Henry A. La Farge.*

ing year he entered into a formal relationship with Herter Brothers, the prestigious furniture makers, in order to bring his services to their well-heeled clientele. La Farge, however, felt compelled to justify what he feared some (including himself) might regard as his devolution from the more prestigious and "pure" occupation of easel painter to the more commercial ranks of decorator. His defense of his new enterprise drew on the pervasive theme, already stated by Brooks and a host of others, that one route to social evolution was located in a nurturing cultural environment.

La Farge's 1886 interview with Anna Bowman Dodd, who was writing an article on the artist for the *Art Journal,* disclosed his personal version of the popular belief that self-refinement could be effected through aesthetic

experience, specifically through the sensuous impact of color. Dodd confronted La Farge with the assertion that decorative art was a less intellectual and didactic form, and thus a less socially redeeming arena, than oil painting. La Farge rebutted with an explanation of the social function of his stained glass windows. Because most Americans lacked an artistic education grounded in the Greek models or the Old Masters, he reasoned, they could more readily appreciate a medium such as stained glass, which could dazzle with immediate sensuous gratification more easily than the intellectually demanding form of easel painting. "He believes he is doing more for his Art, his country, his fellow-man by leading the people," Dodd recounted, "through a love for colour and illuminated figures to a right appreciation of the true principles and aims of Art."[43] La Farge agreed with his critic that the artist had the "opportunity to sow the good seed, to teach the people, the common people, by means of the most beautiful colour and fine decoration, the alphabet of Art." Through the beauty and color of stained glass the artist could raise public taste "more quickly to a finer level,. . . by the elevating influences exercised by it, than by any other Art teaching, for it appeals to the most unlearned." In La Farge's later public lectures he reasserted that through art, the artist contributes to the "moral refinement of mankind."[44]

La Farge never got the opportunity to fulfill this goal for his stained glass—to provide a means of education for the "unlearned." His completed windows were for the most part placed out of reach of the "common people." Only the murals completed near the end of his life for the Minnesota State Capitol (1904) and the Baltimore Court House (1907) would have been accessible to a broader spectrum of society. His stained glass embellished Episcopal, Presbyterian, Unitarian, and Congregational churches; in other words, the Protestant denominations whose members at this time were almost exclusively middle- and upper-class Anglo-Americans. It is interesting that only two Roman Catholic churches commissioned windows from La Farge's firm, possibly because their immigrant parishioners could not finance such costly projects, or perhaps their churches already had decorative programs in place. The list of private clients for his domestic glass and decorative painting reads like a "who's who" of the rich and powerful in society, including such capitalists and plutocrats as William H. Vanderbilt, Cornelius Vanderbilt II, J. Pierpont Morgan, Samuel J. Tilden, Cyrus W. Field, Whitelaw Reid, and John Hay. La Farge's windows commanded such extravagant prices as $10,000 (approximately $250,000 in 1994 currency) for a memorial window in 1887, and as much as $18,000 (approximately $394,000 in 1994 currency) in 1908.[45]

Other notable decorative and stained glass commissions for public places—for example, the Union League Club (1880) in New York, the *Battle Window* (1882) for Memorial Hall at Harvard College, and the Crane Memorial Library (1883) in Quincy, Massachusetts—were likewise directed toward elite audiences. The narrative or allegorical forms of La Farge's mural decorations and windows were drawn from Western literature, from ancient or biblical history. As La Farge surmised, this cultural tradition was familiar to the educated upper middle class, but largely illegible to the uneducated. Hence he depended on the appeal of color rather than tradition when contemplating the social efficacy of his decorations on the "unlearned." In La Farge's lifetime, however, the aesthetic forms most often chosen as vehicles for the education and improvement of the working classes and foreign-born were not costly stained glass windows. Preferred instead were public sculptures and murals with allegorical programs that were often equally illegible to these groups. The Colonial Revival was thought to be a conciliatory dressing for settlement houses, community playhouses, museums, and churches that would efface social differences by educating foreigners in America's Anglo-Saxon patrimony.[46]

La Farge's optimism—his devotion to aestheticism as a means of progressive social improvement—meanwhile exasperated his friend Henry Adams, who remained skeptical of progressive and liberal ideologies. Adams was able to locate coherence only in the beauty of the medieval past, because from the distance of several centuries the medieval era seemed to be more psychically and spiritually unified, as well as unadulterated by the scientific reason that had created the modern malaise of divided consciousness. Adams's search in the past for psychic revitalization, however, was not unlike the quest for a mystical wholeness of body and spirit that La Farge sought in nature and in the Far East.[47] But the two men could not agree on a prognosis for American society. Adams expressed their differences of viewpoint:

> I was always brutally telling him that he was living in illusion; that he imagined a public and a posterity which did not exist; that he was tearing himself to pieces for a society that had disappeared centuries ago, and would never appear again; and that we were only a little knot of a few dozen people, who talked about each other, and might as well burn up all we had done, when we should take our departure;—he admitted the fact, but sheltered himself behind the screen of mice-catching for a living. This was only his word-play. Really he worked

only for the grade of a great artist among the great artists of the world of the past. He wanted to be coupled with Delacroix and Hokusai. On that point I was wholly with him. We could both of us live in,—and for,—the past, with infinite satisfaction; where we parted was in living for the present. I really suffered to see him working to create an audience in order that he might please it. The double task passes any endurance.[48]

In that La Farge's list of patrons included the most powerful and wealthy of the 1890s, Adams's cynicism seems unfounded—a comment more on his own self-imposed isolation than on La Farge's lack of harmony with his time.

La Farge dissented from contemporary evolutionary thought, however, in that he did not see history "progressing" according to the Spencerian evolutionary scheme, with civilization peaking at the top of an upward spiral. In place of the reigning idea that the nineteenth century enjoyed an enlightened status in the historical continuum, La Farge believed that civilization had produced a series of "golden ages." He counted among these the cultures of ancient Greece, Japan, medieval Europe, and the Italian Renaissance, and trusted that America too was on the verge of entering the "doors of the kingdom," that is, into a new period of enlightenment. La Farge's version of American history was ultimately informed by the popular belief in the evolution of a new world civilization from an impending synthesis of the best of East and West.[49] Shortly after the founding of the American Academy in Rome, for example, La Farge expressed the hope that this institution would prove to be another bulwark supporting America's claim to world cultural preeminence. To the American Institute of Architects, he summed up these millennial ambitions:

We are now at this very moment going to add to our aspirations, to the promise in the future, to the glory of the future, to the future charm of life for the artists of all kinds, a connection with Europe which has been wanting, the placing of the names of our young men in the great city of the past. We are going to be established in Rome. . . . This is in itself a statement that we, too, are rivals of all that has been done, and intend to rival all that shall be done, and we can then feel that the old cycle is closed, and that a new one has begun.[50]

All the same, La Farge's view of cultural development was conservative, organicist, and Spencerian: change proceeded slowly through habit and

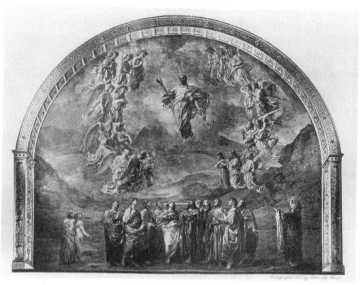

FIG. 2.9. *John La Farge,* The Ascension, *1887–1888, The Church of the Ascension, New York. From Royal Cortissoz, John La Farge (1911).*

adaptation to the environment, and was directed by a collective memory that was at once learned and racially inherited by the individual.[51] La Farge translated this gradual evolutionary process into his own personal artistic practice in his mural decorations and stained glass. By reinterpreting visual forms drawn from the best art of the golden ages, by profiting from the collective memory, La Farge thought American artists could learn to discern the "permanent reality in the midst of the transient."[52] *The Ascension* (fig. 2.9), completed in 1888 at the Church of the Ascension in New York, exemplifies La Farge's method of appropriating compositional elements from diverse cultures into an artistic mode, however unsynthesized. The monumental figure style, handling of color, and compositional scheme were variously adapted from Masaccio, Raphael, Palma Vecchio, and Titian, so that the figures seem grafted onto the flat landscape background he sketched during his trip to Japan, and then overlaid with a mystical atmosphere of colored light—an element that functioned as his signature.[53]

This scholastic way of working, by accretion of traditional forms and symbols, became more habitual to La Farge after he took up public commissions and moved away from the intuitive and sensuous oils of the 1860s. Memory and intellectualization became increasingly important in his later aesthetic theory, just as history and narrative assumed high

priorities in the public works. By the end of his life he had become convinced that collective memory was the primary determinant in the interchange between artist and audience. The response of the audience to the art object should not terminate in the appreciation of the material object; rather, the object existed only to carry the audience to a transcendent reality:

> To imply what it does not say, to bring up memories that are not expressed, and often to bring up memories of other expressions which we have liked and which we wish to see applied again to some different motive. And as all is memory, so this report of the eye applies to what we imagine as well as to what we see. . . . For our imagination, of course, is an arrangement of our memories. Just as our sight is. We see through our memories.[54]

The idea of forging an American culture through synthesizing the best of the past with the present was hardly unique to La Farge. As early as 1867 La Farge's friend Henry James had added his support to the current nationalist dogma that America would soon inaugurate a new era of world culture. We "young Americans," James wrote to Thomas Sergeant Perry, are "men of the future."

> To be an American is an excellent preparation for culture. We have exquisite qualities as a race, and it seems to me that we are ahead of the European races in the fact that more than either of them we can deal freely with forms of civilization not our own, can pick and choose and assimilate and in short (aesthetically &c) claim our property wherever we find it. To have no national stamp has hitherto been a regret and a drawback, but I think it not unlikely that American writers may yet indicate that a vast intellectual fusion and synthesis of the various National tendencies of the world is the condition of more important achievements than any we have seen. We must of course have something of our own—something distinctive and homogeneous—and I take it that we shall find it in our moral consciousness, our unprecedented spiritual lightness and vigour. In this sense at least we shall have a national *cachet*.—I expect nothing great during your lifetime or mine perhaps; but my instincts quite agree with yours in looking to see something original and beautiful disengage itself from our ceaseless fermentation and turmoil.[55]

By the time La Farge visited Japan two decades after James's outpouring of chauvinism, he had come to a similar conclusion: that a synthesis of Eastern mysticism and Western humanism was to guide the future trajectory of American art.

LA FARGE AND THE "HIGHER LIFE" IN JAPAN

During his trip to Japan with Henry Adams in 1886 La Farge focused on exploring those parts of the culture that were still untouched by the analytical modes of the West. One of La Farge's objects in going to Japan was to make studies of its mountains and atmosphere in preparation for the landscape background of his *Ascension* mural, because the atmosphere there was "not inimical, as ours is, to what we call the miraculous." In Japan, La Farge asserted, it was still possible to "fall into moods of thought . . . or feeling,—in which the edges of all things blend, and man and the outside world pass into each other."[56]

Comparison of the Japanese to children in this period was a strategy by which Americans typically defused their fears of Japanese martial strength and also remained assured of Western racial superiority.[57] To La Farge, however, the Japanese were childlike because they preserved an integrated mode of expression, unifying thinking and feeling. Although La Farge pinned this fall from grace on Western science, in American scientific discourse the evolutionary controversy was almost entirely the cause of the shift from the concept of nature as imbued with the supernatural toward nature as a rational series of laws and processes. This philosophical shift had had some considerable complicity in Adams's motivation for fleeing to Japan; he left the country to numb the pain of his wife's recent suicide, which had been precipitated by the death of her father and her inability to console herself by any traditional religious means.

As La Farge traveled from Tokyo to Nikko, Yokohama, Kyoto, and other cities over a three-month period, he collected trinkets and art objects and studied art and architecture, as well as Buddhism. His exploration of Taoism especially led him to understand the essential role of aesthetics within the whole of Japanese life. The Chinese philosophy of Lao-Tzu, called Taoism, specifically captivated La Farge, perhaps because he had already been searching for a unified mode of experiencing the world. In the journal he kept on this journey, one of the most intense passages related his recent introduction into Taoism and its deep impression on him. In a narrative characterized by incantatory rhythms and metaphors of *chiar-*

oscuro, La Farge recounted the mystical power and beauty of the Taoist way
of experience with the zeal of a new convert. Lao-Tzu, the ancient prophet
of Taoism, La Farge said,

> neither preached nor discussed, yet those who went to him empty
> departed full. He taught the doctrine that becomes untrue and
> unprofitable when placed in set forms and bound in pedantry, but
> which allows teaching by parables and side glimpses and innuendoes
> as long as they are illuminated by that light which exists in the natural
> heart of man. And I, too, am pleased to let myself be guided by this
> light. After many years of wilful energy, of forced battle that I have
> not shunned, I like to try the freshness of the springs, to see if new
> impressions come as they once did in childhood. With you I am safe
> in stating what has come to me from outside. It has come; hence it is
> true: I did not make it. I can say with the Shadow, personified by my
> expounder of the Way, that when the light of the fire or the sun
> appears, then I come forth; when the night comes, I lie still: I wait
> indeed, even as they wait. They come and I come, they go and I go too.
> The shade waits for the body and for the light to appear, and all things
> which rise and wait upon the Lord, who alone waits for nothing,
> needs nothing, and without whom things can neither rise nor set.
> The radiance of the landscape illuminates my room; the landscape
> does not come within. I have become as a blank to be filled. I employ
> my mind as a mirror; it grasps nothing, it refuses nothing; it receives,
> but does not keep. And thus I can triumph over things without injury
> to myself—I am safe in Tao.[58]

The tone of the passage, both oracular and meditative, hints at La Farge's
identification with Lao-Tzu: his description of the Chinese sage's manner
of speaking and teaching recalls Cortissoz's evocations of the way La
Farge's friends marveled at the artist's ability to interweave subtly diverse
and fascinating fragments of his vast learning and experience into a single
multicolored meditation—a reflection of his "opalescent mind." Implicitly
through his language, La Farge reveals his attempt to find himself in this
Eastern master and his mystical way, as if he now located a submerged part
of himself he had longed to realize more fully. After being initiated into the
secret knowledge of the East, he was now more comfortable with assuming
a more overtly mystical persona.[59]

La Farge enlarged his mystical self-identity in the same passage by
drawing a picture of himself, sitting by a waterfall in the garden of his

lodging, listening to the hypnotic sound of the water. He suggested that the processes of seeing, thinking, and feeling merged for him as he entered into a trancelike state. The "radiance of the landscape" flickered briefly across his retina, but the impression left him as the stream of consciousness flowed on. The Buddhist conceit La Farge invoked here centered on the body's passive immersion in the universal processes of nature achieved in the act of meditation, with the result that the mind becomes a blank, a mirror across which natural phenomena register and then disappear. La Farge's version of Taoist meditation has Western correspondences in the mystical experiences of Emerson and the English and German romantics, in the "transparent eyeball" and the mind as a *tabula rasa*—states of insight that theoretically afforded reunification with nature. In the merging with nature, one transcended the material limitations of the self and relocated the primal childlike joy of connectedness to the universe—an emotion that is lost to the normal adult psyche. Exalted by the Transcendentalists and the romantics, this sublime moment was contemplated later in the nineteenth century by William James as the essence of religious experience, and by Freud as the mystical oceanic experience.[60]

Listening to the sounds of nature, such as a brook or the wind in the pine trees, was also a Shingon Buddhist meditational practice in which La Farge was receiving some instruction at this time from Ernest Fenollosa, a scholar of Asian art; William Sturgis Bigelow, a wealthy Boston collector; and Kakuzo Okakura, later a proselytizer of traditional Japanese culture. All three had been inducted into a Mikkyo (Tendai) Buddhist sect the previous year.[61] Fenollosa had steeped himself in Emerson, Spencer, and Hegel while at Harvard in the 1860s. When in Japan in the 1870s he introduced the Japanese to Spencer, and while studying Buddhism in the 1880s he again came back to Emerson's works. Bigelow's expression (to Phillips Brooks) that "Buddhist philosophy is a sort of Spiritual Pantheism—Emerson, almost exactly" neatly summed up the attraction of Buddhism for Americans, as well as their tendency to reduce Buddhist, Transcendentalist, and Spencerian thought to a vague pantheism.[62]

La Farge tried at least once and probably several times more to abandon his self-consciousness and enter into the kind of meditative state in which he could regain the child's original vision of the world. Neither La Farge nor Adams, however, seemed interested in the mythic sexual life of the Japanese or the South Sea islanders they visited in 1890. Their friend Clarence King had bragged to them of his relish in experiencing the dark sexual instincts that were enjoyed by such "primitive" societies as the South Sea islanders but repressed by the modern superego. To Adams's extreme

displeasure, he and La Farge twice tried out the services of geishas in Japan. In the South Seas, though, they were content to be entertained, as they had been in Japan, by "primitive *culture*" alone. King later complained that La Farge had missed out on a great opportunity, in opting for "the droll germs of civilization[,] not the full stature of naturalism." "With La Farge," he elaborated, "it is the gay naif's faltering first steps in social matters that tickle his sense of humor just as a very clever man is charmed with the little ways of children."[63] But such a condescending response to the Japanese, of being charmed by their childlike quality, was hardly unique to La Farge: it merely echoes the way Americans generally accepted Spencer's classification of world cultures into progressive stages from savage to civilized, a scheme premised on the idea that "ontogeny recapitulates phylogeny," that individual development from child to adult is analogous to the development of the race from savagery to civilization.[64] Though he was certainly curious and voyeuristic about savage sexuality in Tahiti and Japan, La Farge refused to define himself outside the boundaries of the civilized masculinity of the old school, in the later terms of Roosevelt's primitive virility, as Henry Adams conveyed in remarking that La Farge was "behind his profession, a gentleman, by birth and mind; and he never forgot it."[65]

The perceived unity between the Japanese people and nature that enchanted La Farge was also essentially different from the "primitivism" that attracted Gauguin to the same culture. La Farge let it be known that to him Gauguin's flattened, distorted images of nature were the imaginings of a "wild" and "stupid Frenchman" who was "driven to do something to attract attention."[66] In Japan he struggled to evade Western logical modes of thought in order to know nature in a more antirational and mystical manner that was consistent with his construction of Eastern cultural modes. But in his art La Farge was never really willing to abandon Western naturalism in terms of *chiaroscuro* and three-dimensional spatial definition. He was ready to embrace sensuousness and mysticism in art only if they did not disturb his idea of civilization.[67] A watercolor from his trip to the South Seas, *Samoan Girl in a Canoe* (pl. 3; fig. 2.10), succinctly demonstrates the distance between La Farge's dream of paradise and Gauguin's. Where Gauguin's synthetist vocabulary rendered his Tahitian landscapes into flat shapes of pure colors, La Farge's formal language advances traditionally rounded forms modulated by tone. While Gauguin's subjects straightforwardly represent his fascination with the mysteries of birth, death, and sex, La Farge's daydream presents a transcendent moment of viewing a virginal female native, so desexed as to be androgynous, as her

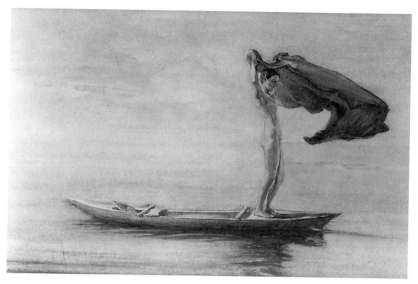

FIG. 2.10. *John La Farge,* Samoan Girl in a Canoe, *c. 1890–1895. Watercolor. The Corcoran Gallery of Art, Museum Purchase.*

graceful form stands bathed in the opalescent light of sunset, demonstrating its unity with the surrounding paradise.

In Japan La Farge also realized that the unified expression he had been seeking in his flower and landscape paintings early in his career was identical to the subjective mode practiced by the Japanese painter, in which the thing seen becomes inextricably fused with the vision of the seer. The painting of a lotus blossom by Kose-no-Kanaoka brought the recognition that the method La Farge had employed two decades earlier when he had attempted to approximate the transparency of the water lily approached that of this tenth-century Japanese artist.[68] Again, as he rediscovered himself in Japanese forms, he felt that he had in a "superstitious sense" reinvented Eastern methods.

AESTHETICISM, THE EAST, AND THE FEMININE

Twenty years after his Japanese trip La Farge was able to articulate more fully the ideal of a transcendent painterly mode that lay behind his pursuit of an intuitionism. Lecturing in 1906 at the Museum of Fine Arts in Boston, he defined "the art of painting" as that which

gives us what words cannot give, and that art begins where language ceases. "Painting," says Delacroix, "is an art in which we use the picture of reality as a bridge to something beyond it." . . . Painting ought to carry the mind to something further than the thing represented, to imply what it does not say, to bring up memories that are not expressed.[69]

La Farge's awareness of the importance of silence to the condition of transcendence in art benefited from his introduction to Taoism and meditation in Japan. What surfaced again in this lecture was his disdain for Western analysis and description that limited thought to the familiar instead of releasing it into uncharted territory. Language destroys the unifying power of feeling, La Farge continued, by breaking down sensation into separate unconnected units. Thus, a higher art form circumvents and precludes language since it exists in the mystical realm of silence; it transcends prosaic material reality by connecting itself in the unconscious mind with racial memories of other times and places. For La Farge, the suggestive modes of the East automatically achieved liberation of the imagination, and his stained glass in effect represents his attempt to advance the socially structuring agency of language and artistic convention through the liberating effect of color.[70]

In his book on Taoism and the tea ritual Kakuzo Okakura, who had introduced La Farge to Taoism in Japan, expanded on the essential correlation between the creation of a linguistic vacuum and the creation of a spiritual or mystical experience in art. La Farge edited Okakura's book on the Taoist ritual of tea before its publication at a time when Okakura was employed as curator of the Japanese collection at the Museum of Fine Arts in Boston. "Teaism," according to Okakura, offered a "religious way of life without dogma or doctrine" and, ultimately, empowered the practitioner to "transcend the mundane" through a "perfection of the mundane" in the silent ritualization of everyday acts.[71] In Taoism the greatest spiritual value resided in the vacuum, since a vacuum was an "all-containing whole, greater than any part." In Zen, too, words, discourse, and analysis were only encumbrances when mind meeting mind was the product desired from the experience of art.[72] Suggestive painting based on the principle of the vacuum provided the consummate example of an enlightened art form. "In leaving something unsaid," he elaborated,

the beholder is given a chance to complete the idea and thus a great masterpiece irresistibly rivets your attention until you seem to

become actually a part of it. A vacuum is there for you to enter and fill up to the full measure of your aesthetic emotion.[73]

The Taoist regarded the encounter with art as spiritual to the extent that it drew the viewer to the discovery of a transcendent reality. Images of unconscious life, such as a flower, "fragrant in its silence," were worthy of the greatest reverence for their inherent spirituality. So too were music and musical modes, which with their harmonies and rhythmic intervals of silence and sound were impenetrable to discourse.[74] In suggestive or semi-abstract painting the viewer's absorption into the rhythms of such a composition repeated the original experience of the artist, as he or she intuitively apprehended the rhythms of life in the "World-soul" and entered into this unconscious life of nature. As Okakura interpreted Taoism, the experience of art could be religious and therapeutic in that it aided the process of self-realization and self-perfection.[75]

In his early naturalist studies, La Farge felt he had made his way also toward the means of suggesting a silent unconscious interaction with the world, a tendency that eventually attracted La Farge to Taoism. At least one instance of his long-standing interest in locating self-integration in the silent working of the unconscious mind can be cited in his now-lost painting *Sleep*, or *Sleeping Woman* (fig. 2.11). In this image La Farge shows himself to be one of a number of English, French, and American painters at midcentury who, like scientists, were drawn to the unconscious mind.[76] What is striking here is, first, that La Farge's subject in representing the unconscious mind is feminine. Second, La Farge's approach to his sleeping female is very close to his representation of his flowers, which are revealed as mysterious feminine presences through a strategy of subtle lighting that hints at their exotic essences. La Farge's version of the romantic "drama of consciousness" involved not only the construction of the feminine as a projection of La Farge's subjectivity but also a search for the strange beauty of the feminine in nature. Reminiscent of the feminine "spirit" of the water lily (fig. 2.4), the sinuous figure of the "sleeping beauty" has been isolated in a dark, abstract setting and is decoratively adjusted to the proportions of the surface. The feminine object here and in the flower paintings is reverenced in its presentation, which revolves around the magnification and centering of the forms, as well as the rhetoric of silence. A preparatory drawing for the painting shows this figure with her kimono partially opened to display a breast, which is covered in the painted version, and an expression on her face "of orgasmic passion."[77]

As demonstrated in his enchantment with the feminine object, La

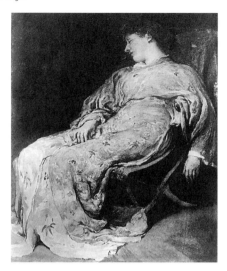

FIG. 2.11. *John La Farge,* Sleep, *or* Sleeping Woman, *1868–1869, (destroyed). From Marianna van Rensselaer,* Book of American Figure Painters *(1886).*

Farge's conflation of the mystical and the erotic was symptomatic of a larger pattern among Anglo-Americans, in which they sought imaginary escapes from the pressures of modern life in premodern cultural forms such as medievalism, Orientalism, mind-cure therapy, folklore, fairy tales, the cult of childhood, and so on. Yet also at work in this late nineteenth-century cultural dynamic was a pattern of ambivalence toward the feminine and ultimately toward sexuality itself. American men learned to think of psychic liberation usually as immersion in erotic, religious, or sensuous experience that facilitated their rebounding to the male sphere of rationality and action as revitalized individuals. Cultural historian Jackson Lears has noted, however, that male achievers pulled back from complete withdrawal into feminized spheres or dependent psychic states that they could access through practices of leisure, religion, and aestheticism. Nineteenth-century male identity hinged on autonomy, in contrast to feminine dependence. Moreover, civilized men were defined as white American males who could control their sexual desires, in contrast to the savage men of primitive societies. Thus "letting go" into the feminine unconscious realm of oceanic feeling was problematic for many men, whose "civilized manliness" was predicated on the notion of control.[78]

The neurasthenic La Farge exhibited a similar pattern of vacillation in Japan: he longed for mystical experience, but then once he had entered into

such unconscious modes of perception, he often stopped short of losing all sense of self-consciousness, and ended by lapsing into melancholy. In one case, visiting the temples of the Tokugawa princes Iyeyasu and Iyemitsu left him only with an impression of the human acquiescence to "the surrounding powers of nature; the yielding of any attempt at permanency, the indefinable sadness," and "the nothingness of man." In another instance, at the Tokugawa tombs, La Farge witnessed a ritual conducted by priests at dusk that again moved him profoundly. While their flute music first seemed a "hymn to nature," soon after, "the shrill and liquid song" began to assume the tone of a "floating wail, rising and falling in unknown and incomprehensible modulations," which he "associated with an indefinite past, little understood; with death, and primeval nature, and final rest." At the moment the final notes of the "funereal song" were sounding, La Farge noted the beauty of the pine needles, sparkling like "emerald jewels," and the "red velvet" at the "powdery edges of broken bark," which appeared with the last rays of the sunset.[79] For La Farge, this absorption in the sensuousness of nature either evoked the poignancy of death, or alternatively it gave him a relief from what he perceived as the burden of the conscious self, as he became immersed in the flow of unconscious life in nature. As Lears observes of elite American men of this period, for La Farge "the association of premodern character with the warm enveloping darkness of unconscious life suggested not only revivified life but also the unconsciousness of death. To submit to the oceanic feeling was finally to drown."[80] Whether in Tahiti or Japan, or even New York, the primitive and the unconscious in association with the feminine led La Farge on, but in the end he drew back into his armor of civilization, as Clarence King observed.

Despite his morbid associations, La Farge was fascinated with Buddhist ritual and its panaesthesia, in the fusion of music with incense and colored robes. His receptivity to the aesthetic structuring of this religious experience was no doubt preconditioned by his upbringing in the ritual of the Catholic Church, whose similarities to Buddhism had already occurred to other Americans.[81] Taoism obviously had an impact on La Farge, helping him to discover himself in Japanese forms and assisting him in a stronger self-definition as a mystic, a development that he felt had been repressed by the rationalism of his American environment. The lessons of Tao also reinforced La Farge's commitment to the aesthetic revision of that environment: Taoism taught how the commonplace could be transformed into the "higher life"; and Buddhist ritual, adapted to the aesthetic ritual of the tea ceremony, taught the art of life.[82] Invoking Spencer's view of successful

adaptation to the environment as the mark of civilization, Okakura wrote that "The art of life lies in a constant readjustment to our surroundings." Described by Okakura as a "Religion of Aestheticism," Teaism (and thus Taoism) was compatible with Spencer's evolutionary theory.[83]

LA FARGE, AGNOSTICISM, AND THE ADAMS MEMORIAL

The manner in which Boston Brahmins and intellectuals took up Buddhism and its permutations as acceptable surrogates for more traditional religious creeds emerges in the history of La Farge's involvement with the *Adams Memorial* (fig. 2.12). Though the memorial was sculpted by Augustus Saint-Gaudens, the conceptual adviser for the project was La Farge. As he was leaving for Japan, La Farge had jokingly remarked to a reporter that he and Adams were going "to seek Nirvana." In reality, however, the search for emotional refuge—for Adams, from the horror of his wife's recent suicide, and for La Farge, from the harassment of business and creditors—in an Eastern paradise was the exact reason for the trip.[84]

After returning to America late in 1886, Adams, who was an agnostic, asked Saint-Gaudens to design a monument for the grave of his wife Marion Hooper Adams. Adams stipulated that Saint-Gaudens was to be guided by the ideas of the Kannon, the god of compassion, and nirvana via La Farge's counsel. While studying Taoism in Japan, La Farge began meditational practice, the goal of which was to reach a state of quiescence—the nirvana in which all worldly passions are extinguished. He also found himself intrigued with the figure of the Kannon, "absorbed in the meditations of Nirvana," as he admitted, "partly, perhaps, because of the Eternal Feminine."[85] La Farge was particularly taken with a painting of the Kannon by the eighteenth-century artist Maruyama Okyo (1733–1795), and soon after he returned from Japan he modeled a watercolor and an oil painting called *Kuwannon Meditating on Human Life* (1887–1908) (fig. 2.13) on Okyo's work. La Farge's digressions from Okyo's white-robed Kannon, however, speak to his own preferences, as well as those of other late nineteenth-century Americans, in the way spiritual and natural forces have been located in the feminine body. While Okyo's bodhisattva is a man, or at least an androgynous being, La Farge's is definitely a human woman and thus draws on the popular Japanese worship of the Kannon as a mother figure, a "goddess of mercy," who demonstrates her compassion for the suffering of humanity by refusing to enter into nirvana.[86]

Like other Americans in this period, La Farge interpreted nirvana as an emancipation of the spirit rather than the cessation of life. The Boston

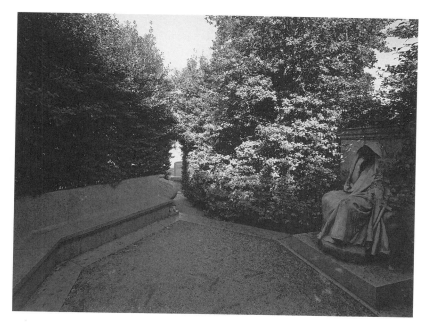

FIG. 2.12. *Augustus Saint-Gaudens (with Stanford White),* The Adams Memorial, *Rock Creek Cemetery, Washington, D.C. Photograph courtesy of Jerry L. Thompson.*

FIG. 2.13. *John La Farge,* Kuwannon Meditating on Human Life, *1887–1908. Butler Institute of American Art, Youngstown, Ohio.*

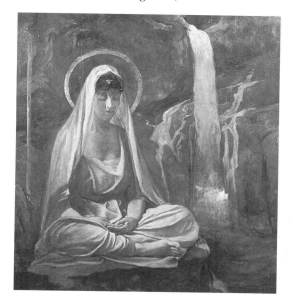

Brahmin Lafcadio Hearn referred to nirvana as the "passing of conditional being into unconditioned being" in his popular volume *Gleanings in Buddha-Fields*. According to Hearn, the "Real Self" was not annihilated, only the "outer" self or ego.[87] Hearn's view of nirvana thus preserved the Christian sense of the survival of a personal spirit, or soul, after death, whereas in true Buddhist belief there is a cessation of life in nirvana, so that no rebirth can take place after death.

In choosing to show the duration of the essential self in the Rock Creek figure, Adams and Saint-Gaudens, like their contemporaries, opted for the more affirmative view of nirvana. In contrast to La Farge's Kannon, Saint-Gaudens created an abstract being, neither masculine nor feminine, without personality and individuality, in which the formal disposition of mass and line communicates a self-contained spiritual state. Designed by Stanford White, the setting is encircled by holly bushes. The space is bounded on one side by the bronze and granite of the marker and on the other (opposite the marker) by an elliptical exedra bench that invites the viewer to the silent contemplation of the figure's meaning. The desire to represent the state of passionlessness at his wife's grave site ostensibly expressed Adams's wish that Marion Adams had now passed on to a state of complete calm after her period of suffering. On their first viewing of the memorial, Adams's brother Charles and close friend John Hay both read Marion Adams's personal history into the buddhalike figure and told Adams what he wanted to hear—that the seated statue expressed "rest,—complete, sudden, painless rest,—after weariness, trial and suffering." When later asked what the sculpture meant to him, Saint-Gaudens similarly responded that it embodied "the Mystery of the Hereafter," a state which is "beyond pain and joy."[88]

Later Adams recounted to friends his perverse delight in overhearing the troubled responses of the clergy, who could find in the enigmatic figure no gesture toward traditional Christian reassurances of an afterlife. Saint-Gaudens had merely "held up the mirror and no more," Adams said, reflecting the viewer's doubt or faith. The figure thus suggests only a state of mind that must be finally determined by the viewer. Though the monumental dignity of Michelangelo's Sistine sibyls is evoked in the expression of the motionless figure, their dynamism is now negated through a synthesis with Buddhist inner calm.[89] The only movement of the form is the elegant sweep and contours of its drapery, which merely serves to underscore the complete psychological self-enclosure of the figure. The figure's sense of isolation is further enhanced by the deep hood over the face and the heavily lidded eyes that elude any contact with the world.

LA FARGE'S LEGACY

Although La Farge's reputation as a painter was in acute decline by the 1890s, the artistic problems he set for himself would continue to impress the next generation of painters. While the younger artists who were just defining their aesthetic in New York in the late 1870s were captivated by Whistler's debacles and self-promotions in London, they also owed "an unpayable debt" to La Farge, who was a quiet yet forceful presence residing among them during these formative years.[90] Through his early flower paintings and landscapes, which he exhibited regularly in New York into the 1890s, La Farge provided the painters who would mature in the 1880s and 1890s with an example of a new painterly mode of expression.[91] In his oils and watercolors, younger painters such as Dewing and Twachtman could observe how the two-dimensional field of the painting reflected the painter's field of consciousness, and at the same time composed a decorative work of art. The significance of La Farge's career for the 1890s, however, equally lay in the value of the decorative work of art in the context of the sensuous environment. When this neophyte group of painters broke off from the old parent group at the National Academy of Design in 1874–1875 and established their own exhibiting organization, the Society of American Artists, in 1877, La Farge played den father to these aspiring artists. He wielded an almost dictatorial role in jurying their exhibitions and gave precedence to works that conformed to decorative—that is, Japanese—principles.[92]

If La Farge's Roman Catholic background insulated him from the personal crises of faith commonly experienced by Protestants in sorting out the evolutionary debate, he was, in the end, drawn into its central issues through his audience and through his own religious bent of mind. It is ironic that his religious difference also uniquely positioned him to offer a new aestheticized religious experience to the Protestant elite. In La Farge personal inclination toward mysticism and early training in a sensuous culture converged to distinguish him as a unique mandarin personality in late nineteenth-century America. La Farge's self-appointed role at this historical moment was to lead the Anglo-American elect to the transcendent experience of opalescent light. Costly and luxurious, yet imbued with spiritual innuendoes, stained glass in his rationale held out a social means of bringing Americans to a state of refinement. Though his production of glass began simply as a fascination with discovering his own opalescent mind in a new artistic form, it ended as a program of progressive aesthetics.

CHAPTER THREE

James McNeill Whistler
and the Religion of Art

NO ARTIST WAS MORE REVERED among young American
painters during the 1880s and 1890s than James McNeill Whistler (1834–
1903). The *Arrangement in Grey and Black: Portrait of the Painter's Mother*
was canonized when it entered the Musée du Luxembourg in 1891, but
by that time Whistler had already been accorded the status of an "old
master" in America, even though not a single one of his paintings had yet
been purchased for an American collection, public or private. The cult of
Whistler among American painters, however, owed its existence to the
degree of celebrity he had attained in England and Europe. Moreover, his
popularization of "art for art's sake" afforded a new cultural capital that
could be exploited to the advantage of this developing generation of
artists, who were then striving to attain a more valorized professional
identity.

Whistler's patriarchal status among younger American artists also points
to the way in which his tonalist art seemed to respond to the quandaries of
this historical moment. As Americans confronted the most stirring prob-
lem of the late nineteenth century, the dilemma of belief in a spiritual
realm, Whistler's view of the individual seemed to reaffirm the existence
of a finer self, purified of its gross, material aspect. The post-Darwinian
controversies provided the ideological matrix of which the Anglo-Ameri-
can establishment availed itself in its efforts to retain its hegemony against
the perceived onslaught of "cruder" foreign peoples. But Whistler's visual

strategies showed Anglo-American artists how they might symbolically picture themselves and their civilization at the apex of the progressive, upward spiraling trajectory of evolution.

Whistler's legacy to American painters and sculptors was a dematerialized tonalist mode in which color and line were orchestrated to approach the harmonies and rhythms of music. As such, this tonalism aligned itself with music in holding out a "consolatory and elevating alternative" to the prevalent materialism of the industrial age that was made sacrosanct by the philosophy of scientific positivism.[1] Considered a medium inherently based on immaterial or transcendent means, for nineteenth-century critics music eluded the parameters of historical reality to the point that it was regarded as a "spiritual force of incalculable influence." Indeed, music replaced poetry as the model of the most perfect art form at midcentury, even though its alleged distance from material reality at the same moment was ironically belied by the attempts of composers such as Berlioz, Liszt, and Wagner to approach that reality in the form of programmatic music.[2]

Couched in terms of the Hegelian aesthetic discourse, Whistler's dematerializing symphonic idiom seemed implicitly to reveal the object as a contiguous part of a spirit world. His project was dependent on Baudelaire, not simply in its drive to legitimate the "autonomy of the aesthetic sphere" but also in its participation in what Jürgen Habermas has termed Baudelaire's search for the *"promesse de bonheur* via art"—a utopian project of "reconciliation with society."[3] Whistler's proselytizing for a religion of art, for the belief in the power of a pure art to transform the world, had a decisive impact on his American audience, in a manner that recalls the American fascination with Wagner and his *gesamtkunstwerk* (complete work of art) in the 1890s.

Whistler's tendency toward musical abstraction displaced the didactic moralism and the narrative domination of the word that typically governed the art of the 1860s and 1870s. In his purified field of vision, quietism replaced action and beauty replaced moral narrative as prescriptive modes of public and private conduct. Whistler's painting was offered not as a window onto the world but as a simulacrum of the world as it should be. Whether the subject be a figure of a beautiful and mysterious woman or a cityscape, the object was dematerialized through the transforming properties of a colored atmosphere. Forms so dematerialized and veiled suggested to Americans the painter's mystical experience of the world as essence. Such an art form then easily lent itself to an agnostic, quasi-religious usage. Worship of a mysterious and spiritualized feminine principle, embodied in

the beauty of a woman or an exquisite work of art, beckoned as a substitute creed for liberals and agnostics searching for a secularized sublime worthy of reverence. The human ability to create and reveal beauty, as well as to appreciate it, satisfied American Protestants' yearning for evidence to believe in the existence of the soul. The possibility that some transcendental plane of experience could be verified held out an escape from the nihilism that threatened in the idea of this world as a finality in itself—a pessimism with which Darwin's evolutionary studies were identified.

Whistler's aesthetic of integrated subject and form, body and spirit, was received in America as a certain disclosure of the human evolutionary trajectory toward spirit, significantly at the moment when neo-Hegelian philosophy and Spencerian evolution were rife in the upper-middle-class Protestant ethos of the Northeast and Midwest. If Whistler's vision proposed reassuring answers to anxieties privately endured, it also was suggestive of ameliorating strategies to problems Americans met in the public arena. His decorative enterprises in the 1870s and 1880s endorsing the salutary effects of the designed environment propitiously came to the attention of an audience on these shores that was ready to contemplate the benefits of a refined, unified environment on the individual and the community as a response to social tensions. After listening for two decades to social theorists and evolutionists debate the problems obstructing the progress of American society, Americans were ready by the early 1890s to employ quietist environmental strategies as solutions for problems ranging from individual neurosis to class and racial conflict. Moreover, the power of the artist to remake the world through aesthetic design was implicitly disseminated in the multitude of paintings Whistler displayed in this country during the last two decades of the century.

This chapter examines how the making of Whistler's antimaterialist idiom, as well as the contemporary interpretation of that idiom, was conditioned by and impregnated with the emerging ideologies of the late nineteenth century. Of particular interest for Whistler's American followers was his religion of art, in which woman figured seductively and the cityscape beckoned as a sphere of social harmony. The utopian topos of Whistler's work, as represented in the body of a woman and the topography of civilization, was one in which the vision of the artist veiled, distanced, and finally evaded the male ambivalence over the feminine body and the dilemmas of the body politic. Elite Americans pondered Whistler's work and made use of it in the context of their evolutionary ideologies; his paintings and ideas lent them strategies that answered the conflicts of modern life with the alternative faith of art.

TOWARD THE RELIGION OF ART

The path by which Whistler finally arrived at an artistic system that supported American evolutionary beliefs was not by any means straight or swift, and it occasioned at the start a tentative exploration of territory that would seem alien to his later objectives. Whistler arrived in Paris in late 1855 during the height of the naturalist ferment. Having spent the seminal years of his youth (1843–1848) in the Francophilic culture of St. Petersburg, he appeared already to be fully gallicized by the time he arrived in Paris. Henri Murger's novel glamourizing the lives of art students there in this period, *Scènes de la vie de bohème* (1848), which Whistler had reportedly learned by heart, supplied for him the myth of the life religiously devoted to a pure art. At first he joined the circle of English art students at work in the studio of the neoclassical painter Charles Gleyre; then three years later his new friend Henri Fantin-Latour introduced Whistler into the literary and artistic group centered around the realist painter Gustave Courbet. The egotistical young Whistler was eager to make a position for himself at the cutting edge of modern art. This essentially meant subscribing to the positivism of realism and naturalism.

At the same time that he sought to master the rudiments of naturalism, seeking out the working-class characters of Paris, he also schooled himself in the rudiments of traditional art, copying paintings by Ingres, Boucher, Veronese, and others in the Louvre. There was no inherent contradiction in these two practices. In fact, the realists emulated the seventeenth-century painters who had studied peasants and the rural landscape. The realists also revered Velázquez's portraits for their seemingly effortless and spontaneous portrayals of the living human presence through the skillful modulation of tone, especially the middle values. Accordingly, Whistler traveled to Manchester in 1857 to see the work of Velázquez at the Art Treasures exhibition there—an experience that would later prove to be fundamental for the technical system he built on the subtle gradation of tone.[4]

Whistler's admiration for Courbet lasted at least until the autumn of 1865, when the two painters went to Trouville together with Whistler's mistress Joanna Hiffernan, and can be said to have ended by the time Whistler renounced "*ce damné Realisme*" to Fantin-Latour two years later. Overlapping his friendship with Courbet was his close association with Dante Gabriel Rossetti and the poet Algernon Swinburne. Whistler had moved to London in 1859, met Rossetti and Swinburne in July of 1862, and taken a house near theirs in Chelsea the following year. Shifting between

his half-sister's bourgeois household in London and his freer life in Paris in the late 1850s allowed Whistler to take advantage of what both the English and French arenas had to offer—the two poles represented by Courbet's naturalism and Rossetti's aestheticism. While devotion to the pleasures of art would eventually pull him away from the world of the lower classes, Whistler nevertheless profited from the subjectivity inherent in the naturalist's viewpoint, and more specifically, from exposure to Courbet's egocentric surfaces and absorptive themes. Courbet's thick, gesticulatory pigment asserted both the work of art's autonomy from nature and the personality of the artist who had self-consciously laid it on, while his self-absorbed female figures, sleeping or reading, furnished models of inner states of being.[5]

During his first years in Paris and London, Whistler made his allegiances with the realist position clear as he painted street merchants of chamber pots and flowers. The etched work of this period, especially "the French Set" (1858) and his etchings of the Thames (fig. 3.1), reflects the conventional rhetoric realists brought to scenes of lower-class life. By focusing on an unprivileged domain, the artist raised the peasant or pot seller to the level of the aristocratic precinct of high art. His lasting tie with the realist movement, however, took its impetus from Courbet's explora-

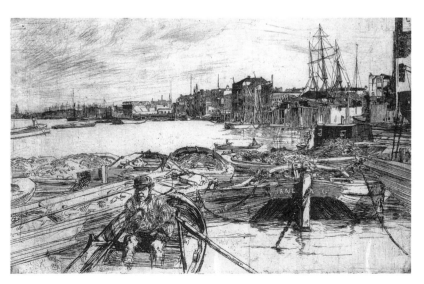

FIG. 3.1. *James McNeill Whistler,* The Pool, *1859. Etching. Freer Gallery of Art, Smithsonian Institution.*

tion of the subterranean levels of the mind, not from the reportage of indigent and profligate scenarios with their liberal political innuendoes. Whistler's first major oil painting, *At the Piano* (1858–1859; Taft Museum of Art), and many of his etchings of this period—for example, *Weary*—are based on seventeenth-century Dutch domestic genres, as well as on Courbet's female figures absorbed in the silent activities of sleeping, reading, playing musical instruments, or sewing.[6]

The degree to which the hidden realm of the mind began to command Whistler's attention as an artistic resource is also indicated by his studies of Horace Lecoq de Boisboudran, who devised a method of utilizing memory in artistic observation. With Fantin-Latour, Whistler practiced filtering observation through memory; this was a process that assisted the artist's development of an imaginative, subjectivized style, rather than a method that relied on the imitation of details recorded directly at the site.[7] The tendency to enlarge the role of the artist's unconscious as well as his rational powers in the creative process increasingly asserted itself from the 1860s onward in Whistler's work in both subject and method. In executing his later "nocturnes" in the studio, away from the observed scene, for example, Whistler came to pride himself on his ability to reconstruct from memory the night's mood from the vantage point of the boat in midriver.

Both realist social themes and the idea of interior experience attracted Whistler during the early 1860s. The way in which they overlapped in his work is demonstrated in the distance between the *Symphony in White, No. 1: The White Girl* of 1862 (fig. 3.2) and *Wapping on Thames* (fig. 3.3). Begun in 1860, *Wapping* originated in Whistler's realist commitment to render the downtrodden of humanity in a manner picturesque enough to win middle-class patronage and exhibition at the Salon. But by the time it was exhibited at the Royal Academy in 1864, Whistler had been drawn into the domain of private experience projected in *The White Girl*.

In *Wapping* the scene is the docks of east London, a neighborhood so diseased, polluted, and dangerous that, as Dickens wrote, only the "accumulated scum of humanity . . . , like so much moral sewage," would inhabit the place. In the foreground is Whistler's mistress Hiffernan. In the earliest state of the painting Whistler cast her in the role of a prostitute enticing two sailors with her charms. As she toyed with the elder of the two in a mocking manner, Jo was originally much more salaciously attired, her throat and bosom displayed with a "superlatively whorish air," Whistler said.[8] Conceived a year after *Wapping*, in late 1861, *The White Girl* transformed Jo from an exemplar of the bad feminine sublime into a

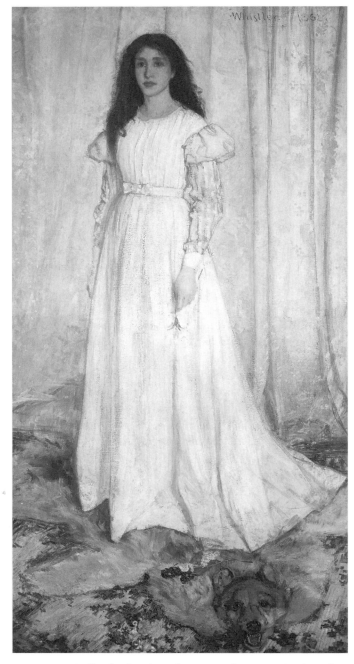

FIG. 3.2. *James McNeill Whistler,* Symphony in White, No. 1: The White Girl, *1862. Harris Whittemore Collection, National Gallery of Art, Washington, D.C.*

paragon of feminine virtue. After *Wapping* Whistler moved away from the woman who asserted her sexual power over man, a type favored by Baudelaire and Courbet. *The White Girl* showed his ambivalence resolved in the direction of the paradoxical beauty, the woman both sensual and spiritual, whom Rossetti found so alluring.

The complexity of Hiffernan's presentation in *White Girl*—her juxtaposition with other loaded symbols—makes problematic Whistler's claim that the picture was simply meant as an technical exercise in painting white on white.[9] What transfixed or amused many contemporary viewers was the image's inherent drama, in which a fragile, pure beauty is menaced by forces of oppressive physicality. This narrative, conventional to English gothic novels of the time, arises from the tensions within the image. The central tension emanates from the way in which Hiffernan's status as a virginal figure, holding a single, white flower—possibly a lily (while others symbolic of love have been dropped to the floor)—is confronted by the bestial presence of a bearskin, its mouth gaping with jagged protruding teeth. The purely white passages above and behind her are juxtaposed with the crude, contrasting pattern, saturated colors, and rough textures below. Though she is posed to look out at the viewer, her eyes focus on no

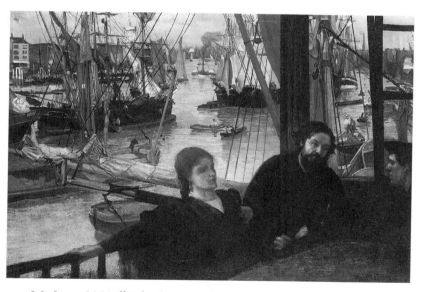

FIG. 3.3. *James McNeill Whistler,* Wapping on Thames, *1860–1861. John Hay Whitney Collection, National Gallery of Art, Washington, D.C.*

particular object; her blank stare can only be directed inward, as if she was contemplating her self-image in a mirror. Hiffernan's dumb figure, seemingly stunned and immobile, is resonated in the muteness of the differentiated whites that surround her. In the white passages that occupy the upper two-thirds of the canvas the only elements that intrude on the bewildered psychological mood are the heavy tactility and scumbling of oil pigment itself which, in emulation of Courbet, has in places been scraped on with a palette knife. On one level, these scrapings call attention to the painter himself and his process, while on another their crudeness echoes the energies below.[10]

Whistler refused to explain the picture through the means of a conventional narrative title, and referred to it simply as *The White Girl* in personal correspondence. The recalcitrant image was rejected by the Royal Academy in 1862 and by the Paris Salon in 1863, and then exhibited as *Dame blanche* at the Salon des Refusés following the Salon rejection. In contrast to the howls of ridicule issuing from the crowds at the Refusés, the picture was accorded a good deal of praise from the *littérateurs* aligned with Baudelaire, who were charmed by this staring woman. Baudelaire's project in these years was the articulation of a poetics based on the abilities of painting and music to affect the emotions directly and instantaneously. This would be a mode that preceded and transcended the intellectualization of rational discourse, a mode in which painterly language would speak "the silent content of the mind, the moment of pure sensation or pure consciousness."[11] *The White Girl* must have struck Baudelaire as a step in this direction: an image that fit Delacroix's model of a painting as a "speaking hieroglyph," delightful in the immediate experience of color, texture, and design, while it simultaneously incorporated a metaphysical significance.

Even before Delacroix, late eighteenth-century German philosophers had urged that painting be freed from narrative and descriptive subjects to move toward a nonmimetic form of poetry. Now in French literary circles music succeeded poetry as the art form that presented a model more immaterial, abstract, imaginative, and elusive of verbal description than any other. Painting was now evaluated in musical terms in Baudelaire's *Salons* through the synaesthetic reframing of color as harmony, melody, and counterpoint. Displayed in this critical climate, *The White Girl* was immediately and approvingly proclaimed by Paul Mantz a "symphony in white."[12] Capitalizing on the painting's narrative obfuscation and formal innovations, this synaesthetic analogy pleased Whistler immensely since

it nicely aligned him with the artistic vanguard. Whistler's full embrace of musicality several years later led him to retitle *The White Girl* and his next picture of Hiffernan in white *Symphony in White, No. 1* and *Symphony in White, No. 2*, respectively. This revision of his early career in light of his subsequent semi-abstraction has led twentieth-century commentators to deny what was actually before them—an image rooted in the anxiety provoked by themes of repression and sexuality common to the English gothic and sensation novels as well as to Pre-Raphaelite painting.

In a sense, Whistler seemed to invite a reading of the picture as a metaphor, as a conflict between the pervasive Victorian constructions of femininity as passionless and masculinity as aggressively sexual and willful.[13] The stunned blankness of the face, the virginal whiteness of the dress, the display of the luxurious mane of red hair unpinned and cascading down over the shoulders, the dropped flowers, the intimations of psychological brutality: all together presented enough detail to entice the viewer into fabricating a subtext of conflict and violation. Even though Whistler had withheld the information necessary to take such a reading further than poetic suggestion or metaphor, the critic for the *Athenaeum* gave in to the temptation to fashion a narrative from the structural tensions when he connected *The White Girl* with Wilkie Collins's recent novel *The Woman in White* (1860), the story of a woman who is emotionally ravaged by her husband.[14] A number of contemporary critical responses, in fact, spoke exactly to what was perceived as the painting's problematic lack of closure. A reviewer for the *Athenaeum* called it "striking but incomplete" and a "bizarre production," while Fernand Desnoyers reflected on the simple and fantastic quality of the painting and the face that seemed both "tormented and charming," with "something vague and profound in the gaze."[15]

The realist critic Jules Castagnary commented that the picture evoked the morning after the wedding night, when the bride wondered if she would ever be able again to recognize her former virginal self: in other words, the asexual figure expressed bewilderment at her sexualization. In 1905 Leonce Bénédite found Castagnary's remarks annoying in light of Whistler's later claims to a pure, abstract art, but he admitted that the phantomlike bearing and Ophelia-like bewilderment of the white figure hinted at a symbolic meaning that served to excuse Castagnary's "ramblings." Finding this jarring element in the work indebted to the images of John Everett Millais, Bénédite regarded Whistler's "expressive mode" as "enigmatic and artificial."[16] As these responses to the painting suggest, some-

thing beyond simple description of appearances was present in the way the construction of the picture provoked narrative interpretation. In short, these critics treated *The White Girl* as the representational picture rooted in nineteenth-century literary conventions that it was, rather than the pure composition with solely formal interest that Whistler said it was.

Whistler's dissatisfaction with the technical execution of *The White Girl*, and his continuing adjustment to it over the years, intimated, however unconsciously, his growing discontent with realism at this time. He especially labored over the expression of the face and hands until they became smooth and tightly painted. Their lacquered surfaces, in contrast to the rest of the heavily impastoed texture and the coarse canvas, signal his eagerness to move beyond braggadocio to quietism.[17] Writing to Fantin-Latour in 1867, Whistler would finally dismiss his earlier allegiance to the movement as a mere reflection of his youthful egocentrism and lack of discipline. Firmly ensconced in Rossetti's circle in 1863–1864, he sensed already that realism was insufficient to meet the expressive needs of the direction he now wished to pursue.[18]

With the *Symphony in White, No. 2: The Little White Girl* (pl. 4; fig. 3.4), Whistler came closer to realizing the elusive, inward image that was also being developed by his English friends Rossetti and Swinburne, as he edged further away from the theatricality of Courbet's brushwork. Living down the street from Rossetti's house in Chelsea, Whistler joined in their exploration of synaesthetic and pure art forms.[19] Though the writings of Baudelaire and Gautier stimulated Swinburne and Whistler in their enthusiasm for these ideas, it was the slant Rossetti's mysticism gave to the idea of pure sensuous beauty that catalyzed Whistler's rejection of realism and narration, method and subject as bound by time and word.[20] Exhibited and reproduced more than a dozen times between 1890 and 1910, the celebration of the mysteries of art in *The Little White Girl* became a visual trope for the power of self-refinement through art for Whistler's American followers in the 1890s.

The spiritualist implications of *The Little White Girl* would also make it a central image for those American painters engaged in evolutionary rhetoric at the end of the century. While Whistler aimed to master a consistent, controlled technique in this image, in the subject he worked against this self-conscious rationalism by advancing an occult meaning in the upper zone of the painting. In *The White Girl* Hiffenan's character displays her bewilderment to the viewer. Here, however, her head is tilted away from the viewer toward the mirror, and her obscured face in the

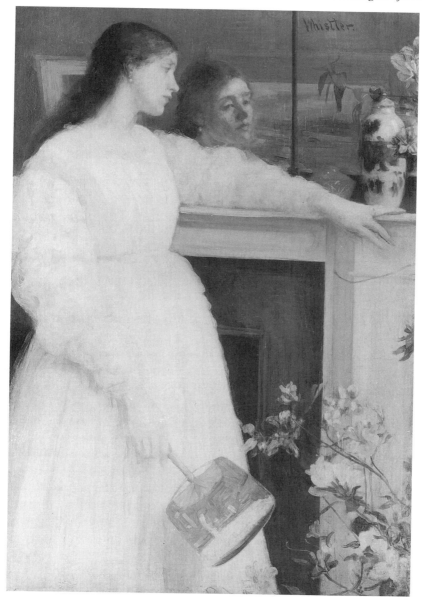

FIG. 3.4. *James McNeill Whistler,* Symphony in White, No. 2: The Little White Girl, *1864. Tate Gallery, London.*

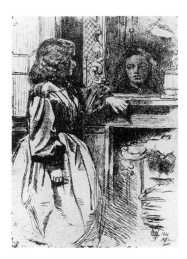

FIG. 3.5. *John Everett Millais*, Before the Mirror, *1861. Etching. From James Laver,*
A History of British and American Etching *(1929).*

reflection is given an expressive melancholy quality that suggested a mind
isolated in a labyrinthine memory.

Whistler found a more inward and self-conscious image in *The Little
White Girl,* but at the same time he became more aware of the intrinsic
coherence and autonomy the work of art can attain when structured
through a disciplined system. Derived from the compositions of Ingres's
Comtesse d'Haussonville (1845; Frick Collection, New York) and Millais's
etching *Before the Mirror* (1861; fig. 3.5),[21] Whistler's "white girl," how-
ever, is lost in a work of art rather than in herself, as the women of Millais's
and Ingres's works are. Flattened and rigidly controlled by the geometry of
the room's architecture, the white figure is pushed up to the surface, so that
it is almost in relief. With the figure now splayed out to conform with the
rationalized scheme of the canvas, the ordering system becomes one of
brightly colored shapes that lie on the surface, as opposed to the atmo-
spheric nuance of the mirrored upper zone.

Whistler thus insisted that the picture be apprehended in terms of its
artifice, as rhythms of line, color, and mass. To this effect, the flowers
shooting up arbitrarily at the lower right corner of the painting—a device
that he would continue to appropriate from Japanese prints—underline
the deliberately constructed quality of the image. The painting refuses to
function as a traditional painted "mirror of nature," much as the mirror

over the mantle, stretched across the painting's surface, is made to reflect only artifice—Jo's face and the paintings on the opposite wall—it functions as a mirror of art. At its first exhibition in 1864 this work must have seemed as strange as *The White Girl* had the previous year. The same model used for the "white girl" of 1862 (that is, Joanna Hiffernan), now completely introverted, refuses to confront the viewer, as she absorbs herself in the blue-figured Oriental jar on the mantle, as if using the vase to stimulate the flow of consciousness. Her perfect self-containment in a silent, imaginative world is analogous to the function of Whistler's ideal work of art: the whole attention of the "white girl" is absorbed into a Chinese vase, just as this "white symphony" is offered for the viewer's contemplation. If the first "white girl" seemed to demand interpretation, the second almost as adamantly refused it. Whistler here, then, approached the work of art as an autonomous object that refuses to explain, comment on, or justify its own action. Rather, through the viewer's experience of its sensuousness, it promotes the enjoyment of beauty and the silent activity of the imagination.

But while Whistler seemed to wish *The Little White Girl* to remain open to interpretation, at its Royal Academy exhibition he pasted onto the frame some verses Swinburne had written on the painting. Swinburne's "Before the Mirror: Verses under a Picture" complemented Whistler's visual image: painting and poem each invested the other with a more complex emotional resonance. Much attention has already been given to the obtuse imagery of white on white in the poem and to Swinburne's synaesthetic technique. But the imagery of the poem, as much as the technique, also reflected a contemporary understanding of the painting as an evocation of the conscious self's subterranean double—a finer self that emerges in the interaction with art. Unknown to this self is a disembodied spiritual self—an unconscious double in which the memory of past experience, tinged with erotic undercurrents, lives unfettered by time and space.

Although Swinburne makes the "white girl" focus her gaze on her reflected image, rather than on the strange blue and white *objet* as in Whistler's picture, both men present her as the exemplary female narcissist who is turned inward, absorbed in her own imaginary world. Swinburne has the girl in the mirror comment on her own narcissism: "I watch my face, and wonder / At my bright hair; / Nought else exalts or grieves / The rose at heart, that heaves / With love of her own leaves and lips that pair." Fascinated with the interpenetrability of her own doubled self, the "white girl" goes on to wonder about that veiled face:

"She knows not loves that kissed her
 She knows not where,
Art thou the ghost, my sister,
 White sister there,
Am I the ghost, who knows?
My hand, a fallen rose,
 Lies snow-white on white snows, and takes no care.

I cannot see what pleasures
 Or what pains were;
What pale new loves and treasures
 New years will bear;
What beam will fall, what shower,
What grief or joy for dower;
 But one thing knows the flower; the flower is fair."

The construction of the narcissistic female here, as in the painted images of Whistler and Rossetti, reflects not the boredom of leisured women in this period, but the envy of men for a childhood paradise they fantasized women still inhabited emotionally. The conception of feminine narcissism in Swinburne's poems, in keeping with Freud's later, classic text describing this nineteenth-century construction of woman, also resonates woman's secret sexual life, a dimension that is implied as well in the physical allure of Whistler's and Rossetti's painted women. In the last stanza the omniscient narrator of the poem again describes the white figure before the mirror:

Face fallen and white throat lifted,
 With sleepless eye
She sees old loves that drifted,
 She knew not why,
Old loves and faded fears
Float down a stream that hears
 The flowing of all men's tears beneath the sky.

It is thus that the life of the feminine spirit is here intertwined with the erotic life of the feminine body—and with death.[22] Swinburne wrote to Whistler that he had wanted to take the poem further, to work out "more fully and clearly"

the metaphor of the rose and the notion of sad and glad mystery in the face languidly contemplative of its own phantom and all other things seen by their phantoms.[23]

This description of the figure's reflection in the mirror as a "phantom" and a "ghost" is of some interest because it underlines the way the painting is rooted in the fashionable spiritualist discourse of the 1860s and in the spiritualist practice of Whistler's personal life. As an intimate of the Rossetti circle, Swinburne would have been well aware that both Whistler and Hiffernan enjoyed performing as spiritualist mediums. Joined at times by Rossetti in séances in 1863, Whistler later continued these practices with his next mistress and model, Maud Franklin.[24] Swinburne's play on Hiffernan's appearance in the image as a phantom—a ghostly or a spiritual apparition that appears to the sight but has no material substance—then referred to the contemporary practice of spiritualism, which Whistler later called "a study . . . that would engross a man's whole lifetime." "I have no doubt," he stated, "the very fact that man, beginning with the savage, has always believed in them [spirits] is proof enough" of their existence.[25] Earlier at its Paris exhibition, Courbet had referred to *The White Girl* as "une apparition du spiritisme."[26] Courbet himself had made unconscious and parapsychological states a central theme in his numerous images of sleeping females. Jo Hiffernan acted as a model not only for one of these (*The Sleepers* [1865; Petit Palais, Paris]) but also for another composition in which she is represented staring into a mirror (fig. 3.6), a pose that relates to spiritualists' use of mirrors in this period to induce hypnotic trances.[27]

Spiritualism had gained a popular audience in America in the 1850s, and it is possible that Whistler had become acquainted with its practices even before his friendship with Courbet. The greatest following for this occult "science" was occasioned by the Civil War, in the wake of the overwhelming grief Americans felt in response to the catastrophic numbers of war dead. During the last quarter-century the uncertainty the grim interpretations of Darwinian science cast on the idea of a Christian afterlife equally rendered spiritualism a viable alternative. Drawing on Emerson's and Swedenborg's writings, spiritualists regarded the universe as a single continuum of matter and the heavenly as merely a more refined version of the earthly. In England and America during the 1880s the Society for Psychical Research tried to put spiritualism on a respectable footing by investigating the table rappings and trances of mediums as legitimate avenues into paranormal psychological states. Whistler was just one among a host of

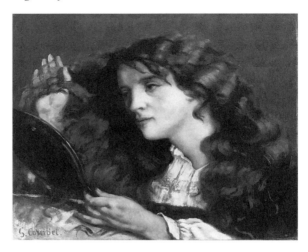

FIG. 3.6. *Gustave Courbet,* Portrait of Jo, *1866. The Nelson-Atkins Museum of Art, Kansas City, Missouri, Purchase, Nelson Trust.*

British and American intellectuals and luminaries, such as John Ruskin, Alfred Tennyson, Lewis Carroll, Charles Eliot Norton, Theodore Roosevelt, and William James, who turned to spiritualism as an agnostic belief in these years.[28]

Whistler's spiritualist beliefs and practices in the 1870s would become all-important to his development of a landscape of the unconscious that is evoked through a feminized color mode and the body of woman. As his first attempt to construct an image of the soul, *The Little White Girl* is ambivalent: while the female body is constricted by masculine will and geometric structuring, the power of feminine imagination, signified in the masklike face and dreaming eye of the mirror image, eludes such rational definition. Whistler attempted to master, control, and constrict the female figure within the geometry imposed by the intellectual act of ordering. The feminine realm of the imagination, concretized in the mirror in the upper region of the canvas, however, remains finally elusive to the willful imposition of limiting, masculine reason.

Ordering the canvas in terms of the opposing constructions of masculine reason and feminine spirit, Whistler responded here to the contemporary gender ideology that bifurcated social roles according to sexuality. Whistler's opposition of reason and imagination emanates from neo-Platonic dualisms that by the nineteenth century were deep-seated in Western thought. The *philosophes* in particular articulated this bifurcation of West-

ern culture into masculine and feminine—rational and affective—modes that then were codified and increasingly rigidified in nineteenth-century thought and social forms. While the doctrines of separate spheres and the complementarity of the sexes did not actually reflect social reality in this transitional period, the representation of this ideology in the symbolic universe of cultural production was efficiently utilized by influential middle-class intellectuals in a program to destroy the old aristocratic order and thereby reshape the social order and entrench themselves in positions of power.[29]

Following the French Revolution, cultural and social modes were polarized strictly along lines of gender, identifying femininity with imagination, emotion, and spirit and masculinity with intellect, reason, and physicality. Medical writers, philosophers, theologians, historians, and others—including Hegel, Comte, and Michelet—followed Diderot and Rousseau in defining woman's character and appropriate role in society according to her physiognomy. In this scheme anatomy was destiny. Woman's soft rounded forms—the concavity of the uterus and the convexity of the breast—typed her as a nurturer of men, the central mystery and source of life.[30] If woman was the great mother, she could also be seen as the archetypal Eve. As sex incarnate, she was man's passive "other" who inspired his great heroic deeds. Her nervous system and smaller brain fixed her as sensitive, emotional, instinctive, childlike, and thus irrational, while her male complement with his strong physique and larger brain was ideally suited for intellectual and scientific achievement.[31] Where her realm was that of the affectual, darkness and mystery, fantasy and the imagination, his was that of the rational, light and consciousness, abstract knowledge and thought. She ruled the private and domestic spheres; he dominated the public and the political spheres.

Whistler's concept of feminine sexuality was, however, also conditioned by a line of Protestant Evangelical thought that arose in the decades from 1790 to 1820. Evangelicals like Hannah More and Bishop Wilberforce encouraged the replacement of the Eve archetype in British and American Protestant thought with the image of woman as an angel, a being endowed with the highest moral and spiritual values. This image gave the ideological category "woman" conflicting and paradoxical aspects that at times effaced one another, depending on the particular cultural context. While the prostitute figured largely as an allegory of modern urban life in French culture in the middle decades of the century, the woman who publicly sold her body as a commodity was permitted few incursions into British or American literature and art.[32] In marked contrast to the Continent, women

in America after the Civil War were idealized as agents of a higher, spiritualized domain, and as such they prevailed in the ranks of spiritualist mediums, to the near exclusion of men from this category.

Though they are still imbued with the paradox of the dual construction of woman, Whistler's mature works exploit the image of the dematerialized woman positioned between man and the divine, an image that functioned as an archetype for American artists in promoting the idea of evolutionary refinement as embodied in a woman—now identified with the civilizing function of culture. In his early works, however, Whistler's subtexts—such as in *Wapping* and the "white girls"—still moved between the polarities of nineteenth-century feminine sexual typology, responding to the flux in the differing moral positions on women. Rejecting the beauty of the bad sublime type—the prostitute who cynically ensnares and seduces men in *Wapping*—Whistler turned to the mystification of chaste beauty. Feminine frigidity was confronted with aggressive masculine sexuality in *The White Girl*, while the curvilinear female body of the desired was circumscribed and controlled with the structures of reason in *The Little White Girl*.[33]

That Whistler's conceptions of gender approached Freud's theorizations of the silent female hysteric and the aggressive, sexualized male was determined by their historical contiguity: they are all essentialist social constructions of femininity and masculinity that were produced by the same cultural matrix.[34] Yet these social constructions were also reified by Whistler's formative experiences of male and female sexuality in the persons of his mother and father. A paragon of Evangelical feminine virtue, Anna McNeill Whistler was a zealous Southern Calvinist who managed to rear her children in the Anglican Church while living in Russia, and she made it clear that she hoped Whistler would become a minister. As a boy in St. Petersburg, he had been made to distribute her religious tracts, attend church three times on Sundays, and memorize a Bible verse each day "for support on the sick and death bed." His father, Major George Washington Whistler, descended from a family of military men. As a graduate of West Point and the civil engineer who masterminded the Russian railroad system in the 1840s, Major Whistler exemplified the ideal of masculine rationality.[35]

Whistler eventually resolved the dualism of masculine desire and feminine mystery in a manner that was entirely conventional to Anglo-American culture of the period: that is, the sublimation of male desire through foregrounding the experience of aesthetic uplift. In the 1870s Whistler opted for a more nonmaterial, though not nonsensuous, process of paint-

ing. To that effect, the effacement of the body beautiful—and its mystification and sacralization—became a purifying aesthetic ritual made systematic in his work.

TOWARD AESTHETICISM: THE *SIX PROJECTS* AND THE SPEAKING BODY

Whistler's fixation on a beautiful feminine presence in the 1860s has often been connected with the Pre-Raphaelite enigma of the red-haired "stunner,"[36] the woman whose emotional distance and impenetrable silence renders the male modes of rational discourse useless and unintelligible in deciphering her mystery. In several of these paintings, particularly *Rose and Silver: La Princesse du pays de la porcelaine* (1863–1864; Freer Gallery of Art), *Purple and Rose: The Lange Leizen of the Six Marks* (1864; Philadelphia Museum of Art), *Caprice in Purple and Gold: The Golden Screen* (1864; Freer Gallery of Art), and *Variations in Flesh Colour and Green: The Balcony* (1865; fig. 3.7), he imagined the quotidian existence of languorous females immersed in the strange beauties of Asian artifacts. The female figures who are absorbed in the Japanese print or blue and white jar reflect Whistler's own attempts at this time to learn the principles of Japanese design from similar objects. Specifically, he became more adept at stylizing nature through subordinating all formal elements to the uniform flatness of the surface.[37] But with the field of vision abstracted into geometric patterns, Whistler still remained bound to the world of objects, as he detailed the kimonos, fans, screens, vases, and prints in these pictures, as he grafted the exotic patterns of the premodern Orient onto his Chelsea milieu.

In the imaginary present of *The Balcony*, for example, there is no perceived disharmony between the distant Thames riverscape, complete with the plumbago slag heaps and factories of Battersea, and the fantastic domesticity of the foreground. At the upper left, pastel-colored butterflies pasted over the industrial landscape syncretize these two disparate worlds. The pleasure the women within the frame take in looking, listening, and tasting is set before the viewer as a pedagogy of the artfully structured life. In *The Little White Girl* and *The Golden Screen* contemplative absorption in the art object is presented as a transcendent activity. The appreciation of beauty in *The Little White Girl* heightens everyday experience to another, higher plane, while in the larger and imperfect modern world of *The Balcony* it transforms and perfects mundane existence into a virtual paradise.

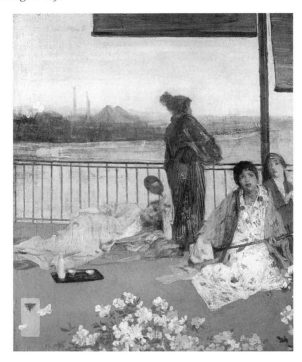

<small>**FIG. 3.7.** *James McNeill Whistler,* Variations in Flesh Colour and Green: The Balcony, *1865. Freer Gallery of Art, Smithsonian Institution.*</small>

In the late 1860s Whistler explored the premodern cultures of Greece and Japan for a means of developing a musical idiom that would answer Baudelaire's demand for a painterly image that eluded narration. Rossetti and Swinburne had been at the fore of the English project to evolve a musical form of painting—Rossetti, at least since his watercolors of 1857–1858 associating color with music, and Swinburne, since 1862, when he reviewed Baudelaire's *Les Fleurs de Mal* (1857) for *The Spectator*. In addition to translating Baudelaire's poems into English, Swinburne was responsible for interpreting Baudelaire and Gautier to English readers.[38] The idea of synaesthesia, meaning the assignment of the qualities of one art form to another, was given consummate expression in Walter Pater's essay "The School of Giorgione," at the same moment that Whistler was developing his musical visual mode in the late 1860s.[39] Swinburne's theorizing provided Whistler with one stimulus in his efforts to formulate a musical system of using color, rhythmic mass, and line. But he had visual models

as well, most notably, Albert Moore's classical compositions, as well as Rossetti's equivalences of music with the eternal feminine.

The works of Albert Moore and Frederic Leighton in the 1860s further suggest that Whistler was not alone in the pursuit of musicality, nor was he even the first to attempt it in the "white girl" paintings. More accurately, this Baudelairean project, to develop the utopian promise of art, was an effort common to late Romantic English and French poets and painters whose mutuality of purpose was made concrete in Fantin-Latour's *Homage à Delacroix*.[40] Already in Leighton's work of the early 1860s the impulse to reform English culture in the direction of the aesthetic had surfaced in the form of a reinvented Greek world.[41] In *Lieder ohne Worte (Songs without Words)* (c. 1861; fig. 3.8), Leighton invoked the power of music as a Hellenizing means of freeing painting from the Hebraist authority of the descriptive word, from the necessity of the image to provide a moralizing narration as justification of itself to the viewer. Playing off each other's work in the late 1860s, Whistler and Albert Moore both developed a stripped-down musical style from their studies of the Elgin Marbles in the British Museum.

Whistler's renunciation of realism in 1867 yielded a series of decorative studies begun in that year and which he kept in his studio for inspiration until the end of his life. In the "white girls," Whistler explored the "dream-

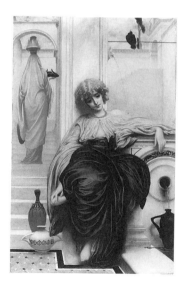

FIG. 3.8. *Frederic, Lord Leighton,* Lieder ohne Worte (Songs without Words), *c. 1861. Tate Gallery, London.*

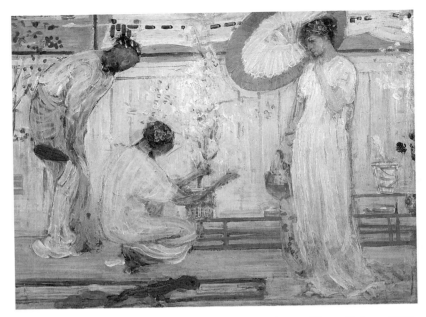

FIG. 3.9. *James McNeill Whistler,* The White Symphony: Three Girls, *c. 1868. Freer Gallery of Art, Smithsonian Institution.*

ing eye" and the "mask-like face." In the *Six Projects* (c. 1868) he now exploited the expressive feminine body—but the body regularized by virtue of a methodical rhythmic stroke, the feminine presence abstracted and reduced to an impersonal type of graceful movement (figs. 3.9 and 3.10).[42] Whistler found his essential feminine form in the prints of Kiyonaga and in Greek terracotta figurines from the fourth century B.C., which since the mid-1850s had been entering the collections of the British Museum in large numbers.[43] The most finely crafted and proportioned terracottas were found in the early 1870s at the pottery center of Tanagra, located just twenty-five miles north of Athens, which gave rise to their generic denomination as "Tanagras." Like Japanese fans, prints, and pottery, Tanagras numbered prominently among the precious *objets* coveted by European and American collectors until the end of the century, when the discovery of a series of forgeries considerably dampened the enthusiasm for them.[44]

Whistler was undoubtedly attracted to the Tanagra as an irreducible embodiment of feminine grace. The ephemeral touch and fugitive coloring of Whistler's pastel drawings are indebted to their rococo delicacy and faded, powdery surfaces. But beyond these affinities of texture and sensibility, the figurine's most significant characteristic was its integration of

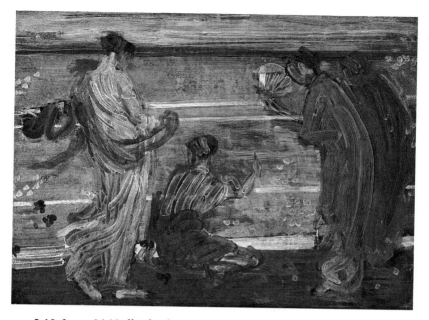

FIG. 3.10. *James McNeill Whistler,* Variations in Blue and Green, *c. 1868. Freer Gallery of Art, Smithsonian Institution.*

form and expression. The perfectly proportioned female figure provided the ideal type of organic beauty, in which the body *was* the soul. Contemporary French writers advanced just such an understanding of the figurines in which they were seen as projecting the Greek concept of *eurythmie*— the harmonious balance of intellectual, physical, and spiritual faculties.[45] In the diminutive clay sculptures (as well as in the *Three Goddesses* of the Parthenon pediment), the abstract rhythms of drapery folds moving against the larger forms of the body constructed musically pure compositions— figurative symphonies (see fig. 3.11).

In several of the *Six Projects,* Whistler's brushwork suggests the ridges of drapery folds and the movement of the female figures, thus echoing the modeling of the figurines, but his painted figures are also heavily reworked with layers of color over color.[46] A number of pentimenti indicate that Whistler did not come by his system of expressive, rhythmic brushwork easily on the first try, nor was it a preconceived, intellectual formulation but rather a system he intuitively pushed toward. Though Whistler intended these sketches as preparations for large decorative panels in the dining room of Frederick Leyland's first London house, he never successfully brought the *Six Projects* to completion. Through them, however, he did find a mode in which form became indivisible in its execution with the

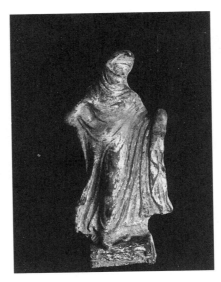

FIG. 3.11. *Photograph from Whistler's Album (page 23 from an album of the Ionides Collection), after 1879. Hunterian Art Gallery, University of Glasgow, Rosalind Birnie Philip Bequest.*

material presence of paint—in its sensuous texture, color, rhythm, and flow of stroke.

The comprehension of Whistler's "subjects" lies precisely in an empathic apprehension of their sensuous form. In fact, his aesthetic here anticipates Pater's ideal work of art, in which form and subject

> are so welded together, that the material or subject no longer strikes the intellect only; nor the form, the eye or the ear only; but form and matter, in their union or identity, present one single effect to the "imaginative reason," that complex faculty for which every thought and feeling is twin-born with its sensible analogue or symbol.[47]

Given these conditions, the painting becomes unapproachable for the normative middle-class understanding based on naturalism; it becomes accessible only to the elite that knows how to recognize abstraction as beauty. The distance of Whistler's aesthetic disposition from the middle-class moralistic ethos asserted the pure taste of the artist and his friends as distinct from the more common preferences of the uninitiated. These paintings of the late 1860s, then, are not "subjectless" but rather nonnarrative and antidiscursive, a state to which Whistler called attention in his musical titles.[48]

Swinburne saw the *Six Projects* in Whistler's studio in 1868, and his account of these small panels in his Royal Academy review of that year makes clear how Whistler hoped to advance a musical idiom that necessitated this different, elite mode of aesthetic appreciation. Faced with paintings "so subtle and sublime," words are powerless, "hoarse and feeble," Swinburne wrote, as he gave voice to the mystique Whistler was forging for the antidiscursive object. The critic can thus only evoke the painter's effects through musical analogy, and so Swinburne spoke of Whistler's sketches in terms of their "varying chords," "interludes," "tones," and "keynote."[49] This inwardness of the image, an image that does not *mean* but simply *is*, forces the viewer to take it on its own painterly terms.[50] Proper appreciation requires entering into the technical and emotional process of the painter, retracing the motion of his hand and mind.

Swinburne's comments on three of the *Six Projects* in 1868 also draw attention to the importance of feminine seductiveness in the "hothouse" imagery of "flowers and figures of flowerlike women," as well as the luscious peach and verdigris hues of the painted surface. Addressing *Variations in Blue and Green,* he attempted to imagine the pleasured world of the women inside the painting.

> The symphony or (if you will) the antiphony is sustained by the fervid or the fainter colours of the women's raiment as they lean out one against another, looking far oversea in that quiet depth of pleasure without words when spirit and sense are filled full of beautiful things, till it seems that at a mere breath the charmed vessels of pleasure would break or overflow, the brimming chalices of the senses would spill this wine of their delight.[51]

Here, the sensuous "pleasure without words" the women experience in their hermetic world is identified with the silent, visual gratification the beholder receives in looking at these paintings. Again, a beautiful woman is like a painting. The *Six Projects* implicitly demonstrate an identification of the feminine form with the aesthetic object, in the way that, in the sensuous embodiment of its idea, the work of art emulates the feminine integration of body and mind. As Whistler had implicitly suggested in *The Little White Girl,* both the beauty of a woman and a work of art can be starting points for the imagination, a point of entry for the masculine artist into a mysterious and hidden feminine realm and a source of refinement for the higher faculties.[52]

SEMANTIC VOID AND FEMININE SUBLIME

As Swinburne's commentary made clear, the embodiment of idea in the fluid color and movement of the brushwork provided for Whistler a visual correlative to the medium of music. In the Tanagra, Whistler found the historical prototype for the body beautiful. Abstracted into pure rhythmic movement, the female body seemed to provide the key to this painterly musical idiom. But Whistler had trouble drawing the human body on a large scale. Frustrated with his inability to translate *The White Symphony: Three Girls* into a mural decoration for Leyland's Prince's Gate dining room, in the early 1870s Whistler simply gave up the attempt to draw in the classical manner of an Albert Moore.[53] Thereafter, he depended more exclusively on the propensity of tonal color to project an abstracted view of contemporary life as perfected and utopian. The indeterminacy of his forms conceived as slowly graduated tonal masses allowed for open-ended interpretations that catered to an avant-garde taste, in distinction to the bourgeois demand for moralism and closure in art.

Whistler's exploitation of tonal atmosphere in the "nocturnes" and portraits of the 1870s resulted in his essential rediscovery of the semantic void as the key to musicality. This semi-abstract manner of composition was directed to an elite of artists, *littérateurs,* and collectors whose embrace of agnostic creeds of spirituality in pure forms of art would signify not only their alienation from but also their superiority to the "vulgar" disposition of the middle class. Whistler knowingly cultivated these "lacking" qualities, perhaps using Watteau as one point of departure, and Velázquez, Greek sculpture, and Japanese prints as others to reform his technique.[54]

The dualities of masculine and feminine, rationality and imagination, line and color had emerged in Whistler's work in the early 1860s. A long-standing controversy in academic art circles had sustained these oppositions since Le Brun codified Cartesian dualities in his academic system, pitting matter against spirit, sensation against intellect, and color against line.[55] Whistler had thought of his classicizing experimentation in the late 1860s as a struggle to control color with line. The terms he used to describe this conflict reveal the way in which gender, and thus positions of superiority and inferiority, was imputed to artistic modes.

> Color—color is vice. Certainly it can be and has the right to be one
> of the finest virtues. Grasped with a strong hand, controlled by her
> master, drawing, color then is a splendid girl with a husband worthy

of her—her lover, but her master too—the most magnificent mistress in the world, and the result is to be seen in all the lovely things produced from their union. But coupled with indecision, with a weak, timid, vicious drawing, easily satisfied, color becomes a filthy whore making fun of "her little boy," isn't that true! and abusing him just as she pleases, taking the thing lightly so long as she has a good time, treating her unfortunate companion like a simpleton who constrains her—which is just what he does. And look at the result: a chaos of intoxication, of trickeries, regrets, unfinished things.[56]

Whistler here predictably ascribed to color the cultural characteristics deemed feminine, while he attributed to drawing the intellectual discipline considered masculine. In its sensual and emotional properties color is affective, and the seductiveness of this wanton strumpet can—like a good woman—be converted to sublime virtue if controlled by the higher, suprasensuous principle of masculine reason. This is a line of reasoning that builds on the received bifurcation of nineteenth-century culture into complementary masculine and feminine—rational and affective—cultures.

The historical groundwork behind Whistler's understanding can, on the one hand, be traced to Rousseau's social theory, in which man's fear of woman's seductiveness is allayed by her transformation into nurturing mother and wife. On the other hand, it is also distantly indebted to the Kantian categories of aesthetic experience, in which the beautiful and sublime were engendered with male and female attributes. The beautiful, as a category that was innately feminine, thus corresponded to woman's social function as a provider of love and pleasure. The sublime alternatively reflected the appropriate masculine sphere in its pain-inducing cogitation on truth. After Delacroix the dominant aesthetic theory favored music instead of poetry as an antisensuous ideal of sublimity and, in its abstraction and sublimation of the physical world,[57] it is this displacement to which Whistler's work in the 1870s is attuned. Whistler dematerialized the beautiful body and transformed color into a quiet, feminized sublime.

Whistler's desire to wed feminine color to masculine design, the beautiful to the sublime, was realized in the "nocturnes" and mature portraits that followed the *Six Projects*. By the early 1870s the palpable physicality of the painted surface was thinned out and coloristic sensuousness melded with geometric structure. Since aesthetic theory now identified the sublime with the painter's creative process, Whistler's overt abstraction, ma-

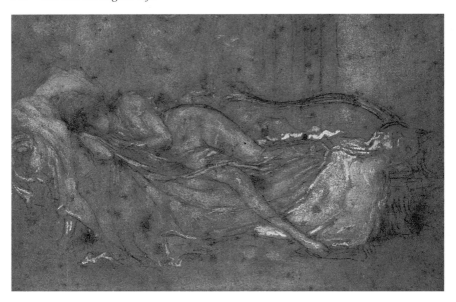

FIG. 3.12. *James McNeill Whistler, Sleeping, 1880–1902. Chalk and pastel on paper. Freer Gallery of Art, Smithsonian Institution.*

nipulation, and stylization of the subject could be regarded as evidence of a sublime vision, "a carrier of spiritual truth."[58] He abandoned the showy, opaque brushwork of the early 1860s and instead devised a megilp, a homemade "sauce" of linseed oil and turpentine in which smaller amounts of pigment were suspended.[59] The greater sense of transparency that resulted allowed his images to become increasingly incorporeal. In the portraits, faces appear veiled and muted and bodies almost disappear in envelopes of tonal atmosphere. In the "nocturnes" the contours of the city are wrapped in the expansive horizons of sky and water. When Whistler did return to the beautiful female body in the pastel and oil nudes of the 1890s, line no longer controlled color into firmly delimited, rhythmic shapes. Seen through a quivering, low light and often through the veil of diaphanous draperies, the contours of the body are evoked by a softened, almost enervated line that merges the figure with the atmosphere (see fig. 3.12).

Whistler discovered the muted idiom of the mature portraits and "nocturnes" in working out the design for the portrait of his mother. In *Arrangement in Grey and Black: Portrait of the Painter's Mother* (1871; fig.

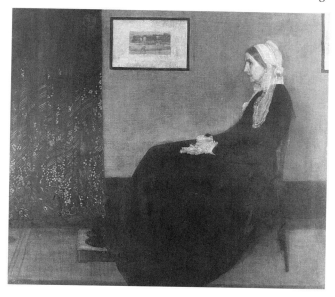

FIG. 3.13. *James McNeill Whistler,* Arrangement in Grey and Black: Portrait of the Painter's Mother, *1871. Musée d'Orsay, Paris, Réunion des Musées Nationaux.*

3.13), the black iconic shape of the mother is hung against the geometric background. The essential Anna Whistler was presented by her son as a figure totally submerged in an interior Calvinistic world, oblivious to the flux of the modern world.[60] In place of the lush colors of the *Six Projects,* a harmony of neutral colors, a system of greys touched with yellow and pink reprised from Velázquez, expressed Whistler's reverence for her, now presented as an icon of age and wisdom. In the later 1870s these muted tonalities with their sobering effects would purge the playful *japoniste* mannerisms of the *Six Projects* from his work altogether.

THE UTOPIAN CITYSCAPE

With the "nocturnes" that were completed just after the portrait of his mother, Whistler began to evolve an affective color mode, by working negatively and reductively—stripping away at the composition, leaving only horizontal color bands—and also additively—engulfing forms in a unified tonal atmosphere. By investing in the gendered mode of suffused color and ephemeral form, Whistler risked being labeled as feminized in

his work, though he could still lay claim to the male prerogative of genius by virtue of the transformative artistic act. The critic George Moore, for example, stopped just short of calling Whistler's "nocturnes" "feminine" when he interpreted their "exasperated impotence" as a reflection of Whistler's nervous temperament and small, frail physique. Thus, his pictures seemed to be troubled by "an exasperated sense of volatile colour and evanescent light," Moore offered, in contrast to the robustness of Michelangelo, Rubens, or Hals, whose "physical constitutions resembled more those of bulls than of men."[61]

Although Whistler did not use the term *nocturne* until 1872, the concept of the night landscape or marine seen through a heavy veil of monochromatic atmosphere had its origins in the work he did at Valparaiso, Chile, in 1866.[62] And before that, since the early 1860s, he had frequently availed himself of the seashore and the riverscapes and bridges along the Thames as subjects. Whistler's fascination with the coastline can be traced back still farther to his etchings for the U.S. Coast and Geodetic Survey in 1854–1855. A familiarity with the design of bridges had also been an integral part of his life since childhood, when his father had served as the chief engineer for the building of the railroad system in Russia in the 1840s, a project that entailed the design and construction of at least 200 bridges and 70 aqueducts, and had used his talented son to delineate engineering prints for him.[63] Over the course of the ten-year period from 1866 to 1876 Whistler modified his view of the river along a trajectory from realist discursivenss to symbolist silence. His later characterizations of London, presented within the terms of this feminized coloristic void, lent Anglo-American artists a visual strategy with which to frame the socially conflicted urban centers of the Northeast as harmonious, and even utopian, environments.

Whistler's first approach to the Thames was made in the graphic medium of etching in 1859. *The Pool* (fig. 3.1) exemplifies the way in which he overlaid the topographical technique he had garnered from the U.S.C.G. Survey with the irregularity and whimsical detail of the picturesque. As a strategy with which to render lower-class life as a subject appropriate to a work of art, the picturesque was the mode employed by French realists such as Charles Jacque and Charles Meyron, and before that, since the 1790s, by British painters.[64] But illustrators of the weekly London journals of this period and earlier had also found the picturesque useful in making the city's more unpleasant realities acceptable to their middle-class readership. While the countryside was still being commemorated in paint for its ability to provide physical and spiritual renewal, most artists at midcentury shunned the city as a hellhole to be avoided at all costs, with the result that

cityscapes in the forms of oil or watercolor paintings were rarities at London exhibitions in the 1840s and 1850s. Blighted with the unforeseen consequences of the Industrial Revolution, London in the first half of the century was in dire need of sanitation measures and sewage disposal, efficient transportation routes through the city and over the river, and housing for the burgeoning numbers of the poor. In spite of the general perception of the urban as diseased and chaotic, however, optimistic views of London in the topographical tradition predominated in weekly journals devoted to celebrating the expansiveness and progress of the city, a measure that more than compensated for the lack of such images at art exhibitions.[65] Perhaps understandably then, Whistler's Wapping etchings were received as novelties at their first public exhibition.

In one sense, it was not very remarkable that Whistler had chosen the Thames as the locus around which to view the city, since the river, as the great waterway flowing through the heart of London, could be pictured as one of the city's most noble prospects. Literary figures and painters as diverse as Engels and Gautier, Canaletto and Monet would all admire the grandeur of the Thames. By making the wharves picturesque, Whistler had done for east London what Canaletto had done for Venice, as one reviewer noted.[66] At the same time, however, the wharves Whistler etched at Wapping and Rotherhithe bordered some of the most dangerous slums in London. When seen in this light, Whistler's etchings are perhaps most surprising for what he chose to leave out, rather than what he chose to include. In Dickens's contemporaneous novel *Our Mutual Friend* (1864–1865), for example, Rotherhithe comes to life as a dangerous, degraded place where the river was polluted by sewage and dead bodies floating along in the current.

Residing there briefly in 1859 and 1860, Whistler loved to terrify and astonish his friends by touring them through the neighborhoods surrounding the docks, then entertaining them at the inns on the wharves after the initial fright had worn off.[67] *The Pool,* however, is symptomatic of Whistler's experience of the wharves: the focus on certain details is selective. There is no hint of the slums as they emerge in the description of journalist Henry Mayhew as the havens of the worst criminal element, drunken rivermen, prostitutes, and homeless children.[68] The seamy side of life there has been edited out in favor of an old codger who presides over a boatyard aestheticized by rhythmic intervals of textures and lines. Surface patterns and variegated touches of ink to the paper, describing the ages of the structures and their material composition, construct a narrative about the antiquarian charm of the place—a narrative that provides reassurance that even parts

of London as desperate as this are accessible to the respectable citizen. The miserable conditions of human habitation thus are not simply distanced from the viewer, rather they are elided altogether.

The lack of social concern for the poor, the treatment of peasants as staffage (typical of the picturesque artist), and the distancing by his social status from the suffering were conventions Ruskin considered immoral and cruel. The degree to which Whistler's version of Wapping assumed the form of a picturesque scenario both comic and charming is made clear by the critical reviews that emphasized the "quaintness of form" and "pleasant oddities of outline" of Whistler's etchings. Frederick Wedmore commented in 1879 that, like Dickens, Whistler was interested in the lives of Londoners in these prints, "as he [Dickens] recorded the shabbiness that has a history, the slums of the Eastern suburb, and the prosaic work of our Thames."[69] Again, however, in Whistler's pictorial account these lives take the form of a minor comedic interlude, while they are given fuller tragicomic treatment in Dickens's tales.

Though Whistler was under the sway of Courbet when he executed the Thames etchings, he was at heart never committed to the political and social constituents of realism, as is made baldly apparent when the prints are set against the historical reality of the place. Baudelaire praised these prints for their re-creation of the mise-en-scène of the wharves, the "wonderful tangles of rigging, yardarms, and rope; farragoes of fog, furnaces, and corkscrews of smoke."[70] Like Baudelaire, Whistler was interested in the aesthetic possibilities he could find in the strangeness of the city, the reaches outside the parameters of ordinary bourgeois experience. After he had made the most of his slumming adventure, he returned to the solidly middle-class enclaves of his sister's house in Sloane Street or his own residence in Chelsea.

Though Chelsea too had its slums, it was regarded by contemporaries as "choice," "picturesque," "quiet, law-abiding, and hard-working"; in other words, it was a neighborhood in which British artists and writers enjoyed quiet, private lives in a manner that blended them into the English middle classes, in contrast to the bohemian rituals of the Latin Quarter in Paris that were intended to set the artists apart from the bourgeoisie. Chelsea in the 1860s still retained the charm of its recent past as a suburban village that developed around a number of estates and manor houses, and it was from the security of this westerly, more respectable end of the Thames that Whistler conceived the utopian topography of the "nocturnes."[71] Residing in Chelsea in the early 1870s, Whistler stopped working from the direct observation of place and adopted instead a

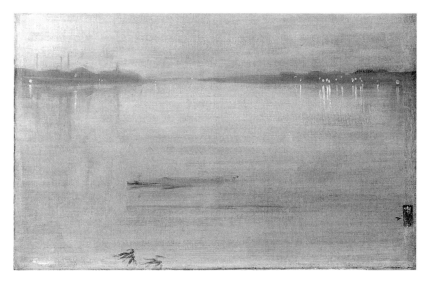

FIG. 3.14. *James McNeill Whistler,* Nocturne in Blue and Silver: Cremorne Lights, *1872. Tate Gallery, London.*

practice of imaginatively re-creating the sense of place through memory. His former close-up focus on specific details was abandoned for a soft-focus on the subject; human narrative was absented from the picture, and in its place human mood was projected onto the scene (see fig. 3.14). From the later perspective of his distanced aesthetic, the Thames etchings with their narrative detail now seemed despicable to Whistler.[72]

Comparing *Nocturne in Blue and Silver: Cremorne Lights* (1872; pl. 5, fig. 3.14) with *The Pool* demonstrates Whistler's shift in strategy, from the early close-up view of a man in a boatyard in clear light of day, to the later long-distance view of the riverbanks colored with a heavy veil of fog and darkness. Though such foggy views of London at night were staple nourishment for the imagination of the poet Arthur Symons, the sight of London by daylight that confronted Symons as he returned to the city from the countryside revolted him: it was all "swarming with men and machines . . . a vast ant-heap . . . this crawling and hurrying and sweating and building and bearing burdens, and never resting all day long and never bringing any labour to an end."

The single visual artist to depict this aspect of London was the Frenchman Gustave Doré. Though Doré's illustrations of London executed in

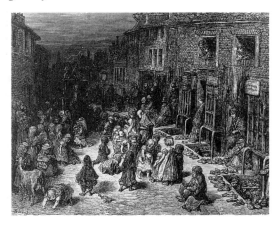

FIG. 3.15. *Gustave Doré,* Dudley Street, Seven Dials. *From Blanchard Jerrold,* London: A Pilgrimage, *1872.*

1872 were equally rhetorical in their social vision, they disturbingly related and implicitly condemned the tragic side of the modern city Whistler evaded in the "nocturnes." The thick masses of people in the constricted dark streets of Doré's *Dudley Street, Seven Dials* (fig. 3.15) elicit the sense of suffocation and hopelessness Symons suddenly faced as he looked out from the window of the train bringing him into the city. Interestingly, the "Thames Set" was only published in 1871, at the time Whistler was conceiving the "nocturnes" and just before Doré's prints were made available to the public. While Whistler's picturesque interpretation of the docks found an appreciative audience at this moment, Doré's prints were condemned as false and were accused by an English critic of more accurately reflecting the conditions of Paris, rather than those of London.[73]

In Whistler's Thames "nocturnes" of the early 1870s the city and the products of human rationality—the factories and bridges—are consistently unified with the boundless expanses of nature—sea, river, and sky. But what is exalted is not nature but culture. The eye is drawn to the small highlights of yellow and white within dark blue masses of silhouetted buildings and factories representing the lights of civilization. If Whistler's view of the metropolis was at all directed by Baudelaire's evocations of the city as the consummate mystery, his interpretations of Baudelaire served a completely different ideology than the paintings of Manet and Degas, who recorded the libertine underbelly of the city, the night traffic in sex and alcohol at the café. It's not that the sites Whistler selected were devoid of such incidents. The bridges and riverbanks of the Thames were commonly

places both of refuge for the homeless and of suicides, especially of "degraded" young women.[74] The social circumstances of the figures in Whistler's "nocturnes," however, are too negligibly detailed to suggest such scenarios.

The darkness of night seemed to level individuals of differing social stations, putting, as Whistler described them, "the working man and the cultured one, the wise man and the one of pleasure" all in the same position below that of the enlightened artist, since the imaginative powers conferred the right to stand above the masses. Thus, for George Moore, the night reduced the crowd moving across Battersea Bridge (c. 1872–1873; fig. 3.16) to small dark shapes all equally insignificant in their relation to the vast city spread out in the distance.[75] In *Cremorne Lights* an equivalence is constructed between the industrial landscape of Battersea and the pleasure garden of Cremorne on the right, on the western border of Chelsea. The skyline of Battersea, with the chimney stacks of its factories and slag heaps clearly evident, may be more interestingly shaped, but it is balanced by the

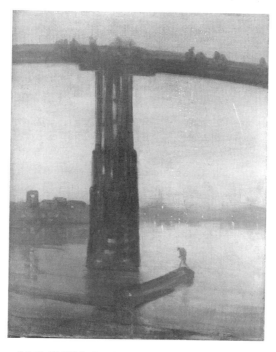

FIG. 3.16. *James McNeill Whistler,* Nocturne in Blue and Gold: Old Battersea Bridge, *c. 1872–1873. Tate Gallery, London.*

more glittering appearance of Cremorne. What was earlier in *The Balcony* a more to-and-fro relationship, between the distant grey working-class landscape and the near colorful array of pleasures intrinsic to the artist's life (as Whistler conceived it) in Chelsea, has now become a laterally ordered movement between different but equal social precincts. Conforming to the long shot of topographical convention, the "nocturnes" elide any possible sense of disharmony between the classes of these precincts.[76]

Increasingly dangerous and ugly by midcentury, London became increasingly difficult for artists to represent without some strategy of "veiling" or censorship. That most artists and writers gave in to pessimism at this point only makes Whistler's intimations of harmony and order all the more distinctive in the 1870s. Atmospheric obfuscations of social reality such as Whistler's were responses symptomatic of the city's oppressiveness. It would be misleading, however, to regard Whistler as an artist solely directed by the tastes of potential clients, even though his upper- and upper-middle-class patrons ultimately constituted the audience to whom the socially ameliorative imagery of *Punch* and the *Illustrated London News* appealed.[77] Rather, Whistler also generated the "nocturnes" to satisfy his central concern in the 1860s: his desire for an internally harmonious painterly idiom, a musical mode in which feminine sensuality was transformed into a good feminine sublime by masculine principle and virtuosity.

The interplay of gendered associations in the "nocturnes" had resonances, and possibly even their origins, in Whistler's personal history. The fact that Whistler's father had employed him as a draftsman for his engineering projects in 1848, coupled with Whistler's repetition of the bridge as a motif and sometimes a superstructural device—for example, in *Nocturne in Blue and Gold: Old Battersea Bridge*—brings to mind Whistler's association of rationality, drawing, and the human-made emblems of bridges, boats, and factories, with the nineteenth-century construction of masculinity. During the years the "nocturnes" were carried out, Whistler's mother had lived with him (1867–1875), and he allowed himself to marry only after her death at age fifty-four.

While he rejected outright his mother's narrow religion of Scripture, as well as his father's equally narrowly proscribed masculine world of engineering and technology at West Point, the personal dynamic of his art yet depended on a balanced interplay between the nineteenth-century stereotypes of feminine and masculine, affective and intellectual modes.[78] In *Nocturne in Blue and Gold: Southampton Water* (1872; fig. 3.17), as well as the *Cremorne Lights* and *Old Battersea Bridge* "nocturnes," for example,

nature performs its typologically feminine role as an agent that provides a nurturing atmosphere in which humankind is harmonized and unified. Areas with human associations—the dwellings and structures of the shoreline—are blended into the boundlessness of sea and sky. At the same time that feminine elements lend unity to and signify the transcendence of masculine culture, Whistler's intellectual process orders and limits the affective potential of the painting, so that the seductiveness of color—potentially an aspect of a bad feminine sublime—is controlled and repressed into a chastened vehicle of expression.[79]

By the mid-1870s, however, Whistler had purified all vestiges of rationality from the "nocturnes." Bridges, factories, and boats and geometric structuring receded until the subject was grasped only in its essence of mass and color, as it gradually became one with atmosphere. In *Nocturne in Black and Gold: The Falling Rocket* (c. 1875; fig. 3.18), the actual landmarks of Cremorne Gardens have been rubbed down to appear only as virtually indecipherable spectres. While some reviewers were contemptuous of what they judged as Whistler's eccentricities, affectation, and "tricks of jaunty and whimsical defiance," other contemporaries eager to identify themselves with the socially distinguishing cult of spiritualist mysteries found in these cityscapes epiphanies of the superrational, "landscapes of the mind, summoned with closed eyes and set free from everything coarse and material."[80]

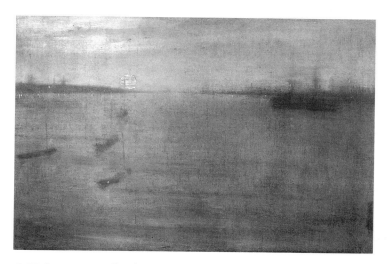

FIG. 3.17. *James McNeill Whistler,* Nocturne in Blue and Gold: Southampton Water, *1872. The Art Institute of Chicago, Charles Stickney Fund (1900.52).*

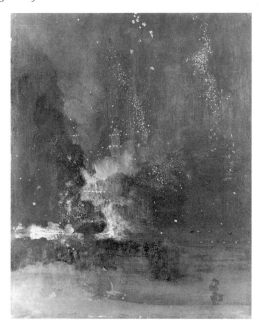

FIG. 3.18. *James McNeill Whistler,* Nocturne in Black and Gold: The Falling Rocket, c. 1875. *The Detroit Institute of Arts, Purchase, Dexter M. Ferry Jr. Fund.*

THE ESSENTIAL SELF AND THE NURTURING ENVIRONMENT

Whistler refined his abstracting, essentialist mode based on a syntax of muteness and atmospheric void during the mid-1870s. He continued to systematize his palette, blending colors into a harmonizing "sauce" with which he stained the entire canvas. As he thinned out his pigments and rubbed down the surface, his procedure seemed to erase all materiality, all physical movement and sound from the image until the figure stood "without solidity and nonexistent on any real plane," as his follower Walter Sickert explained. This technique, in the eyes of Whistler's sympathizers, enabled him to suggest an intangible world and presented the subject of the portrait with the sense of being pared down to an essential self.[81] Often, in his choice of color and pose, Whistler seemed to conceive the sitter in the terms of a nineteenth-century archetype: *Cicely Alexander*—the virginal girl-woman; *Arrangement in Black and Brown: The Fur Jacket* (1876; fig. 3.19)—the mysterious feminine object of desire; *Arrangement in Grey and Black: Portrait of the Painter's Mother*—the pious and aged maternal figure; *Sarasate*—the artistic (male) genius; and so on.

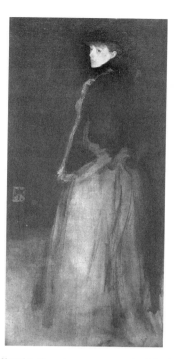

FIG. 3.19. *James McNeill Whistler,* Arrangement in Black and Brown: The Fur Jacket, *1876. Worcester Art Museum.*

The Fur Jacket (1876) typifies Whistler's use of the thin washes of pigment he called "sauce" and his rubbing down of the image until all traces of stroke, movement, and sound were erased and the figure merged imperceptibly with the void around her. This hermetic effect deceptively seemed to be achieved without the exertion of effort or force. Henry James, for example, characterized Whistler as a "votary of tone," whose technique was "to breathe upon the canvas."[82] In reality, Whistler exerted considerable effort to perpetuate this mystification: "A picture is finished when all trace of the means used to bring about the end has disappeared," he stated.[83] When later giving instruction in figure painting at his Académie Carmen, Whistler encouraged his students to heighten the ethereal qualities of the image by presenting the figure "in a simple manner,"

> without an attempt to obtain a thousand changes of colour that are there in reality, and make it, first of all, *really and truly exist in its proper atmosphere,* so that it should present a brightly coloured image, pleasing to the eye, but without solidity and non-existent on any real plane.[84]

Though his strong atmospherics and vague masses often led contemporary writers to refer to him as an "impressionist," he deliberated over these portraits for long periods, and his method was searching and laborious rather than spontaneous. Even though Monet grew to an appreciation of Whistler's art in the 1890s, he had no use then or in his high impressionist phase for the higher metaphysical sphere that the symbolists claimed to locate in Whistler's late works, while Whistler had no use for the empiricism and fleeting appearances that preoccupied Monet in the 1870s.

In the late portraits Whistler managed to bring to the final hermetic stage of completion, he satisfied himself with the realization of a perceived inner character, although he infuriated sitters who expected a physical likeness. This vision of an essential self, the soul conceived as a unified sensation of color and atmosphere, was also being developed contemporaneously in the literary works of Walter Pater and the French poet Paul Verlaine. Pater's idea of the inextricability of person and place, the psyche and its nurturing environment, is especially close to Whistler's approach to a portrait as an interior landscape.[85] Whistler's later pronouncements on his working method in these portraits finds him situating them within this fin-de-siècle spiritualist discourse.

As the light fades and the shadows deepen all petty and exacting details vanish, everything trivial disappears, and I see things as they are in great strong masses: the buttons are lost, but the sitter remains; the sitter is lost, but the shadow remains; the shadow is lost, but the picture remains. And that, night cannot efface from the painter's imagination.[86]

The personalities encountered in his full-length portraits, like Maud Franklin in *The Fur Jacket,* are introverted and withdrawn in their own dark, mysterious environments. Several of the female figures twist around, present their backs to the viewer, and elude contact with the world outside the frame altogether. Their introverted bodies, as well as their melancholy faces, recall those of the Tanagra figurines, those miniaturized totemic female forms that drew their fascination for collectors and artists—Whistler included—from the feminine mystique in which woman was identified, like nature, as a source of life and godliness.[87] In the open display of her mental and physical states, woman was "natural law revealed." Exactly such a typological construction of woman as a projection of her essential physiognomic and moral virtues, as her inner space exteriorized,

is offered in *The Fur Jacket,* a portrait of Whistler's mistress. The murky atmosphere, which Whistler insisted must be inseparable from the figure, has thickened around his mistress so that it takes on the softness and warmth of a nurturing womblike void.[88]

As late as the 1920s Americans still subscribed to this feminine ideology. Alfred Stieglitz, for example, was of the opinion that woman experiences the world through her womb.[89] Since woman's identity rested on her mysterious life-giving reproductive capacity, she, like nature, presented a challenge to masculine scientific and intellectual ventures to unveil and penetrate that mystery, in order to make man's own place in the universal order comprehensible to himself. Both nature and women were regarded as instruments subserving masculine creative acts of ordering society and civilization. For nineteenth-century intellectuals and scientists obsessed with understanding the essential nature of woman, her "mysterious orifices" promised revelations when they were placed under the scrutiny of the dissecting table.[90]

Whistler, the artist/genius, however, acknowledges his failure to penetrate or dissect the mystery of woman/nature through rational means of language and analysis and falls back on worshipfully reconstructing her mystery—surrounding her with the penumbra of silence, a mystery that can be related only by affective and sensational means such as music.[91] It is as if Whistler has here moved through the looking glass to enter the dematerialized sphere of the phantomlike face Swinburne found so entrancing in *The Little White Girl.* Just as the passionate, "natural" woman had a civilizing potential if she would submit to masculine or self-regulation, Maud—as a transcendent image—is presented as nature supernaturalized: her body (and thus her disruptive potential) is effaced, and so the painter's desire for that body repressed; she represents Whistler's version of the good feminine sublime, a being mystified and sanctified by the silence of the encircling void.

In the eyes of his contemporaries, it was Whistler's own finer, feminine self that was projected onto the surface in terms of his feminine object and his dematerializing—feminizing—atmosphere. This was possible in the nineteenth-century perception of male artists because an ideological space opened earlier in the discourse on gender gave male artists a special latitude to operate from the affective arena officially coded as feminine. Critics thus noted a dichotomy between the often-pugilistic Whistler and the private, "real" man revealed as spiritual and refined in the art.[92] In constructing his persona, Whistler to a certain extent justified Moore's identification of the delicacy of Whistler the artist with the delicacy of Whistler's painted

surface. That Whistler identified with his mother was indicated in his appropriation of her name, McNeill, as well as her Southern origins and manners. Even after his bankruptcy of 1879, when he fled London to escape his creditors, he continued to polish his image in his mother's eyes. Writing letters to her from Venice, he kept his double life with his mistress a secret from her (as he had always done) and regaled her with accounts of his new artistic successes that were contributing sweetness and light to the world.[93] Whistler refused to become a minister, as Anna Whistler had wished, but instead toyed with the role of a spiritualist medium, a role usually reserved for women because of their supposed intuitive link to the higher world, and then grafted that role onto that of the artist.

Whistler deliberately encouraged the spiritualist reading that French, Belgian, and American critics brought to his work in the last two decades of the century. Huysman, for example, evoking Desnoyers's description of *The White Girl* as a medium, interpreted the mature portraits as spiritualist representations of souls and compared the "nocturnes" to Verlaine's poetry in their "releasing [of] the suprasensible from the real." The portrait of Sarasate, exhibited at the Salon of 1886, was similarly termed "an apparition . . . called up by some medium in a spiritual trance" and a "symphony in black [that] gives us the darkness of the soul." Shortly after Whistler's death Camille Mauclair published undoubtedly the most elaborate version of Whistler's construction as an artist who sought "to penetrate and understand the essential person." According to Mauclair, the mystery in Whistler's painting arose from the shadow world of Whistler's vision, which isolated the soul in its distinctness from everyday life. Thus, Whistler's painterly idiom based on a vacuum only confirmed the presence of the infinite, and his special genius was termed an ability to give expression to the soul, an accomplishment demonstrated in the "nocturnes" as well as in the portraits.[94]

French, Belgian, British, and American aesthetes at the end of the century all searched Whistler's works of the 1870s and 1880s for signs of soulfulness that would reassure these agnostics in their anxieties over the human inability to fathom the unknown, the mysteries of life and death. The "nocturnes" inspired the British poet William Ernest Henley, for example, to write morbid sentiments of "The terror of Time and Change and Death, / That wastes this floating, transitory world." For George Moore, Whistler's nocturnal visions merely reminded us of our "pathetic" understanding of "the casualness of our habitation, and the limitless reality of a plan, the intention of which we shall never know."[95]

It is important to understand how Whistler's nuanced effects were situated and interpreted within the twin discourses of spiritualism and agnosticism in the 1880s and 1890s, a dialogue that engaged Pater and Rossetti, as well as a generation of British and American intellectuals who feared the advance of materialism and science. Overall this class explored a number of aesthetic means which they hoped would lead them to locate transcendence in this world. Edward Burne-Jones was one of an army of painters who attempted to counter materialism with the conventional signs of the ideal. "The more materialistic Science becomes," he vowed, "the more angels shall I paint."[96] Whistler and Rossetti, however, were part of another contingent, which invested religious meaning in secular practices, primarily in the worship of romantic love and aesthetic domesticity favored by the English middle classes in the late nineteenth century.[97]

In this regard, it becomes apparent that Whistler—who was as a young boy schooled in his mother's Protestant perfectionism—transformed her orthodoxy into a gospel of the aesthetic life for an elect.[98] His "Ten O'Clock" lecture presented his manifesto of art as religion. After announcing at the beginning of his sermon that he was appearing in the role of "The Preacher," Whistler chastised the public to convert to the true religion of art in his biblical cadences and phrases that denounced the popular following garnered by "blasphemous doctrine" and "false prophets." Through the purified but sensuous work of art, Whistler—as the high priest of aestheticism—intended to lead the elect few who could appreciate such refinement to an "intensity of consciousness," the purpose of which was to raise the sensibility of the viewer to a higher plane.[99] If Whistler overstated his case in arguing for a sensuous beauty that was bereft of any indwelling meaning, a decade later he reversed his position and indicated his willingness to view his work in symbolist terms more suggestive of Poe's mysteries rather than the brightly colored world of Hokusai that he had championed in the "Ten O'Clock." In fact, not only was Whistler praised by symbolist critics in the 1880s, but he was also welcomed into the fold of the Belgian symbolists, "Les XX."[100]

Meanwhile, Whistler's abstracted and highly personalized imagery seemed to threaten a form of extreme relativism and left him open to the charges of solipsism. At least one contemporary complained that Whistler's philosophy seemed to negate "the existence of anything beyond our own private sensations." Setting himself against the middle-class demands that art respond to normative perceptions of truth and morality, Whistler advocated instead an appreciation of the art object that depended wholly

on the individual's ability to master the internally legitimating formalist discourse of modernism.[101] The viewer's capacity to discern "pure beauty" to Whistler's mind differentiated the elect individual from the bourgeois masses and imputed to that individual a self-refinement that in turn justified a superior social status.

It was Whistler's quite overt lack of regard for the values and well-being of the social polity as a whole that infuriated Ruskin, who as the evangelistic preacher of middle-class morality in art was in every sense a match for Whistler, the defender of elite aesthetics. Though the critics had attacked Turner's late work, Ruskin had promoted Turner's nearly formless canvases because Turner overlaid them with historical and literary glosses and thus gave the middle-class viewer access to them via moral and narrative meaning. Unembellished by literary myth and narrative, however, Whistler's almost equally formless paintings could claim as their only justification the mandarin language of artistic formalism.[102] Whistler may well have desired a condition of universality for his paintings, but as certain reviewers noted, the "untranslatable" language of his art, its resistance to conventional forms of narrative intelligibility, rendered it outside the bounds of understanding to most of the public. It was inexplicable other than in terms of pure sensation and composed of "little juggleries of effect, which only the initiated shall be able to detect." In short, his art was elitist, accessible only to the few, and directed toward individuals who deemed themselves spiritual aristocrats by virtue of their superior sensibilities.[103]

But for Whistler and other aesthetes, the transforming powers of beauty had an application beyond the individual art object. The religion of art could be extended into a religion of life; it could reform life by impressing the principles of beauty on the larger structure of the environment. The "nocturnes," for example, had exemplified one version of this redemptive function of art. In their view of a mythic London harmonized and ordered, the "nocturnes" presented London as it should be when revised by the artist of genius. By imposing the aesthetic of the painting on its frame—and then on the surrounding interior—Whistler also proposed that the designed domestic environment could foster a harmonious, ritualized interchange within its walls. To that effect, a dining room or drawing room was also a space that could nourish the lives of its occupants if it were unified in movement and color. Whistler's two houses on Lindsey Row, in which he resided from 1863 to 1878, and the "White House" in Chelsea, designed for him by E. W. Godwin in 1878, were environments arranged for his own self-nurture with walls painted in pastel harmonies or left a clean white and

sparingly decorated with Japanese prints, paintings, *objets d'art,* and other furnishings with classical lines.

Whistler's most dramatic gesture asserting the importance of design in the art of life was his transformation of an ordinary dining room—a site of bourgeois ritual—into a flamboyant stage set for one of his earlier works, the *Princesse du pays de la porcelaine,* owned by Frederick Leyland. In restructuring Leyland's dining room (*Harmony in Blue and Gold: The Peacock Room* [1876–1877; fig. 3.20]) into a unified ensemble of color and motif, Whistler imbued it with the heightened atmosphere of a sacred liminality, a space marked off from common usage by its special purpose. Activity in such a room proceeds in a ritualized fashion; it is shaped by the aesthetic stylization of the enveloping walls and the furnishings, which prompt human behavior and body language.[104] As in Whistler's "nocturnes" and portraits, where all is harmony and repose, *The Peacock Room* issued from the Victorian utopian discourse that also produced such contemporary escapes into atemporal worlds as William Morris's *News from Nowhere* (1890) or Rossetti's medievalized gardens. In these schemes the pleasure-giving beauty of art has the power to perfect and transfigure mundane reality into an earthly paradise.

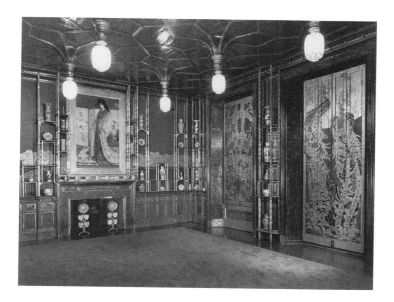

FIG. 3.20. *James McNeill Whistler,* Harmony in Blue and Gold: The Peacock Room, *1876–1877. Freer Gallery of Art, Smithsonian Institution.*

WHISTLER'S LEGACY IN AMERICA

Even American critics as supportive of English aestheticism as James Jackson Jarves was in the 1870s conveyed some reservation over the extremism of Whistler's "art for art's sake" rhetoric. Jarves especially objected to Whistler's anti-intellectualism and the degree to which his painting required a completely individualized response. By 1904, however, Whistler's status in America had drastically changed. That year the Whistler memorial exhibition organized by the Boston Copley Society was declared "the most important and interesting art exhibition ever held in America." This appraisal signals the reconfiguration of Whistler's work as the touchstone of the evolutionary program in which the northeastern establishment had advanced during the 1890s.[105] Whistler's reverence for art, his use of religious metaphor in his aesthetic theory, and his regard for art as a source of authority for the conduct of life reinforced the liberal Protestant ethos of the Northeast in the 1880s and 1890s. Boston's elite especially seized on Whistler's aesthetics as a philosophy of art and life that put into practice the correlative truths of Spencer, Emerson, Hegel, and Buddhism. Into this milieu Kakuzo Okakura's art of tea was received as a similar aesthetic practice that could fill the void left by orthodox Protestantism, which now failed to satisfy the need for religious and political reassurances.

Ernest Fenollosa, who in Japan had tutored Okakura in evolutionary thought, at the same time—throughout the 1890s and after—promoted an evolutionary scheme in which the impending course of history was an upward spiraling movement—the unfolding of a global civilization in which East and West would be incorporated into a higher, completed order. In describing the new world order, Fenollosa drew on nineteenth-century gender typology, projecting the dichotomy of feminine and masculine constructions onto East and West. While feminine spirituality and aesthetic sensibility characterized the East, he thought, the West was defined by its masculine scientific and industrial enterprise. For Fenollosa, art offered one agency by which this synthesis could be accomplished. The principles of art could teach harmony and unity: its lessons in "harmonious spacing" could be translated into methods of "harmonious living" in the redesign of industrial, urban, and domestic environments.[106]

Fenollosa had gone to Japan in the 1880s to teach Spencer's and Hegel's philosophies, and during this period had acquired a rare knowledge of Asian art. He was lured to the post of curator of Oriental art at the Museum of Fine Arts in Boston during the 1890s, then returned permanently to America in 1901, when he began a nationwide lecture tour touting art as

an agent of social reformation. Within the decade he became the trusted adviser of Charles Lang Freer, the foremost collector of Whistler and Asian art in America, and assisted Freer in refining his collections. The result was that Fenollosa's conviction of art's instrumentality in social progress shaped not only Freer's collections but, ultimately, the philosophy of the Freer Gallery of Art (Smithsonian Institution, Washington, D.C.) as well.

Reviling both formalism and hedonism as inferior forms of experience, Fenollosa thought Whistler's culling of the best from Eastern and Western cultures could lead American society toward a more "perfect type of spiritual living," the individual life becoming a work of art. In Fenollosa's estimation, Whistler had been the first to synthesize Occidental naturalism with Oriental design into universal principles of a pure art in a consistent, systematic manner. "Standing at the meeting-point of the two great continental streams," Whistler functioned as "the nodule, the universalizer, the interpreter of East to West, and of West to East." Thus Whistler's achievement was elevated to a central place in the evolution of American culture into a universal culture, and Whistler's art was considered the keystone of Freer's collection. That he had positioned himself as a romantic artist who stood against the masses, an artist who worked only for himself and others able to grasp the rarefied terms of his art, mattered little to Fenollosa. He was determined to use Whistler's example to appeal to wider audiences and democratize the experience of art. To this end, Fenollosa regarded Freer's collection, given to the nation in 1906 and installed as a public museum in 1923, as an educational tool from which artists, craftsmen, and laymen alike could learn how the great artists and craftsmen of the East, as well as contemporary American painters, had built up "structures of harmony."[107]

The criticism of Charles Caffin closely echoed Fenollosa's understanding of Whistler. Caffin was an influential and popular writer who worked for the *New York Evening Post* (1897–1900) and the *New York Sun* (1901–1904), among several periodicals, and published two of the first histories of American painting. Freer must have recognized Caffin's 1907 essay on Whistler as a statement sympathetic to his own, because in 1909 he paid and arranged for Caffin to lecture on Whistler at the Detroit Museum of Art.[108] Caffin's perception of Whistler was that he had appropriated a Japanese technique with which to symbolize the indwelling spirit: unity of effect and harmonious color in Whistler's "nocturnes" produced essence of form rather than material fact. Bathed in "the tranquil half-light of the soul," Whistler's modern London was "poignant in cleansing sadness." Caffin expanded on this antimaterialist reading of Whistler's tonalism in his Detroit lecture in a manner that recalled Fenollosa's sanctification of historical process. Whistler had seen the "significance of the lotus flower,

the emblem of the eternal cycles of existence once more united and once more symbolizing the unity of life and death through eternity." In his art this was reflected in the silence, as well as in objects' distance from the modern world. The "nocturnes," like all great art, "preserve the mystery and aloofness of time" as they exist in a "vacuum undisturbed by the stir of life."[109]

Yet in his treatise on modern life, titled *Art for Life's Sake* (1913), Caffin showed himself also to be of Fenollosa's anti-elitist faction in the social use of art; he welcomed efforts to democratize the experience of art and apply the principles of art to the reformation of modern life. But his philosophy was not antimodernist; rather, Caffin advocated exploiting the forces of modernism—science and industrialism—in a dialectical union with the forces of spirit—beauty, growth, and harmony—to realize a democratic society of a higher order. The artist's participation in this scheme was essential: painters, sculptors, and craftsmen should join architects, scientists, and inventors in "beautifying the city, the improvement of tenements, the eradication of disease and every other organized effort to enhance the Beauty of Living."[110]

Other critics, such as Sadakichi Hartmann, also a spiritualist based in Boston and New York, Royal Cortissoz, who wrote for the *New York Tribune* in the 1890s, and Theodore Child, voiced similar understandings of Whistler premised on his antimaterialism and refinement. Appraising the American paintings at the Paris Exposition Universelle in 1889, Child, for instance, wrote that Whistler's "constant aim is to eschew materiality, grossness, and ugliness, and to evoke only the most delicate visions of . . . form and color in luminous air." Meanwhile, Whistler's impact on American artists, singly and collectively, was increasingly noted in the press. Already by 1888 Clarence Cook had observed the "great influence" Whistler's work was producing "on the younger artists in England, in France, and notably here at home."[111]

Whistler's aesthetics of dematerialization and perfectionism obviously suggested to his American contemporaries Hegel's concept of art as a sensuous embodiment of spirit, a material body that would over the course of evolution be refined into pure spiritual expression. According to Fenollosa, Japanese abstraction had freed Whistler from the limitations of materialism in the Western representational system to evolve the higher art form of the future. Contrary to orthodox artistic practice, his tonal color was allowed to become expressive through its intrinsic, sensuous qualities.

Though bound up with the feeling of the thought implied, they [areas of color] are as positive and transcendent as the world of pure

instrumental music. Subject, indeed, is not lost; but rather absorbed by, or translated into, the beauty of form.

Whistler, then, committed "heresy" by voiding form of its normal "thought-burden" and absorbing subject into technique. His variations of form and color constituted, "in their own right, a highly organic universe" with "orderly progressions of individual beauty, capable of almost infinite variation and extension." A transcendent experience was provided for the viewer, because the order of the method was conceived in terms of transcendence: color was pushed through vast varieties of harmonies and "endless new . . . chords," "infinite ranges," and gradations of tone, and "shifting values" to yield effects of transience, translucence, transfusion, and half-revealed, half-concealed forms. Impressionist brilliance was rendered "coarse" and "sensational" in comparison with this subtle "form-music . . . of color." Each color chord—especially the greys, which were the foundation of Whistler's art—pulsated "with imprisoned colors."[112]

The many unified into the one; spirit and sense resolving into harmonious form: this was the perceived Hegelian dynamic of Whistler's art, as his sympathetic critics articulated it. Whistler had publicly harped on late romantic ideas such as the artist as messiah, the redemptive function of the harmonious environment, and the quasi-religious status of the unified artwork. Thus, to those who were already receptive to antimodernist aesthetic mystification, Whistler seemed to invite interpretation of his art in the context of symbolist mysticism, especially after he positioned himself within the symbolist fold in the late 1880s and 1890s. The school of neo-Hegelian philosophy that had been gathering strength in Boston since the 1860s arrived full-blown two decades later to dominate philosophical and aesthetic discourse in America in the form of Absolute Idealism.[113] The correspondence between this doctrine and the dematerialized, musical idiom of Whistler's art helps to explain how American audiences were predisposed to interpret his new sensuousness as an implicit spirituality—especially as it played to the needs of those attempting to construct a progressive, evolutionary trajectory for American culture.

Even though the dramatics of Whistler's career were conducted in London and Paris, his impact on American artists was profound. Younger painters such as Dewing, Chase, and Duveneck and "his boys" closely followed the newspaper accounts of the lawsuit that Whistler brought against Ruskin in 1878 for libelous accusations. After the trial young Americans sought him out in London, Venice, or Paris, and he responded warmly and gratefully, cultivating their admiration at a time when he needed to repair his personal resources.[114]

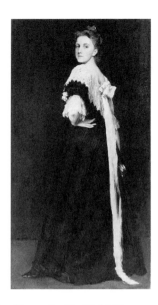

FIG. 3.21. *William Merritt Chase,* Lydia Field Emmet, *c. 1893. The Brooklyn Museum, Gift of the Artist.*

Whistler's imagery of unity, harmony, and synthesis resonated with the rhetoric of the Spencerian evolutionary program. His metaphors suggesting a gradual metamorphosis and refinement of the self came to the attention of Americans at the same historical moment when the practice of self-culture as a means of evolutionary progress for American society was gaining a popular following, particularly among the Anglo-Americans of the Northeast. Steeped in late nineteenth-century versions of transcendentalism, Whistler's American audience valued his tonalist aesthetics as a reaffirmation of the soul and therefore as a reassuring answer to the troubling questions engendered by Darwinian science. The galleries of exhibition halls during the 1880s and 1890s were filled with nocturnal landscapes and marines, as well as paintings of female figures aping the attitudes of the "white girls" or the *Fur Jacket,* for example: E. A. Bell's *Portrait—Study of a Lady in Grey* (1889; Memphis Brooks Museum of Art, Memphis, Tennessee) or Chase's *Lydia Field Emmet* (fig. 3.21). The tonalist technique was imitated by painters, photographers, and printmakers alike, while even students of sculpture in New York were taught to dematerialize the contours of their figures so that the subject seemed to be one with its atmosphere.[115] Of the younger generation, Dewing, Tryon, and Twachtman, among a host of others, and after them Stieglitz and Steichen, would find in the silence of Whistler's musical idiom the key to expressing the spiritualist mysteries they were seeking.[116]

Aesthetic Strategies
in the "Age of Pain"

THOMAS DEWING AND THE ART OF LIFE

ON A JUNE DAY in 1905 a group of artists and writers summering in the art colony at Cornish, New Hampshire, transformed a pine grove at Saint-Gaudens's home there into a theater for the performance of a masque. Assembled at Aspet for the occasion was a select audience of two hundred men, women, and children. When the theater curtain, hung with two large gilded masks, was drawn aside, a small Ionic temple with an altar was revealed, and about seventy men, women, and children impersonating the pantheon of Greek gods and goddesses emerged into the area before the temple, accompanied by strains of music performed by the Boston Symphony Orchestra. Costumed in white, gold, pale blue, silver, yellow, sea-green, and rose, the group around the temple suggested Puvis de Chavannes's *Sacred Grove* come to life, or any number of contemporary paintings devoted to the idea of ancient Greek ritual. First on the program was a bit of bumptious comedy poking fun at the locals, and then Saint-Gaudens, the representative genius of the art colony, was presented with a golden bowl. In the "Masque of the Ours," or the "Masque of the Golden Bowl," as it would come to be known, these writers and artists paid tribute to Saint-Gaudens and his founding of the Cornish colony twenty years earlier (fig. 4.1). Inadvertently, however, they also expressed and reified their communal self-identity as an elite devoted to an ideal of life perfected by aesthetic experience.[1]

Although on a mundane level the Cornishites seemed to be indulging in humorous self-parody, on another level they were dead serious in their attempts to cast themselves into a mythic framework within which they

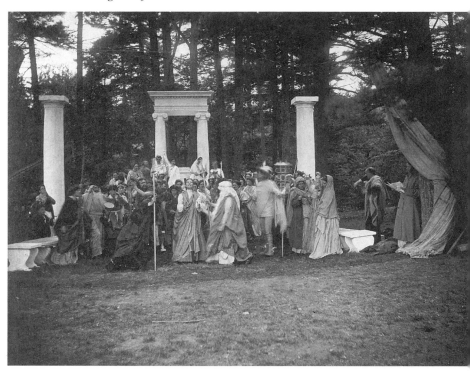

FIG. 4.1. *The "Masque of the Ours, the Gods and the Golden Bowl" at Aspet, residence of Augustus Saint-Gaudens, Cornish, New Hampshire, 1905. Photograph courtesy of the U.S. Department of the Interior, National Park Service, Saint-Gaudens National Historic Site, Cornish, New Hampshire.*

could see their accomplishments as exceptional and distinct in the American scene. Though there were other art colonies in America during this period, more than any other group Cornish was directed by the belief in the religion of art and its own preeminence in conforming to the dictates of that cult. Following Whistler and Pater, these artists measured the quality of life by the degree to which it approached Anglo-American aesthetic trends in the 1880s and 1890s. That Thomas Dewing's 1887 painting *The Days* (fig. 4.2) uncannily prefigured the 1905 masque demonstrates how the visual arts structured the communal rituals of those devoted to the aesthetic conduct of social relations.

Dewing was a leading personality at Cornish, and his life presents a paradigm of American aestheticism in the Darwinian "Age of Pain." In an examination of his career, a dynamic becomes evident, in which his art can

be seen to be dependent on the intensity of the life he lived at Cornish, just as that life was informed by the same theatricality and stylization he brought to his art. Dewing and his fellow colonists seized the opportunity presented by rural New England: unlike the chaotic streets and diversified sights of New York, in pastoral New Hampshire daily experience could be aestheticized, unified, and controlled. As such, it offered the ideal plastic environment in which to construct an antidote to the real present of urban, industrial America.

Living by a morality of aesthetics, the Cornishites castigated the philistines—the nouveaux riches—of American society more frequently and loudly, but perhaps no less seriously, than critics elsewhere in the country in the era of aestheticism. Theirs was not a retreat to primitive, uncultivated nature, but as the writer and colonist Herbert Croly noted, the artists carried their civilization with them to the countryside.[2] The utopian impulse at Cornish enjoined the community to construct rituals of leisure that were positioned between nature and culture. These rituals are symptomatic of the agnostic religion of art, which constituted one succinct Anglo-American response to the dilemmas presented by evolutionary thought at that historic moment.

With the arrival of Arnold's gospel of civilization in America after the 1876 Centennial celebration, culture—literature and the fine arts, in

FIG. 4.2. *Thomas Dewing,* The Days, *1884–1887. Wadsworth Atheneum, Hartford, Connecticut.*

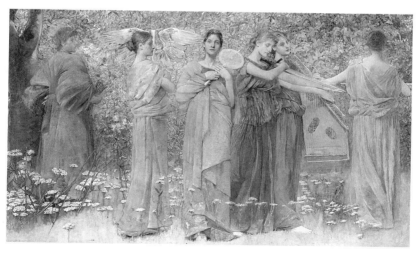

particular—was assigned the value-making authority formerly reserved for Christian scripture and doctrine. In 1882 in New York Spencer encouraged Americans to enhance their leisure activities in order to alleviate the physical and psychological demands placed on the individual by the accelerated pace of the urban environment. Thus the therapeutic use of art and literature appeared as a desirable tactic to ameliorate the problems of modern life. Self-culture—the practice of refining the self through the instrumentality of art—had enjoyed a considerable history in Anglo-American society. From the Puritans through the second-generation Transcendentalists, this practice was promoted as a means of transforming the self into a member of an elect, and later a civilized, society.

Spencer buttressed this liberal program by giving it a "biological" basis, and through his popularizers the philosophy of self-culture was amplified and shifted to the center of the popular and intellectual discourse concerning the relation between American civilization and "American nervousness." But this philosophy also appealed to those searching for more than simply a relief from physical and nervous exhaustion. In the practice of self-culture the transcendence asserted for the work of art maintained a deep hold over agnostics who clung to the beauty of art as a religion they could substitute for an orthodox Christian faith that had been eroded by the challenge of Darwinian science. For a growing number of agnostics in the Northeast at the end of the century, art provided evidence of the human soul, as soulfulness was evoked in the response to beauty. Proof that the human race was different in kind from the lower animals was surely apparent in the ability of the human animal to appreciate and experience the higher realm occupied by art, though it remained ambiguous as to what degree that realm invoked the supernatural.

Of the artists who catered to the agnostic need for soulfulness in art, conceiving their images in terms of a sign system that could be read in this way, Whistler was foremost among a group that included Puvis de Chavannes and Corot. In the process of transplanting Whistler's spiritual semiotics to the United States, Thomas Dewing was his truest acolyte. Their backgrounds linked the two culturally. Born in Lowell, Massachusetts, Whistler was subject to the idealism inculcated in him by his mother, even while he spent much of his life translating her Calvinist version of it into the secularized romantic terms of Gautier and Baudelaire. Raised in Boston, Dewing was likewise drawn toward a perfectionist vision of life. He adapted Whistler's dematerialized idiom, though his art went beyond a literal copying of Whistler's prototypes. More fundamental was Dewing's grasp of

Whistler's social ideologies, especially his prescriptive translation of British aestheticism into images that served the evolutionary beliefs of the Northeast.

THE ART OF LIFE AT CORNISH

At Cornish Dewing and his colleagues took Whistler's aestheticism to its logical culmination, not stopping at the unified and designed environment but extending the rhythms of the perfectly structured work of art into the ritualization of life. In such a utopian moment, time seemed to stop and life shared in the transcendence of art. After the "Masque of the Golden Bowl," for example, the participants recalled the pleasure they received throughout the evening's festivities from the sight of the "gods and goddesses" spontaneously regrouping into familiar compositions. This was a pleasure that came from life taking on the form and the timeless duration of art: the past seemed to interpenetrate the present, and the mythic stuff of ancient Western civilization appeared alive in the Yankee farmlands of New Hampshire.[3] If this experiment in the "poetry of living" was partly a nostalgic return to the earlier pastoral myth of the New England landscape, it was a return mediated by the cosmopolitan experience of artists who had spent years studying in the academies and museums of European capitals. Pleasure that came from viewing the masque and its aftermath was derived too from the knowledge that one was initiated into a cultural practice of which the locals were ignorant and which therefore marked the participant with the cultural capital commanded by an elite group.

The artists and writers that congregated at Cornish were connected by the artistic and social networks of Boston and New York. Over the two decades following the founding of the colony in 1885, the tight circle that formed around Saint-Gaudens and Dewing included Louis Saint-Gaudens, Herbert Adams, Frances Grimes, Daniel Chester French (briefly), Maria Oakey Dewing, Kenyon and Louis Cox, Henry and Lucia Fairchild Fuller, Frances Houston, Anne, Maxfield, and Stephen Parrish, H. O. Walker, and Charles Platt. Nearby at Dublin, Vermont, were Abbott Thayer and George de Forest Brush. Some only summered at Cornish, while others resided there permanently. Around the turn of the century came a second generation, primarily composed of writers: the architectural critic and founder of the *New Republic*, Herbert Croly; the editor Norman Hapgood; the playwright Louis Shipman; the poet Percy MacKaye; and the novelist Winston Churchill. This younger group was close to Woodrow Wilson and was

active in formulating the Progressive policies of the prewar era, in contrast to the strong Republican leanings of Dewing and the older generation. Other residents and intermittent visitors, such as the architect Stanford White, the composer Arthur Whiting, musicians Grace Lawrence and Otto Roth, and the actress Ethel Barrymore, further contributed to the insular focus on aesthetic experience as the code of living in the colony.[4]

The myth of Cornish reflected the colonists' self-image as they wished to see themselves and to be seen by others. By the early twentieth century the myth had spread from the back country to New York City. A reporter for the *New York Daily Tribune* in 1907, for example, articulated this myth in terms of an intellectual elite: it was an "aristocracy of brains" determined to "keep out that element which displays its lack of gray matter by an expenditure of money in undesirable ways."[5] Years later Frances Grimes, who was Saint-Gaudens's studio assistant there in the 1890s, similarly recalled that Cornish "was said to be not a place but a state of mind, like Boston," though she admitted that this "reputation was not wholly good." Outsiders who tried to get inside the circle, for instance, were often snubbed and "rejected on some basis that was not understood." Before his first visit to the colony, Philip Littell remembered being intimidated by the description of Cornish as a place populated by "Blessed Damozels" and aesthetes—"a shrine at every four corners, with a Botticellesque figure inside." When these inhabitants weren't worshipping at their shrines, they reputedly worshipped "each other or themselves."[6]

Though Dewing and his colleagues were consummately bourgeois in their preoccupation with domestic design and ritual, the antimaterialism of their own self-definition comes through strongly in these descriptions. The bane of the community was the nouveau riche or the *arriviste*—in other words, the men and women with money but without the brains or breeding to provide direction in the tasteful and cultivated expenditure of it. In fact, Cornish defined itself against this type, as a bastion of the elect who would reform the philistine element in American society. "I can still reproduce in my mind the tone of the word *Philistine*," Grimes recounted. "How often I heard it."[7] The uninitiated were not simply annoying in their ignorant pronouncements on aesthetic matters, but they were threatening to the social norm at Cornish in their valorization of money over "taste."

By way of contrast, the philistines' display of wealth could potentially reverse the hierarchy the Cornishites had established and simply redefine the artists as moneyless pretenders to stations of social power; their aspirations to constitute a spiritual and intellectual elite would be revealed as groundless. The aesthetic mores of classic simplicity that were implicitly

understood and enforced in the community by peer pressure could perhaps be perceived to be inadequate in the face of more vulgar but luxurious appointments. In short, the colonists' claims to the status of an elect group rested on a distinction between aesthetic dispositions that marks classes and dominant groups from one another, as Pierre Bourdieu has noted.[8] In the eyes of the Cornishites, the philistines condemned themselves by their inability to participate in the interlegitimating discourse of formal analysis by way of reference to works of past masters and by their vulgarity as revealed in their choice of commodities for everyday use. Thus the Cornishites asserted for themselves a privileged position in social space through the traditional means of aesthetic markers or taste.

The colonists' gentrification of Cornish demonstrated for them the potential of New England when raised to a higher power through the refinement of European civilization—the ancient Anglo-Saxon Puritan homesite cross-pollinated with, and improved by, the taste for classical Italy. The landscape they constructed in the New Hampshire hills seemed the consummate New England landscape. Distinguished by its fine proportion of natural elements, the valley was further improved by the cosmopolitan culture the colonists brought with them. Though it was a "sheltered site," surrounded by gently rolling hills, Cornish remained connected to the "main roads." Thinking of themselves as a "highly-civilized gentry" who carried their "civilization with them" and had no need of a conventional return to primitive nature, the artists attempted to make the landscape over into a reflection of that self-image. By their efforts the simplicity of New England became more complex and interesting when combined with the architectural forms of ancient Italy, and the environment seemed more comfortably adapted to them.[9]

Dewing began the practice of adding elaborate flower gardens with exedra benches and formal gates to the house, integrating it into the landscape. Lombardy poplars were planted everywhere, and eating porches facing Mount Ascutney were de rigueur. Stanford White helped Dewing add classical details to his house, and Charles Platt developed a type of American country villa at Cornish based on a hybridization of vernacular New England houses with Italian villas. Platt's own residence there, complete with formal gardens, suggested "a kind of American Italy," while Saint-Gaudens completely renovated the old inn he purchased "to make it as little like New England as possible." The crowning jewel of these structures was High Court (fig. 4.3), a large house Platt designed for Annie Lazarus, sister of the poet Emma Lazarus and patron of the arts. Set high atop a hill with a magnificent view of the valley and the mountain spread

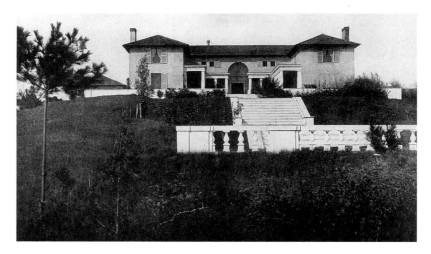

FIG. 4.3. *Charles Platt, High Court, residence of Annie Lazarus, c. 1892, Cornish, New Hampshire. From Charles A. Platt* Monograph of the Work of Charles A. Platt *(1913)*.

out before it, the colonnaded veranda of this New England villa provided the scene of countless dinners and entertainments (fig. 4.4), many of which were orchestrated in design by Dewing.[10]

To outsiders the colony seemed obsessed with transforming this rural farming spot into a utopian community devoted to an aesthetic domesticity. The painter Dennis Bunker, for one, had no stomach for such schemes and found those whom he respected as his colleagues in Boston and New York only "strange and comic" in Cornish, "with their houses and their plans and their poor little flower beds." The place was "too arty," the sculptor Daniel Chester French told his wife after they spent two summers there, and the community insufferable in its determination to impose aesthetic criteria on the most trivial of matters.[11] Though the New Hampshire hills were blazingly hot in July and August, screens in windows and doors were considered ugly and therefore nowhere to be seen. Feuds between households and between couples did occur, but were conducted with discretion in private. In public such dissension was frowned upon, and a decorum of communal harmony held sway.[12]

Social affairs functioned to foster group identity, distinguishing the artificers and the knowers from the philistines. But these activities also supplied material for the artists' work, and presented an abundance of opportunities to compose life as art. Dewing was the dominant force

behind many of these affairs, to which outsiders were rarely invited, although in the 1890s the entire community attended, in contrast to the small group gatherings preferred there after the turn of the century. Frances Grimes remembered that parties "were planned days beforehand and were always for eyes to look at more than affairs where friends met to talk or young people to dance." At picnics or outdoor gatherings, for example, women were careful to dress in white or pastels, self-consciously providing decorative accents in the deep blue-green landscape. Satirical skits and charades—again, often directed by Dewing—were a favorite form of entertainment, while tableaux vivants that recalled painted masterworks received serious analysis as well.[13]

The various aspects of domestic life—women, children, houses, and gardens—were governed by the painterly aesthetic. If the aesthetic vision seemed favored in group activities, a more complete spectrum of the aesthetic sensibilities was exercised at masques that combined theater, music, and poetry. Similarly, at evening soirées in the home, for example, the Kneisel Quartette playing in Dewing's parlor or an ensemble led by Arthur Whiting at Frances Houston's, a musical performance of a high caliber might be accompanied by sumptuous arrays of food and flowers.

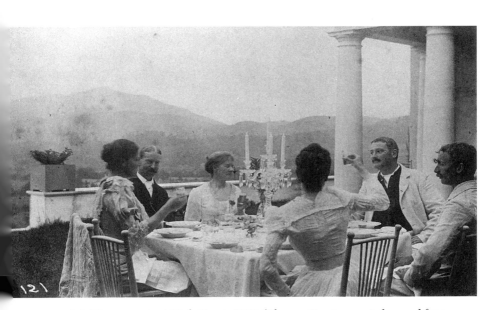

FIG. 4.4. *Dinner party at High Court, 1893 (Thomas Dewing, seated second from the right; Maria Dewing, seated third from the left). Photograph courtesy of Elizabeth Gunter.*

Grimes recalled that "music heard looking out at the landscape with people who were sensitive to the beauty of both, was heard, we felt, as it should be."[14]

The masque, however, provided a communal art form in which the panaesthetic experience of dance, music, painting, and the spoken word provided, to the mind of Percy MacKaye, "a mighty agency of civilization" as a form of individual and group refinement. One of the leaders of the pageantry movement in the prewar decade, MacKaye saw this "poetry for the masses" arise in its nascent form at Cornish and then under his leadership expand to the monumental proportions of a full-fledged movement in civic theater. In his hands, pageantry ultimately became a pedagogical art form, the ideological goal of which was to enhance social harmony and amelioration among the diverse groups (WASPs with non-WASPs) within the larger culture.[15] MacKaye's rationalization of the pageant—as a redemptive use of leisure that resuscitates time instead of "killing" it—emanates from the agnostic attitude toward art (as essentially a preserve of spiritual energy) endemic to the period. Through the activity of theatrical play the idea was to "refill . . . [time] to overflowing with that quality of charmed eternity which it always possesses in normal childhood." Stopping time through ritualization of aesthetic experience, refreshing and re-creating the self through imaginative play: these were the motives behind the therapeutic use of art at Cornish.[16]

"Life in the poetry of living" is the phrase Maud Howe Elliott used to describe the years she spent at Cornish. This was good Yankee country, and hard work in the studio predominated until five in the afternoon, at which time one was free to call on neighbors for afternoon tea, a critique of work in the studio, or a musical soirée. Elliott's description of one typical evening in the "poetry of living" summons up a ritual in which the participants orchestrated a succession of theatrical gestures in order to lengthen the moment and arrest time.

> Sometimes we joined an evening picnic. I remember one when the guests assembled on a high hilltop in time to watch the sun set, and remained to see the full moon rise. The children made oak garlands to deck the tables and crown themselves. In the gathering twilight they danced like joyous elves against the purple background of the . . . [mountain]. There was music too; someone had brought a guitar, another a flute; the piping treble of the children's voices was deepened by the velvet notes of Grace Arnold's contralto.[17]

Elliott's denomination of this period at Cornish as "an Arcadian age" alludes to the utopian ideal of the colonists, especially in the landscape morphology and the social ritual they created, both of which suggest that history was culminating in a period in which there was no sense of time other than an eternal present: the conflation of past and present, as well as the conjoining of American nature with European gardening forms, in aesthetic experience conveys a desire to transcend time and place through that experience. Slowing time was a major concern to agnostics who feared, as Walter Pater did, that "we are all under sentence of death but with a sort of indefinite reprieve":

> We have an interval, and then our place knows us no more. Some spend this interval in listlessness, some in high passions, the wisest, at least among "the children of this world," in art and song. For our one chance lies in expanding the interval, in getting as many pulsations as possible into the given time. Of such wisdom, the poetic passion, the desire of beauty, the love of art for its own sake, has most. For art comes to you proposing frankly to give nothing but the highest quality to your moments as they pass, and simply for those moments' sake.[18]

Pater's agnostic credo of aesthetic experience, his admonition to expand the interval through the frisson of submersion in the exquisite work of art, would have been familiar to Dewing and his circle. This poetic trope invoked by Elliott is descended from Pater, but it is also implicit in Whistler's images. Even if the Cornishites had not read Pater's *The Renaissance* (published in the United States in 1877), as the Dewings had, Whistler's promotion of the art object as an agent of transcendence—for example, in *The Little White Girl*—had the same result of popularizing this essential romantic doctrine.[19]

As early as 1882, the year after the Dewings' marriage, their joint venture in publishing a manual for the art of life, *Beauty in the Household,* speaks directly to their concern with the redemptive possibilities of leisure, both in Thomas's illustrations and Maria's text.[20] As a kind of motto to live by, the (ungrammatical) Latin phrase "Horas non numero ni si serias" (I have none but serious hours)[21] is printed over a vignette of several women— some singing, dancing, and making music and others listening and looking in the setting of a sacred grove (fig. 4.5). This design for a painted arras in a hall thus announces the inhabitants' determination to fill their time with the higher things in life. It succinctly visualizes the trope that would

FIG. 4.5. *Thomas Dewing,* A Painted Arras for Small Hall. *From Mrs. T. W. Dewing,* Beauty in the Household *(1882).*

become central to the Dewings' life at Cornish. "Seize the moment, there may be no tomorrow." was the agnostic philosophy of British and American aesthetes, and it was the philosophy that shaped private aesthetic experience as well as public ritual at Cornish. There in the sacred groves of New Hampshire, looking at a rolling green landscape that was graced by the lyrical figures of women and children and listening to music induced the slowing of time, until one was nurtured, enriched, regenerated in the expanding energies of the self into the boundlessness of nature.

In summer the misty atmosphere of Cornish that veiled the soft rolling hills and the masses of deep green woods endowed the landscape with a sense of mystery. Musing on the character of this region, Henry James found here the essence of "the Arcadia of an old tapestry, an old legend, an old love-story . . . an idyllic *type*,"[22] which for him made the hills appear to be the perfect backdrop for human activity. James especially responded to their silence in the absence of human settlements, their "strange conscious hush" that suggested a lack; these hills of charm and mystery seemed lonely and simply begged for human intimacy. The quietude, small scale, and delicacy of the forms made the scenery "feminine from head to foot, in expression, tone and touch, mistress throughout of the feminine attitude and effect."[23] Dewing responded to New Hampshire in a similar fashion, for in his landscapes Cornish comes to life as an amorphous world seen at twilight through a watery blue-green atmosphere. Dewing's paradisiacal

landscapes, eroticized with the presences of alluring women, pose visual analogues, in fact, to James' feminization of the local topography.

The type of private experience that provoked Dewing to project his desires onto the landscape is epitomized in his painting *The Hermit Thrush* of c. 1890–1892 (pl. 6; fig. 4.6). Two women have wandered into a dusky meadow and stopped, suddenly riveted by the liquid and reedy notes of the elusive thrush that is unseen. Wearing evening gowns that expose expanses of slender limbs and back, the one at the left has sat down to concentrate on the bird's song while the other, standing, lifts her head and is lost in this serene interlude. Cushioned in the tall grass that billows up around them in waves of color, their finely drawn forms contrast and yet blend with the color and the shape-shifting of nature. The aqueous pigment has been rubbed into the canvas, so that it moves effortlessly from hues of green to blue, mauve, and yellow across the coarsely woven surface. As in other Dewing paintings of this type, the earth seems released from the

FIG. 4.6. *Thomas Dewing, The Hermit Thrush, c. 1890–1892. National Museum of American Art, Smithsonian Institution, gift of John Gellatly.*

weight of gravity so that it floats up around the women, merging with the atmosphere. Above and beyond them stands a weirdly shaped, windswept white pine that hides the hermit thrush in its long boughs. The loping, rhythmic contours of the tree synaesthetically mimic the elaborate trills in the cadenza of the bird's song, and the bold, abstracted form of the tree rivets the viewer's gaze, just as the women are captivated by the music. Dewing thus evokes the quintessential moment at Cornish when, in the simultaneous apprehension of sight and sound, consciousness is expanded, time seems to stop, and one is lifted above the quotidian to the higher plane of experience.

Such quasi-religious, therapeutic rituals were regularly sought out by Dewing's colleagues. If the house was not close enough to the woods to hear the thrush, the artists would leave work in their studios to go to the woods to hear the bird.[24] The reticence of the hermit thrush kept it hidden from human sight. At distances greater than seventy feet, however, the nuances of its song, the undertones, overtones, and pianissimo effects would be lost.[25] Contemporary naturalists rated the song of the thrush as one of the most serene and beautiful sounds to be heard in the wild. To John Burroughs, for example, it suggested "a serene religious beatitude as no other sound in nature does . . . the voice of that calm, sweet solemnity one attains to in his best moments." In fact, the bird's song inspired emotions that "belong to a higher order" and emanate "from our deepest sense of the beauty and the harmony of the world."[26] In essence, the literary testimonials to the thrush's music reveal how late nineteenth-century Americans in the Northeast narrated their agnostic understanding of nature: the natural world was imbued with their own spiritual longings and regarded as a work of art, as an exerciser and a "playground of the soul."[27] The thrush in Dewing's nature drama functions as a locus of his own religious impulses.

To say that Darwin's studies diminishing humankind's difference from the animal species were disturbing to Dewing's milieu would be an understatement. But those studies coupled with Spencer's positivist declaration that any unseen higher order could be spoken of only as an Unknown, an eternal uncertainty, effected a crisis of faith among Dewing's generation, who as adolescents had witnessed the fervent, evangelical pietism of the Civil Wars years. Now the reverberations of soulfulness provoked in the aesthetic response to nature or to the art object were received as prized confirmations of the spiritual grace of humankind and as evidence of a clear differentiation of civilized men and women from the lower orders.[28]

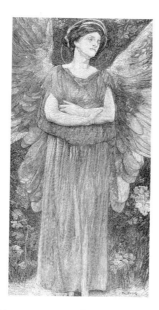

FIG. 4.7. *Robert Hoskin, engraving after Dewing's* The Angel of Sleep, *c. 1886. From Sylvester R. Koehler,* American Art *(1886).*

AGNOSTICISM AND THE MODERN WORK OF ART

At several points critics responded to Dewing's work as attempts to promote mysticism in the form of the aestheticism. In 1886 Sylvester Koehler, editor of the short-lived *American Art Review* (1879–1881) and an art critic resident in Boston, called for an American painting that would represent the experience of modern life, the pervasive constituents of which were doubt and complexity, he stated.[29] Among the few expressions of this peculiarly modern mood, Koehler singled out Dewing's recent *Angel of Sleep* (1885; fig. 4.7), a figure derived from the melancholy angels of Burne-Jones.[30] With arms clasping its body and its eyes half-closed and turned upward, the angel expressed "modern sadness, strongly tinged with mysticism." This state, according to Koehler, was born of "despair,—the consequence of a lost hold upon the supports of the past before new supports have been found in the present." While Dewing had succeeded in delineating a state of suprahuman weariness, a yearning for release from the modern human dilemma (in the form of sleep that is death), Koehler found his method highly curious. Instead of playing on the idea of emotional weightedness that comes with such despair, or exploiting ponderous or heavily shadowed forms, the artist presented "a dreamlike vision" of opalescent color that threw "an aesthetic charm, even over grief and

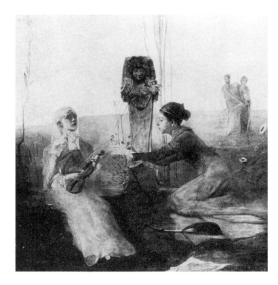

FIG. 4.8. *Thomas Dewing,* The Song, *1878 (location unknown). From Ezra Tharp, "The Art of Thomas W. Dewing,"* Art and Progress 5 *(March 1914): 160.*

exhaustion."[31] Dewing's method implicitly encouraged the viewer to seize the best this life has to offer, to substitute delight in artifice and beauty as a consolation for the lack of certainty, if we are doomed to suffer the modern fate of not knowing ultimate metaphysical truths.

Dewing's tendency to substitute art for religion emerged very early in his work. Born and raised in Boston,[32] he harbored a very serious bent of mind even as an adolescent. A sketchbook dating from the early 1860s, for example, finds him not only sketching from the panorama of life around him, but also copying plates such as *Death's Door* from Blake's engraved folio *The Grave.*[33] A continuing fascination with the supernatural is evidenced in Dewing's Parisian academic exercises (1877–1878) representing figures engaged in sorcery. Back in the States he continued this trajectory in a late medieval fantasy with two nunlike figures, called *The Song* (1878; fig. 4.8), in which he connected the rituals of music making with the rituals of religion. A violinist with a Boston orchestra in his youth, Dewing gave the priestess on the left a violin as the accompaniment to her song in homage to some pagan god. The second priestess has temporarily abandoned her lute in order to arrange a vernal branch before the archaic hermlike altar.

Ten years later, Dewing made his sole foray into biblical subject matter with *Tobias and the Angel* (1886–1887), just after he set up a summer studio

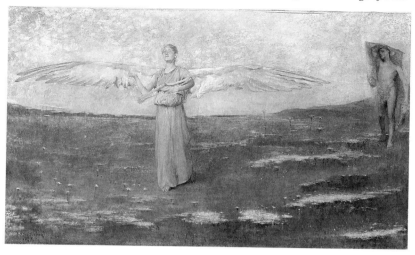

FIG. 4.9. *Thomas Dewing,* Tobias and the Angel (Tobit's Walk with the Angel), *1887. The Metropolitan Museum of Art, New York, Gift of Edward D. Adams, 1919.*

at Cornish. That Dewing was not very familiar with the biblical source, however, is indicated from the original title, *Tobit's Walk with the Angel* (fig. 4.9), which incorrectly identified the protagonist of the story as the father, Tobit, instead of the son, Tobias.[34] What seems to have occupied him more was the relationship between the figures: the weightlessness of the heavenly figure, brilliantly lighted and buoyant in the attenuated horizontal of the wingspread that floats the figure above the earth; in contrast to the shadowed and bodily introverted human figure, condemned to wander in quest of meaning for the signs given him, which only this supernatural being can decipher. As discerned by one contemporary critic, the "spiritual longing" for the supernatural enlightenment with which Dewing invested the human figure relates it to *The Angel of Sleep*.[35]

The closest any other American artist came to Dewing's expression of agnostic angst at this particular moment was Elihu Vedder. Paralleling Dewing's admiration for Burne-Jones in the 1880s, Vedder was drawn to the implicit agnosticism of English aesthetes such as Frederic Leighton and George Watts. Vedder's *The Sorrowing Soul between Doubt and Faith* (c. 1887–1899; fig. 4.10), like Dewing's *Angel of Sleep*, presents an example of what Robert Goldwater has termed *Gedankenmalerei* (thought painting), a form of painting that is allied to symbolism. Essentially these works are allegories in which meaning is conveyed in a more naturalistic or represen-

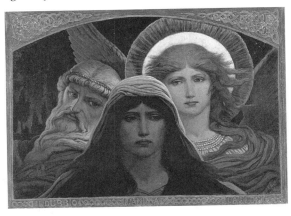

FIG. 4.10. *Elihu Vedder,* The Sorrowing Soul between Doubt and Faith, *c. 1887–1899. The Baltimore Museum of Art, Gift of Mme. A. W. L. Tjarda van Starkenborgh-Stachouwer.*

tational manner, as opposed to the abstracted, antipositivistic idiom of the symbolists, who have thrown off the materialism of naturalism.[36] Yet, in contrast to the affirmations of orthodox Christianity being turned out in this period by American painters such as Carl Gutherz and Mary Macomber,[37] Vedder, like Dewing, will not admit of resolution to the modern dilemma of doubt and faith.

That this quandary struck a mainstream nerve with the Anglo-American elite is suggested by the huge success in Boston of Vedder's illustrated edition of Edward FitzGerald's *Rubáiyát of Omar Khayyhám,* published in 1884. A rather solemn exhibition of the drawings for the *Rubáiyát* along with sixteen related oils, such as the *Soul between Doubt and Faith,* in Boston in 1887 demonstrated Vedder's unitary obsession with the same agnostic questions, an obsession that would continue to direct the themes of his later works, such as the *Soul in Bondage* (1891; Brooklyn Museum), as well as his religious explorations of Buddhism and theosophy.[38]

Yet the expression of modern doubt Koehler called for was still to come in Dewing's landscapes. In 1886 Koehler warned American artists away from old mythologies that the modern psyche could no longer support, and Dewing's personal response to the critic (with whom he was corresponding at that moment) was to construct new mythologies inspired by the aestheticism of his life at Cornish, as well as by the agnostic verses of Dante Gabriel Rossetti and Algernon Swinburne. In order to render intellectual ambiguity and melancholy in the terms of contemporary life, Koehler recom-

mended the shadowed world of tonal painting, or *Stimmungs-Maler*[39] as he
called it, and this was the mode taken up by Dewing at Cornish in the first
years of the 1890s. In paintings such as *The Hermit Thrush* and *After Sunset*
(1892, originally called *Summer Evening;* fig. 4.11), the religious anxieties
of *Tobias and the Angel* were now translated into more secular terms.

Commissioned by the Detroit industrialist Charles Lang Freer, *After
Sunset* draws on Rossetti's sonnet "The One Hope," from his sonnet cycle
The House of Life, and was meant to recall Swinburne's poetry as well, as the
poppies—which were originally planned to appear there—and the lilies—
which actually did—would suggest.[40] The last sonnet in what Rossetti had
termed his "complete dramatis personae of the soul,"[41] "The One Hope"
poses the question most troublesome to agnostics: what can the individual
soul expect to encounter beyond this world after death? Rossetti's poem
revolves around the conceit of a search in the landscape for some certainty,
some vital essence that connects humanity to the eternal life of the uni-

FIG. 4.11. *Thomas Dewing,* After Sunset (Summer Evening), *1892. Freer Gallery
of Art, Smithsonian Institution.*

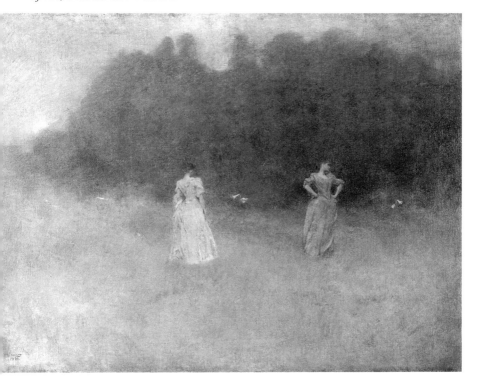

verse. In the vast unknown of nature the soul waits for a sign that the one reassuring word will be found there, "only the one Hope's one name," the name of the beloved.

Rossetti's conflation of the transcendent experiences of love and art into a personal religion is reiterated by Swinburne in his regard for poetry as the only salvation left to modern man.[42] Swinburne's "On the Cliffs" typically evokes the poet's twilight contemplation of a wild green landscape to the accompaniment of bird's song or the music of a female goddess. For Swinburne, the figure of Sappho mediates between the immortality of song and the domain of mortal love, and at the same time he equates spiritual and physical love with aesthetic experience. The woman's song ("Song's priestess, mad with joy and pain of love") and the bird's song ("Love's priestess, mad with pain and joy of song") for the poet merge at the climactic, transcendent moment.[43]

Undoubtedly, Swinburne's musical and expansive use of language must have pleased Dewing since he also aspired to an open, semi-abstract syntax built on Whistler's musical idiom. Moreover, in paintings such as *Tobias,* Dewing had also pursued a landscape type that would serve as a stage set for the drama of human longing, and this concern finally culminated in the landscapes with female figures—a type of "soul-refuge," as Sarah Burns has termed it—that he produced in the early 1890s.[44] *After Sunset,* like *The Hermit Thrush,* locates the transcendental moment in the apprehension of nature's mysterious disembodied voice. Two women search through the half-light of dusk for signs of some other spiritual presence, quietly stopping and tilting their heads as they listen. That they have found or will find the reassurance they seek is signaled in the white lilies that appear to the right and center of the composition. This literal symbolism is superfluous, however, in the presence of the larger oceanic world they inhabit, since the formal unification of the painterly surface metaphorically links the natural and spiritual worlds.

Engaged in a natural setting as mysterious as it is soothing, the women of *After Sunset* are positioned to receive the sustenance that the boundless energies of nature can provide. In Dewing's version of the oceanic experience, unity is achieved between woman and nature at the moment of reception: as they hear nature's unseen voice, the female figures simultaneously open at their bases to blend with the ground around them. As a religious encounter, the psychological dynamic of the "oceanic feeling" has been regarded by Freud and his later twentieth-century followers essentially as the regressive movement of an adult back to the state of awestruck dependency the child feels for the mother while

nursing at her breast. In later life such an experience could be evoked by aesthetic structures—for example, an architectural edifice such as a church.[45]

Posing these women as models for the viewer, Dewing evolved an oceanic landscape form that functions like Richard Wagner's "theatre of the psyche," as Carl Schorske has described it: a musical nature drama that in its cathartic and purgatory emotional effects affords regenerative psychotherapeutic benefits for the viewer/listener. Indeed, this is exactly what drew late nineteenth-century Americans to Wagner, Dewing included, when he and his wife Maria visited Bayreuth after the death of an infant son in 1883.[46] During the last quarter of the century a cult of Wagner flourished in New York and Boston, encouraged by an avalanche of articles in literary periodicals and all-Wagner performances in New York's Central Park, as well in Chicago, Cincinnati, Pittsburgh, and San Francisco in 1882–1883. The arrival in New York of Anton Seidl, who had been Wagner's assistant at Bayreuth and in 1885 assumed the post of resident conductor of German opera at the Metropolitan Opera, further facilitated Wagner's domination of elite musical taste among northeastern intellectuals and artists.

For this younger generation Wagner's music defined the progressive, modern sensibility with which they wished to identify themselves. At the historic moment when Spencer's evolution framed the evaluation of the arts and music according to a work's place on a scale from "lower," simpler aesthetic forms to "higher," more complex forms, Wagner's opera rated as a "sacred drama." To be moved by Wagner, then, was to manifest another form of cultural capital. It was to display one's civilized taste, as the remarks of the critic Charles Dudley Warner suggest when he typically wrote that to hear "Parsifal" was to be "moved to the depths of . . . [one's] better nature." By the end of the 1880s all of fashionable Boston, including the collector Mrs. Jack Gardner and the young Bernard Berenson, were making the pilgrimage to Wagner's home to hear his works.[47]

While the taste for Wagner's music emerged as a new form of cultural capital for northeasterners, the therapeutic benefit this audience found in the oceanic feeling the music engendered provides insight into the manner in which cultural productions were enmeshed in the discourse of the civilization and the overcivilization of Anglo-Americans—that is, in the condition called neurasthenia. The experience of the "pure" work of art, which was formally analogous to musical form, could be undertaken as a therapeutic practice. Through providing a conduit from the unconscious mind to the greater spiritual unconscious of nature, the abstracted, musical work of art was valued by the elite establishment for its ability to reinstate

a feeling of wholeness and energy in the individual depleted by the frenetic pace of modern life.

Such a therapeutic engagement with the pure work of art recapitulated the more explicit psychotherapeutic practice of mind cure. Depending on the "husbanding of resources," mind cure was one of a host of new therapies intended to interrupt the neurasthenic cycle of depletion and breakdown of body and mind that Philadelphia physician George Beard had theorized as an overactive response of the nerve system to the accelerated rhythms of the urban environment. Combining Spencer's concept of universal force with von Helmholst's theories of electricity, Beard came up with the idea of nerve force, an intangible energy that was conducted like electrical current through the body.[48] Aimed at alleviating the anxieties of Beard's neurasthenics, mind cure understood the replenishment of human nerve force by natural energy as a meeting of two realms, the natural and the spiritual.

Psychic renewal in mind-cure practice, then, involved opening the mind to the reservoir of cosmic energy, through meditating on a pleasant thought or an image of inflow.[49] It is no strange coincidence that Dewing's aqueous blue-greens, smudged and bled into one another, present this late nineteenth-century sense of nature as an all-source and an all-harmony. The subtle flow of blue-green ether that composes Dewing's oceanic surface resonates with the spiritualist language of mind cure, and especially the idea of a reservoir of spiritual force that courses through nature, an image that borrowed its currency from Emerson's writings and from

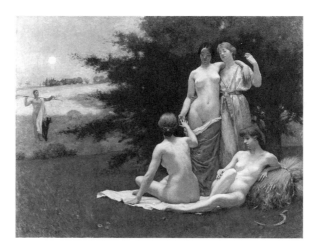

FIG. 4.12. *Kenyon Cox, An Eclogue, 1890. National Museum of American Art, Smithsonian Institution, Gift of Allyn Cox.*

Spencer's evolutionary theory.[50] For romantics such as Emerson, to whom the Dewings were devoted, the oceanic experience reunited the individual self with the world, subject and object. In terms of Dewing's late nineteenth-century perspective, Emerson's watery image of nature is apprehended through the Spencerian discourse as a landscape of panpsychic force.[51] The formlessness of Dewing's nature, which is thrown into relief in contrast to the finely drawn forms of the women, surrounds them with an oceanic environment of nuanced colors and soft textures, a painted psychotherapeutic music of the most rarefied sort. The landscape thus exists in Dewing's vision only to minister to the fragile human presence.

The paradox of Dewing's response to nature was that it affirmed the existence of some kind of spiritual force in the cosmos at the same time that the melancholy mood established in the low tonalities of the scene questioned that existence, in accordance with Koehler's sense of the *Stimmungs-Maler*. Twilight might have been necessary to the mysterious moment of the unseen, but it also implicitly suggested the atmosphere of modern doubt—the inability to verify empirically truths that might be read more clearly and affirmatively in the full light of day. It is significant that Dewing and his colleagues at Cornish—Kenyon Cox, for example—consistently chose summer as the setting for utopian ritual. Intuitively, they gravitated to the season that could sustain the rhetoric of vitalism, rather than face the uncertainties opened up by the spectacle of waning life in autumn and winter (see figs. 4.12 and 4.13).[52]

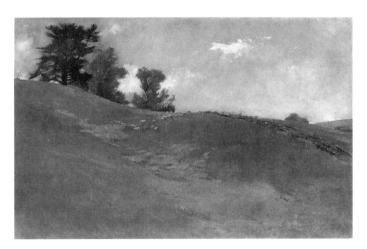

FIG. 4.13. *John White Alexander*, Cornish Landscape, *c. 1890. National Museum of American Art, Smithsonian Institution, Museum Purchase.*

THERAPEUTIC STRUCTURES OF NATURE AND ART

Whether art is more informed by life than life is by art in Dewing's landscapes is open to question. The rhetoric of a painting such as *After Sunset* has to do with the experience of a transcendent moment in nature, but nature and culture equally seem to inform the experience. The extent to which the painting portrays a ritualized moment is evident in the theatricalization of the scene—in the evening costumes and poses of the figures. As focal points of the composition, the graceful female presences relegate the rest of nature into a generalized blur around them. Dewing seems to promote the romantic convention pictured in Rossetti's *Veronica Veronese* (1872; Delaware Art Museum), in which inspiration for the work of art is thought to issue from a divine source, the ideal sphere of the imagination, and is then mediated by nature, as it is translated here into bird's song. Despite the amount of sheer footage given to nature, Dewing's late romantic vision, however, is as anthropocentric as Rossetti's and in its self-consciousness and stylization strikes at the very least a balance between abstraction and naturalism—the powers of art and nature.

The mythic episodes of life at Cornish in the 1890s that Frances Grimes later illustrated elucidate the way in which life there was structured by art. Grimes recalled a summer afternoon at Aspet, the home and studio of Augustus Saint-Gaudens, when she and Louis Saint-Gaudens sat by a fountain in a garden

> facing a little gold Pan. The trickle of water was pleasant for the sun was hot on the landscape and the shade of the white birches which spread over the seat was agreeable. The white-throated sparrows threaded the air with their long sweet notes and Louis talked on, loving the heat and the sunshine, unconscious of the hours that were passing.[53]

Though this incident seems uneventful, almost to the point of being nondescript, for Grimes these minutes assumed the dimensions of a small epiphany. At another point in her memoirs, Grimes recalled that lunch was usually eaten at Saint-Gaudens's studio "with our eyes on the landscape and the songs of the birds and the sighing of pine boughs in our ears."[54]

If Grimes here seems to recapitulate the ritual of Dewing's landscapes, both Dewing's and Grimes's narratives of these quotidian episodes reconstruct the poetic trope fashioned by Pater as he evoked the daily life of Giorgione's Venice. Thinking of the *Fête Champêtre* in the Louvre (then

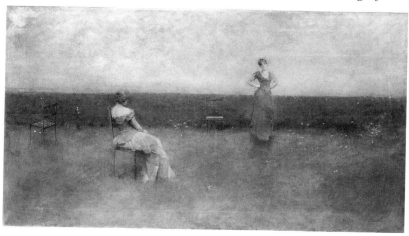

FIG. 4.14. *Thomas Dewing,* The Recitation, *1891. The Detroit Institute of Arts, Purchase, the Picture Fund.*

attributed to Giorgione and now given to Titian), Pater had celebrated such pastorals for the manner in which "life itself is conceived as a sort of listening—listening to music, to the reading of Bandello's novels, to the sound of water, to time as it flies." In "the musical intervals in our existence," in periods when we are artfully at leisure, he proposed, we become our best selves, and life attains the perfection of art.[55]

The sense of life ritualized into art in Dewing's landscapes is underscored by their theatricality, with his female figures dressed in evening gowns, as if for a night at the theater. Often, as in *The Hermit Thrush* (fig. 4.6), they act as an audience attending a performance given by nature. Posed in a shallow stagelike setting, or at other times singing or reciting (fig. 4.14), they resemble costumed actresses presented for the viewer's pleasure. The performance of dance too occurred to Dewing as a visual embodiment of musicality (*Summer*, 1890; Yale Gallery of Art), and so a series of female figures were translated into the equivalent of musical notes, linked in a rococo chain of arabesque movements, their arms spreading laterally against the staccato chords of birch trees in the background.[56] In New York, where Dewing lived during the eight months of the year when he wasn't in Cornish, he and Stanford White together were avid theatergoers, taking in both popular shows at Barnum's and at the opera.[57] While Dewing had already experienced Wagner's *gesamtkunstwerk* (the complete work of art) at Bayreuth, the predominance of Wagner's operas at the Metropolitan Opera in New York during the late 1880s and 1890s must have also

underwritten Dewing's interest in synthesizing the forms of painting, music, and drama into a psychotherapeutic landscape, a preoccupation that is recorded in the panaesthesia of paintings such as *The Hermit Thrush*.

Perhaps predictably, Dewing's models for achieving a quietist and ultimately therapeutic relationship with nature were women. Since the feminine was intricately bound up with the properties of the affective and the natural spheres in nineteenth-century America, woman provided the logical exemplar of how ego boundaries might be relinquished to allow the drifting in, and merging with, the flow of natural energy. Nineteenth-century masculine identity was, meanwhile, invested in the faculties of reason and will, which demanded to be actively impressed upon feminine nature in order to generate culture. This essentialist view of feminine and masculine modes is in the late twentieth century most often judged to be a part of the ideological apparatus that produces cultural practices in which females are trained to assume passive, cooperative, and dependent identities, in contrast to the masculine formation of more highly individuated definitions of self. In the nineteenth century, however, biology and culture were confused and conflated, since these social constructions of gender were regarded as biologically encoded characteristics.[58]

Though the nurturing and eroticized female figure had an obvious allure for Dewing's male patrons, both elite American and European men at the turn of the century have been noted to have registered anxiety at the loss of the autonomy and the degree of dependence necessitated in the merging with the feminine in either oceanic experience of the sexual or religious type.[59] That the masculine viewer of Dewing's feminized landscape might have felt conflicted and ambivalent about engulfment in the eroticized arena of Dewing's landscape is suggested in the critical rebuke he received in the early 1890s from Charles de Kay for displaying "too pronounced a feminine element."[60] Dewing's female figures, however, do not reflect the actuality of any given woman; rather, the feminine, in terms of Dewing's women and his vision of nature, are constructions, and as such they are impressed with the painter's own sexual longing.

Both the centering of the composition on the female figures and the portrayal of nature through the affective, coloristic mode associated with the feminine in this period suggest the way in which Dewing, Henry James, and others of their generation approached woman as a veiled mystery and the New England landscape as a mysterious, nurturing presence, a "great mother."[61] Just as nature absorbs the female figures in these landscapes, the surfaces of Dewing's canvases absorb the viewer intuitively in subtle changes of hue and intensity that mimic the mysterious nature-music appre-

hended by the women in the landscapes. Foremost in Dewing's mind in the years 1890–1893 was Whistler's musicality—his simplification, transparent and flowing color washes, and system of tonal harmony—as Dewing worked out the painterly expression of eroticized spiritual and aesthetic experience.[62] His new patron, Charles Lang Freer, who had returned from a visit to Whistler in London in 1890, encouraged Dewing to move further away from the oily, enamel-like surfaces and finely woven canvases of his previous work toward the powdery textures and veiled, nuanced forms resembling the pastel drawings he was executing at this time.[63] In *The Hermit Thrush*, for example, there is no longer any movement from stroke to stroke, but rather aqueous color is rubbed in and out to stain the canvas (primed white), giving the impression of an atmosphere that envelopes the human presences within the picture space, while it absorbs the viewer without into a similar musical relationship.

In improvising a musical idiom, Dewing looked not only to Whistler but also to the delicate surfaces and graceful movement of the Tanagra figurine with its fugitive bits of color still barely clinging to the surface, and to the landscapes of Corot, which were situated somewhere between the pastoral present and an idyllic past. Similarly, the flattened, pastel-colored arcadias that Pierre Puvis de Chavannes was painting on the walls of the Boston Public Library at this time have certain formal and thematic resonances in Dewing's Cornish landscapes. Another formal influence in Dewing's development of a semi-abstract idiom must be located in the Muromachi ink paintings that had begun flooding into the country in great numbers two decades earlier, in addition to Japanese prints that Freer had begun to collect in 1892. Muromachi landscapes, including masterpieces by Sesshu and Shubun, were also available for study in the Fenollosa-Weld Collection at the Museum of Fine Arts in Boston, a city in which the Dewings had social and familial ties.[64]

Dewing's landscapes from the early 1890s, some of which measure as large as 3.5 by 4.5 feet, were themselves intended as mural decorations that would extend over a generous portion of the wall. Confronting the viewer with such a large expanse of wall space enhanced an imaginative submersion in the seductive, feminized surface of shifting blue-green—a slow wafting of color across the canvas that was intended "to produce a rhythm of emotion," as Dewing's colleague Dwight Tryon said of his own landscape murals.[65]

Dewing and Tryon had the opportunity to transform an entire wall into a rising and falling wave of emotion when they together executed a triptych of decorative panels (fig. 4.15) for Freer's business partner, Frank J.

FIG. 4.15. *Thomas Dewing & Dwight W. Tryon, The Seasons Triptych, 1893. Tryon, Spring and Autumn panels, left and right; Dewing, Summer, center. The Detroit Institute of Arts, Gift of Frank J. Hecker .*

Hecker, in 1893.[66] Moving from spring to autumn across the wall, the color harmonies of ochres and greens culminated in the saturated viridian of Dewing's *Summer* in the center, which corresponded to the deepest emotions sounded in the human song of that work. Winter was omitted from the ensemble, because Tryon disdained the suggestion of decaying life almost as much as Dewing did.[67] Dewing's panel more overtly than ever conflates his regenerative experience of nature with his desire for the centralized feminine object. Bringing to mind Swinburne's image of "Song's priestess, mad with joy and pain of love," the woman on the left is overcome with the beauty of nature and so, raising her arms above her head, is moved to sing. In her psychic union with nature in which she seems to respond to a panpsychic force generated by the moon, this actress is directed by the painter to reenact his own longing for a moment of enthrallment. The waves of harmonious blue-green engulfing the women express the rapture of this oceanic moment.

MARIA OAKEY DEWING AND THE THERAPEUTIC ENVIRONMENT

The therapeutic propensity of color harmony was laid out in detail in the books written by Maria Dewing, Dewing's wife, who was esteemed as an authority on color and decoration by her husband. Her theory of color had been supplied by John La Farge, with whom she studied at Newport in the early 1870s, while her philosophy of life and art was assimilated from the Transcendentalists, to whom she had personal entrée. Through her mother Maria Dewing was related to Cyrus Bartol, one of the youngest of the Transcendentalists, and was very close to the Bartols' daughter, Elizabeth Howard Bartol, with whom she studied at Hunt's and for whom she later named her only child. That Maria Dewing had closely studied Emerson's and Thoreau's essays is indicated in the way she loosely paraphrased their writings at several points in her treatise on aestheticism in the domestic sphere, *Beauty in the Household* (1882).[68]

For Maria Dewing, the use of complementary colors popularized by Chevreul's theory in this period was "false" and extremely undesirable in art, for it produced only "a screeching contrast that is painful to the eye." Though "contrast is as important as harmony," she maintained, "[it] . . . must be used more sparingly" since "harmony of color depends more on repetition than on contrast," as nature had revealed.[69] Rejecting the Darwinian concept of struggle or opposition as the desirable lens through which nature could be viewed, Maria Dewing preferred the Spencerian

complexity of secondary, blended colors. Her prescriptions for harmonious color schemes in the home forecast the landscape decorations yet to come from her husband's palette in which cool and warm greens are smoothly graded into one another. Even the female figures in Dewing's landscapes reflect this diaphanous scheme. Blue, mauve, and rose lights mysteriously emanate from their moonlighted forms, which in their opalescent delicacy recall the flowers of La Farge. The particular inflection given to the language of color for Maria Dewing bespoke a particular state of mind, if not a particular social status. Thus, while the parvenu might prefer the brilliant sparkle of the diamond, those of truly cultivated sensibilities, like herself from old Boston families, chose the discrete beauty of opals, pearls, moonstones, turquoises, and chalcedonies.[70]

The decorative paintings Dewing and Tryon completed on the walls of Freer's Detroit residence in 1892 relate how they expected the emotional properties of color to transform an ordinary living space into a therapeutic psychic space. Dewing had already accumulated experience with decorative painting in the 1880s, when he assisted his friend Stanford White on several residential commissions. In its abstract washes of colors, however, the work for Freer's walls departed from conventional decorative painting and approached the blended waves of rarefied blue-greens and mauves that characterize Dewing's landscape backgrounds of the same period. For the reception room in which *After Sunset* was to hang, Dewing devised a scheme that resembled "an opalescent, shimmering dream of color and pattern, comparable to a peacock's breast or the wings of a butterfly," while on the ceiling of the hall, Tryon blended Antwerp blue and Van Dyke brown into Dutch metal, with the result that it had a "curiously mottled, thrush-egg effect." The idea was that the walls should be rich but quiet backgrounds for the art Freer had begun to collect.[71]

If these iridescent and mottled walls suggested the glazes of the Arts and Crafts pottery or the Asian ceramics Freer admired, this was no accident. Endemic to the aesthetic movement was a breakdown between the parameters of the fine and decorative arts, a development that Dewing and his circle promoted in practice and theory. Elaborating examples of this breakdown, the architect and brother of Maria Dewing, Alexander Oakey, described the glaze of some tiles manufactured by the Chelsea Keramic works in a manner that evokes the graduated movement of color in Whistler's "nocturnes" or Dewing's landscapes with equal precision: "a blush of a certain tone seeming to spread and deepen over the surface, . . . a thin glaze overlying a mellow molten depth."[72] Not only would the general quality of utilitarian household objects be raised to a finer level

under the influence of Greek and Japanese art, Oakey mused, but the fine arts would also appear "less as a new and delightful pastime, and more as a natural constituent part of material and intellectual life."[73] This was the ultimate rationale of aestheticism: to enrich a quotidian existence by submitting consciousness to the stylization and ritualization of art; to induce a state of inward repose through outer material beauty; in short, to obliterate the distinctions between the conditions of art and the conduct of life.

Thomas consulted Maria in making suggestions for the colors of mouldings and walls in Freer's house, and his philosophy of interior design clearly followed the general principles she had set down a decade earlier in *Beauty in the Household,* which he illustrated for her. The object of the ideal house and its furnishings, Dewing told Freer, was to establish a "cheerful" effect. According to Maria Dewing, the whole purpose of personal space was to provide a refining, nurturing environment that sequestered the psyche from the "sordid strife" of the modern urban reality, which depleted body and soul.[74] Freer's shingle-style house designed by Wilson Eyre was consummately suited to this purpose, since this architectural style was conceived for summer retreats. Freer's house was located in a residential area to the north of Detroit's business district, on a street just off the main traffic artery of Woodward Avenue. The inglenooks and alcoves in Eyre's well-shaded interiors provided the intimacy and restful mood—the sense of shelter and contemplation—Freer obviously was after. The painted decorations by Dewing and Tryon further enhanced this quietism, so that living in this house was like living inside an art object, perhaps a ceramic box, rough-hewn and unprepossessing on the exterior, but exquisitely glazed with soft, mesmerizing effects within. It was well-suited to the life of an aesthete, the state of mind into which Freer was metamorphosing at this moment.[75]

The Dewings' brand of aestheticism congenially melded with the English gospel of beauty and with Spencer's "gospel of relaxation." Both Spencer and Oscar Wilde had lectured in New York in 1882. Wilde proclaimed the secret of life to be art, and in a personal interview with Maria Dewing he praised a theater curtain she had embroidered, and encouraged her to "go into decoration & wipe them all out." Warning about the potentially disastrous effects of overwork and the need for physical relaxation and mental repose in the daily routine,[76] Spencer's remarks approached Arnold's call for more "sweetness and light," beauty and repose in everyday rituals, as well as Wilde's aestheticism. The proper use of knowledge, Wilde declared, was "to make living complete"; money in and

of itself was not important, but only "what it can do." His message must have been enormously gratifying to the Dewings and their circle, as the doctrine of self-culture elaborated in *Beauty in the Household* suggests how the idea of making "living complete" was already being embraced by the northeastern elite.

Dewing's book is actually one of a number of volumes that formed the literature of euthenics, a domestic "science" for "right living" explored by women in the 1890s and the following decades of the twentieth century in the name of social progress in the feminine sphere.[77] Maria Dewing's object was to apply the study of color and form to "technicalities of household art" and "methods of living." By elevating the practical through art, an atmosphere of "ease and beauty" would offer a nurturing space "in which the mind and heart may expand, instead of wearing themselves smaller and smaller against the friction of sordid striving."[78] She found the affective properties of color especially useful in structuring the house as an inner space remote from the Darwinian strife of the world exterior to the self. Thus, while contrast was an important element of any color scheme, as the dominant principle it was outranked by harmony—the repetition of tones—and should be minimally present. Since dead white made some nervous, she reasoned, walls should be tinted shades gentle to the eye.[79]

Landscapes used as wall decoration were also undeniably therapeutic; they promoted a "peaceful, restful influence" on family life and imaginatively placed the viewer in the "sweet, caressing breath of nature," she wrote. Furthermore, "little figures, introduced in a subordinate way [in the landscape], only seem to increase this effect" (see fig. 4.16). Maria Dewing mentioned Corot's works as models of this effect; however, the landscapes her husband created ten years later are certainly prefigured in this passage as well. Decorative panels with figures playing instruments and dancing in pastoral settings were recommended too, along with mottoes such as "Give me not riches, but repose."[80] Repose was obviously the central consideration in bedrooms, which meant that patterns should be forsworn for quiet walls and the singular, exquisite object on which the mind could rest as it drifted off. Her comments on the importance of children's rooms as formative environments also recall the centrality evolutionists such as Spencer assigned to the physical culture and education of children—the future of the Anglo-American race.[81]

The most Spencerian rationale of her treatise, however, was the repeated emphasis on the reposeful environment as an agent of the "expansion of the mind." With misguided optimism, Spencer had forecast a trajectory of

FIG. 4.16. *Thomas Dewing,* Design for a Painted Arras for Music Room: Classic Landscape and Figures. *From Mrs. T. W. Dewing,* Beauty in the Household *(1882).*

increasing intelligence with every passing generation in the history of humankind. Addressing the wider public in conclusion, Dewing heartened her (presumably feminine) reader "of moderate means" that the house beautiful was even within her reach, for with higher intelligence money became an insignificant factor. "The tendency of civilization is to make it more and more possible for people of moderate means, who will intelligently avail themselves of the advantages the times afford, to live with comfort and elegance." At the same time she exhorted women of her own class to leave mundane chores to servants while they cultivated the "really important things of life," in other words, providing their husbands and children with "an atmosphere of peace and beauty" that would enhance the "expansion of the mind."[82]

These commentaries speak to the belief in the aesthetic as a psychotherapeutic agency, and specifically to a concern with the affective properties of color and landscape that could induce desired states of repose and reverie. Near the end of her life Maria Dewing regretted that she never painted the "groups and figures in big landscapes" she had always longed to execute.[83] Instead, they were realized by her husband. Her writing on the therapeutic effectiveness of the harmonious environment, and especially the decorative landscape, meanwhile offers an illuminating gloss on the work Thomas Dewing produced in the 1890s, and it suggests too how aestheticism in this period fostered an engagement with "progressive" programs and ideologies that catered to an upper-middle-class professional elite.

CHARLES LANG FREER AND THE THERAPEUTIC OBJECT

Dewing found the ideal patron for his therapeutic decorations in the person of Charles Lang Freer (1854–1919), whose fortune was made in manufacturing railroad cars and through investing in pharmaceutical stocks. After retiring at the age of forty-six, he spent the rest of his life forming the distinguished collections of Whistler's work and Asian art now housed in the Smithsonian Institution's Freer Gallery of Art in Washington, D.C. Before he was completely at liberty to pursue these pleasurable avocations, however, Freer weathered with great unease the storm of labor unrest in the railroad industry throughout the 1890s. He probably suffered physical and nervous collapses at least twice: once in 1879 after the Detroit, Eel River & Illinois Railroad, for which he was working as a bookkeeper, merged with the Wabash (resulting in the loss of his job as an assistant manager); and a second time in 1898–1899, when the Michigan Peninsular Car Company, of which he was the secretary-treasurer, merged with others to become the American Car & Foundry Company.

Earlier in the decade the depression of 1893 had hit Freer's company hard at a moment when it was about to expand. Production slowed, and profits shrank, as business became "damnable" all-around. Freer's car company laid off 5,000 men, most of them German or Polish immigrants, who were normally paid 19¢ a day. Still hovering in the air was the spectre of the three-day riot of 1891 instigated by streetcar workers in the cause of a ten-hour day. The depression and lay-offs thus undoubtedly engendered considerable trepidation in the management. Freer's own fear of and contempt for immigrant laborers surfaced in the callous attitude he displayed toward the on-the-job death of one of his workers. Perhaps defensively Freer termed this man a "Polander of the lowest type," who with his family "lived more like brutes than human beings."[84] Faced with this disastrous turn of events in 1893, Detroit's liberal mayor, Hazen Pingree, chastised the directors of Freer's company for paying laborers "barely enough to keep body and soul together" and moreover for abandoning these several thousand men to the "charity of the community." His attempts to make the Michigan Peninsular Car Company more responsible to the welfare of the destitute city through paying municipal taxes on local property, however, were ultimately defeated by the political power wielded by the Republican managers and allies of the company.[85]

Of Dutch and French Huguenot ancestry, Freer emerged from humble origins in New Paltz, New York, to become an industrialist who gradually gave over his entire energies and focus to collecting art. His intense

identification with the refinement he valued in the art objects he purchased served his claim to membership in the elite—the elect few who lived, as he did, for the "higher things." Freer's growing involvement with art of a specific, abstract order, however, was more than simply a means of attaining social status or of displaying his wealth: it also conforms to the pattern displayed by late nineteenth-century agnostics in the Northeast, in which the aesthetic realm became the nexus of a viable religious belief. For example, Whistler's fatal illness in 1902, during which Freer had attended to the artist, prompted the industrialist to ponder the essence of earthly existence. To his business partner Frank Hecker in Detroit he wrote, "The world is a curious shell, and I wonder of what is the real kernal [sic]?"[86]

If Freer found no answer to this question, he did locate in art and nature the twin sources of personal renewal, a therapy that was simultaneously spiritual and physical. Aestheticism comprised one bond between Freer and Dewing, but the preoccupation with retreat to the New England countryside also cemented their friendship. Dewing kept a room in his Cornish house he called "Freer's room," and he constantly entreated Freer to come and enjoy the slower, more leisurely life there. In turn, Freer, after roaming the Catskills as a young man, later built rustic hideaways at Sheffield, Massachusetts, and Great Barrington, Vermont.[87] The aestheticism he practiced in private in the quiet interiors of his Detroit home found him meditatively exploring the art object for its revelation of "mystery." To get this effect, he would move a painting such as Dewing's *The Piano* (1891; Freer Gallery of Art) around the rooms of the house until he found exactly the right light conditions. He followed much the same routine with Tryon's *Daybreak, May* (1897–1898; Freer Gallery of Art) several years later until the effect he sought emerged, and he could appreciate "its marvelous interpretation of the mystery accompanying day-break during the spring days."[88] At the point at which he could apprehend the picture's effects of beauty and weirdness, the picture came into sight as perfectly realized.

Freer relished the "exercise of spiritual influences" in abstruse forms of Chinese and Japanese art, or the "unceasing mystery" in Whistler's "nocturnes."[89] For Freer, the display of phenomena that was beyond language and rational explanation, that which refused understanding in logical, physical terms and remained impenetrably bound in silence, possessed the greatest allure. Thus the suggestion of mystery in nature seemed to confirm the reality of a higher realm in the cosmos, just as the strange and inexpressible beauty of the art object verified the existence of soul in the maker and in the viewer who could recognize such beauty.

Freer's attachment to mystery in art figures as the principal expression

of his search for an affirmation of the spiritual. The course of his investigations began in the 1890s with the occult texts of theosophy—basically a synthesis of spiritualism, Hinduism, and Buddhism with some enhanced occultism from the Egyptian cult of the dead—and rested at the conclusion in an embrace of general Buddhist tenets as they were filtered through popular spiritualist beliefs. In between these poles he schooled himself in psychology and psychic phenomena, Egyptian religion, reincarnation, yoga, and mind cure, as well as British romantic and decadent poetry.[90] That these religious explorations were directly related to Freer's responses to art was conveyed in the ruminations of a letter Freer wrote to Tryon from his isolation in a Japanese hut in 1895.

> One grows to greater intimacy, keener appreciation of the object he most loves after the memory has been toned by other impressions: shadowy recollections of unknown places, glimpses of faraway coasts and strange horizons that leave a mysterious something.

"If the Buddhistic idea is correct and I am inclined to think it is," he confided, "not one earthly existence alone is sufficient but several are required to develope [sic] an imaginative mind."[91] Later, suffering from the debilitating effects of a stroke, he made notes to himself on small scraps of paper that testify to his belief in the transformative possibilities of the art experience. "Art is properly concerned with the living of our lives," he mused, and there is "an instinctive sense that there must be some way through it to reach an understanding that redemption does exist."[92]

Long before Freer reached this moment, however, he had turned to the art object as a source of therapy that answered his intellectual and emotional needs. According to his confidante Agnes Meyer, Freer believed he was subject to a congenital disease (perhaps congenital syphilis) that might possibly become active at any time in his life. In 1893 his brother Watson was stricken with a condition of partial paralysis and nervous instability that resembled the illnesses their father and grandfather had suffered.[93] Whether or not he actually suffered from such a disease, the possibility of an early death or loss of mental faculties was never out of Freer's mind for long. The many hours of study spent in the shadowed confines of his shingle-style cottage, poring over volumes of poetry or meditating on dimly lighted paintings, were as crucial to his sense of self-nurturing and physical restoration as his annual outings in the New England countryside.[94]

Agnes Meyer remembered Freer's belief in the restorative power of the refined art object, and the image of him at the end of his life clutching

"certain pieces of jade with deep satisfaction and with an almost religious faith in its comforting and restorative powers." That such talismanic objects possessed paranormal powers seemed fundamental: according to Freer and Meyer, these superior objects required "broad spaces" in which their beauty could "expand and radiate," as if they were generating a field of energy. When designing his gallery during this period, Freer deemed the exercise of meditation on the art object to be so important that he designated as the center of his museum a courtyard space where the visitor could go to reflect on the objects just viewed.[95]

Freer's anxiety over the possibility of an impending illness, in tandem with the pressures and agitations of his business, provides the psychological framework within which his aestheticism emerged. That art and nature could serve as potential restoratives for the psyche of the Anglo-American elite worn down by the frictions of modern life has already been suggested in examining Dewing's paintings such as *The Hermit Thrush,* but this cultural practice is even more explicitly demonstrated in the form of Freer's commission to Dewing for a pair of folding screens in 1896. Like the landscape murals Dewing had already completed for Freer, the screens sensuously evoked the therapeutic domain of the natural world, only now their larger, nearly life-size scale more fully enhanced the enclosure of the viewer within a desirable environment that was simultaneously natural and aestheticized.

The formal impetuses to undertake the project might have originated either with Freer's recent experience of *rimpa* screens in Japan or with Dewing's possible viewing of Whistler's screen, *Nocturne in Blue and Silver: Screen with Old Battersea Bridge* (1872; Hunterian Gallery of Art, University of Glasgow) in London. During a recent year-long sojourn in England and France, Dewing had occupied Whistler's London studio, and Freer had just returned from a trip to India and Japan via Europe from autumn 1894 to autumn 1895. Over the following year, while Dewing was executing his pair, Freer purchased several *rimpa* screens. By January 1896 Dewing had settled on the Japanese format of the panels, bordered with gilded strip frames similar to Whistler's, and by June he was researching "the subject." Dewing originally explained the screens, now called *The Four Sylvan Sounds* (1896–1897; figs. 4.17 and 4.18), as suggesting "the four forest notes: the Hermit thrush, the sound of running water, the Woodpecker, and the wind through the pine trees."[96] Each panel displays a female figure, clad in a belted chiton, holding an instrument: the hermit thrush is suggested by a gilded flute, the woodpecker by a drum, the running water by a xylophone, and the wind by a harp. The visual idiom Dewing devised for

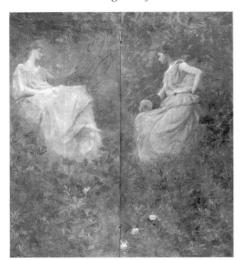

FIGS. 4.17 and 4.18. *Thomas Dewing,* The Four Sylvan Sounds (The Four Forest Notes): The Wind through the Pine Trees, the Woodpecker, the Sound of Falling Water, and the Hermit Thrush), *1896–1897. Freer Gallery of Art, Smithsonian Institution.*

the screens advances an attempt to synthesize Eastern semi-abstraction with Western figural representation. Although the plastic forms of the women are softened by a veil of atmosphere laid over their figures, their mode of representation is disjunctive with the stylized, flat piles of leaves that are stencilled in around them.

In a parallel manner, the intellectual program for the screens also embodies the synthesis of East and West so commonplace in the writings of Americans, who filtered their perceptions of Asian thought through the lens of their own romantic preconceptions. Emerson's nature poetry, particularly his poem "Woodnotes I," which presents a virtual catalogue of the sounds of the New England forests, might have served as one possible source for the imagery.[97] While Emersonian sentiments about nature were central to Dewing's ethos, such a source would not have demanded the effort he indicated was necessary to finding out "all about the subject" that he and Freer had discussed. It's more likely that Dewing and Freer were investigating a nexus of thought that was new and stimulating to them, but also a tradition that they as yet little understood—in other words, the Buddhist philosophy that Freer was continuing to probe since his trip to Japan.

To some extent Dewing's conception of the screens in terms of nature-music evoking an unseen spirit world recalls John La Farge's ruminations while in Japan in 1888 on the three great mysteries of word and thought in Shingon Buddhism: the wind whistling through the trees; the sound of the river breaking over rocks; and the movement, speech, or silence of human-kind. Wearied of Western rationalism, La Farge during the trip hoped to locate some trace of mystery and the supersensible in nature, an elixir he trusted he could find in Japan. The idea of the buddhahood of all natural forms, however, La Farge translated into a version of the romantic worship of natural divinity in a manner reminiscent of Dewing's hybridized con-cept. The connection between La Farge's and Dewing's explorations of Buddhism at this moment deserves consideration, because La Farge was personally well known to Dewing (Maria Dewing had been La Farge's student) and because Dewing had access to La Farge's thoughts on Japa-nese culture through their publication in the *Century Magazine* in 1890 and then as a book in 1897.[98]

After returning from his own trip to Japan, however, Freer was himself studying Buddhism by way of Lafcadio Hearn's books on Japan and possi-bly a "handbook" on Buddhism by Rhys Davids, the most influential scholar on the subject at that time, who had made a lecture tour of the United States in 1894–1895.[99] Earlier Freer read several volumes by Ma-dame Blavatsky and Annie Besant in investigating theosophy. After his return from Japan, his interest in esoteric beliefs deepened; he not only perused Buddhist texts but also took out subscriptions to *The Bramhamvadin* and *Far East*.[100] While a melange of literary sources from Emerson and La Farge to Buddhist texts may have held suggestions that parallel the imagery of the screens, the fundamental conceit of nature, or the art object, as offering a panacea to the viewer saturated genteel literature and popular philosophy during the last decade of the century. Freer, in fact, was quite familiar with a number of these texts by authors such as Hamilton Wright Mabie and Bliss Carman; for example, he owned nearly every volume Carman published in this literary genre of self-culture, a genre that ad-dressed Beard's concern over the depletion of nerve force in holding out the experience of art and nature as opportunities for spiritual and physical refinement.

Passages from Mabie's *Essays on Nature and Culture* (1896), which extolled the experience of solitude in nature as a "healing balm" and a "tonic for the fatigued mind," illuminate how such aesthetic objects as Freer's screens might have been read to evoke the sounds of nature, and to provide a surrogate agency of psychic repose.

In the woods the very sounds make the silence more evident and refreshing. The murmur of the pines, the song of birds, the rustle and fall of leaves, the ripple of the brook conspire to preserve the essential silence even while they seem to violate it. They are sounds so detached from the world of society, so free from all association with it, that they deepen our feeling of detachment from it; they do not interrupt and disturb; they soothe and harmonize. The quiet which reigns in the woods, so delicious to tired nerves and the spent mind, is not the repose of death, but the harmony of a fathomless life; it suggests not effort and distraction, but ease and play; it is not so much absence of sound as harmony of sound.[101]

The tropes of self-culture Mabie articulated here were those Dewing adopted in the screens and later in speaking of the woods as "the finest kind of a tonic" and a "cure."[102] The natural environment or the aestheticized environment—both imbued with harmony and quiet—could insulate the world-weary individual, in Maria Dewing's words, from the "sordid striving" of life.

Another passage from Mabie's book, describing the therapeutic music of nature, again precisely evokes the figures and the flux of Dewing's screens:

Insanity goes out of one's blood when the song of the pines is in one's ears and the rustle of leaves under one's feet. In the silence of the wood health waits like an invisible goddess, swift to divide her stores with every one who has faith enough to come to the shrine.[103]

In fact, Dewing's screens could stand as a visual gloss on Mabie's text in the way their repetitive patterns of foliage and sensation of cool, blue-greens surrounding his goddesses simulate the relaxing, hypnotic sounds of nature.

The appeal of such therapeutic nature tropes for agnostics such as Freer becomes apparent in surveying their numerous visual and literary appropriations. To take another example: reiterated, pulsating forms both in art and in the rhythmic sounds of nature also figure as transformative moments in the poetry and prose of Bliss Carman, the Canadian poet laureate whose volumes Freer pored over. Good art, Carman wrote, impressed the deeper self and engaged sense and soul through such strategies, and nature, as well as art, was equally adept at providing moments of experience that

could induce the most thoughtless to meditation and solitary self-reflection. In the fluting of the thrush, for example, the silent intervals between its "liquid notes" could entrance the listener into a serenity essential to the psychic renewal required to navigate the strife of modern life.[104] According to Agnes Meyer, Freer came to value Chinese art later in his life similarly for these reasons, because the Chinese "love of nature," which suffused Chinese art, held out a tonic "for our turbulent era in the calm [Chinese] acceptance of the world."[105]

The assertion that the habit of meditation was integral to the life of a productive individual appeared as a regular refrain in books on self-culture such as Mabie's and Carman's. Not only was the experience of quiet and calm to be found in nature or art extolled as a ritual that conditioned silent strength and deep spiritual growth, but the practice of repose was promoted too as an exercise of enormous benefit to the artist who sought to create objects of "essential and enduring values." In locating artistic prototypes of repose, Mabie directed the artist to the rhythms of Greek art, while he encouraged the artist to incorporate as well the amorphous space and asymmetry of Japanese art as epitomes of nature's ceaseless flux and process.[106] These are precisely the two traditions Dewing invoked in Freer's screens: at the center of each panel the Greek represented in the calm goddesses, surrounded by the Japanese-style, rhythmic profusion of foliage.

Ernest Fenollosa, curator of Asian art at the Museum of Fine Arts, Boston, in the 1890s and Freer's adviser after 1901, offered the rationale for such an aesthetic fusion of East and West, Asian tradition and Anglo-American tradition, in art. Rooted in Hegel's dialectical view of history and Spencer's spiral of evolutionary progress, Fenollosa's argument baldly revealed the political dimension of this aesthetic trend. East and West were destined to become one world civilization, Fenollosa reasoned as early as 1892, and the site for that new civilization was to be either Japan or the United States. Such a fusion was already taking place, as evidenced in the work of Whistler and his followers Dewing and Tryon, on whose work Freer focused his art collections.[107]

Though Fenollosa never advocated the loss of traditional Japanese identity—indeed, he was appalled by Japanese Westernization—Dewing's absorption of Eastern form into a traditional Western figural idiom is wholly in keeping with contemporary Anglo-American cultural practice. Such a fusion mirrors in aesthetic form the larger sociopolitical policies expounded and carried out by Roosevelt and the Progressives after the turn of the century: in other words, the absorption of non–Western European cultures into the dominant fabric of Anglo-American life.

In the sphere of aesthetics, then, the seemingly innocuous wedding of Eastern and Western forms practiced by Dewing and the generation of the 1890s rehearsed the American political agenda of the period preceding World War I, when the American self-identity as an elect nation would be played out on an unprecedented global scale. On a philosophical level, the rhythmic, cyclical movement of nature envisioned by Dewing consoled agnostics like Freer with the presence of a "benign power" in the world, keeping them from hope and despair, while on a more pragmatic, therapeutic level, nature could be pictured as offering health and sanity to an overworked, overrefined upper middle class alarmed at the prospect of their loss of so many old certainties all at once. Again, Carman's prescription for self-culture, that one should make a "daily contact with the elements, with elemental conditions of being—sunshine, and rain, and roads, and honest grass, and the swish of winds in the trees," invoked the familiar rhetoric assuring Anglo-Americans that their Protestant valorizations of nature and meditation could still furnish an effective "sedative and tonic in one," a cure-all for the ills of modernization.[108]

That the landscape at Cornish had acted in such a capacity for Dewing became apparent after he and Maria relinquished their retreat there for the more remote and uncultivated countryside of Green Hill, New Hampshire, in 1905. After returning to Cornish from London and Paris in 1895, they failed to find the community at Cornish as tractable as before the trip. Dewing, who had previously dominated the group, possibly was no longer able to maintain what had been a comfortable, commanding position in view of the younger, more literary professionals from Cambridge who settled there in the late 1890s and after. The fierceness of the Maine wilderness with which Dewing was now faced seemed to require a vigorous, imputedly masculine response, and as such it failed to nurture Dewing's art the way that the soft and imputedly feminine landscape of Cornish had. Although he found his new setting "beautiful" and the "finest kind of a tonic . . . a 'cure,'" the black spruces and pines of Maine were too "savage" for him to paint and "all utterly outside of . . . [his] art."[109]

Though Dewing went on with his formula for misty landscapes with tenuous female figures well into the early 1920s, these works merely document his inability to escape from a cycle of feeble self-parody, as much as they signal his investment in the Spencerian ideology of culture as the agency of human progress. In the decade after he left Cornish, however, Dewing shifted his creative investment from nature—the landscape as the site of boundless renewing energies—to the interior space, a psychic

landscape that prescribed the power of beauty in the experience of the art object or the objectified Anglo-American woman as a desirable form of self-nurturing.

SELF-CULTURE AND INTERIOR SPACE

The simplified interior scenes Dewing produced largely after the turn of the century visualize the late nineteenth-century experience of art as a transforming moment. The quasi-religious aspect of the aestheticism shared by Dewing and Freer was succinctly verbalized by Tryon when he wrote to Freer:

> I cannot imagine a higher life than the rare moments when one is attuned to a really great art work; it seems to me to contain the essence of all religions and comes the nearest to true spiritual manifestations that are known.[110]

As agnosticism spread among the northeastern elite the aesthetic object was invested with the power to offer the transcendent experience formerly considered the province of orthodox religion. Another intimate of Dewing's circle, Augustus Saint-Gaudens, read this agnostic worship of art in terms of an evolutionary trajectory to which humankind was subject beyond its will, and he ruminated on how the object of beauty represented the artist's "only offering to progress, . . . a drop added to the ocean of evolution, to the something higher that . . . we are rising slowly to."[111] In the narrative of Dewing's interior scenes, which portray a consistent and unified reality, communing with the art object held out the opportunity to transcend the psychic confines of the self and tap into reservoirs of unlimited energy. Restoring the depleted self to fullness and stability, this transaction could be effected in the act of listening to music, gazing at the rarefied object, or reading a work of literature.

A Reading of 1897 (fig. 4.19), one of the earliest of these interiors, pictures two young women seated at a polished mahogany table in a shallow space that is stripped down to its basic, architectonic aspect. The room has been emptied of all accoutrements except for a looking glass in a baroque frame and a tall Chinese-style vase of Dewing's imagining.[112] With the room deprived of all ordinary domestic properties, the resulting vacuum produces a silence that confers upon the reading of a poem the tenor of a ritual. Immured in a silent interior world, both women look

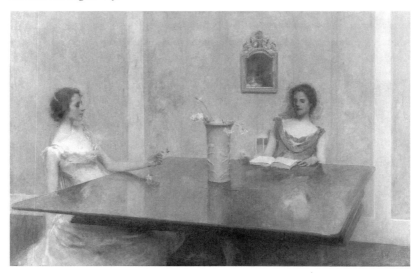

FIG. 4.19. *Thomas Dewing,* A Reading, *1897. National Museum of American Art, Smithsonian Institution, Bequest of Henry Ward Ranger through the National Academy of Design.*

FIG. 4.20. *Thomas Dewing,* The Letter, *1908. Toledo Museum of Art, Gift of Florence Scott Libbey.*

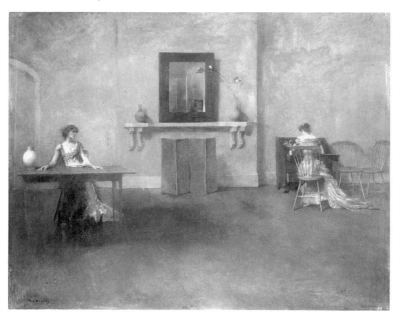

down, one intoning the words as she reads, the other listening as she contemplates the words and the fragile white flower in her hands. The contact between the two, it is hinted, occurs at an imaginative juncture that is visually signaled in the vase at the center of the composition, the point at which the axial lines extending from their bodies meet. In the weird greenish-gold atmosphere the women's faces are veiled and their bodies dematerialized into attenuated forms that bear obvious affinities to the elongated vase and its wiry, insubstantial contents.

This is not a realm that offers indulgences in sensual beauty—rather, an intellectual pleasure in art is suggested in the bodilessness of forms; thus, the highly polished surface of the table and the mirror establish this world as a reality primarily consisting of reflections. The touchstone for Dewing's compositions of this type was the dualistic reality of Whistler's *Symphony in White, No. 2: The Little White Girl* (fig. 3.4). The dematerialized image of Whistler's woman in the mirror speaks of the imaginative realm to which she has gained access through the experience of art. This theme announces the dualism of Dewing's metaphysic.[113] In several compositions in which the subject is that of reflection and the self-reflexive experience of art—the seeking of a deeper, finer self through the agency of art—Dewing evokes the state of weightless, floating serenity stimulated by meditation on the rhythmic movements of color or the musical cadences of words, thus encouraging the viewer to enter an ideal reality on the other side of the looking glass. To contemporaries, the implied dualism of such interiors might invoke spiritualist metaphors, as is made clear in a lampoon of Dewing's *The Letter* (1908) (fig. 4.20) that appeared in the *New York Times*:

More charm is seen in "The Letter," where this youngish-old person of generous lengths is seen front face and with her back turned. There is an air of spirit-rapping in this bare interior with aggressively severe mantel and the black-framed mirror which reflects an unseen door.

Off to the right the young person is writing at a desk almost offensive in its disdain of ornament. Off to the left the Double is seated behind a savagely demure table with an open book thereon, both her hands spread out to the right and left, as if she expected that table to obey. Meantime she is looking at her Other Self at the writing desk with a malignant obstinacy, which no lady ought to practice, even in her own mirror. Dim ultra-simple vases on that cruel mantelpiece contain two white flowers, which regard themselves in a ghastly way in the mirror. . . .

But one shudders to think what that sort of girl would commit to a letter, if [a] letter she is writing. The postman would need fur gloves.[114]

A mystical atmosphere in which spirit-rappers might feel at home is even more explicitly developed in *The Fortune Teller* (c. 1904–1905; pl. 7, fig. 4.21), which was purchased by Freer's friend and associate in the railroad car business, William K. Bixby of St. Louis. Here a woman, reclining into the shadows of the background, submits herself to the prescient mind of a female medium at the right. The power of her mediumship, emanating from her occult knowledge of the unseen world, is articulated through her extroverted body, which is opened out to dominate the interaction and at the same time turned inward to focus intensely on divining the meaning of the cards on the table. With her arms outspread in an undulating serpentine line, the fortune teller is posed like a radio antenna to receive the vibrating consciousness of her reticent female subject. Following the axes of their bodies, the women's arms meet in a right angle at the table's center. This axial alignment facilitates the flow of psychic force between medium and subject, thus giving visual form to the popular conception of psychic energies as electrical currents.

During the period when Dewing was engaged in these interiors, he was romantically linked to female friends such as Lucia Fairchild Fuller, a blue-blooded Bostonian and miniature painter who lived also at Cornish and in New York. In the early 1890s Fuller had been entranced with the occult and had studied palmistry.[115] Such interests had considerable currency among Boston brahmins, who were also caught up in the fashionable study of Buddhism, theosophy, mind cure, psychic research, and evolution.[116] The Back Bay's fascination with otherworldly female types—for example, the Olive Chancellors and Verena Tarrants of Henry James's Boston who claimed for womankind a privileged access to the spirit realm—directed the implied narratives of Dewing's interior scenes as well. Dewing's women, like James's, are predicated upon the nineteenth-century construction of woman as a sympathetic and intuitive being possessed of a preverbal, preternatural wisdom and understanding. In James's novels it is from this mystique of second-sightedness that woman derives her source of power over men, who, in contrast, appear as "blind" to the veiled truth of their environment.[117]

After examining spiritualist mediums for years, even Henry's brother, the psychologist and philosopher William James, subscribed to this gendered

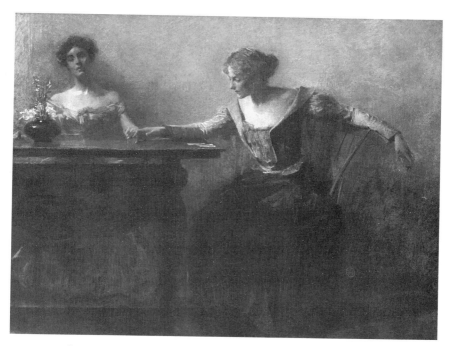

FIG. 4.21. *Thomas Dewing,* The Fortune Teller, *c. 1904–1905. Collection of Mr. and Mrs. Willard G. Clark.*

dichotomy of intelligence in his psychological studies: the intuitive mind that could reach beyond the empirical realm was characterized as "femi-nine-mystical," while its antitype, the analytical, was (presumably mascu-line) "scientific-academic."[118] After the Civil War female mediums had seized on and exaggerated the construction of femininity as bodilessness, selflessness, physical frailty, intuitiveness, ethereality, and passivity in order to lay claim to the profession by virtue of these special qualities. The result was that by the end of the century mediumship was defined almost completely as a feminine prerogative—an outgrowth of woman's special nature, whereas at the outbreak of the Civil War male mediums had been nearly equal in number to female mediums.[119] Woman's proprietary claim on this kind of occult knowledge, as well as the popularity of mediums and mind curists (whose ranks were also composed principally of women), had presented such a threat to male hegemony in professions such as medicine that the city of Philadelphia in the 1890s passed ordinances against fortune telling, and mediums found in violation of the ordinance were rounded up and jailed.[120]

It is important to understand how enmeshed Dewing's imagery of self-culture is in the discourses of spiritualism and mind cure, how his elite

social practices centering around the art object are directed toward the therapeutic goals that are explicitly laid out in the writings of aesthetes such as Bliss Carman, in which the ubiquitous metaphors of spiritualism and mind cure were commonly invoked to describe the social and religious function of the art object. For Carman, art was a manifestation of spirit that assumed a material presence in the form of beauty and it therefore deserved worship. More than this, however, the sensuous and pragmatic influence that beauty exercised over human life was paramount. Art offered an escape from the actual, from the pressures of modern life and the "lower self" of "degrading hurry." Through the experience of art might be located a serenity in the "secret chamber of the soul," a state of mind that offered protection from the agitation of the larger, outer world. In essence, Carman's philosophy offered up Pater's aestheticism, translated into the pragmatism and the jargon of mind cure: the regularized ritual of yielding to moments of pleasurable relaxation in leisure hours is posed as a means of building up "spiritual capital," so that a "fund of abiding serenity" might be stored up for spirit and body.[121]

The husbanding of bodily and spiritual resources through relaxation and cultural practice was a project promoted by early mind curists such as Prentice Mulford, who wrote of the power of beauty and repose in art to renew the mind and the therapeutic effects of aesthetic rituals.[122] The people most in need of such therapy were those especially susceptible to nervous collapse—Anglo-American "brain-workers" (white collar workers or businessmen) and young women with delicate nervous systems, according to George Beard. In this diagnosis, Beard built on Spencer's sociology in rating ethnic groups according to their nervous organization on a sliding scale from savage to the most highly civilized (i.e., Americans). The refined nervous system thus went hand-in-hand with the refined (Anglo-Saxon) physiognomy, and both were marks of a highly evolved, highly civilized individual. If beauty in women could thus signal a tendency to nervousness, such a sensitivity, Beard speculated, was also related to the popularity of "mind-reading" among American women.[123] The medical remedies prescribed for neurasthenia, such as the notorious rest cure, were based on the principle of conserving physical and mental energies, which would become the controlling principle of mind cure as well. For aesthetes such as Carman, however, as well as men and women following mind-cure regimens, regular meditational practice and relaxation in the experience of art promised replenishment of personal resources and the staving off of collapse.

In Dewing's interiors the object of contemplation offered to the viewer is the woman who performs the exemplary aesthetic ritual, and as such, she is herself aestheticized. Rather than the nymphetish showgirls Stanford White pursued, she is represented as the mature "woman of thirty" who has "looked at the sun," her mental and spiritual cultivation expressed through the attenuation of her body. The combination of intelligence, experience, and sympathy with which James endowed the women of his late novels was also attributed to Dewing's female figures by contemporary critics such as Sadakichi Hartmann, Ezra Tharp, and Charles Caffin.

The identification of the male viewer, patron or artist, with the female figure in her mysterious domestic space provided an imaginative release from, and a private resistance to, the aggressive, competitive mode of the masculine marketplace, as Carol Christ and Barbara Gelpi have suggested in their studies of high Victorian artists and poets such as Tennyson and Rossetti.[124] Approached by these male viewers as a narcissistic creature who is seemingly complete in herself and thus impels masculine longing, Dewing's woman is mystified, and this mystique in turn grants her the status of an exemplar who shows the male viewer such as Freer a higher way in the conduct of modern life, which is defined by nervousness and melancholia. She demonstrates the private rituals in the religion of art that will support agnostic belief in some eternal truths, and she shows the practice of self-culture that leads away from masculine grossness toward feminine refinement and soulfulness—toward the evolution of a higher self.

But if Dewing and his patrons valued these feminine images for their refined, "spiritual" qualities, which emanated from the subtle color schemes and elegant forms, the images were unmistakably charged as well with an erotic innuendo for elite men. Dewing's female figures were doubly constructed, mirroring the contemporary double-headed definition of masculinity in which ideal men were simultaneously civilized and virile. The internal contradiction of masculine ideology required that Anglo-American men exhibit protectiveness and self-restraint in relations with refined Anglo-American women and at the same time combat the effeminizing effects of such behavior by celebrating and acting out a "primitive" masculine sexuality in terms of aggression, strength, and violence in arenas of leisure such as athletics, hunting, riding, and mountaineering.[125]

It is to this anxiety over masculine identity as civilized and sexualized that the double lives of Dewing and his cohorts White and Saint-Gaudens speak. Throughout the late 1880s and most of the 1890s Dewing, along

with White and several other male friends, rented an apartment on West 55th Street in New York, where they entertained female acquaintances on the sly, separately or communally.[126] The fraternal members of the "Sewer Club" paying rent on the studio, known as "the Morgue," in 1888 were Dewing, White, the painter Frances Lathrop, Augustus Saint-Gaudens, Louis Saint-Gaudens, and the architect Joseph Wells. Freer, Dewing, and White together in this period also indulged in "sprees," which probably involved taking in erotic shows in New York and Paris. Freer refrained from participating in the "club," and his fear of the congenital syphilis that had supposedly stricken several male members of his family discouraged him from marrying and thus passing on the disease to a respectable middle-class woman. The same fears, however, failed to prevent him from the "casual pursuit of desire," which was conducted alone, as opposed to the group activities of the club. Freer's "numerous relationships with the opposite sex" were presumably carried on with lower-class women who did not appear to Freer as marriageable. Yet Freer claimed that the sexual experience he, White, and Dewing prized was simultaneously aesthetic, poetic, and spiritual.[127]

This taste for the conflation of the erotic with the spiritual is reflected in the way Dewing's feminized interiors allowed his ideal male patron, such as Freer, to feel both civilized and virile. The physiognomies of these female figures are marked with the signs of upper-class Anglo-American status, as suitable Back Bay courtesans for an elite. Dewing's fascination with his models, particularly with Mollie Chatfield, a sandy-haired woman who figures prominently in his works from 1896 to 1898, revolved around their slender, fine-boned physiognomies that for his milieu bespoke an intellectual presence. All he ever required in his models, he said, was that they have "brains."[128]

In the oil portrait of Chatfield (fig. 4.22) Dewing painted in a studio kept secret from all save Freer and Stanford White, she is displayed to the viewer with the bodice of her blouse and undergarments pulled down to reveal the long expanses of thin white shoulders, neck, and arms. Centered in the composition and presented as the object of contemplation, Chatfield is veiled and rendered as a pink and white mass glowing within a sea-green darkness. In pictures such as *The Spinet* (c. 1902; fig. 4.23), the back of the model is turned toward the viewer to reveal the shoulders and neck, while in still others—for example, *Girl with a Lute* (1904–1905; fig. 4.24)—a low décolletage exposes a soft white bosom to the viewer. Even more explicitly erotic are the small, subtle nudes in pastel Dewing executed for the private view of his male confreres such as Freer and White, as opposed to the

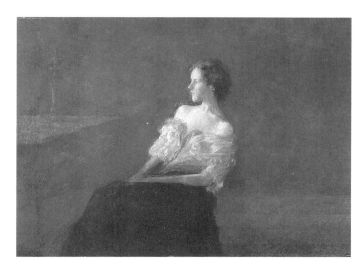

FIG. 4.22. *Thomas Dewing,* Study of a Woman Seated, *1897. Freer Gallery of Art, Smithsonian Institution.*

FIG. 4.23. *Thomas Dewing,* The Spinet, *c. 1902. National Museum of American Art, Smithsonian Institution, Gift of John Gellatly.*

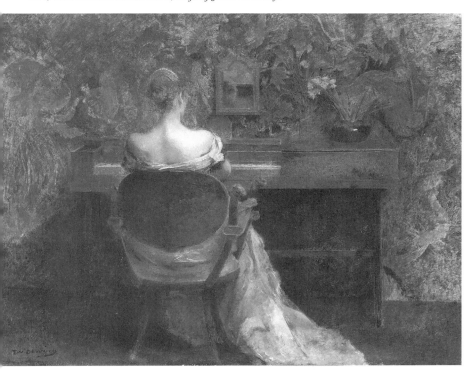

figures in interior spaces that after 1900 almost exclusively represented Dewing at public exhibitions.

In *Reclining Nude Figure of a Girl* (fig. 4.25) Dewing decontextualized the female nude from any specific historical setting. There is an implicit assumption here that in the aestheticizing process the subtle manipulation of limbs and torso will situate the figure within the universalized context of art and preclude it from the purely titillating sphere of the vulgar and pornographic gaze. Thus, the hips are tipped up to display the lower torso frontally to the viewer and the upper torso is arched back and her arms thrown up to the head to accentuate the rhythmic rising and falling of the contours in the modulated swelling of hips, rib cage, breasts, and arms. Meanwhile, the glint of light from the single bracelet she wears throws her nudity into relief, and the figure seems to stretch in enjoyment of her own body in a languorous feline manner. Though Dewing boasted that he would paint a nude for White that would be a "gaudy rose bush" and "so alluring and lithe" that White "would not be able to keep it in . . . [his] room," the nude Dewing produced for White failed to satisfy the architect's taste for more explicit representations of feminine sexuality: it was nearly impossible, White complained to Saint-Gaudens, "to tell whether it was meant for a girl or a boy."[129]

Such a response underlines the ambivalence of Dewing's circle toward the female body and female sexuality. To contemporaries, the mystery and allure of Dewing's female figures emanated from their "subtle contradictions." Reflecting the desire of the masculine viewer, male critics who wrote about them referred to their "chaste voluptuousness," meaning that the signs of sexuality were conveyed through their aestheticizing.[130] Their flesh was painted "cool over a warm undertone," which engendered a fantasy of his women as essentially "warm-blooded animals" under chilly, aristocratic exteriors.[131] With their faces veiled, often in a stippled penumbra recalling Vermeer, or at times turned away from the viewer, they offer no resistance and make their bodies available to the viewer's gaze. Their smooth expanses of exposed skin invited touch: wrote critic Ezra Tharp, "you feel the smoothness and softness of their skin, and its coolness too. You feel the just weight of the body."[132]

Yet, enclosed in self-contained, hermetic environments where they are absorbed in aesthetic experience, these women are completely indifferent to the viewer's presence. They remain psychically and emotionally unavailable. Critics who, like Charles Caffin, interpreted these figures as permeated with "passionateness" simply read their own desires into the feminine figures. These women fascinated because they were cool and warm at the

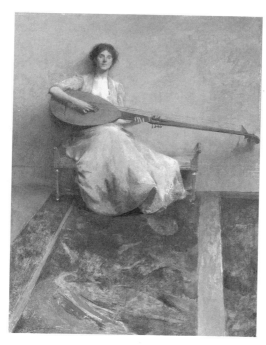

FIG. **4.24.** *Thomas Dewing, Girl with a Lute, c. 1904–1905. Freer Gallery of Art, Smithsonian Institution.*

FIG. **4.25.** *Thomas Dewing,* Reclining Nude Figure of a Girl, *n.d. Pastel on paper. National Museum of American Art, Smithsonian Institution, Gift of John Gellatly.*

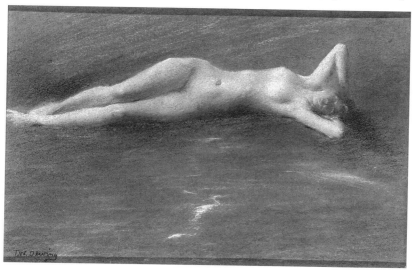

same time, inexplicably giving off contradictory signals to the viewer. Even if they were engrossed in intellectual activity, to Caffin their "habit of intellectual control . . . clarified, but not effaced, the essential passionateness." This rationalization of male desire, the redemption of the body by the mind, that was offered in Dewing's representation of the feminine responded reassuringly to the anxieties of the elite male viewer over his self-definition and reflected there a masculine self-image as civilized, but not overly civilized, by virtue of its manifest desire. Dewing's female interpreters, such as Penelope Redd, Catherine Beach Ely, and—most of all—his wife, however, also responded enthusiastically to the encoding of spiritualism and refinement in his work. Their responses affirm that there were enough varied qualities in Dewing's female figure to appeal to a number of different subject positions, but also that women were willing to read his works selectively and look past what might be construed by women as undesirable erotic innuendoes.[133]

EVOLUTIONARY FEMININE TYPOLOGY

While Dewing's male contemporaries might have perceived his eroticized women as alluring, if problematic in relation to their implied physical and social refinement, their connotations of a highly evolved, American type of woman were straightforward. According to Martha Banta, the American woman at the end of the nineteenth century was placed at the "center of the evolutionary scheme for American culture" being publicly manufactured by American men: her refinement served as a clear sign of the progress of American civilization.[134] While it disavowed the import of the body, the visual rhetoric of Dewing's evolutionary agenda privileged mind and intellect, even though masculine desire for the feminine body has its way of quietly reasserting itself in his female figures. For Dewing, the body was an expression of mind, its attenuation signifying the sloughing off of the body, of the coarser matter of existence. This infatuation with mind in the American woman, however, did not necessarily mean the bookish or the college-educated contingent of women that was emerging at this time. Rather, it signaled instead a reaffirmation of his inherited Bostonian ethos and renewed the transcendentalist paradigm that valorized the "higher things," such as soulfulness and beauty in art, music, and literature, now in the form of an agnostic religion of art.

Neither Dewing's wife, the painter Maria Oakey Dewing, nor his daughter, the novelist Elizabeth Bartol Dewing Kaup, were college-educated, and he sent his granddaughters to St. Walburg's Academy in New York because

he considered the French nuns there to be "ladies."[135] Other women with whom he became close friends—for example, Fuller and the collector Annie Lazarus—were likewise involved in the arts, but none challenged the exclusive male prerogative to genius that predominated in the nineteenth century. Maria Dewing began her career as a figure painter, but after her marriage she abandoned this prestigious genre and took up flower painting in order not to compete with her husband.[136] Dewing essentially shaped his female types in the image of his wife, not literally to reflect her physical form, but to respond to her ideology of woman, particularly as it engaged the traditional transcendentalist aspirations toward self-perfection.[137] The female figures in interiors, for example, speak to qualities of general cultural erudition through the practice of self-culture, as these women lose themselves in a work of literature or music.

Dewing's reinforcement of the status quo for woman's role—as the mistress of the domestic, the spiritual, and the aesthetic spheres—reproduced the received wisdom of the late nineteenth century. On the question of education for women, evolutionists, for example, continued to come down solidly on the conservative side of the issue, as they used their science to support stereotypes of woman's place in the patriarchal order. Symptomatic of this consensus was Spencer's warning against excessive education for women lest it deter them from their proper social function of bearing the race, especially those fittest to contribute to what he identified as the upward spiral of human intelligence. This fear seemed to be confirmed by the studies of social scientists in the 1890s who observed decreasing birth and marriage rates among college-educated women. The "new woman," it was concluded, had opted for satisfying her own desires rather than fulfilling her reproductive obligations to society.

There were social benefits to be gained from keeping women out of competition with men in the work force, however, according to evolutionists such as Spencer. Societies that exempted women from labor appeared quite clearly to be more "highly evolved" than primitive groups in which females were treated as slaves. Moreover, history had demonstrated, they observed, how secondary sex differentiation between males and females increased from ancient to modern times, a development that seemed to be paralleled in the nineteenth-century contrast between lower and upper classes.[138]

In keeping with the progressivism of the northeastern intelligentsia, Dewing's attitude toward women is marked by the ambivalence engendered in men by the woman's movement in late nineteenth-century America, but it also shares the evolutionist's class bias, in the elevation of Anglo-

American women to the pinnacle of human development, at the expense of other cultures considered lower on the evolutionary ladder. Maria Dewing's treatise on the ideals of female beauty, entitled *Beauty in Dress* and published in 1881, makes explicit the ambivalence of her husband's later feminine imagery and illuminates the ideological significance of intelligence to his evolutionary feminine type. The physical type that Dewing frequently selected as his models—for example, Julia Baird, Minnie Clark (fig. 4.26), or Mollie Chatfield—was for the most part a sandy-haired woman, a type that according to Maria Dewing was also marked by "a delicate form of the bony structure of the face, by fine teeth, and delicate hands and figure" and who represented "our most intelligent and quick-witted women."[139] Another type celebrated in her book, as well as in her husband's paintings, was the plain woman whose quietness and fragile health lent her a "delicacy of form," a "peculiar elegance," and a charm associated with her pronounced "spiritual and intellectual" qualities.[140]

FIG. 4.26. *Thomas Dewing,* Figure of a Girl in Blue *(Portrait of Minnie Clark), c. 1891–1892. University of Michigan Museum of Art, Gift of Raymond C. Smith.*

For Maria Dewing, intellectual distinction was directly translated into physical refinement and was transmitted racially. "With educated people," she wrote,

> the modelling or finish of the face is oftener much finer . . .; with uneducated people, especially in handsome races like the Irish (although among them very degraded types exist), we often find a very beautiful type, both in face and figure; but never in the uneducated face do we find that final modelling, that subtle finish of little parts that is the greatest charm of the educated face.[141]

Implied here is a catalogue of conventions—charm, delicacy, elegance, frailty, and a general sense of cultivation and education that comes from "good breeding"—that trades on contemporary mythologies and hierarchies of race to differentiate upper-middle-class, WASP women from their lower-class, non-Anglo-American counterparts.

Maria Dewing advocates a finishing school education, an initiation into social conventions that could be accomplished in the home, not a college education of the type available to men. The degree to which she felt women should keep within their own separate sphere is indicated in her discussion of dress reform, which she felt was wrongheaded. Not only did dress reformers who adopted masculine clothing betray the true nature of feminine form and grace, but their fashions unforgivably encouraged masculine behavior as well. If a functional, comfortable style of beauty was wanted, she advised American women to study the Japanese.[142] Her suggestion that a race her contemporaries considered childlike (and the women doll-like) be adopted as a model for contemporary reform exemplifies the Dewings' tendencies to offer programs that they considered progressive and yet that easily accommodated the existing order of things.

These twin desires, to reap the benefits of evolutionary progress while essentially not disturbing the status quo, governed the polemics surrounding the woman's movement at roughly the same moment.[143] Literary periodicals geared toward a northeastern upper-middle-class readership abounded with anxiety-ridden essays—by men and women—on the damage to the social fabric that could be exacted by the new demands on women. In an 1880 issue of *Atlantic Monthly*, Kate Wells, for example, advocated a cautious feminist stance and warned that while evolution might refine away the weaker elements in woman's character, something valuable could be lost in the process. Woman stood at a crossroads, in a transitional state, to the point that marriage—which had been formerly

regarded as an institution that would produce "the highest development of woman"—was now regarded with some suspicion. Echoing the standard liberal program, Wells optimistically predicted that feminist radicalism would eventually result in a balance "between the women of the past and the present."[144]

In line with the majority of his peers who were not convinced of the social benefits of the feminist movement, Dewing's imagery straddled a middle position that pays lip service to the progressive value of feminine self-culture, while at the same time reestablished an essentialist model of femininity in terms of qualities that express a woman's sexual availability, as well as her biological and mental differences from a man. His position is similar to that of Marianna van Rensselaer, the prominent New York critic of contemporary art and architecture: van Rensselaer endorsed higher education for women, but only because she felt college training would help woman become a better wife, mother, and manager of the household, which was her only true calling, and not because she felt that it would lead to a female challenge in the male professional sphere.[145]

This liberal agenda was implicitly matched in the emblematic body of Dewing's women, who to contemporary critics represented a mature woman who could think.[146] The bodilessness of Dewing's female figures (fig. 4.27), with their elongated limbs, attenuated proportions, and long sweeping curves, went against the popular full-figured, voluptuous type associated with working-class women that in the 1870s was prevalent in New York society and the popular theater. This attenuated female not only defied the canon of amplitude exemplified in the figure of Lillian Russell, but she also challenged the fashionable beauty that succeeded Russell—the athletic society belle who relished bicycle riding, tennis playing, and Delsarte's "society gymnastics."[147] Here bodilessness defines Dewing's women as antitypes to the popular physical type, and it functions as a sign of their status in the elite, highly evolved order of the civilized.

Reasoning in the dualistic terms of spiritualism, Sadakichi Hartmann explained how the elongated and refined forms of an artist such as Dewing signified a refusal of the "earthly and sensual" for the purer "rhythms of beauty." Form was "expressive to the spirit," he wrote, and the "peculiar elongation of form" encountered in the imagery of Dewing and Botticelli posed "a more direct inlet into the realm of beauty."[148] For, Hartmann maintained, "it is a psychological peculiarity of all cultured beings that they find more esthetic gratification in long and thin objects than in short and heavy ones."[149] The formal order of *A Reading* (fig. 4.19), for example, is that of attenuation, so that the lines of Dewing's women with their long

FIG. 4.27. *Thomas Dewing, In the Garden, c. 1889. National Museum of American Art, Smithsonian Institution, Gift of John Gellatly.*

limbs and backs are all of a piece with the elongated stems of flowers, table legs, and vases. Similarly the skin of the female figures, especially those with their backs turned toward the viewer (fig. 4.23), seems as smooth and polished as the surfaces of the mahogany tables and looking glasses.

While Hartmann's commentary also makes clear how Dewing's female figures could imply an art experience that is inspiriting, transforming, and thus therapeutic, it also, however, articulates how these women were at the same time apprehended as eroticized objects of beauty. For him these attenuated, angular figures evinced an adolescent physique, "like that of a young girl before having reached maturity." Such a rejection of the mature, rounded feminine form for a presexual physique could also connote a state of androgyny, as witnessed in the paintings of Khnopff, Toorop, Burne-Jones, and Beardsley. But for Hartmann this physical type conjured up a fantasy woman who was "both present and yet far away," a "demi-virgin," part "Parisian demi-monde" and part Puritan descendant. Their faces, veiled in reverie and "dreamy delicacy," projected a sense of melancholia and desire, a sense of longing, that made them seem "veritable Decamerons of twentieth-century love, . . . perhaps too much so."[150]

Dewing's bodiless woman presented a paradoxical configuration: she offered a model of eroticized aesthetic experience that was yet "intellectual," anticorporeal, and thus "higher" in its rejection of the commonplace depiction of sexuality as the carnal, voluptuous body. At least this was true for the northeastern elite, who valued aesthetic refinement as a mark of membership in a group distinguished from a less evolved quotient of humanity by virtue of its greater "spiritual" and mental development. This was the received wisdom according to Spencer's social hierarchies as popularized by John Fiske in the late 1880s. Spencer had alleged that human intelligence was steadily increasing in accordance with the growth of mental activity in each succeeding generation. Fiske elaborated on this idea that a sign of the culmination of human evolution was to be located in the spectacle of the material body receding in the wake of the expansion of human mind—an image that found favor with a popular audience and is reverberated in Maria Dewing's reading of intelligence in the delicate facial morphology.[151]

Dewing's abstracted reality was interpreted as some "indwelling spirit or essence" rendered as matter. The chief figure in this spiritual syntax was the perfected American female, who was construed as an index to modern American evolutionary superiority.[152] American character in the last quarter of the century was defined in terms of New England cultural traits, an observation that points to the cultural hegemony of the Northeast in this

period. The nostalgia for the Puritan heritage after the Centennial, in the form of the Colonial Revival in literature, architecture, and the fine and decorative arts, presented a somewhat melancholy spectacle of a lost past. That Boston was overbearingly rife with "the Puritan temperament" and Anglo-Saxonism in this period betokened its pervasive fear of cultural extinction at a moment when it seemed that non–Anglo-Saxon-Protestants might soon outnumber those of original Puritan ancestry.[153] If the survival of Puritan instincts seemed questionable at the end of the century, then, the traditional New England woman, plagued by nervousness and attenuation from a life of introspection and altruism, appeared to some to be a cultural type doomed to extinction as well with the advent of the "new woman."[154]

The female figure of Dewing's landscapes and interiors, however, preserved the Anglo-Saxon character and was even framed as a mysterious energizing force that propelled American culture along its evolutionary trajectory. Dewing was identified by his contemporaries as a descendant of the Puritans, and his Boston background was credited with endowing him with a residuum of the Puritan ethos in his spare and elegant aesthetic, which had been raised to a higher power by the classicism of his Parisian training. Following the public perception of the artist, his female figure was also deemed a type of ideal American woman.

Whether or not his actual model was of Anglo-Saxon descent, the model merely offered Dewing a starting point that he then made over to conform with a canon of beauty that he had earlier fabricated in Boston during his formative years.[155] This point is underscored by the fact that both Dewing and Charles Dana Gibson at times utilized the same professional model only to arrive at very different constructions of femininity. For example, Minnie Clark, whose background was working-class Irish, was transformed through Dewing's eyes (fig. 4.26) to suggest a remote, ethereal being commonly connected with the self-restrained Puritan daughter. Yet Gibson, looking at the same woman, projected a feminine type who similarly posed no challenge to the activist sphere of male professionals. Instead, she was an extroverted, athletic type who self-consciously and self-confidently asserted her bodily presence (fig. 4.28), in contrast to the bodily effacement of Dewing's ideal.

The Gibson girl was a figure who also accommodated conventional feminine ideologies with the emergence of a "new woman." She not only reflected Gibson's political stance on the woman question, but she also demonstrated the tendency of New York society, to which Gibson had entrée, to appropriate the signs of radical feminism, only to turn them into fashion.[156] Dewing's woman functioned similarly, in that she projected the

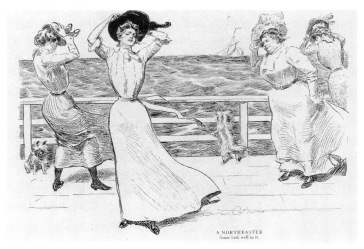

FIG. 4.28. *Charles Dana Gibson,* A Northeaster: Some Look Well in It. *From* Life *(New York) (1900)*.

Boston ethos of his upbringing into the symbolic field of visual art. The stereotype of the New England woman that emerged in the controversy surrounding the feminist movement in its imagery corresponded to the critical appraisals of Dewing's woman. The customary inventory of her features composed the picture of an independent type who, while repressing her emotions and sexuality, lived an inner life of seclusion devoted to reform and intellectual pursuits which in turn occasioned a wasting of the body.[157] Dewing drew on this stereotype of a woman whose devotion to the "higher things" of life lent a "chrism to the mental atmosphere." While essentially posing an antimodern response in contrast to the activism of the "new woman," in her absorption in the practice of self-culture Dewing's woman could yet be construed as "modern" and perhaps "transitional."[158] But her straddling of positions on the question of woman's proper social role projected the political stance most often supported by the upper middle class. It left women in their separate sphere of domesticity at the same time that it endowed them with a mark of advancement that was nonthreatening to male hegemony in the public sphere.[159]

Dissent from this form of evolutionary typology could often be heard among those raised outside Boston. Others simply had no wish to belong to the cult of this spiritualist beauty and preferred naturalist philosophies to the idealism of evolutionary progress. Sargent, for example, criticized Dewing and Saint-Gaudens for searching out a [feminine] subject that was

"angelic, far-away, and thin, the real flesh and blood thing, rustical thing ... not being good enough for them."[160] Theodore Robinson likewise expressed hostility to Dewing's "everlasting ladies, 10 heads high."[161] Their objections, however unfavorable to Dewing's ideology, nevertheless clarify the way in which Dewing's peers read his practice of elongating form as a sign of his reach for a perfected state of being that is accomplished through the private rituals of self-culture. Frances Grimes commented on this tendency when she observed that the "cultivated and informed" women of Dewing's paintings

> like Dewing himself, looked on, criticized, chose, perhaps ruthlessly from life what seemed to them exquisite. They felt, as once Mrs. Dewing told me she did, that the mark of what was most civilized was that it was farthest removed from what was animal.[162]

From the view inside Dewing's circle, these women clearly embodied the essence of "what was most civilized"; in their repression of the physical body and their cultivation of the spiritual and mental they were conceived as the "farthest removed from what was animal."

In Dewing's synthesis of historical sources for these female types there is a sense too in which they recapitulate the ascendant movement of Western culture that was thought to be culminating in the American race. Contemporary viewers acknowledged the lineage of Dewing's New England woman as springing from the grace of Greek Tanagra figurines, the wistful beauty of Botticelli's Florentine woman, and the seductive ethereality of the Pre-Raphaelite stunner.[163] Invoking the most highly valued historical periods of Western European culture, Dewing's feminine construction rehearsed the generative female role as one of hereditary conservation, in accord with the prevailing theories of evolutionists, which again simply reinforced the status quo. For example, W. K. Brooks and Joseph LeConte placed the authority of evolutionary science behind the idea that in civilized societies men and women were highly differentiated from one another: the sexes functioned as complements to one another, as opposed to primitive cultures in which both men and women worked and thus tended to duplicate each other in mental and physical capacities.

The function of modern women was thus to store and transmit the past and its habits, laws, and instincts, as well as to ensure the stability of the race, while men were judged to possess the powers of genius in generating new characteristics.[164] The degree to which evolutionary science was so unilaterally authoritative that dissent was inconceivable on these issues is

revealed in the fact that even intelligent women such as van Rensselaer and feminists such as Charlotte Perkins Gilman and Anna Garlin Spencer accepted as received wisdom the essentialist doctrine of feminine/masculine complementarity.[165]

In Dewing's New England women America's evolutionary aspirations are played out on the symbolic feminine figure. In a three-paneled folding screen Dewing decorated for Frank Hecker (fig. 4.29) costume and pose conflated late nineteenth-century Anglo-America with the golden ages of European culture. Suggesting the grace of the Greek Tanagra (fig. 4.30), the wistful self-absorption of Botticelli's goddesses, and the elongated elegance of Rossetti's or Burne-Jones's English women, the Anglo-American woman is presented as the culmination of Western evolution.[166] This historical movement from Aryan Greece and Hellenized Italy to Aryan Britain invokes the Anglo-Teutonic germ theory of Aryan cultural progress, as promoted particularly by John Fiske, and inflects it differently only by insinuating into this movement Renaissance Italy—the point at which Hellenic culture was cross-fertilized with Christianity.[167]

Since men alone generated new traits, while women could only conserve inherited traits, the condition of women in general was regarded as a reflection of the genius and achievement of men, and the American woman was scrutinized for concrete signs of American progress. For Matthew Arnold she evidenced the rare "note of civilization" found on this

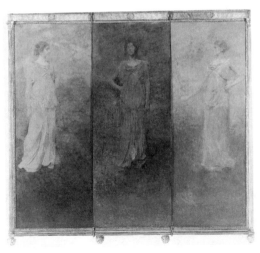

FIG. 4.29. *Thomas Dewing, Classical Figures, 1897–1898. Three-paneled folding screen. The Detroit Institute of Arts, Gift of Mr. and Mrs. James O. Keene in memory of their daughter Sandra Mae Long.*

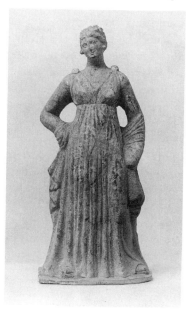

FIG. 4.30. *Greek (Myrina) artist,* Standing Woman, *third to first century* B.C. *Terracotta. Museum of Fine Arts, Boston, Gift by Contribution.*

side of the Atlantic, and her achievement of natural charm could be explained by her formation in a democratic environment. Another outside observer of the American scene, Paul Bourget, also apprehended the American woman as an index to American evolutionary progress, particularly as she was symbolically visualized in the works of artists and represented

> like a living object of art, the last fine work of human skill, attesting that the Yankee, but yesterday despairing, vanquished by the Old World, has been able to draw from this savage world . . . a wholly new civilization, incarnated in this woman.

The social utility of this assessment of American women as "the consummate fruit of human society at its best" to northeastern hegemony was acknowledged by Harvard College president Charles W. Eliot in his Phi Beta Kappa address of 1888.[168] "Unsurpassable in grace, . . . serenity and dignity," the American woman presented a cultural standard to which foreigners of non–Anglo-Saxon descent entering the country could aspire as they assimilated themselves into the fabric of American society.

One of Dewing's most supportive critics, Sadakichi Hartmann, thought he could observe this peaceful process of assimilation at work as early as 1905. Hartmann's thesis, in fact, reflects his own process of assimilating himself into the northeastern elite and abandoning his German heritage, through identifying himself with Anglo-American forms of cultural capital in the spiritualist movement as manifested in symbolist art and literature.[169] "Already," he wrote, "the American-born children of immigrants of the very lowest class show certain traits of refinement that one would seek in vain in their parents." Following the earlier rationale of Darwin and other evolutionists commenting on the American scene, Hartmann discerned the process of natural selection at work in the way in which

> our severe, disagreeable, ever-changing climate . . . seems to call forth the elongation of limbs and gradually remodels the buxom German maid of one generation into a tall, slender American girl of the next.[170]

This model of assimilation was predicated on the ideal type of American woman—"one of the most perfect expressions of beautiful womanhood." According to Hartmann, this type had emerged at the high points of history, "when a community is steadily growing in prosperity and power as Athens before the reign of Pericles and the dukedoms of North Italy in the fourteenth century." That this elongated and refined type had now been achieved by the American race was verified by the statistics compiled by the physical culturist professor Dudley Sargent of Harvard College Gymnasium, who had measured a representative sampling of collegiate Anglo-American women.

Hartmann believed that though several artists, such as John White Alexander, Whistler, and Sargent, had sporadically hit upon such a type, the representation of this American woman who signified the emergence of America into a golden age of civilization was being produced consistently only in the visual art of Dewing.[171] The feminine construction that Hartmann described and Dewing gave visual form to poses a correlative to Henry James's conceit of the young American woman as the "heir of all the ages": she is essentially the personification of Anglo-America as the consummation of history.[172] European past and American present are now conflated into a single cultural moment in which the sensual allure of that past is redeemed in the sublimated and highly evolved woman of Dewing's dematerialized art.

INTO THE TWENTIETH CENTURY: PARADIGM SHIFT
AND THE NEW ENGLAND HEGEMONY EMBATTLED

While Dewing's Cornish landscapes represent his investment in the uto-
pian possibilities of the New England community in the 1890s, the interi-
ors with female figures from the early twentieth century register his with-
drawal from that community into the hermetic world of art. Dewing
claimed that he was driven away from the Elysian fields of Cornish by the
invasion of a more affluent, philistine set, though his inability to dominate
a newly arrived, younger intelligentsia undoubtedly also exacerbated his
frustration. Where communal life in 1890 had cohesively revolved around
a strictly observed regimen of work and recreative leisure, group recreation
a decade later was carried on within smaller coteries that might or might
not include the Dewings.

The liberalism of Progressives Herbert Croly and his Harvard classmates
Norman Hapgood and George Rublee, who adopted Cornish just after the
turn of the century, must have been galling to a conservative Republican
like Dewing. During a summer night of drunken revelry at Cornish,
Dewing made his politics known when he burned down a teepee with a
picture of Henry George—whom Dewing despised—pinned to it. Dewing
thus vented his spleen against the land reform policies George designed to
benefit the immigrant masses pouring into the country, and he signaled his
loyalty to vested corporate interests in property like Freer's and those of his
other businessmen patrons. Traditionally defended by the economic theo-
ries of Adam Smith and David Ricardo, in the 1880s these corporate
prerogatives to property were given new authority by invoking the
Spencerian rationalization that the fittest individuals—"the highest types
of their race"—held the right to exploit natural resources and drag society
upward with their progress.[173] While Dewing had complained to Freer in
the late 1890s that Cornish was becoming too expensive, it was only in
1905 that he sold his house and property and purchased an isolated retreat
in the forests of Green Hill, New Hampshire.[174]

Until well into the 1930s the Anglo-American community continued to
value the aestheticized rituals of leisure of the type organized by Dewing
at Cornish, in which pageantry and theater were integrated and presented
as therapeutic participatory activities for public consumption. During this
period, when European modernism was taking root in urban centers,
however, the advocates of cultural diversity had begun mounting attacks
on the northeastern hegemony and its morality of aesthetics. This political

invective, in turn, eventually infiltrated critical judgments of contemporary American art.[175] Symptomatic of this paradigm shift was Charles Caffin's remark on viewing a Dewing painting hanging in a New York exhibition in 1916: "Poor old fin-de-siècle exquisiteness, how completely everybody but the artist has grown beyond you!" Less than a decade earlier Caffin had played the part of Dewing's champion and applauded his work (along with Whistler's) as an example of progress in "evolving from material appearances their essence." Now Caffin found Dewing's harmonies unmoving and tiresome, and his languorousness insipid.[176] While Caffin never abandoned his spiritualist aesthetics, which were epitomized in Whistlerian dematerialization, he had now encountered those same principles revitalized in Stieglitz's modernist painters. This was a group no less elitist in their aesthetics than the followers of Whistler, but to Caffin it included painters who represented "a natural evolution from the example of Whistler."[177]

After suffering a couple of bewildering critical responses to the landscapes he exhibited at the Montross Gallery in 1900, Dewing withdrew his landscapes from the public eye altogether. At the beginning of the 1890s Dewing had railed about the uselessness of sending his pictures to exhibitions in Philadelphia. "The New York public is stupid and provincial enough without going back into the interior," he wrote to Freer.[178] His landscapes did not speak to the "great public who go to an exhibition like the Pan-American," he rationalized, because they belonged "to the poetic and imaginative world where a few choice spirits live." In the estimation of at least one of Dewing's colleagues, these semi-abstract images were pitched at a level "far beyond" the general comprehension of the public. Dewing's interpretation of Emersonian self-culture appealed only to an elite—those already initiated into the dematerialized idiom of Whistler and the rhetoric of evolutionary progress. To Freer, Dewing, and their circle, their aesthetic discrimination set them in a category above that of the middle-class masses, whose taste was for the materialistic and the banal.[179] Although it was rumored that Dewing's patrons were above average in their cultivation—and a majority of these men were from Anglo-American families and could trace their ancestry back to seventeenth-century Massachusetts settlements—in reality, however, the fortunes of his clients were self-made in the railroad or some manufacturing business with connections to Freer or White.[180]

A flattering appraisal of Dewing's landscapes in the terms of evolutionary progress had been offered by Royal Cortissoz, writing for *Harper's New*

Monthly Magazine in 1895. Describing the effects of Dewing's work as an "instinctive uplifting of the senses to a higher plane," Cortissoz speculated that Dewing's imaginative quality would function as "the leaven of the future" in the evolutionary "refining process" that for him distinguished the movement of contemporary American art. Delighted with Cortissoz's article, Dewing made it clear that this was the kind of understanding he had been seeking when other critics had ascribed to him unwelcome "intellectual motives."[181] For Cortissoz, Dewing's mode of poetic semi-abstraction placed his art in a higher category than that occupied by the "sterile school of craftsmen who have sought to establish in America the Parisian ideal of mere technical polish, irrespective of theme."

In 1900, however, Dewing's "rare skill" of the hand was nearly the sole admirable quality reviewers could find to save his images, while Dewing himself was accused of being indifferent to the public.[182] By 1906 critics of Dewing's works couched their quibbling over his defects in the polite terms of his "limitations," a mood bordering on "listlessness," or his "saccharine brush," and the press reaction to the paintings he exhibited at the Montross Gallery or with the Ten American Painters, an elite exhibiting society formed in 1898, remained mixed for the next several years. At the end of the decade newspaper reviewers felt even freer to label his contemplative female figures "retrogressive," "complacent," and "old-fashioned,"[183] epithets that signaled a new critique constructed on sociopolitical grounds.

The collective appearance of Robert Henri and the Ashcan School in the exhibition of "The Eight" in 1908 marked a sea change in American culture. Corresponding to their illustrations for the socialist journal *The Masses*, their paintings privileged the raw energy of New York's ghetto streets, and as such cast a new light on the uptown imagery produced by the generation of the 1890s. This inherent contrast between the old and the new art made all too apparent what the newspaper critics had been hinting more or less strongly for the last several years: that the tonalist aesthetic of Dewing, Tryon, and others preserved a northeastern cultural norm that reified Anglo-American hegemony. Overtly politicizing the field of American art, Henri and his followers gave center stage in their pictures to what they perceived as the raucous vitality of the culturally diverse working-class population that was filling up tenement houses in lower Manhattan.[184] To a younger artist like Guy Pène du Bois, who would become associated with the painting of urban life over the next two decades, the elitism of Dewing and his colleagues first and foremost stood out in relief. He commented that "proper behavior" directed their artistic production,

to the point that this behavior "has become instinctive in them, and is no longer to be considered a hindrance—a damper placed upon personal expression. The cultivation of aristocratic older families is similar to it."[185]

If the younger generation regarded the entrenched tonalists as bulwarks of the aristocratic order, these defenders of tradition considered the new painters to be "insurgents, anarchists, socialists, all the opponents to any form of government, to any method of discipline."[186] The absurdity the older generation found in Henri's new, inverted social hierarchy was voiced by the critic Charles de Kay, who was also a member of Dewing's New York circle. De Kay's satire on Henri and the Ashcan school was built on the standard evolutionary metaphor, by ridiculing their street subjects as the highest products of evolution. "Their method of painting flesh," he wrote,

> is such as to suggest very unhealthy specimens of the highest order of primates, who, so Mr. Alfred Russel Wallace has just assured us, very positively, are not only the crown of life on this globe, but monopolize all human existence, having no rivals in other planets or other solar systems. What would Dr. Wallace say to the prizefighter by Mr. Luks, and how could he survive his own belief in the absolute pre-eminence of mankind if the same painter's "Whisky Jim" is really and truly alive? Even the portraits of alleged gentlemen by Messrs. Glackens and Luks inspire one with the question—so sinister is their appearance—whether they be not gentlemen of the road.[187]

The explanatory strategies of Dewing's few remaining apologists were also drawn, like de Kay's, from the rhetoric of evolutionary progress and self-culture. Dewing's art was appreciated as a therapeutic defense against the abrasiveness of modern life that was needed now as never before. To those who still cherished brahmin quietism in painting, tonalist harmonies furnished a welcome respite, a rest for the eye after "strained optics" and "the blazing fireworks of the new men." "In Dewing's tiny pictures," one sympathizer offered, "nothing happens, exquisitely":

> Life is not insistent; your eye is wooed from tone to tone . . . the art is subtle, and the result is quintessence. . . . [Dewing and Tryon's] withdrawal from the more brutal statements of every day normal painters, are gradually putting them in the "precious" class. . . . We note this not as a defect but as a fact. There are days when life crowds upon us too insistently; when to go on a simple daily errand becomes

a torture; when Wagner is too brutal; Byron too bald; . . . when even certain phases of Chopin seem too obvious. Then is the moment for Whistler or Dewing or Debussy. They revalue values.[188]

The profound difference in worldviews between the old guard of the 1890s and the young revolutionaries of the prewar years was sharply delineated by the Armory Show of 1913 in its successful promotion of European modernist movements. In the response of the old guard to that event, another opportunity is presented to understand how those who matured in the 1870s and 1880s continually discerned evolution or devolution, civilization or savagery as the master narrative of cultural change. To another member of Dewing's social circle at Cornish, Adeline Adams, for example, the distortions of the Fauves and the Cubists constituted a retrogression, a "return to the barbaric." Their childlike naivete demonstrated a "degeneration in viewpoint," an inferior posture just this side of insanity. While some of these examples of "delicate decadence" might be seductive, "our higher selves" provided a word of sanity in quietly cautioning us as to their true perversity. Such proportions, so "violently degraded from the harmonious type," amounted to "crimes against Nature." When art should be "reformatory," this was a "deformatory" art, produced by the "corroding neurasthenias spewed out of European capitals." It violated the evolutionary order of life, wherein "the spirit of progress is 'the one secret.'" "The goal of the normal creative spirit" was to "incorporate its work into the onward movement of man."[189]

Dewing's personal sense of embattlement against this perceived assault of modernism is evident in his remark to his dealer, Macbeth: "Those of us who share a regard for beauty must stand together now when painting is being practiced by the Goths."[190] This embittered response is not surprising, however, considering that not only was America's first avant-garde commandeering the art scene in New York but also the political radicals were crashing the gates of the civilized turf around Washington Square, where Dewing and his colleagues lived and kept studios. Forbes Watson, who occupied a studio near Dewing's, noted that Dewing seemed dislocated and bewildered at the changes that came to the city in the early twentieth century, especially to Greenwich Village, which had been the province of New York's Anglo-American literary and artistic coteries. Stepping outside his studio, Dewing "would stop and look up and down the street as if he had come from another world and for the first time was seeing the noisy streetcars that rattled through Eighth Street before the buses came."[191]

In the cause of enshrining the "higher art," and particularly Whistlerian aesthetics for future generations, Freer made a magnanimous gesture in the gift of his collection to the nation in 1906. After Stanford White's murder, Freer chose Charles Platt, the architect of the hybrid Italianate-Colonial country houses at Cornish, to design his understated classical museum. Placed on the Mall just below the Capitol Building in Washington, D.C., the Freer Gallery of Art at its opening in 1923 seemed to be authorized by its federal site to promote Whistler, Thayer, Dewing, and Tryon as the American culmination of world evolution in art. Tutored by the philosopher of Spencerian aesthetics, Ernest Fenollosa, Freer installed the numerous works he had collected by these artists each in his own room in the gallery. According to Fenollosa, the progressive abstracted aesthetic Whistler and his followers demonstrated would provide public instruction in the universal design principles that promoted harmonious living.[192] Freer rejected what he perceived to be the degraded forms of modern art and in his will prevented any further additions to his collection.[193] In the marble rooms on the Mall his vision was thus preserved in the shape of a pure, closed entity, as an absolute aesthetic finalized and unchanging in perpetuity.[194]

In the years following World War I the Dewings spent much time and energy attempting to place his paintings in museum collections. The opening of Freer's museum was a large step toward preserving Dewing's besieged art form, while the gift of John Gellatly's group of Dewings along with the rest of his collection to the National Collection of Fine Arts in Washington, D.C., (now the National Museum of American Art) at Gellatly's death in 1929 constituted a second major victory for Dewing, even as his reputation was being eclipsed by those he considered the "Goths."[195] During the postwar years Dewing busied himself either repainting old compositions (sometimes with disastrous results), or producing banal self-parodies—altogether a negligible production in the oil medium. In pastel and silverpoint, however, he managed a respectable output and clientele for them, until Maria Dewing underwent surgery for a breast tumor in 1924, and Dewing then suffered a complete breakdown. "After all these years," Maria Dewing wrote, "Tom has lost faith."[196] The Spencerian edifice during the war had had its last remnants of credibility stripped away. A strong-willed individualist, Maria Dewing was her husband's buffer against the harsh modernist world of uncertainty, and she had been the bulwark and expositor of the morality of aestheticism to which they had devoted their lives. The threat of her personal loss at that

time had the effect of finally forcing Dewing to confront the collapse of the paradigm of progress. With his personal and ideological defenses shattered, Dewing's suffered a year-long paralysis that was both physical and emotional. Maria died in 1927, and Thomas Dewing died alone, a broken man, in 1938.

THE VEBLENIAN CRITIQUE AND SELF-CULTURE

The demise of the Spencerian evolutionary paradigm was accompanied by the demise of aestheticism as an agency of self-perfection and transcendence. Since Lewis Mumford's critique of the late nineteenth-century "genteel tradition" in 1931, it has become somewhat routine when confronting that tradition to invoke Thorstein Veblen's attack on the capitalists, who at the end of the century buttressed the hegemony of the "genteel tradition" against the onslaught of non–Anglo-Saxon, "foreign" cultures taking root here.

As a critique of the Anglo-American ethos in the 1890s, Veblen's *Theory of the Leisure Class* (1899) has provided a convenient text to "explain" the multitudinous images of middle-class leisured women generated by Dewing and his colleagues.[197] That the painters of the Ten objectified women by presenting the female figure as "a kind of precious still-life object or rarified possession," as Linda Nochlin phrased it, is undeniable. Still there is a recognizable degree of difference between the interiors of Benson and Tarbell, where shiny, expensive objects tend to vie with the female figures for the viewer's attention, and Dewing's sparsely furnished chambers that are projections of the contemplative mental activities in which his female figures engage. Given its ideological parameters, the Veblenian analysis is not equipped to recognize the differences between these two forms of late nineteenth-century imagery—they represent the polarities of materialistic display and transcendentalist self-culture—and it therefore does not acknowledge the existence of positions between these poles.

Veblen's critique of Anglo-American industrial society was formulated from a viewpoint outside the ethos of the Northeast. Born in Wisconsin of Norwegian peasants, Veblen studied at Johns Hopkins and Yale, where he took a doctoral degree in philosophy in 1884. Though he would have liked an academic appointment at a northeastern university, Veblen's Norwegian farmboy manners marked him as a foreigner, just as his skepticism revealed him as an agnostic, with the result that no teaching post was forthcoming. After schooling himself in the works of Marx, Darwin, Spen-

cer, and the sociologist Frank Lester Ward, Veblen declared himself a socialist in 1890. His rejection by the Eastern establishment, his early identification with immigrant farmers victimized by unscrupulous businessmen, and his observation of the violence between labor and capital in the 1870s and 1880s now all merged to underwrite his development of a healthy animus against the machinery of finance capitalism. A position in the economics department of the University of Chicago in the 1890s finally led him to synthesize his studies of psychology and anthropology into a new approach to economic theory. Focussing at first on the pecuniary values of conspicuous waste displayed by the business class, Veblen lectured the very community of Anglo-Americans—the sons and daughters of the Puritans—at whose hands he had experienced rejection.[198]

While Veblen's outside perspective is useful in succinctly unmasking the foibles and pretenses of that upper-middle-class Anglo-American milieu, he also found the spiritual values of that ethos completely useless in his preferred socialist model, in which society is motivated only by the incentive of economic gain. Veblen despised teleology, whether in the Hegelianism of Marx or in Spencer, whom he attacked in the early 1890s as an apologist for American capitalism.[199] The descendants of the Puritans who dominated the country politically, socially, and intellectually still clung to a mystical medieval culture, he felt, that promoted absurd beliefs in the mysteries of a spiritual realm beyond the facts of material existence and just as barbarically the Lockean theory of private property as a natural right. The ideology of the world as a divine harmony these Anglo-Americans had constructed was no more than a facade to disguise the profane chaos they had in reality created.[200]

Orthodox Christianity was thus rejected, and the widespread contemporary need to locate transcendence outside orthodox belief in the aesthetic order dismissed. For Veblen, then, art objects and beautiful women functioned only as evidence of the wealth of their male possessor. Art and beauty merely reinforced one's status in the community; they gratified no inner emotional need. As forms of "vicarious consumption," however, they "enhance, not the fulness of life of the consumer, but the pecuniary repute of the master for whose behoof the consumption takes place."[201]

Leisure, for Veblen, was a morally contemptible condition that primarily served as "an evidence of pecuniary ability to afford a life of idleness." This involved the display of status in terms of "trophies of exploit," which could take the forms of scholarly or artistic achievements. The modern Anglo-Saxon wife, however, served as the ultimate sign of "Vicarious

Leisure and Vicarious Consumption."[202] It is worth quoting a substantial passage of Veblen's prose to get the full impact of his rhetorical construction of the trophy wife.

Propriety requires respectable women to abstain more consistently from useful effort and to make more of a show of leisure than the men of the same social classes. It grates painfully on our nerves to contemplate the necessity of any well-bred woman's earning a livelihood by useful work. It is not "woman's sphere." Her sphere is within the household, which she should "beautify," and of which she should be the "chief ornament." According to the modern civilised scheme of life, the good name of the household to which she belongs should be the special care of the woman; and the system of honorific expenditure and conspicuous leisure by which this good name is chiefly sustained is therefore the woman's sphere. In the ideal scheme, as it tends to realise itself in the life of the higher pecuniary classes, this attention to conspicuous waste of substance and effort should normally be the sole economic function of the woman.

According to Garry Wills, for Veblen no woman better illustrated this conceit of the trophy wife than Mrs. Potter Palmer, for when Veblen alludes to the "vulgar rich, he always, implicitly means the Chicago rich." Not only were the "Gothic excrescences" of her castle on Prairie Avenue the ultimate symbol of her husband's "predatory prowess"[203] but also her beauty—stylized into the fashionable body—signified Chicago's only standard of value—wealth.

Wherever wasteful expenditure and the show of abstention from effort is normally ... carried to the extent of showing obvious discomfort or voluntarily induced physical disability, there the immediate inference is that the individual in question does not perform this wasteful expenditure and undergo this disability for her own personal gain in pecuniary repute, but in behalf of some one else to whom she stands in a relation of economic dependence; a relation which in the last analysis must ... reduce itself to a relation of servitude.

To apply this generalisation to women's dress, and put the matter in concrete terms: the high heel, the skirt, the impracticable bonnet, the corset, and the general disregard of the wearer's comfort which

is an obvious feature of all civilised women's apparel, are so many items of evidence to the effect that in the modern civilised scheme of life the woman is still, in theory, the economic dependent of the man,—that, perhaps in a highly idealised sense, she still is the man's chattel. The homely reason for all this conspicuous leisure and attire on the part of women lies in the fact that they are servants to whom, in the differentiation of economic functions, has been delegated the office of putting in evidence their master's ability to pay.[204]

Nor was Veblen's scorn any less for the emancipated woman. Women of Berthe Palmer's class, to Veblen, were mere "chattel" to their husband's fortunes, despite their pretensions to empowerment through forms of philanthropic and educational work. On this question Veblen quoted the biting remarks of a recent observer who found the "new woman" to be "'petted by her husband'" and "'surrounded by the most numerous and delicate attentions. Yet she is not satisfied. . . . The Anglo-Saxon *new woman* is the most ridiculous production of modern times, and destined to be the most ghastly failure of the century.'" Veblen acknowledged that this critic had missed the point of the women's movement's demand for a place in the masculine sphere of work, but he felt that this characterization was "well placed" in its evocation of the unpleasant truth of the upper-middle-class woman's social position. In contrast was the lower-class woman who, although she worked as a "drudge," was "fairly contented with her lot" because she "has something tangible and purposeful to do" and no time for rebellious self-assertion.[205]

In a manner as sarcastic as Veblen's satire, H. L. Mencken mocked the economist's theory by noting Veblen's complete disregard of the negotiation of power that characterized modern marriages—a process that was perhaps absent at least in Veblen's second marriage, in which his wife and her daughter, day and night, devoted themselves exclusively to the caretaking of his every need.[206] Within the text quoted above, however, the irony of Veblen's passages turns on his repetitious use of the term *civilised* to connote what for him were modern vestiges of medieval feudal society—the barbarous rituals and customs that fostered the display of "honorific waste." He reverses Spencer's system, in which the privileged status of leisure or exemption from labor accorded to women was a mark of advanced societies, only to become reconfigured in Veblen's critique as a sign of reversion and arrested spiritual development. For Spencer, it was the industrial state that encouraged pacifism and altruism, while Veblen

romanticized the "savage state" as an epoch of perfect harmony with nature.[207]

Veblen's critique of the upper-class American woman's social position holds more validity for some images of women by Dewing and his peers than for other images that constitute the rubric of the "genteel tradition." Published in 1899, Veblen's sentiments were absorbed by left-leaning art critics and reverberated with some frequency in the press in the years after the Eight and the modernist vanguard began exhibiting more actively in New York. At the exhibition of the Ten in Philadelphia in 1908, for example, the critic for the *New York Times* charged Dewing and his colleagues with materialism, with equating the human figures with things.[208] The painting cited by the reviewer, *The Necklace* (c. 1907; National Museum of American Art), shows a Vermeeresque interior with a woman facing a mirror in order to try on a necklace. While this image seems to offer a typical instance of the female consumer's infatuation with frippery, it is more an anachronism in Dewing's work than the rule. Dewing, in fact, abhorred the philistinism of the nouveau riche. His model patron was Freer, whose aesthetic ritual consisted of a zenlike meditation on the single art object within a setting so simplified as to suggest a space without time, a transcendent realm, and this practice is reflected in the visual trope of self-refinement in Dewing's typical interiors, such as *A Reading*. It is a practice that seeks a spiritual and physical renewal through aesthetic contemplation, not the display of status; it connotes the therapeutic practice of a spiritual elect. The rarefied material object in this scheme functions as both the agency and the sign of this spiritual election.

Veblen defined leisure as a nonproductive consumption of time, but he also exempted from his definition the state of quiescence, a state that is central to the aesthetic rituals of Dewing's interiors.[209] In fact, his socialist critique is better applied to the ubiquitous imagery of middle-class American women in the works of the Boston painters Edmund Tarbell (1862–1938) and Frank Benson (1862–1951). Benson's painting *The Black Hat* (1904; fig. 4.31), which displays a female figure trying on a new fashion, also becomes the occasion for the display of expensive objects—Oriental porcelain, Japanese chests, a Japanese print, a silver hand mirror, a pile of jewelry on a mahogany table, and yards of laces and satins. Veblen's economic paradigm of consumption is here more concretely suggested, in contrast to the quasi-religious paradigm of progress through self-refinement of Dewing's images—both paradigms for which Veblen had only contempt.

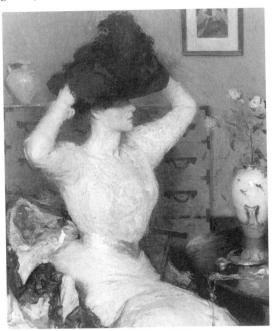

FIG. 4.31. *Frank Benson,* The Black Hat, *1904. Museum of Art, Rhode Island School of Design, Gift of Walter Callender, Henry D. Sharpe, Howard L. Clark, William Gammell, and Isaac C. Bates.*

In Tarbell's *The Breakfast Room* (1902–1903; fig. 4.32) a décolleté young woman is again joined by an elegant group of glass, silver, and porcelain items to make up a sensuous still-life arrangement in the foreground that is complemented in the background by an equally interesting accretion of *objets d'art*—a marble bust, a Japanese screen, and other oil paintings and prints. Tarbell specialized in producing Vermeeresque interiors of domestic tranquility that are constructed around a female figure crocheting or reading and in the subtle light that filters into the space through translucently draped windows. As Bernice Leader has demonstrated, the popularity of this trope is linked to the conservative stance on the woman's movement evidenced by the Boston school and their patrons. While the boundaries of the upper-middle-class domestic sphere in the 1890s might have been enlarged to accommodate a larger role for women in the public, masculine domain, they were not dissolved, as these pictures attest.[210]

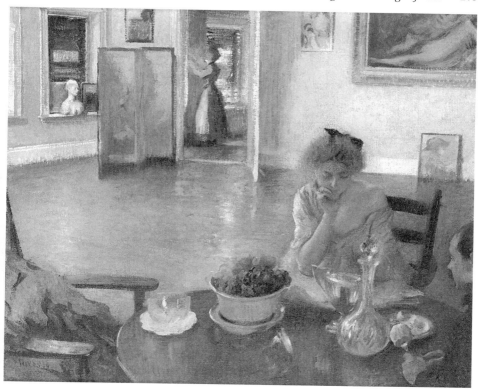

FIG. 4.32. *Edmund Tarbell,* The Breakfast Room, *1902–1903. The Pennsylvania Academy of Fine Arts.*

Thus the paintings of the Boston school situate the practice of self-culture in an ethos of pecuniary values signified in the glistening surfaces of a variety of costly accoutrements—silk gowns, polished mahogany tables and chairs, and blue and white porcelain vases. The mise-en-scène of Tarbell's *Girl Crocheting* (1904; fig. 4.33), for example, suggests a veneration of the present order that is empowered by the authority of the past. In Benson's *Rainy Day* (1906; fig. 4.34) acts of contemplation or self-culture are inextricably bound up with their affluent settings to the point that the performance of these cultural rituals seem to be conditioned by an interior that proclaims its heritage from middle-class Puritan stock. Contemporary reviewers saw in these paintings the expression of a New England patrimony. Like the majority of the Ten, Benson and Tarbell traced their ancestry back to seventeenth-century Anglo-Saxon settlers in Massachusetts. Benson was a "conservative son of Salem," one reviewer

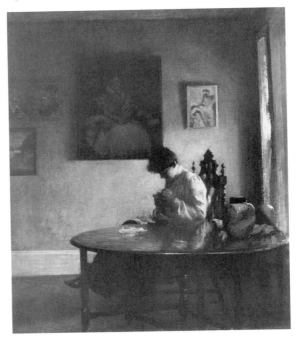

FIG. 4.33. *Edmund Tarbell, Girl Crocheting, 1904. Canajoharie Library and Art Gallery, Canajoharie, New York.*

FIG. 4.34. *Frank Benson, Rainy Day, 1906. The Art Institute of Chicago, Gift of the Friends of American Art.*

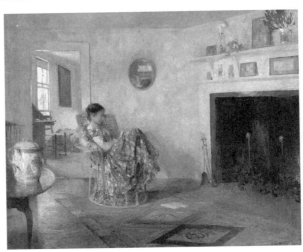

noted in 1905, and his paintings were filled with the delight in "old mahogany" and "distinguished, good-looking or beautiful people"; his art was the product of a certain pedigree, redolent with Salem's "tone of antique distinction and stability in the Americanism of the dwellers therein, who are unmixed with any but the pure Puritan strain."[211]

Filled with beautiful antique objects, these settings describe an entrenched plutocracy that extends generations back. The filtered light establishes the quiet ambience of the well-mannered Back Bay home and, glinting off surfaces, gives a luster and sheen to the inanimate objects; the light also reifies both the objects and the women in the room in terms of a tangible actuality. The female figures are rendered as solid physical bodies firmly situated within a socioeconomic milieu that identifies them as wives, mothers, and daughters, as opposed to the abstracted, attenuated, and dematerialized presences—the projections of intellectual and spiritual beauty—that dominate Dewing's images. In these Boston interiors, then, there is an "equal grasp of thought and externals":[212] the insistent materiality of precious objects is interchangeable with the assertion of New England cultural norm—the practice of self-culture in which the study of the aesthetic can lead to emotional and spiritual refinement.

In explaining why Tarbell had chosen to style his work after Vermeer's, Kenyon Cox in effect related the interest of all the Boston painters in locating northeastern cultural practice within the internal legitimating process of the history of art: "to accept the forms of nature as they are, yet to invest them with a nameless charm . . . , to achieve what seems a transcript of natural fact yet be in reality the finest work of art—this is what Vermeer did and Tarbell is trying to do." In Cox's apologetic it becomes clear that the Boston school self-knowingly prided itself on its roots in "the soundest and sanest painting of the past," and promoted itself as part of a conservative middle-class agenda.[213]

The extent to which aesthetic refinement also signified a means to social advancement to the Anglo-American moneyed classes is registered in De Camp's *The Blue Cup* (1909; fig. 4.35), which captures a parlor maid at the moment when she awakens to the subtle pleasure to be found in a blue and white teacup. This suggestion of social mobility is eluded in Dewing's interiors, in which the environment is all thought. Though Dewing's surfaces at times have a precious enamel-like finish that telegraphs their connection to the craftsmanship of the Dutch "little masters," his insistence on darkness or shadow in the veils of tone laid over the whole points to a reality that is located on another level of consciousness. These images

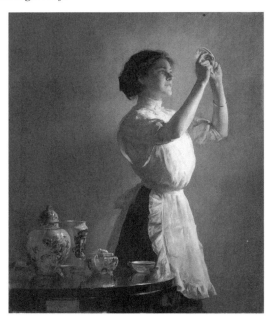

FIG. 4.35. *Joseph Rodefer De Camp,* The Blue Cup, *1909. Museum of Fine Arts, Boston, Gift of Edwin S. Webster, Laurence T. Webster and Mary M. Sampson in memory of their father Frank G. Webster.*

are structured to be read as projections of interiority, psychic spaces filled with a silence usually associated with feminine modes of intuition.

Perhaps the artist who came closest to Dewing's images of feminine interiority in promoting the therapeutic effects of affective aesthetic experience was John White Alexander (1856–1915). In paintings such as *Panel for Music Room* (1894; fig. 4.36) an elongated horizontal format accommodates two women seated on a divan, one of whom is playing a guitar while the other listens. A muted palette of greens and golds suggests the softness of the musical performance taking place. Not unlike Dewing's technique, the surface is dematerialized through a technique of washing aqueous pigments into an absorbent, coarsely woven canvas, and a rhythmic pattern of undulating lines is traced on the contours of the figures and within their gracefully curving draperies. This absorptive surface serves to enhance the engagement of the viewer in the abstract movement of the composition, just as the women are absorbed into the lyrical melody they are producing. In another related canvas, *Repose* (1895; pl. 8; fig. 4.37), a single female

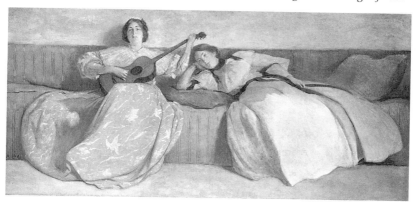

FIG. 4.36. *John White Alexander,* Panel for Music Room, *1894. The Detroit Institute of Arts, Founders Society Purchase, Beatrice W. Rogers Fund, Dexter M. Ferry, Jr. Fund, Merrill Fund, and Eleanor and Edsel Ford Exhibition and Acquisition Fund.*

FIG. 4.37. *John White Alexander,* Repose, *1895. The Metropolitan Museum of Art, New York, Anonymous Gift.*

FIG. 4.38. *John White Alexander,* The Great Strike—Pittsburgh in the Hands of the Mob. *From* Harper's Weekly *(August 11, 1877).*

figure reclines on a divan, the lines of which curve down in sympathy with the weight of her figure, while the black interior lines of her costume curve in the opposite direction with the torsion of her body, abstracted here into the flattened mass of the white dress she wears. Reputedly modeled after Loie Fuller,[214] the body of the dancer is still perceived as rhythmically animated even in repose. By movement and countermovement of line, tones placed and modulated into related tones, Alexander engages the viewer empathically in a musically structured moment.

Such moments comprised the bulk of Alexander's subjects in the 1890s and the following decade. Settling in Paris for ten years beginning in 1891, he had escaped from a job illustrating for *Harper's Weekly* in New York. Still earlier in his native Pittsburgh Alexander had captured the great railroad strike of 1877 in wood engravings for *Harper's* (fig. 4.38).[215] Befriended by Whistler in Paris in the 1890s, Alexander reiterated in his imagery and technique the therapeutic benefits of silence and meditation. For the tensions and violence of the American industrial scene, he thus exchanged Whistlerian muteness and harmony. In paintings like *Repose,* his female figures evade identification as national types and are rendered instead as generalized models of female beauty that are the products of a cosmopolitan European environment.

The enterprise of Dewing and the Boston school was concerned with locating contemporary Anglo-American culture in the evolutionary spiral of history, a trajectory presumed to emanate from the golden ages of Greece, Italy, France, England, and Holland and finally to culminate in the Anglo-American culture of New York and Boston elites at the turn of the century. Situated within the realm of domesticity and affective experience, the feminine figure served as a tangible embodiment of that evolutionary progress. These domestic images were intended to reinforce cultural norms and rituals, as well as a sense of Anglo-American social harmony and well-being; they reaffirmed commitment to that ethos. At the same time Dewing's colleagues who had appropriated and modified the impressionist idiom were also pursuing this agenda. From the 1890s to the advent of World War I, American artists would focus on Anglo-American cultural practices and modulate the painterly vocabulary of flux and instantaneity to suggest, as the tonalists did, the superior status of the American arena within the evolution of world civilization.

CHAPTER FIVE

The Ideologies of American Impressionism

PICTURES AREN'T MADE out of doctrines. Since the appear-
ance of impressionism, the official salons, which used to be brown,
have become blue, green, and red. . . . But peppermint or chocolate,
they are still confections.
—Claude Monet to Gustave Geffroy, c. 1915[1]

The ironic resonances of this remark must have been many for Monet. Not only did his status change from iconoclast to icon among the next generation of painters who adopted the impressionist style, but his revolutionary idiom also afforded the newcomer to the art arena the latest form of cultural capital, a fashionable mark of distinction, acceptable even for the walls of the salon. Moreover, in its second-generation reappearance impressionism was so reconstructed in intent that for Monet its meaning was lost. Indeed, pictures *were* now made out of doctrine, a formula that although based on his own art was anathema to Monet.

For Monet the ascent of impressionism to the dominant position on the walls of the salons was a dubious turn of events to say the least. The simulation there of his high-keyed reds and blues, of impressionist mannerisms, in his mind constituted acts of artistic dishonesty. He had developed his system of color-light notation as a translation onto canvas of his immediate ontological perception of himself in an original relation with the world. Now codified into a style—into a sign system of broken brushwork, colored light, framing devices, and points of view—the idiom no

longer suggested a transparent lens, the idiosyncratic temperament of the artist through which he or she had experienced the world. Ironically, this second-hand impressionism intruded itself between the artist and the world as a willful and artificial mediation that to Monet was relegated to the status of a "confection," a borrowed and thus reconstituted language that could not possibly speak of the artist's unique sensation of nature. In the 1890s and after, the appropriation of the previously despised impressionist aesthetic became the strategy whereby younger painters distinguished themselves both from the stodgy brown tonalities of the old guard and from the latest perversities of the symbolist avant-garde. While Monet himself was elevated to the ranks of the consecrated avant-garde, second-generation impressionists asserted themselves as the new establishment at the salons, the bulwarks of the status quo, and the darlings of the bourgeois art patron.[2]

This was by no means a phenomenon confined to the international salons of Paris and the Continent. In the hands of both the American and French painters who took it up three decades after its gestation in the late 1860s, impressionism was practiced as a conservative idiom. Not only were the works of the French being rapidly absorbed into American collections by that date, but also the exhibition walls of the official art establishments, the National Academy of Design and the Society of American Artists, like their counterparts in Paris, testified to the strength of impressionism in America by the turn of the century.[3] While it is possible to view this conservatism as a by-product of these painters' earlier academic training,[4] such schooling cannot be viewed as an ultimate determinant cause, since the original French impressionist painters enjoyed this same academic training. Within the space of the fifteen years in which Americans got their first substantial look at French impressionism, the Parisian avant-garde had become the old guard, with the middle class co-opting this once radical way of seeing the world. In the United States, the assimilation of impressionism was guided by the dominant cultural paradigm of evolutionary progress.

A parallel to the American appropriation of impressionism can be found in Scandinavia, where painters also came to the impressionists' naturalist idiom later in the 1880s and 1890s, as Kirk Varnedoe has shown, and in a nonlinear development synthesized impressionism with the psychological concerns of symbolism. Inevitably, however, these painters were engaged in local ideological problems and reproduced them in the terms of this hybrid idiom.[5] The inflections American painters gave to impressionism tell of their measured response to its perceived discordance, both in its

formal and optical experimentation and in its modern mythos. These artists embraced the same ideological paradigms as their upper-middle-class public; thus they were directed not only by their own notions of the successful work of art but also by the pressures placed on them by that public to put their acquired technical proficiencies to the service of a nationalist culture.

The early critical response to the French impressionist paintings Americans saw in New York, Boston, or Paris reveals contemporary American ideologies coming into conflict with the perceived philosophy and social program of impressionism. The paintings Americans produced in their moderated version of the idiom also posed a critique of, and even a resistance to, French modernism. But it was deemed no less imperative that the recognized "scientific" advances of the potentially disruptive impressionist idiom be somehow salvaged and incorporated as a "progressive" force into American art, since the American Spencerian school of evolutionary thought had persuaded a significant number of powerful men and women that the United States was to be the site of a new world civilization. In keeping with the traditional dialectic of American political rhetoric, radical or revolutionary forces required assimilation into established cultural practices in order to be defused. At the same time, such assimilation satisfied the American appetite for the new.[6]

The Darwinian paradigm structured the popular perception of the 1880s and 1890s as a culture of conflict: of capital against labor, the urban landscape against the countryside, foreigners against native Anglo-Americans, religion against science, and the idealism and elect self-identity of the Northeast against the nihilism and skepticism of European modernism. Not least of all, the paradigm also conditioned the American response to the modernist ideologies and techniques of the French impressionist mode. The term *impressionism,* as it has been used to describe the aims and achievements of the French painters, in fact fails to convey the aesthetic and ideological nuances of this mode in the hands of the Americans. Impressionism is not simply a style, a collection of formal mannerisms intended to violate and subvert the conventional Western norms of composition and vision. Rather, the social and philosophical implications of impressionism require articulation in the terms of contemporary ideological programs as well.

Writing in 1971, Linda Nochlin established the connection between the Comtean philosophy of positivism—the Religion of Humanity—with the Realists' demand for contemporaneity in art. Their concomitant rejection of the metaphysical dimensions of art and life in favor of a completely

secularized, modern context led to the naturalists' emulation of scientific practice—that is, observation that is restricted to physical phenomena only. This positivist program was established as early as the late 1860s, in Monet's project for *Déjeuner sur l'herbe,* a painting that constituted a monumental precedent for the attempt to capture "presentness" and "immediate experience," in contrast to the mythological terms prevalent in salon paintings.[7] The parallels between the integral aspects of experience as expressed in impressionist vision and the varieties of positivist doctrine have been further elaborated by Richard Shiff.[8] Meanwhile, Monet's search for visual truth, specifically his working procedure based on observation of natural phenomena and comparison of results, has been related by Joel Isaacson to the scientific model of experimental procedure outlined by the followers of positivism's founder, Auguste Comte.[9]

In part, then, the radical quality of French impressionism can be construed as resulting from this positivist experimentation. In contradistinction to academic painting, Isaacson defined the impressionist moment of the 1870s as a period dominated by the paradigm of scientific investigation of "time and change as constituent elements of our experience of the modern world," as well as an inquiry into the possibilities of the constituent elements of painting—line, color, space, and point of view, especially considered through the format of the sketch.[10] Both T. J. Clark and Robert Herbert have explored the intricate relation between the impressionists' concerns and the social history of the 1870s and 1880s, in particular the extent to which their paintings rehearse contemporary social ideologies and the myths of modern life—namely, the nature of subjectivity and the impersonality and theatricality of urban existence that came with the acceleration of the capitalist commodification of leisure and entertainment.[11]

In analysis of the category of painting called impressionism, then, formal development, thematic repertoire, and its resulting ideological alignment have become requisite components of the discourse. In cross-cultural comparisons between French and American versions of impressionism, the way in which high-keyed color and spatial experimentation appeared to contemporary American viewers to be inscribed with current social and political controversies now needs to be fully explored. The significances Americans apprehended in French impressionist works arose from the particular ideological matrix, from the social and philosophical dilemmas, that took shape at that historical moment in the northeastern and midwestern United States. Such a fit between Americans' formal modulations of the idiom and the ideological constellation cherished by

the American audience requires examination. In the early 1890s, for example, John Twachtman's first paintings in a looser, high-keyed mode were read by his contemporaries as projecting a quietist, even spiritualist imagery that was antithetical to the stridency and materialism apprehended in the French.

As such a reading of Twachtman's works suggests, what is often construed as "impressionist" painting should more properly be aligned with its contemporaneous European counterpart—as a form of postimpressionism with significant affinities to symbolism.[12] As Wanda Corn and John Wilmerding have asserted, American painters in the last quarter of the nineteenth century did not follow the chronology of European modern developments. The American response to European impressionist and postimpressionist painting, rather, was eclectic and compressed into the shorter time span from the mid-1880s through the first decade of the twentieth century. "Americans *were* post-impressionists," Corn and Wilmerding state, "in their obsession with surface, their rejection of science and naturalism, and their insistence on art as a reflection of subjective experience."[13] Moreover, American painters were capable of recognizing the differences between the early positivist phase of French impressionism in the 1870s and its later permutation in the late 1880s, when Monet had gravitated from the scientist's detachment and the abolition of hierarchies of meaning to a taste for more manipulated images and Mallarmé's mystery in nature.

As Monet moved from decomposing the landscape into "a little square of blue, here an oblong of pink, here a streak of yellow," to images that speak of his memory and fantasy, of a self-contained, even hallucinatory world, in the early 1890s, he amplified the subjectivity of his vision to the point that the symbolists claimed him as one of their own.[14] Other impressionists, such as Cassatt, Pissarro, Caillebotte, and Degas, also gravitated toward neoconservative styles, as well as toward symbolist imagery and psychological concerns in these years. Monet's later aesthetic philosophy—resonant with Mallarmé's poetic—involved precise observation simultaneously with the use of surface design and atmospheric *enveloppe,* to capture the mystery in nature. This was the philosophy he communicated directly to Theodore Robinson, whom he befriended at Giverny in the early 1890s. Shortly thereafter Robinson in turn impressed this philosophy on his close colleagues Twachtman and J. Alden Weir, who in the eyes of their peers were to become two of the most venerated American landscapists in that period. Twachtman and Weir had already been exposed to impression-

ist painting during earlier periods of study in France, but only several years after their return to the States did they begin to transform impressionism through the lens of northeastern Anglo-American ideologies.

Against this historical background, it might be noted that American painters such as Robinson, Twachtman, and Weir have been judged to fall short of impressionist formal radicalism. They deliberately held back, in the fragmentation of form and in the overall vibration of atmosphere, from the extremist practices of Monet and Renoir in the 1870s, at the height of the impressionist period.[15] In addressing the American rejection of French daring, however, what requires questioning is whether these painters would have wanted to emulate such fragmentation, since this formal radicalism was freighted with political and social extremism. For these American painters, who came out of a middle-class ethos and who aspired to attain middle-class social status as professionals, such a stance was anathema.

Before examining the American interpretations of the impressionist idiom and determining their significance for American culture of the 1890s, however, it is essential to determine first what the paintings of Manet, Monet, and their colleagues were saying to Americans of that era. What kind of aesthetic did American painters think they were appropriating and modifying, and how did they bend this aesthetic to their own ideological agendas? Americans by no means responded uniformly to European impressionist and postimpressionist painting, but the pattern of objections voiced in the periodical literature and the art press tellingly recapitulates the cultural climate that also generated the American artistic response. These critical voices not only directed artists, perhaps encouraging and discouraging them in certain tendencies, but they also expressed the middle-class values that these painters embraced without exception.

In examining the negative pronouncements on impressionism, in particular the objections to the figure paintings of Manet, Renoir, and Degas and to the landscapes of Monet, we begin to confront the ideological basis of the American resistance to social and philosophical change. Political and social conflict were displaced into the arena of aesthetics, as the Anglo-American elite struggled to maintain its definition of reality in the semblance of its traditional self-image as an elect people.[16] Thus, the bolstering of conventional economic and political hierarchies was reenacted in the symbolic universe of art in the 1890s, as a resistance to certain aspects of naturalism was mounted in the face of its perceived potential to disrupt established Anglo-American social norms.

THE CRITICAL RESPONSE TO FRENCH IMPRESSIONISM

Americans received their first extensive exposure to French impressionism in 1886, when Paul Durand-Ruel, the impressionists' Parisian dealer, was approached by the New York entrepreneur James Sutton to mount a large exhibition in his American Art Association galleries.[17] Monet was against this proposal to send his pictures to the New World, for it was only in Paris, he insisted, that some taste still survived; thus, it would be fruitless to seek this phantom golden apple in "the land of the Yankees."[18] In serious need of funds at this time, however, Durand-Ruel complied, by sending Sutton almost three hundred paintings, a mix of works by impressionists and salon artists. Of the pictures shown, approximately five-sixths were by the impressionists and their associates, while the remaining portion was comprised of the kind of conventional fare with which Monet and Degas would not have wished to be associated.

Shrewdly, the first gallery the viewer saw was installed almost entirely with the works of these salon painters. Occasionally a Manet or a Pissarro was slid between studies of dogs by Mélin, hunting pictures by John Lewis Brown, horses or an exotic African scene by Huguet, a blacksmith by Henri Chenu, a military subject by Jean-Paul Laurens, and so on.[19] The initial encounter with impressionism was thus softened, and the visitor gradually introduced to the shock of the bright blues and reds. But essentially this strategy was to little avail. The *Art Interchange* announced that "all the works of art worth seeing" were located in this first gallery.[20] Critically, the show achieved the status of a sensation, a *succès de scandale*. After its run at the American Art Galleries was up, the exhibition moved over to the premises of the National Academy of Design, where crowds continued to come to laugh. Even though a few sympathetic reviews were published, Durand-Ruel managed to find only a few buyers for Monet. Out of the nearly three hundred paintings, about 20 percent of the total dollar value of the paintings and a group of more than thirty Monet paintings were sold, many of these purchased on speculation.[21] Monet's prediction proved essentially correct: as of yet there was little taste in America for the impressionist aesthetic, as the majority of the published reviews of the exhibition confirmed.[22]

The most vituperative attacks of the press were aimed at the figure painters' unorthodox subjects. For his large-scale depictions of absinthe addicts and destitute men who had been displaced by the recent modernization of Paris (fig. 5.1), Manet was derided by the *Art Amateur* for his

FIG. 5.1. *Edouard Manet,* Philosopher (with Hat) (Le Philosophe drapé), *1865. The Art Institute of Chicago, Arthur Jerome Eddy Memorial Collection.*

"perverse but not very powerful imagination."[23] These straightforward, unsentimentalized images of poverty were novelties on the walls of an American exhibition gallery. Displayed there, the "hard brutality of the naked truth,"[24] as the *Critic* put it, was difficult for American audiences to confront, since it disrupted the conventional aesthetic function of the art object in this period—to enchant through sensuous beauty—with a commonplace subject imbued with the overtones of social discontent.

Such a "connection between 'realism' and ugliness" revolted the *Art Interchange:* like the French naturalist writers who sought to impress the reader with the sordidness of the urban underbelly, Manet, Degas, and Renoir seemed to render even the most harmless themes in "the most dyspeptic and suicidal manner . . . conceivable."[25] The connection to the corrupting influence of French naturalist literature seemed ever-present in the reviewers' responses. The *Churchman* labeled the impressionists' efforts sheer "Zola-ism," "sensualism and voluptuousness," and "sheer atheism," while the *New York Times* also hinted at perversion, sensing something "unnatural" about these works.[26]

Americans who managed to see the impressionist exhibitions in Paris in the years before the New York show had also made it a point to object to Manet's choice of subject. Though Lucy Hooper noted that he was "less mad than the other maniacs of impressionism," the realists' reputed devotion to "the mean and hideous," the dispossessed, or a working man drinking beer, for example, seemed unnecessary.[27] For similar reasons John Van Dyke, a professor of art at Rutgers, scoffed at Manet's *Woman with a Parrot* and *Boy with a Sword* after viewing them in New York in 1883. "In subject," he wrote, this "scrawny old maid" and "disreputable, dirty-looking boy" both posed examples of "concentrated ugliness" that were mesmerizing in their "repulsiveness" and "ugliness."[28]

Degas was the impressionist whom critics singled out as the most redeemable of the figure painters. Though his subjects apparently belonged to the same underclass that was derided in the work of Manet, his tendency to distance himself from his laundresses, ballet girls, and café singers produced such weird and abrupt effects that viewers were fascinated, and the shock of his disreputable subjects thus was ameliorated (fig. 5.2).[29] Degas's striking, aestheticized vision seemed somehow to blunt the barbs of his cynical relish in the seamy side of human nature, a predilection that allied him with literary naturalists. This ambivalent response to Degas was epitomized by the critic for the *Art Age* after viewing Durand-Ruel's 1886 New York showing:

Degas, the leader of the extremist side of the school, possesses in some respects the strongest individuality of all. His eccentricity almost reaches the sublime. There is a moral and artistic depravity in him which is almost Mephistophelean. His ballet compositions, with their vicious, ugly-faced women, pathetic to the last degree, are like nothing so much as modern Parisian sabbats at which Satan presides. *The Ballet of Robert Le Diable,* showing a row of male heads in the orchestra chairs, and the darkened stage with its phantom shapes, is strikingly original in composition and in its sharp contrasts. There is more in Degas's pictures than mere painting. They are terribly significant. The literary side of them is strong and subtle, and he who runs may read, if he know [sic] his Paris, the stern and bitter cynicism that lies behind the brilliant fantastic débauche of brush or pastel-crayon. There is great knowledge of art, there is greater knowledge of life, in this Frenchman's handiwork.[30]

FIG. 5.2. *Edgar Degas,* Cabaret, *1876. Pastel over monotype. The Corcoran Gallery of Art, William A. Clark Collection.*

Renoir's monumental figure composition, *The Luncheon of the Boating Party* (1881; fig. 5.3), along with his other works exhibited in New York in 1886, also provoked strident accusations of sensualism. Renoir's art lacked the mitigating aestheticism of Degas's, as one reviewer perceived, and seemed to indulge in "a vulgarity of color and of types that is well-nigh bottomless."[31] Though *The Luncheon* actually represents an upscale social group including Renoir's fiancée, fashionable models and actresses, a banker, a journalist, and the upper-middle-class impressionist painter Gustave Caillebotte,[32] the public no doubt was led to view this picnic as a scene of working-class leisure, either because critics such as William Howe Downes remembered its exhibition at the Boston 1883 "Foreign Exhibition" as *Boatmen's Breakfast at Bougival*[33] or because men in various states of undress, displaying their well-developed muscles, casually and intimately interact with women who seem to ignore middle-class conventions of propriety. Also attracting a good deal of press attention in New York in 1886 was Caillebotte's picture of floor scrapers, exhibited with two of his canoers, which only added to the perception that the impressionists celebrated the lower classes.

The impressionists' focus on "vulgar" working-class types had already become an issue several years before the Durand-Ruel exhibition, in the pages of *Lippincott's Magazine.* Throughout the 1870s this Philadelphia journal published a series of articles on culture and travel in France. One of the first evaluations of impressionism to be printed in America, in 1879,

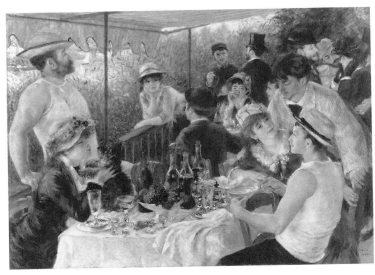

<small>**FIG. 5.3.** *Auguste Renoir,* The Luncheon of the Boating Party, *1881. The Phillips Collection, Washington, D.C.*</small>

"The Impressionist School of Painting" attempted to debunk the impressionists' claims for their art and expose their socially subversive element. These painters insist that their art descended from a line of Barbizon landscapes, this correspondent argued, but the impressionists don't paint the rural countryside at all. Instead, they

> immure themselves within the town-walls to paint studio, dramshop or theatre interiors, seeking freshness in the worn, painted, spectral faces such as haunt Baudelaire's verses, and gathering what Baudelaire has called the *fleurs de bitume.* If they go to the country at all, it is on a Sunday excursion just outside the city—to Asnières, Chatou, or Bougival, where Paris has discharged her crowd of grisettes, with their attendant dry-goods clerks got up for the day as *canotiers* to make the river hideous with their loudness.[34]

Not at all disguised here is the writer's contempt for the socially marginal, whose haunts were the streets and the dramshop, and the working class— the shop girls and clerks with their indifference to bourgeois codes of social deportment.

In the late nineteenth century American critics clearly articulated and denounced this violation of middle-class norms and its social and philo-

sophical implications.[35] If the realists' and the impressionists' symbolic celebration of the lower classes was threatening to the French establishment in terms of that country's shifting political enfranchisement and power base, as Clark has suggested, in America this menace took on the nuances of the nativist debate over the peril to the traditional definition of American identity as Anglo-American, a peril which in the 1880s was perceived in the growing population of eastern and southern European immigrants in the northeastern United States. At the moment when the American middle class embraced a stereotype of the average worker as a foreigner, a radical, and a rioter, it should not be surprising that strident objections were hurled at the impressionists' displacement of the conventional objects of beauty as the subject of art with the very element that seemed to threaten a pervasive and imminent class war.

Speaking for the vast majority of her readership, Lucy Hooper in 1880 had expressed frustration over why these French painters couldn't value the "reality in noble and lovely objects" rather than in the "mean and hideous ones" they enjoyed: why not celebrate the reality of "a refined and beautiful woman" or a rose, she asked, in place of "an ugly, coarse peasant"?[36] Unlike the peasant subjects of the Barbizon school (with the exception of Millet's), the destitute who appeared in the canvases of Manet and the Batignolles painters did not suggest a sense of nostalgia for an era of agrarian harmony. Rather, they all too directly echoed the hardships and discontent of the American working class, with its vast numbers of immigrants now organizing to make their exploitation known.

As historian Robert Wiebe has pointed out, the fear of social chaos in this period intensified to the point that even prominent middle-class intellectuals looked past the spectacle of urban misery and developed a pattern of denial. In contrast to French naturalist writers, for example, the novelist William Dean Howells, America's principal expositor of literary realism in the 1880s and 1890s, refused to admit into his fiction the phenomenon of violence as a way of life in the slums because he considered it "unnatural." Likewise, the economist David Wells could walk past the vilest tenements near his workplace in Manhattan in the 1870s and yet deny the very existence of the poor.[37] Only the next generation of naturalist writers such as Frank Norris and Stephen Crane in their antilabor novels grappled with the anxieties surrounding the nation's growing proletariat, examining "the beast in man [that] constantly lurked in the shadows of his mind," a beast that "once loosed, . . . would destroy all reason and ravage society."[38]

While twentieth-century modernists characterized the fin de siècle as the "gay 90s" or the Gilded Age, an era that was carefree, pleasure-loving,

and concerned with the pursuit of material wealth, to many who lived through it, such as Charles Peirce, it was an "Age of Pain." The modernist reconstruction of history facilitated the tactic of legitimating and celebrating its own, supposedly more authentic, suffering partially by way of castigating the late nineteenth century for its pretensions and hypocrisies. This perception is regrettably short on accuracy, however. Though middle-class Anglo-Americans might have kept up a blithe facade, especially in the 1880s they remained privately and deeply disturbed by changes in the social and religious spheres—changes that to them rarely connoted progress. Soon after an entire generation of men had been lost in the Civil War, evolutionary science seemed to assault traditional religious beliefs about the metaphysical structure of the universe. Uncertainty over the existence of God, or life after death, made the sacrifice of the war especially hard to bear. And then, with the massive immigrations of non-WASPs in the 1880s, the demographic structure of American society began to shift. Wiebe writes of this time of "nationwide crisis" when "men from all walks of life, already shaken by an incomprehensible world, responded to any new upheaval as an immediate threat."[39]

The most obvious targets for this defensive response were the immigrants whose swelling numbers focused the conflict on the major eastern cities and midwestern industrial centers. By the mid-1880s the northeastern Anglo-American communities were experiencing a loss of confidence in their power to maintain America's traditional social order and identity, specifically since the Irish Catholics were successfully challenging the Anglo-American political order in New York and Massachusetts.[40] Tensions festering between dwindling small towns and growing urban populations, small businesses and large corporate enterprises, and labor and capital were further exacerbated by major depressions in each decade from the seventies through the nineties. A staggering and seemingly irreconcilable gap opened up between the very rich and the very poor: the richest 1 percent of the country owned more wealth than the remaining 99 percent combined, while the poorest 12 million families on the average lived on less than $380 a year (below the poverty line of $500 a year).[41]

Workers obviously bore the greatest brunt of these downturns, with the result that their poverty and degradation at the hands of large, impersonal, and exploitative corporations led to a massive labor uprising in the mid-1880s, a movement that saw membership in the Knights of Labor rise from 50,000 to 700,000 members in the space of two years.[42] Of the thousands of strikes that shook the American workplace in the 1880s, one of the

bloodiest and most violent occurred in 1886 in Chicago's Haymarket Square, when a bomb was thrown into a line of policemen confronting an anarchist demonstration for the eight-hour workday. The explosion of the bomb and the policemen's fire of bullets eventually produced at least 67 casualties. The bloodshed finally culminated in the execution of four radicals after a trial in which no firm evidence had been presented to convict them. As Henry David has commented, the Haymarket affair provoked the first "Red scare" and catalyzed the nation's fears of labor radicalism, although only one-third of all industrial workers were immigrants.[43]

Perceived as "dispirited breeders of poverty, crime, political corruption and simultaneously as peculiarly powerful subversives whose foreign ideologies were undermining American society,"[44] Catholic and Jewish immigrants became obvious scapegoats for the outpouring of anger and abuse aimed at them, a torrent that sharply accelerated after 1886. Labor protests, as they reached a crescendo in these years, were received by the Anglo-American community as "mass sedition," a "preface to a political revolution," and the beginning of an "American Reign of Terror." In their wake followed the rhetoric of law and order, as well as a number of attempts to crack down on the radicals. That the prominent Christian Socialist Washington Gladden likened the state of industrial society to "a state of war" denotes the widespread panic after the Haymarket Riot in 1886, the year not only of the Great Upheaval but also of Durand-Ruel's New York exhibition of impressionist paintings.[45]

If this climate seemed to portend an impending social Armageddon, then, it can hardly seem surprising that the art-buying upper- and upper-middle-class public did not want to see the "great unwashed and unenlightened"—whom they suspected to be potential bomb throwers—glorified on the canvases of contemporary painters. Just as the United States was struggling to regain its lost unity after the Civil War, the country seemed to be again on the verge of cataclysm, this time in a war of classes. In his histrionic bestseller *Our Country* (1886), published just before the Haymarket Riot, Josiah Strong warned that over five million immigrants who had entered the country since 1880 had brought the diseases of Romanism and socialism with them.[46] Suspecting that they had grown more genteel and weaker as they settled comfortably into an overcivilized life, Anglo-Americans feared that these healthy and vigorous peasants would overpower and subsume them, the original settlers of the country. Spencer himself had warned of this at the end of his American tour in 1882.

Understandably, given the scope of such social discontent, the Darwinian struggle for survival was never out of mind for long. Both as metaphor and as science, Darwinism was invoked on every occasion as the frame for contemporary class frictions.[47]

The Darwinian paradigm was at work providing a military metaphor for the struggle for dominance not only in the political and social fields in the 1880s and 1890s but also in the war of science with religion and the embattlement of radical cultural modes with traditional styles.[48] The artistic field reproduced on a microcosmic scale the larger struggle for dominance and national self-definition being played out simultaneously in the political and social spheres. As a method that was based on the laws of contrast as opposed to the entrenched tonalist principles of unity and harmony, impressionism, particularly in America, summoned up the dreaded eidolon of Darwinian struggle. Manet was credited with beginning the vogue "of representing nature out of tune, as some men begin great social or political revolutions."[49] The landscapists Monet and Renoir failed to resolve discordant tones into atmospheric harmonies; instead, they substituted a "lustful rioting in color," and technical crudities were cultivated to a point at which Monet in particular seemed to relish "the harsh juxtaposition of unrelated tones."[50]

Until the mid-1890s, to be an impressionist was to revel in artistic chaos and incoherence and to indulge the senses in a manner that threatened the rational operation of the intellectual faculties[51]—to force color to such high keys that it "shrieked," to produce "horrors," "atrocities," and "monstrosities,"[52] and to jeopardize "moral and mental harmony" for the sake of ugliness.[53] The impressionists' vision was so extreme, they had carried "their analysis of color in diffused light so far," Theodore Child lamented, "that no ordinary healthy eye can follow them."[54] The brutal and violent use of saturated colors constituted artistic abuse, it was protested, inducing effects of "an unhealthy nervousness, exasperated in some instances even to a painful degree."[55]

Admittedly, the French impressionists suffered similar accusations of artistic chaos and brutality from critics at home, especially in the late 1870s.[56] In the context of the American culture of conflict, however, the experimentation and marginalized lower-class types of the French were assigned specific unsavory political implications. Responding to the works of Manet and the figure painters at the 1886 American Art Association exhibition, the *Art Age* foregrounded the perceived anarchist subtext of these pictures:

A bas les bourgeois! is the cry that echoes from one wall of these galleries to another, and the good bourgeois of New York art, whether professional or lay brothers, are flocking to look at the impressionists and to read their own condemnation inscribed on these monuments of revolutionary art. Communism incarnate, with the red flag and the Phrygian cap of lawless violence boldly displayed, is the art of the French impressionist.[57]

Other common epithets castigated the impressionists not simply as radicals and extremists but also as "mad outlaws," maniacs, madmen, morally depraved souls, and animalists.[58]

For American viewers, then, the correlations between social ideology and aesthetics were direct: Manet's working-class sympathies seemed to be cut of the same cloth as the anarchist mode of Monet's "pure" impressionism—in terms of its vibrating forms violent and distorted to the point of pathology, its aggressive, broken brushwork, and its shrieking, riotous contrasts of complementary colors.[59] Building on this discourse, William Brownell, a critic for *Scribner's,* deduced that the impressionists were lacking a sense of order, a condition that was tectonic as well as moral, for it was "the passion for order" that distinguished the civilized from the savage. Brownell was willing to admit that Monet's works captured an "incomparably vivid effect of reality," but this was not enough; they were irresponsibly devoid of all thought, philosophy, or values, except "the temper of the radical and the rioter."[60]

Not only were American eyes in the 1880s conditioned to the quiet monochromatic schemes of the Barbizon school, which were but a rebuke to the perceived shrieking of the new painting, but Corot and Whistler also delivered a sense of mystery and harmony that in turn reassuringly spoke of an intact transcendent structure of the universe, as well as of the transcendent art object that was in tune with this structure.[61] According to Spencer's evolutionary scheme, and specifically his predictions for American civilization, harmony and unity were signs of humankind's increasing mental and spiritual progress—of progress to the higher life that Americans would unquestionably enjoy in the utopian future just ahead. By regressing the viewer to a solely instinctual response, by abandoning the intellectual or philosophical component of art, the impressionist seemed to be leading the viewer straight to sensualism and chaos.[62]

Unquestionably, several American critics were appreciative of Monet's contribution to the problem of creating a spontaneous work of art, as well

as his achievements in the science of vision. But they considered these accomplishments insufficient to count him among great artists, or to rank his works equal to those of Corot, for example, who was considered the poet-painter par excellence. Quite typical of this response, especially in the 1890s, was Theodore Child's perception that Monet's mind was "framed analytically after the model of modern rationalism." For Child and others, this attitude that upheld truth as all-sufficient had still failed to produce a work with "that Beauty, that taste, and that mysterious and definitive charm which stamp the creations of the consummate artist."[63] Brownell delivered what was to become a majority report when he concluded that Monet's scientism and "lack of philosophy" led only to impersonal and mechanical qualities in the painted image. The emphasis on optics in artistic vision, he decided, was materialism, pure and simple: Monet did "nothing with his material except to show it as it is"; either his painting "suggests nothing" or it "too closely resembles a scientific demonstration" until it was reduced to "'colored stenography.'"[64]

There were also those critics such as Clarence Cook or Brownell who were able to appreciate impressionism as a formal advance that allowed the viewer a greater apprehension of "nature's splendor and vivacity."[65] Cecilia Waern, for example, similarly argued for impressionism. In her rationale the painterly innovations of impressionism emanated from an act of vision, in which the obedience to the laws of focus and the choice of a single moment lent that vision a startling unity.[66] While Waern spoke of Monet as a poet and a genius, others felt that it was left to American painters to realize the artistic potential of this newly discovered "elemental speech of nature." Still underwriting the traditional doctrine of Anglo-American election, the moral imperialists among American critics determined that the future of impressionism now lay in the hands of Americans who would wed its science to "imagination in design and spiritual and poetic significance in motive."[67] Moreover, by the late 1890s, if not earlier, it had become obvious to some observers of European art that a reaction against impressionism had set in among French painters and that they had moved beyond impressionism. Color-light investigation had been exhausted, tone had been reinjected into color, and the symbolist movement, directed by the works of Puvis de Chavannes and the English Pre-Raphaelites, had reoriented art toward religious feeling and subject.[68]

Thus American complaints against Monet's scientism centered around the perceived lack of any philosophy guiding Monet's vision: he simply played the role of the scientist who objectively records the disorder and the

chaos of nature. As a technical achievement, this art form was admirable. But ultimately, if the artist was expected to function as a seer, and if the artwork was expected to provide reassurances in the form of reflections of the transcendent order of the universe, then the impressionist painting, as it mirrored only the blank surface beauty of material reality, offered a profoundly disturbing vision. It yielded no opinion on the single most contested issue of the day—the presence or absence of God in the universe. Or, even more troublesome, this neutrality might be taken to signify the philosophy most agonizing to those Americans who sought to refute the skepticism engendered by Darwinian science—the agnostic stance of the unknowability of God, which is the first cause problem in philosophy. A case in point is the fears of one of Monet's most earnest supporters, Helen Abbott Michael.

A native of Philadelphia, Michael was herself trained as a scientist—an organic chemist. After seeing the New York exhibition of French impressionist paintings in 1886, she was inspired to write an appreciation of Monet's work, which she published as *Science and Philosophy in Art* under the pseudonym of Celen Sabbrin.[69] In this pamphlet Michael pronounced Monet "a master thinker who feels the power of the infinite, and can reflect it to others." For Michael, Monet did play the seer and the philosopher: he had brilliantly penetrated "into the internal structure of things" by evoking the underlying geometrical principles of space, as well as "harmonies of color tones." Monet saw into the essential structure of nature, supplying the laws of molecular dissymmetry with form, translating the laws of force into triangulated compositions, and teasing from color its psychological suggestiveness. He thus gave "expression to the most serious truths of our life."[70] When it came to confronting the substance of those truths Michael intuited from his paintings, however, her adulatory tone darkened.

She analyzed the precise, almost symmetrical composition of Monet's *Poppies in Bloom (Poppy Field in a Hollow near Giverny)* (1885; fig. 5.4), and her sense of Monet's revelation of geometrical principles only filled her with dread.

> Its depth is interminable, and a sense of solemnity steals over the observer. He is brought most terribly near the source and origin of things. The sky is in marked contrast to the poppy field and hill, where it is the present that offers. Here is the beginning of life's course. Unconscious of what is back of the hill, the soul is absorbed by the immediate; though she may step forward, through the gay-

flowered field, onward to her future, the past is locked in mystery. Nature throws no obstacle to her progress; there is no warning hand to hold the soul from running to her own destruction; and the indifference of nature to suffering or happiness is terrible to contemplate.[71]

Michael here isolated her fear of the artist's agnosticism: Monet had laid bare the brutal physical truths of nature, of its chronometric limitations to the immediate, and he refused to speculate on the existence of a realm beyond the present that would accommodate and perpetuate the life of the soul. While Michael longed to find in art the symbolist affirmation of natural supernaturalism, she suspected the presence of what Spencer had named the Unknown, lurking in the distances behind the hill. She despaired to encounter in Monet only the positivist here and now, even though she was enthralled by the "atmosphere of magic grace and purity" of that present moment.

A Landscape at Giverny, the companion picture to *Poppy Field,* merely confirmed for her this message of "hopelessness, of the unattainableness of absolute truth, and a confirmation of science's teachings, in the ultimate uselessness of human effort":

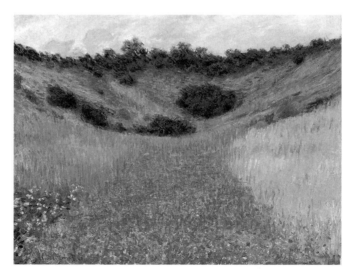

FIG. 5.4. *Claude Monet,* Poppy Field in a Hollow near Giverny, *1885. Museum of Fine Arts, Boston, Juliana Cheney Edwards Collection.*

The mathematical principles are fully expressed in this picture, and vivify the thought that geometry is soulless, and that natural forces are relentless and pitiless. . . . On and on the eye travels. . . . Speculation can go no further; what is beyond these hills may never be known. The heart weakens and the soul is faint at what she sees. It is the end of the struggle of the human race; all work and thought have been of no avail; the fight is over and inorganic forces proclaim their victory. . . . Nature is indifferent, and her aspects are meaningless, for what indications of the unavoidable end come from seeing that gay flowered field? It is a mockery, and that mind which has once felt the depth of the thoughts expressed in this painting, can only seek safety in forgetfulness.[72]

In a manner typical of the Anglo-American intelligentsia at this moment, Michael's meditation struggled to come to terms with the questions that emerged from Darwin's studies. Monet's agnostic vision seemed unsympathetic to the dilemma, in which the educated classes found themselves grappling with a choice between the apparent revelations of Darwinian science and traditional religious belief in a spiritual world beyond the present.

William James addressed exactly this historical phenomenon when he attempted to convince the northeastern elite that life was worth living and of the rightness of belief in the face of science's inability to provide evidence for, or even its contradictions of, such faith.[73] If Darwinian science, as James maintained, was unable to verify the legitimacy of Protestant practice, artistic production now had to assume that role of asserting the existence of the human soul as evidenced in the transcendence of human culture. Art had to fill the void left by science. Limited to the immediate observable reality, the perfected designs and pure hues of Monet's landscapes seemed to weigh more heavily in the scientific camp than the soulful. They heightened the perception of nature as eternal, but they were bereft of the pictorial conventions that Michael and her contemporaries recognized as hinting at the supersensory mysteries of life. In place of the shadowed, twilight world of a Ryder, a Tryon, or a Dewing, Monet revealed this world in the bright light of high noon. His world gave the sense that earthly, physical nature was absolute, the be-all and the end-all, which only resulted in a painful awareness of human mortality and the uncertainty of an afterlife.

THE POLITICS OF GARLAND'S ENDORSEMENT

As Michael's response indicates, Americans trying to protect their religious investments from the incursions of Darwinian science could and did perceive Monet's impressionism as a dreaded spectre of positivism and agnosticism. By the same token, however, impressionism could also be useful to those dedicated to Comte's Religion of Humanity, particularly to those committed to a politics that prescribed the development of cultural forms suited to the needs of a nonelitist, egalitarian society.

Such a persuasion motivated Hamlin Garland's advocacy of impressionism. Almost immediately after he surveyed the paintings exhibited at the Chicago World's Columbian Exposition in 1893, Garland published an essay celebrating impressionist iconoclasm.[74] While Brownell and others abhorred the expression of "the radical and the rioter" they found inherent in impressionism, Garland based his promotion of impressionism on its potential to embody a form of cultural anarchy that would "slay" the old artistic regime, leaving no middle ground. This stance evolved from his own populist politics. Garland's push for a democratic art and literature that addressed the local concerns of midwestern farmers emanated from the same political commitment apparent in his support of Henry George's call for land reform, a movement that aimed to unseat the dominant capitalist elite in the Midwest and West.[75] For Garland, impressionism shattered the early nineteenth-century tradition that pictured the American landscape in terms of an aristocratic pastoral ideal, and, as such, it provided a painterly parallel for his own short stories.

Garland's polemic was premised on an "inexorable march of art"—a progressive movement of art he predicated after Spencer's evolutionary spiral of human civilization upward toward the consummation of greater glories.[76] To Garland, such a movement forecast the inevitable overthrow of the tyrannical critical and commercial forces that had elevated past art over current production. This ceaseless spiraling trajectory also meant that impressionism itself would eventually give way to the new and revolutionary art of the future.

To construct his evolutionary scheme, Garland set up a neat contrast between past and present, using what he termed the effete and effeminate mode of the Barbizon landscapes that dominated the market in the 1870s and 1880s as a foil for the health and virility he perceived in the impressionist mode.[77] The picture he drew depicted the impressionist as a cheerful hard worker, who sought out freshness, vigor, and vibrant color, banishing

from the canvas the traditional mystery and sentiment that produced only ambiguity, weakness, and lifelessness. By virtue of the pronouns used, as well as the gender-inflected character attached to this artist, Garland cast the impressionist into a masculine role: "His eyes had not been educated to despise the vigor and splendor of nature," and he fearlessly mixed "raw" untoned colors on the canvas, in contrast to the timorous, genteel concern for harmony manifested by the Barbizon and tonalist painters. The worst that could be said about the impressionist was that he was "daring" in choice of subject and "over-assertive" in handling. As they are couched within Garland's decidedly masculine ethos, however, even these "faults" take on the quality of masculine virtue.[78]

Garland seemed not to mind if American painters borrowed a mode of painting that had originated in Europe, as long as the subject was characteristic of the specific geocultural region under study. "Art, to be vital," he said, "must be local in its subject," and "its universal appeal must be in its working out,—in the way it is done."[79] Thus the virile brushwork and color of impressionism lent the painting its universal appeal, while the local subject rendered it politically palatable. The privileging of local content, however, made Garland's ideal a moderated, middle-of-the-road impressionism, as opposed to the high impressionist aesthetic of Monet. The "impressionist" work in the "Loan Collection" at the Columbian Exposition he singled out most for praise was a painting that corresponded to many of the rural vignettes in his *Main-Travelled Roads* (1891). *The First Communion (Confirmation Party),* by the Norwegian Nils Gustav Wentzel (1887; fig. 5.5), presented a brightly colored example of realist peasant genre that celebrated rural Scandinavian religious ritual. "It is like Dagnan-Bouveret with better color," Garland observed.[80] Following the precepts of Hippolyte Taine, Garland held that the painter's goal, like the writer's, should be that of the naturalist; in other words, artistic process should be patterned after the scientist's method. It should conform to a straightforward observation of the local milieu and the material conditions of that existence.[81] The realist concern with narrating the hard conditions of agrarian life, then—not the French impressionist's concern with evoking urban modernity or capturing the fleeting, optical phenomena of vibrating atmosphere—was to provide a model for an American impressionism.

Garland's emphasis is more on the polemical content of subject than the penetration of presentness or the conditions of urban modernity as in the works of the French impressionists. In Garland's advocacy of a naturalist idiom, direct observation precluded the "cooked up," fussy, and contrived

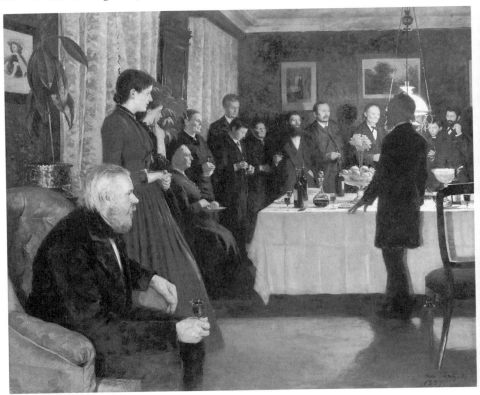

FIG. 5.5. *Nils Gustav Wentzel,* The First Communion (Confirmation Party)*,
1887. Nasjonalgalleriet, Oslo.*

effects of the grand traditions. This rejection of an elitist formal apprecia-
tion of the artwork, in preference for a more bourgeois narrative aesthetic,
in turn meant that those who were uninitiated into the historical aesthetics
of Claude, Corot, Gainsborough, or Ruisdael might still connect with the
striking truth of the down-home, rural subject in its forthright, narrative
presentation.[82] Though the common man and woman were prevented from
participating in the intertextual discourse of formalist art appreciation,
they could still participate in a narrative discourse of art and thus in the
validation of their own culture.

In line with his own fiction, Garland's rhetoric aimed to galvanize
American artists to expose the harsh conditions of rural life in the Midwest
and to extol the rewards of communal ritual, as well as the natural beauties
of the landscape there.[83] Garland's commendation of what he deemed

impressionism served only as a vehicle in his call for artists to liberate Americans from the shackles of history. His plea for American painters to abandon the effeminate Eurocentric culture of the past drew on the myth of America as the West, for it urged on them the yet untamed and uncivilized masculine topos of the midwestern and western territories as the locus of America's true cultural identity.

At this very moment, at the meeting of the American Historical Association, held at the World's Columbian Exposition in July of 1893, Frederick Jackson Turner had just declared the frontier to have disappeared and the experience of the West to have provided the definitive shaping of the American character as coarse and restless, but independent and virile.[84] The conjunction of Garland's discussion of naturalism as a localist mode that could record the untold and neglected narratives of the middle and western states with Jackson's thesis of the West as the definitive American arena suggests that they had tapped into a strong patriotic and nativist current to redefine the American character in terms of adaptation to the native environment. As George Stocking has noted, this was a view indebted to Lamarckian assumptions of evolution.[85] In his stories, however, Garland's sense of the West as a place pervaded by movement and transiency emanated from his own formative experience. Both Jackson and Garland, in fact, were products of the rural culture of the Midwest (Jackson, Wisconsin; and Garland, Wisconsin and Iowa) and knew firsthand the brutal demands of farming. To a great extent it was Garland's guilt at escaping from the purgatory of farm life to the stability and order of the East Coast that impelled his localist literature, as well as his insistence that American painters join him in returning to that forsaken heritage.[86] His endorsement of impressionism must thus be seen not so much as an aesthetic prescience that ultimately led to the early twentieth-century elevation of impressionism as a true modernist idiom; rather, for Garland naturalism was a tool with which he and his allies could combat the ideological hegemony of the Northeast and its claim to be the exclusive forger of American identity.

MONET'S AMERICAN MOUTHPIECE: THEODORE ROBINSON

Shortly after Garland announced his desire to persuade impressionist painters to back the midwestern cause, he focused his efforts on recruiting Monet's first American disciple, Theodore Robinson (1852–1896). Though Robinson did not like to think of himself as "a pupil of Monet,"[87] his diaries from the early 1890s reveal the degree to which he carefully recorded and

savored Monet's pronouncements during the time Robinson lived at Giverny.

Like Garland, Robinson had grown up in the farmland of Wisconsin. From his pious mother and his father, who was a Methodist minister, he received a thorough religious training that stayed with him as an adult in the forms of Calvinistic introspection and rigorous self-examination.[88] After several years of study in the 1870s at the National Academy of Design and the Art Students League in New York, and then in Paris under Carolus-Duran, Gérôme, and Benjamin-Constant, Robinson supported himself by teaching art and painting decorative murals for La Farge and Prentice Treadwell in Boston and New York in the early 1880s. Returning to France in 1884, he spent the next three summers at Barbizon before discovering in 1887 the artistic possibilities of the rolling and intimate landscape at Giverny. Over the following five years in Giverny Monet warmed to Robinson. To the younger man the fatherly Monet seemed to be a font of artistic wisdom. Monet's admonition to approach nature in a reverent yet honest manner in the all-important search for nature's mystery was reiterated in Robinson's diaries as if it was a maxim to live by. As Robinson took stock of his and Monet's works, for example, he wrote: "The only way is careful, slow, looking hard-at-nature sort of working, a thought between each touch—for fine involved color and the mystery nature is full of."[89]

By 1894, when Garland sent Robinson an offprint of his call for a naturalist mythology of the American Midwest, Robinson had already connected this search for nature's mystery with the necessity of returning to his native Vermont.[90] The step toward localism, he thought, would not only reinvigorate his own art with mystery but it could also assist the return of American artists to subjects of national significance. Only a short time earlier, during the summer of 1892 in Giverny, Robinson had admonished himself to paint freely without regard to subject.[91] But a year later in New York, perhaps feeling the mounting tide of nationalism at the opening of the World's Columbian Exposition, he now contemplated the greater virtue of returning to American views and panoramas. Toward that goal he had oblong rather than square canvases made, and encouraged himself to abandon "old formulae and ideas of what is interesting or beautiful from the European standpoint." By December of 1893 Robinson felt heartened that he had achieved a recognizable American character, a "true American atmosphere," in his landscapes painted that summer.[92]

Finally, the following year Robinson left France to return permanently to New York—a move that allowed him to devote himself entirely to the project of constructing a contemporary imagery of the American scene. He

now began to mull over the "strange" and broad vision required to capture the variety of life in New York, and with this in mind he copied into his diary a passage from a recent letter to the *Sun Herald* that gave a conventional and reassuring interpretation to America's new cultural plurality: "There never was, there is not now, and in all human probability there never again will be such another mixture, such another variety of life, such another throbbing pulse of human movement as one finds in America."[93]

Perhaps the thought of finding a visual equivalent for the idea of America as the melting pot of nations was overwhelming, however, since it was not the city to which Robinson turned for his nationalist program, but the countryside of the Northeast. Painting in New Jersey in autumn 1894, he had trouble finding the right scenery, as he mentally inventoried the obvious motifs of American small-town life—buggies, churches with spires, fences, wooden sheds, barns with Revolutionary War associations, and mulberry trees connected with Indian lore.[94] Though Robinson never exploited these motifs in his New England landscapes, they would eventually comprise the repertoire of visual symbols signifying New England small-town life, a repertoire that would prove to be the bread and butter of Childe Hassam, J. Alden Weir, Willard Metcalf, and others who gravitated to the local scenery of Connecticut, Massachusetts, Maine, and New Hampshire after the turn of the century. At the homes of his cousins in Jamaica and Townshend, Vermont, during the summer of 1895, Robinson finally determined that this was the place that would allow him to produce a landscape resonating with personally felt natural mysteries and national significances—the American motherland to which his own blood ties would respond.

In actuality, this was stretching it a bit, since Robinson and his family had left this rural Vermont locale when he was three. Nevertheless, he reasoned that since his ancestors had lived in Windham County, Vermont, this region—his "native" country—exerted a deep and mysterious hold over him. American painters should not gravitate to their native country "on principle," Robinson decided, but because they "are drawn there by ties of race" and therefore were better able to give expression to its character than other painters. So, even though Wisconsin had been the site of his formative years, he refused Garland's pleas to return to the Midwest.[95] Robinson's reasons for staying in the East were undoubtedly complex. The social and cultural amenities of the Boston–New York–Philadelphia circuit in which he traveled offered an escape from an ungratifying, harsh, cultural environment, and his emotional link to the Midwest seemed to be severed with the death of his mother in 1881. Moreover, as his diaries reveal,

Robinson thoroughly connected the national identity with the New England past.

By mid-June of what was to be the last summer of his life, Robinson congratulated himself with the thought that he was a refashioned "Hudson River man" as he worked on a panoramic view of the Vermont Valley. He constantly searched for motifs in the landscape—for example, barns and other structures that would connote a sense of history and antiquity equal to that of "old world castles." He noted that Twachtman and Weir had already discovered such symbols of ancient Anglo-American identity in Connecticut. That fall mornings in rural Vermont offered a delicate atmosphere similar to those he had experienced at Giverny also greatly pleased Robinson and, in effect, supported his choice of New England over France and the Midwest. Later that autumn he enjoyed reading Harriet Beecher Stowe's *Old Town Folks,* a novel that venerated the mythology, cultural traditions, and religious experiences of post–Revolutionary War New England, and he pondered how the tone of village life in the book resonated with the rural Vermont he knew. Immersed in his program for visualizing a new New England–inflected nationalism, Robinson was self-conscious of the desire and responsibility he felt to serve as a guide for younger American artists in creating a "Native American Art."[96]

While Garland specifically, and the cultural atmosphere in general, surely encouraged Robinson to develop a nationalist imagery, a consideration of the anguish recorded in his diaries suggests that Robinson was also propelled by highly personal motives. As he searched through the classics of Western literature and philosophy for meaningful direction during his last four years, Robinson intermittently experienced depressions that escalated to an emotional and physical breakdown during the winter of 1895.[97] The diaries speak all too frequently of a relentless self-criticism aimed at his personal conduct and his artistic performance. With "eternal vigilance" as their self-inventorying refrain, a pattern emerges in the diaries that suggests a puritanical self-loathing and a resolve to reconstruct himself along lines that would better satisfy the dominant social norms. In other words, Garland's connection of an important national subject with a masculine virility in art was shared by Robinson to his psychological disadvantage.[98]

Garland had fashioned the persona of the impressionist painter in terms of a masculine robustness that he contrasted with the effeminate sentimentalism he constructed for the tonalist painter of mood. The character Garland constructed for Robinson was that of the ideal impressionist: Robinson was "a lover of unaffected, manly, and simple art." "His eye was clear and sane, and his hand uncommonly cunning and certain in its

action," and his color sense "sound and buoyant."[99] Robinson meanwhile was privately waging a war within himself and in his art against qualities that were gendered as feminine by nineteenth-century society. He admonished himself to paint more "man-fashion" rather than "staining," in other words, "fussing, piddling over useless detail with a dry, anemic brush."[100] This suggests the nineteenth-century scenario of the masculine genius acting aggressively on feminine nature, or "the great mother," as Robinson phrased it, operating with his masculine powers of scientific analysis on the feminine object in order to penetrate its mystery and charm.

This too was Monet's essential "desideratum," as reiterated by Robinson in his diaries.[101] His every perusal of Monet's work, however, merely provided an occasion on which he could berate his own work as tenuous and weak in comparison to Monet's mastery. Monet's touch was dynamic, sure, bold, virile, healthy, "large, solid, and intangible," whereas Robinson perceived his own painting to be lacking in all these strong points: his work appeared flimsy, facile, hesitant, incomplete, spotty, confused, sentimental, and compromised.[102] Most of all, he urged himself to emulate Monet's exactness and precision, the kind of impersonal, scientific "research into nature" that allowed Monet to hit the *note juste* frankly and squarely."[103]

Nearly equaling Robinson's admiration for Monet's virility was his appreciation for Corot's more delicate poetry, the sense of repose Robinson thought Corot's paintings offered in contrast to Monet's boldness and vibrancy. According to Robinson, both painters expressed the "joy of living," but from complementary perspectives: masculine and feminine, truth and beauty, science and poetry, the half-light of evening and the bright light of midday.[104] Though he disdained what he called "foggy" vision in other artists, such as Twachtman, Dewing, Carrière, and Wyant, he responded affirmatively to Corot's tonalist atmosphere, finding it replete with "charm"—an imputedly feminine quality. Perhaps this response can be construed as Robinson's affinity for the mauve and grey tones that made his own palette seem melancholy to his peers. Robinson's appropriation of Barbizon motifs—French peasant girls with cows set in remote villages—displays his special fascination with subjects he was at the same time afraid were sentimental and feminized. Yet translating the atemporal agrarian topos through the technique of impressionist design and brushwork allowed him to indulge in such sentiment without feeling that he was compromising his commitment to the truth of the more imputedly masculine, analytical vision.[105]

Within his reservations over his failures to realize the type of aesthetic he desired can be apprehended Robinson's discomfort with what he most

likely feared was a sentimental and feminine side of his personality. On several occasions the confidences of the diaries convey his ambivalence to women and to the "woman question" in general, with which his contemporaries were then being confronted. His responses to women varied from the misogyny typical of the period to complete admiration.[106] Escaping one serious romantic entanglement in France when he returned to the States, Robinson thereafter distanced himself emotionally from the female sex, although he was attracted to women and seemed to enjoy flirting with his female students.[107]

Such ambivalence was manifested in his taste in art, which swung from Monet and Homer, whose style was considered masculine by Robinson's peers, to the feminine subjects of Puvis de Chavannes, Corot, Bessie Potter Vonnoh, and Robert Loftin Newman. His choice of subjects for his paintings similarly vacillated between a centralized feminine figure and an impersonally observed landscape from the mid-1880s on, when Robinson began to summer at Barbizon.[108] Paintings such as *In a Daisy Field* (1884; private collection), *At the Piano* (1887; National Museum of American Art), *Madonna Mia* (1886; location unknown), *The Layette* (1892; fig. 5.6), and *Girl in a Hammock* (1894; fig. 5.7) are structured around a quiet female figure and are variously informed by the works of Millet, Whistler, and La Farge. In Robinson's alternate landscape composition, the geometrically divided surface reflects his study of Whistler's "nocturnes" as well as Monet's method of distancing and analyzing the subject. Compositions such as *Macherin, Flanders* (1885; Spencer Museum of Art), *A Bird's Eye View* (1889; fig. 5.8), *Port Ben, Delaware and Hudson Canal* (1893; Pennsylvania Academy of the Fine Arts), and *West River Valley, Vermont* (1895; fig. 5.9) emulated Whistler's empty foregrounds, high horizon lines, and closely related color harmonies, as well as the regimentation of the surface that he found in his favorite Monet landscapes executed at Argenteuil.[109]

Royal Cortissoz noticed this duality between sentiment and analysis in Robinson's work, and regretted that the landscapes seemed "a matter of purely visual observation . . . developed through skill alone, with next to no aid from temperament or emotion." In Cortissoz's opinion, there was "something dry, if not positively prosaic, about his [Robinson's] view of the universe." But while these landscapes were rendered in terms of a "dry light, scientific in its abstention from anything like poetic effect," there was, then, another side of Robinson in works such as *Girl with Lilies [A King's Daughter]* (1889; location unknown), which showed imagination and suggested "more than the simple realism with which the painter was

FIG. 5.6. *Theodore Robinson,* The Layette, *1892. The Corcoran Gallery of Art, Museum Purchase and Gift of William A. Clark.*

FIG. 5.7. *Theodore Robinson,* Girl in a Hammock, *1894. Private collection.*

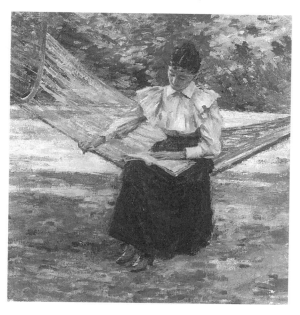

FIG. 5.8. *Theodore Robinson,* A Bird's Eye View, *1889. The Metropolitan Museum of Art, New York, Gift of George A. Hearn, 1910.*

FIG. 5.9. *Theodore Robinson,* West River Valley, Vermont, *1895. Private collection. Photograph courtesy of the Museum of Fine Arts, Boston.*

ordinarily content."[110] Critiquing Robinson's production in 1894, Robinson's friend Twachtman echoed Cortissoz and told Robinson his handling was too studied, "deliberate," "whacked out," and deficient in mood.[111] Even while Robinson acquiesced to the veracity of these criticisms, they must have been devastating to his morale since he was so consumed with Monet's dictum to seek the mystery of nature. "All I have done up to this year's work has not been an emotional statement of myself; I have not *felt* my subjects," he confessed to Garland in early 1896—thus his decision to gravitate to the Vermont hills of his ancestors, and his resolution to "paint subjects that touch me," to locate that "mysterious quality in the landscapes of one's native place."[112]

The desire for "solidity" and "completeness," recited like a personal litany in the diaries over Robinson's last four years, speaks of Robinson's envy of the strong, simplified forms that he found in the works of Monet, in Japanese prints, and in Holbein's portraits.[113] These catchwords, however, also intimate his desire for personal integration and the development of the masculine self he discerned in Monet. This was a quest that was not to be realized in his work in the time that remained to him. During that last summer of 1895 in Vermont, Robinson only managed to repeat his earlier landscape and figure painting formulas. His Giverny production *A Bird's Eye View*, for example, does not significantly depart from *West River Valley, Vermont,* nor does *Girl in a Hammock* (1894) from *Correspondence* (1895; private collection). In Vermont Robinson also labored over such insipid subjects as *Pumpkin Pies* (present location unknown), which he hoped would be recognized as an American version of Vermeer's "sobriety" and veneration of the commonplace.[114] Again, Eliot Clark's observation on Robinson's style as "precise and calculated" seems to explain in part Robinson's failure to locate a mysterious experience. He was never able to lose himself in the sensuous experience before him, as he would have wished it, in his native countryside, or to express a sense of wholeness and integration in the face of that experience.[115]

The ruthless perfectionism that drove Robinson's intense self-doubt had culminated in what was perhaps his most severe physical and emotional collapse in January 1895 in New York. Robinson had long suffered from asthma, a condition that can be psychosomatically induced, but he was also a victim of chronic depression, a situation often brought on, as he admitted, by his unrelenting self-condemnation and "fear of the future."[116] He had toyed for some time with the notion of undertaking mind cure, and at this point he decided to seek treatment. Robinson at first saw

Emilie Cady, who gave mind-cure techniques a strong infusion of Christian gospel, and then in late in 1895 he began going to a Mrs. Montgomery, who provided him with motherly sympathy and reassurance.[117] At first Robinson reported feeling and sleeping better, but by Christmas he suffered a relapse and in early April of the following year died of an acute asthma attack.

Robinson's inner conflict, his failure to resolve his ambivalences about the female sex and about the side of himself gendered feminine by the nineteenth century, in part produced his misgivings about his art, in terms of his inability to formulate a manner considered masculine and assertive, national and personal. It is tempting to understand his tenuous, melancholy palette, his delicate brushwork, and his focus on the centralized female figure as projections of his longing for female intimacy, of his identification with his mother, whom he thought of as "his inspirer and most helpful critic,"[118] and especially of his mourning for his mother, who died in 1881 just before his thirtieth birthday and his maturation as an artist. Then too, complicating Robinson's perceived need for solidity and integration, was the loss of the religious beliefs in which his mother had reared him. As a lapsed believer who had fallen away from the Methodism of his parents, his search for "higher truths" about reality helps to explain Robinson's attraction to Monet's system of patient, honest observation, a system which in turn could lead to a revelation of nature's mystery.

Monet's search for the mystery and charm of feminine nature suggests the late nineteenth-century agnostic's location of a spiritual energy in feminized nature, a beauty and a power that would be deserving of human reverence and capable of serving as a surrogate outlet for religious energies in place of orthodox beliefs.[119] In the eyes of Robinson's contemporaries, he failed to locate that mysterious presence. Robinson agreed with this judgment and reasoned that the cause of the failure was his inability to act on nature in the virile, masculine manner he perceived in Monet's painterly example.

THE IDEOLOGICAL LANDSCAPES OF AMERICAN IMPRESSIONISM

While Robinson's painting was regarded as lacking in poetry, at the same time his critics applauded his work as a "saner" form of impressionism, perhaps because his color and brushwork lacked the very stridency and aggressiveness he admired in Monet.[120] Twachtman and Weir, to whom Robinson imparted Monet's aesthetic in the early 1890s, were also observed to practice an "impressionism minus its violence." While Monet's

palette appeared "barbaric" in its splendor or violence, depending on the taste of the viewer, the color schemes of the Americans seemed muted and subdued—harmonious rather than clashing.[121] This consciousness of aesthetic harmony was much indebted to Whistler's vision. Twachtman for one had begun to gravitate toward Whistler's quiescent aesthetic in the mid-1880s, with the result that by the early 1890s his landscapes were termed "not fit for the struggle of life in a contemporary exhibition gallery."[122] Whistler's art valorized unification within the frame as well as unification of the object with its environment.

In place of the bold frames of complementary colors some of the French impressionists at times used for their exhibitions, the Ten American Painters therefore orchestrated several of their annual shows completely in white and grey, with white frames and cheesecloth on the walls and light grey straw mats on the floor.[123] A few members of the Society of American Artists associated the Ten with the radicalism of impressionism, using the label as an epithet to discredit the group, which had seceded from the society, the parent exhibiting organization. Nevertheless, the painters who made up the Ten—Frank Benson, Joseph De Camp, Thomas Dewing, Childe Hassam, Willard Metcalf, Robert Reid, Edward Simmons, Edmund Tarbell, John Twachtman (replaced by William Merritt Chase after 1902), and J. Alden Weir—took pains at their first public display and afterward to produce the effect of harmony and tranquility to the point that those pictures considered discordant with the rest were removed from the gallery.[124]

If the impressionist practitioners within the Ten moderated what was considered the French precedent of anarchic form and color, then, the imagery of city and country they devised was likewise moderated in response to the climate of crisis that unfolded in the 1880s as the great waves of immigrants arrived in New York's harbor. In theorizing the ideological overdetermination of landscape representation, Yi-Fu Tuan has observed how a landscape is an "achieved integration," a designed environment of diverse elements that is integrated into an order directed and conditioned by cultural practice.[125] The cultural symbols and the visual structures that encoded communal beliefs in the landscapes of the Ten pointedly reassured their viewers that Anglo-American values were being preserved in the face of growing social diversity and division. Looking back at the Ten in 1927, Royal Cortissoz identified the group with "exquisiteness in painting; . . . an ideal of beauty essentially gracious."[126] The *New York Times* in 1902 had already discerned their distancing from the diversities of modern American society:

Painting as these artists regard it is not a language for the public in which they utter things the public cares to hear, but a Latin understood of the few that possess the necessary schooling, a court cant which employs words that are caviare to the multitude.[127]

This was also how the Ten essentially defined themselves, as painters who stood for a rarity of experience, beauty and quality in art, as opposed to the typical mediocrity to be found at the Society of American Artists.[128] They disavowed the practice of art as controlled by economic and political interests, in preference for the rhetoric of art as transcendence. Their elitist vision that privileged nostalgic and aestheticized experience was possible through identification with a hegemonic cultural position.

Perhaps it is not so surprising, then, that with the exception of Twachtman, the original Ten painters could all trace their ancestry at the minimum back to eighteenth-century Anglo-Americans, and of this group at least six (Hassam, Simmons, Tarbell, Metcalf, Dewing, and possibly Reid) could claim a lineage that descended from the original seventeenth-century English settlements in Massachusetts.[129] Through the selectivity of their vision these artists produced painted environments that had seemingly resisted the forces of change or had accommodated change peacefully within the traditional order. Whether focusing on the urban prospect, the New England pastoral, or the suburban scene of middle-class leisure, they ordered contemporary reality to reaffirm Anglo-American cultural codes: in the countryside they recapitulated an iconography of rural New England virtues that provided a retrospective yet stable American identity; in the city they rehearsed an urban prospect that spoke of the present and future progress of American civilization.

THE URBAN PROSPECT

Structuring the perception of the city in late nineteenth-century America were two archetypes traditional to the rhetoric of American Protestantism: the "blood-red city of man and the white, shining city of God," the "City of Destruction" and the "Celestial City." American writers also frequently translated the image of the city of man into the image of the city as a place of mystery, of "unfathomable darkness and shadow."[130] This was a trope exploited by both conservative alarmists such as Josiah Strong and progressive reformers such as Jacob Riis, each for their own polemical purposes. Strong warned of the "rabble-ruled cities" that posed the greatest "menace

FIG. 5.10. *Jacob Riis,* In the Home of an Italian Ragpicker, Jersey Street, *n.d. Museum of the City of New York, the Jacob A. Riis Collection, #157.*

to our civilization" and vilified the immigrants of Manhattan's ghettos as dangerous criminals who, contemptuous of American customs, stoked the fires of discontent.[131]

To Strong, the ghettos of the lower East Side served merely as breeding grounds of socialism and anarchism. To police reporters such as Riis, the inflammatory conditions of this turf equally sounded an alarm of danger; however, his photo essays of the late 1880s framed his destitute Jewish and Italian subjects in their filthy, airless tenements and coal cellars in a manner intended to play on the sympathies of his middle-class audience and elicit immediate redress (fig. 5.10).[132] It was precisely because of their reversal of the dominant social order that Riis's photographs of subhuman living conditions were so shocking to his middle-class audience, as evidenced in the fits of weeping, fainting, and shouting at the images that took place at Riis's illustrated slide lectures.[133]

The 1880s proved to be a decade in which the United States absorbed twice the number of immigrants of any decade before. In New York the Italian and the Jewish newcomers crowded the Germans and Irish out of

their low-rent housing on the Lower East side, until by 1893 half of New York's population was quartered there—over a million people in only 37,316 tenement dwellings. By the turn of the century the Jewish ghetto had the highest density per square mile of any city in the world. By some estimates over three-quarters of New York's entire population inhabited the slums south of Fourteenth Street.[134] From the vantage point of the major depression of 1893, the experiences of the general economic decline and the violence of the industrial workplace of the 1880s prompted predictions of social cataclysm.

Intensifying the establishment's paranoia about labor was the new need for workers throughout the fabric of the industrial city, which resulted in a breakdown of the *cordon sanitaire* that had formerly separated the slums from the middle-class precincts in large cities. Theodore Roosevelt, for example, made no secret of his desire to see the leaders of the Populist movement taken out and shot; labor, however, was also as paranoid about the "enemy" as the establishment was about labor. While government attempts to institute social control were never marshaled into a unified effort, the violence of the 1880s failed to fulfill the predictions of a class war in the 1890s. Instead, as Wiebe has noted, the rhetoric of individualism and unity (in other words, the protection of elite rights) was invoked in the early 1890s, and it was insisted that the threats of social dissenters be quelled and their activities reconfigured to fit the order of Anglo-American cultural traditions.[135]

Such a framework helps to position the urban views of the Ten and to elucidate the reasons why they avoided focusing on what Henry James termed the "swarming" and the overflowing streets of lower Manhattan's ghettos. For James, the denizens hanging off their tenement perches and fire escapes could humorously evoke one strand of human evolution frozen at the anthropoid stage of monkeys,[136] but the teeming movement he observed in the immigrant quarters of Lower Manhattan was also worrisome in terms of the future evolution of American identity. America's traditional social order, James thought, was entirely opposite to the dynamic posed by the energy of the newcomers. That James's anxieties were symptomatic of middle-class Anglo-American fears can be apprehended in the correlative visions of Childe Hassam and William Merritt Chase. The two principal practitioners of the urban prospect at the end of the century, Hassam and Chase turned their sights uptown, to the fashionable business centers of Fifth Avenue and the upper middle-class preserves of the parks. In the late 1880s and 1890s these two artists established a visual trope of the American urban landscape as the "city of light," by

emphasizing its mythic growth, prosperity, and social harmony. Suggested by the earlier urban views of Monet, Renoir, and Degas, this trope was varied into a taxonomy of ordered vistas in the works of American painters as well as photographers. In contrast to this urban mythology of progress, the socially conscious urban vision was left to photojournalists like Riis and W. A. Rogers, an illustrator who translated New York's poverty into conventional, that is, nonthreatening, picturesque terms for *Harper's Weekly* in the late 1880s.[137]

The image of New York that was crystalized in the early 1890s in the work of Childe Hassam (1859–1935; figs. 5.11 and 5.12) followed the celebrations of London and Paris in the painted views of the French impressionists Jean Béraud and Giuseppe de Nittis.[138] Two trips to the Continent in the 1880s afforded Hassam the opportunity to immerse himself in Baron Haussmann's sweeping public spaces, as well as the newly created pictorial paradigms recognizing this urban modernity. A product of Boston and an old New England family, Hassam adopted a project on his return to New York that, like Robinson's, was nationalistic in its construction of an American urban landscape that equated American civilization with that of European capitals.

Hassam's vistas along Fifth Avenue intentionally recall the atmosphere, broad streets, and spacious squares of Paris.[139] This was no small feat, since as Marianna van Rensselaer acknowledged, with the exception of Fifth Avenue, the constriction of New York's streets prevented the kind of monumental architectural effects Haussmann was able to get in Paris. Union Square and Madison Square were not only fronted by spacious parks but they were also centers of retail, business, and theatrical activity and as such provided convenient sites where the growth of Manhattan's cultural and economic life could be assessed.[140] In the last quarter of the century business was moving uptown along Fifth Avenue, and the middle and upper classes were fleeing to the suburbs, as new immigrants settled into formerly middle-class neighborhoods downtown. Hassam's focus on these two bustling commercial centers commemorated this migration northward and provided it with the evolutionary rhetoric of social progress generic to the advancement of a great world civilization.

Looking down on the street at Union Square or Madison Square from a high vantage point, Hassam was able to observe what he called the "ceaseless ebb and flow of humanity."[141] This "humanity in motion," however, was a preselected upwardly mobile class that frequented the new commercial centers on Fifth Avenue. As van Rensselaer commented, these were the "fine people of New York" who regularly patronized the shopping estab-

lishments, theaters, and restaurants like Delmonico's in the area.[142] As Hassam pictured them, moving in carriages or on foot diagonally back into or out of the frame, the dynamism of this affluent crowd is seemingly unimpeded by any confrontation with adversarial element, as if the *cordon sanitaire* were still intact, containing the chaos of Lower Manhattan's ghettos (fig. 5.11).

Occasionally Hassam's closer examinations of Fifth Avenue, such as his *Washington Arch, Spring* (1890; fig. 5.12) or *The Manhattan Club (The Stewart Mansion)* (c. 1891; Santa Barbara Museum of Art), reveal a uniformed street cleaner, or a newspaper or messenger boy. In contrast to the periodical illustration in which the park could be visualized as a confron-

FIG. 5.11. *Childe Hassam,* Spring Morning in the Heart of the City, *1890, 1895–99. The Metropolitan Museum of Art, New York, Gift of Miss Ethelyn McKinney in memory of her brother, Glenn Ford McKinney, 1943.*

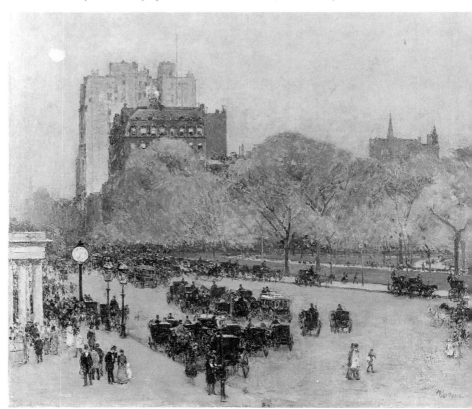

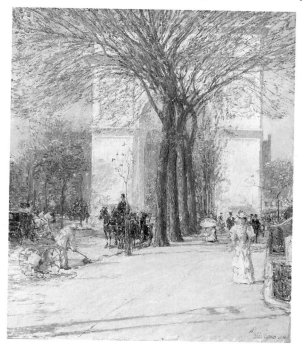

FIG. 5.12. *Childe Hassam,* Washington Arch, Spring, *1890. The Phillips Collection, Washington, D.C.*

tational site between the extremities of poverty and wealth (fig. 5.13), in the privileged spaces of Hassam's world these public servants essentially are kept out of contact with their social superiors, from whom they are distinguished by the stylish dress of silk hats and balloon-sleeved dresses. Down at the street-level view of the city (fig. 5.12), the space is not much more populated than his view of a provincial French town (fig. 5.14). At the human level the crowd is dispersed, its potential effect on the individual passerby is so inconsequential as to be negated.

The sequence of events in Hassam's bird's-eye-view compositions—the wide open, often sparsely peopled or vacant foreground spaces that yield to the orderly flow of traffic, the trees of the park, and then the great architectural structures rising above the foliage in the distance—speaks of the ease and flow of activity in this milieu, the smart society that moves effortlessly between the leisure offered by the parks and the spectacle of the streets or the theaters. Though Hassam condemned what he considered the trickery and artifice of other painters of older landscape schools, he has

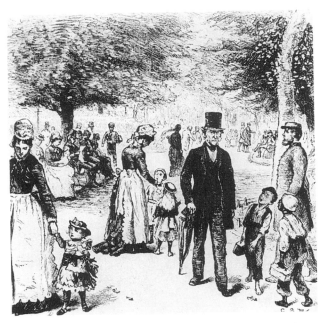

FIG. 5.13. *C. S. Reinhart, "Scene in Union Square." From W. H. Rideing, "Life on Broadway,"* Harper's Magazine *(January 1878).*

simply adopted here a new rhetoric for the "natural," distanced from the particulars of detail and overlaid with an impressionist gloss of glittering light that testifies to the "truth" and immediacy of the painter's vision. His organization of groups in space along orderly geometric lines, as he said, were meant to radiate from the center and propose a "poetry of figures in motion." The buildings meanwhile were as important in the pictorial scheme as the selection and configuration of people in the street, Hassam acknowledged, and so constituted the first elements placed on the canvas.[143]

The degree to which this is indeed an aestheticized and ideologically constructed vision is made apparent by the manner in which recognizable monumental structures—hotels, great mansions, office buildings, and commemorative markers—have been clearly thrust into view, to propose a city of progress in which such civic development knows no boundaries. As in the grand-style, topographical photography that flourished in this period, the spacious thoroughfares of Hassam's cityscapes attest to the capacity of the streets for creating order, while the imposing architectural structures along the avenues serve as indices to the progress of civilization: thus energy is harnessed to order, stability, and permanence.[144] Starting with the Washington Arch at one end of Fifth Avenue and moving steadily uptown, the Beaux-Arts monuments of Richard Morris Hunt and McKim, Mead, and

FIG. 5.14. *Childe Hassam,* Afternoon in Pont Aven, Brittany, *1897. Cummer Gallery of Art, Jacksonville, Florida.*

White, whether public "palaces for the people" or private clubs and palazzos for the upper crust, figured as the symbolic world of Midtown in which the aesthetic order of the architecture expressed the urgent need for social unity. Though spatially segregated from the Darwinian world of the tenement and the sweatshop, the white glittering palaces pose an antitype that indicates how this dark world loomed as an assertive presence in the minds of the builders. Such markers of civilization in the form of neoclassical arches, statues, and other monuments became in the City Beautiful movement not just a strategy, in wishing away the enemy, but also a didactic ploy in inculcating Anglo-American "civic virtue" in all classes and ethnic groups.[145]

The idea of New York as an American urban fantasy that was the equal of Monet's or Béraud's views of Paris was successfully offered by Childe Hassam's New York compositions. Hassam learned techniques of picturing Manhattan as an urban fantasyland from Whistler too, as in *Messenger Boy* (1902; fig. 5.15), which in emulating the geometry of Whistler's small aestheticized shop-front panels of the 1880s implies that a human scale and a picturesque, even intimate relation between the individual and the urban environment was still a viable reality. Still others, such as *Winter Afternoon in New York* (1900; Museum of the City of New York), utilize the Whistlerian

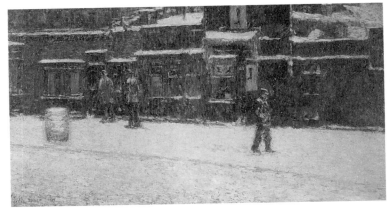

FIG. 5.15. *Childe Hassam,* Messenger Boy, *1902. Museum of Art, Rhode Island School of Design, Jesse Metcalf Fund.*

strategy of distantiation—the atmospheric veil as a method of effecting a sense of the city as an aesthetic and social unity. Suggested by van Rensselaer in her guide of 1892 to "picturesque New York," this practice of veiling became commonplace among artists such as Alfred Stieglitz, Willard Metcalf, and J. Alden Weir when they turned their sights to Manhattan's streets and parks.[146]

Even before Hassam discovered Fifth Avenue, however, William Merritt Chase (1849–1916) presented the park setting as a representative site of civilized public activity in New York. In the mid-1880s Chase first adopted Prospect Park in Brooklyn as the subject of a group of open-air compositions and then in the early 1890s gravitated to Central Park (pl. 10; fig. 5.16). The narrative Chase continually reiterated in these pictures tells of a middle landscape that extends the design and order of the street and yet offers the broad spaces of the greenswards, protected from the street, as alternatives to it. Chase's park scenes propose an obvious complement to Hassam's streetscapes: here the individual has come out of the public space of the street, with its noise and movement of the crowd, and has entered into a zone that supplies a quiet and more solitary experience, where the spectator can still breathe the normative, sunlit air of nature and contemplate its beauty or the domestic scenery of children at their amusements (fig. 5.17).

Conceived by Olmsted as a place where class differences would be effaced in the collective pleasures of nature, Central Park was to serve as a pedagogical structure where the lower classes, mixing with the upper, would learn polite Anglo-American behavior, and meditation on nature in

the park was to function as a normalizing counterweight to the corrupting influences of the big city.[147] In this designed world nature would perform therapeutically not only to foster social harmony in the polity but also to grant a sense of mental repose for the individual fleeing from the stresses of the street.[148] In the terms of the late nineteenth-century evolutionary paradigm, the park offered a refuge from the Darwinian struggle of the streets, a space where the discord of clashing cultures and classes was permanently silenced and harmonized by the designed concordances of the natural landscape.[149]

As in the photographs of Central Park from this period (fig. 5.18), Chase's park scenes, however, depict only the upper and upper-middle classes taking advantage of these public spaces. Though Central Park in the early twentieth century was to become a more democratic preserve, where the working classes picnicked and played, in the 1890s it was still the precinct of the Anglo-American elite, or those who were easily assimilating themselves into that culture. Noting the "variety of accents" in the crowd of pedestrians, Henry James observed in 1905 that the experience of the Park put the mind at "ease about the 'social question.'" Impressed by the

FIG. 5.16. *William Merritt Chase,* The Lake for Miniature Yachts, *c. 1890. Peter G. Terian, New York.*

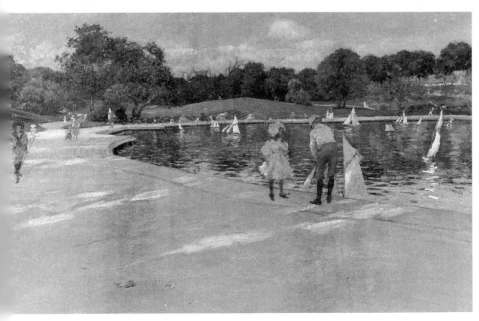

FIG. 5.17. *William Merritt Chase,* In the Park (A By-Path), *c. 1890–91. Thyssen-Bornemisza Collection, Lugano.*

FIG. 5.18. *Central Park, 1898. Museum of the City of New York, Byron Collection.*

ostentatious display and general well-being of the people there, James remarked on the striking "brilliancy of . . . show" and the "air of hard prosperity, the ruthlessly pushed-up and promoted look worn by men, women and children alike" in the upwardly mobile crowd that rendered "the unwashed . . . or the ill-shod, . . . or the mendicant hand . . . strange, unhappy, far-off things," to the point that "it would even have been an insult to allude to them." Instead, the prospect was one of little girls in exquisite dresses and shimmering ribbons, grouped in vistas as they frolicked over the green lawns, daughters of middle-class burghers who shone in their immaculate grooming.[150]

Chase's Central Park and Hassam's Fifth Avenue participate in this urban fiction of social order, as does Olmsted's park itself, through a similar strategy of design overlaid with a naturalistic gloss of light-filled atmosphere. In Hassam's Madison Square the buildings bordering the park impose their order onto the natural setting, regulating and containing the space of the park within its boundaries. Hassam's interplay between nature and culture is in keeping with the changing conceptualization of parks in this period—from the park as a "conscious evocation of the country" to the park as an extension and "a celebration of the city."[151] In Chase's images it is culture and design that redeem as much as nature. While Chase claimed that his observation of the effect of accelerated spatial recession along the lines of railroad tracks had led him to construct space in terms of a "natural" though slightly unorthodox perspective,[152] in his park scenes he characteristically employed two interlocking triangles—a device appropriated from Hiroshige[153]—to suggest a sweeping space in which the parkgoer could enjoy a sense of solitude. Yet it was at the very center of the most conflicted urban arena on the East Coast in this period that Chase located this secure and secluded garden world inhabited by exquisite children, just as James described it, in which the mere contemplation of hardship posed itself as a foreign and distant reality. Like Hassam's streetscapes that proclaimed the power of the designed environment in furthering the progress of entrepreneurial American civilization, Chase's pictures proved to be popular with their Anglo-American, middle-class public.[154]

As Hubert Beck has noted, the possibility of picturing American urban progress in the antimodern terms of the arcadian dream dominated the view of such urban scenery in the works of the Ten during the 1880s and 1890s.[155] Though there are several instances in which these painters caught glimpses of modern labor or modern technological structures,[156] these remain minor incidents in the 1890s, as opposed to the extensive bodies of

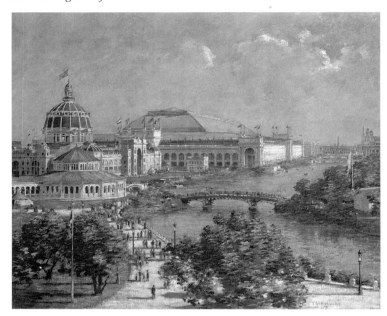

FIG. 5.19. *Theodore Robinson,* World's Columbian Exposition, *1894. Manoogian Collection.*

work devoted to the American urban prospect as a utopian achievement. The rhetoric the Ten and their peers employed in framing Manhattan was visually and ideologically allied to the rhetoric artists and photographers employed in picturing Chicago's White City of 1893, the nation's consummate utopian project of the 1890s in which all vestiges of social discontent were denied.

Panoramas like those John Twachtman and Theodore Robinson composed from photographic sources (fig. 5.19) instead suggest the ramifications of the designed environment in terms of creating a completely unified social order. Commissioned explicitly to accompany Daniel Burnham's official report on the fair, these illustrations of shining white structures posed against azure cloud-swept skies broadcast the organizers' millennial expectations for the "dream city."[157] That the public spectacle of the fair could contain private moments of repose similar to those to be obtained in the natural setting of Central Park was also intimated by Hassam's *Crystal Palace, Columbian Exposition* (1893; Mrs. Norman Woolworth Collection), as he aped Chase's park scenes. Willard Metcalf (1858–1925), on the other hand, drew on Whistler's "nocturnes" to create a mood of hushed mystery in approaching the Court of Honor at twilight (fig. 5.20).

THE FILIOPIETISTIC NEW ENGLAND LANDSCAPE:
THE MYTH OF THE VILLAGE

While Anglo-American ambitions for a millennial future permeated views of New York's cityscape in the 1890s, the social ideals of this future were rooted in the past, in the ideological model of the New England village. Now that the reality of the village had all but receded unrecoverably into the early nineteenth century, it too was ascribed utopian dimensions through the gloss of nostalgia. It was only in the body politic of the village that the traditional Anglo-American ethos responsible for "authentic" American identity was thought to be preserved, since it had been eroded by the growing cultural diversity of large metropolitan arenas.

With increasing frequency as World War I approached, the Ten produced the standard vignettes that established an iconography of rural New England virtues: a pastoral life that promoted communal harmony and homogeneity, individualism and intimacy. This iconography was encoded in a filiopietistic topography in which the markers of such communal experiences were rendered in emblems such as barns, bridges, Congregational churches, main thoroughfares or village greens lined with oak trees,

FIG. 5.20. *Willard Metcalf,* Sunset Hour in the West Lagoon, World's Columbian Exposition of 1893, *1893. Chicago Historical Society.*

and stately homes whose classical porticoes spoke of the stability and permanence of a mythic world hostile to the reality of the modern city.[158] In 1893–1895 Theodore Robinson had contemplated recording this New England topography memorialized by Harriet Beecher Stowe's *Old Town Folks,* a book Robinson was enjoying at the same time he was rejecting the Midwestern landscape of his upbringing. Distinguished by its vast, lonely, and monotonous spaces, the Midwest lacked exactly the reassurances of community and civility offered in the stereotypical New England village.[159]

That the nostalgia of these painters corresponded to a more broadly based yearning in the northeastern elite for a cultural capital heavily invested in the Anglo-American past is reinforced in the writings of Charles Eliot Norton. In 1889 Norton lamented the "lack of old homes in America" as a sign of diminishing American traditions in national cultural practice. The disappearance of such values as domesticity and continuity with the past would have its direct effect on the moral health of the country, he feared, and would subsequently portend the loss of Anglo-American hegemony. Norton understood the function of historical artifacts as encoders of cultural practice and reinforcements of national Anglo-American identity:

> Such is the frailty of our nature that our principles require to be supported by sentiment, and our sentiments draw nourishment from material things, from visible memorials, from familiar objects to which affection may cling.[160]

Directing his analysis especially to the babel of New York—a "city of strangers . . . without common traditions or controlling common interests"—he took aim at the new immigrants, this "confused mixture" of people, as the chief "source of harm to cities" and an impediment to the "development of a high type of civilization." Norton believed, however, that the village, just as the city, suffered from the identical syndrome of transiency and "instability of residence."[161] It would be little more than a decade later when Henry James would wander down a rural New Hampshire road to stumble upon Armenians there. Startled by the "ubiquity of the alien," even in remotest New England, he wondered at the infinitesimal steps it would require to convert the "grossness of their alienism" into an Anglo-American character.[162] But already by midcentury "foreigners," namely Irish Catholic immigrants, composed one-third of Lowell's population and one-half of the factory hands. Finally in the 1890s it had to be admitted that both the demographic and the topographic configurations of this landscape had

changed radically, and that "the historic culture of New England had entered its 'Indian Summer.'"[163]

Yet, at that moment when the old New England was on the verge of extinction, a new proliferation of literary and painted homages to its past signaled a resistance to the acknowledgment of that fact. As preservation organizations were initiated to save whole villages and their artifacts as museums, the painters of the Ten similarly capitalized on the urgency to preserve the past. Such a resistance to change reminds us not only how "the collective memory . . . is based on spatial images," as Maurice Halbwachs has commented, but also of the symbiotic relationship between group identity, cultural habits, and the unchanging environment.[164] What the Ten saved, however, was an edited version of the New England patrimony, as they, like their contemporaries, responded to the need to fortify the established cultural order and resist the forces of modernization.

Of these painters, Metcalf and Hassam in particular played a substantial role in the larger trend to fix the New England village in the American consciousness as a classic symbol of national community, as a "distinctive creation of American society."[165] Ulrich Hiesinger has described the change in the work of the Ten after the turn of the century as a retreat from the formal extremism of French impressionism, as the result of a series of harsh press reviews following the World's Columbian Exposition.[166] This backing away, however, might be better characterized as an ideological amplification in which the Ten rediscovered themselves in their own patriarchal roots. In the cases of Thomas Dewing and the Boston school, the feminized interior they developed complemented the public iconography of the village vignettes and reverenced the private side of New England culture.

While Hassam popularized the visual trope of New York as the spearhead of American civilization, he was also the foremost chronicler of the New England village. His archetypal images, along with similar compositions by Metcalf and Weir, were quickly disseminated to a score of disciples who gathered in art colonies at Old Lyme or Gloucester, or as students in summer art classes in the Connecticut countryside.[167] Over one hundred of Hassam's works can be tied to the Connecticut landscape alone,[168] and increasingly after 1900 he wandered to Old Lyme, Greenwich, Provincetown, Gloucester, Easthampton, and so on. Picturing these towns as fundamentally unchanged since their Federal period formations, Hassam effectively obfuscated the distance between present and past.

The village morphology cherished by these painters and their contemporaries is synopsized in its entirety in Metcalf's *October Morning, Deerfield, Massachusetts* (1917; pl. 11; fig. 5.21). This late painting assembles the

FIG. 5.21. *Willard Metcalf,* October Morning, Deerfield, Massachusetts, *1917. Freer Gallery of Art, Smithsonian Institution.*

compendium of symbolic structures in which both Hassam and Metcalf invested much of their careers: children in quaint pinafores and bonnets making their way home from school along a main street lined with an eighteenth-century Congregational meeting house and old clapboarded houses, as well as tall oaks and elms that bespeak their antiquity. Even the fabled Indian summer of New England is suggested in the atmosphere of the warm autumn afternoon. Often in views from this period Metcalf resorted to the strategy Hassam had constructed for the cityscape, that of scanning the village from a high vantage point for the markers of community—church steeples and ancient elm and oak trees.[169]

Hassam had earlier adapted the topographical longshot in 1899 in his panoramas of such picturesque and antiquated communities as Gloucester,

Provincetown, and New Haven. Metcalf too found that this format worked well when it came to depicting farms, individually or in small groups, protectively nestled into the New England hills. Such imagery compellingly evoked then, as it still does today, the mythic origins and persistence of American identity in the Anglo-Saxon community that is "intimate, family-centered, God-fearing, morally conscious, industrious, thrifty, [and] democratic."[170] The extent to which it still functions as a national symbol in late twentieth-century America is intimated in the proliferation of this imagery in greeting cards, as well as in the incredible popularity of Norman Rockwell's New England.

The refuge the past might offer, the escape to a simpler, safer, quieter, and more comfortable reality, was succinctly visualized by Hassam in his portraits of eighteenth- and early nineteenth-century domestic structures. One of many such pictures from the mid-1880s, *The Old Fairbanks House, Dedham, Massachusetts* (c. 1884; fig. 5.22) clearly finds Hassam at this early date joining his contemporaries in the fields of literature, architecture, and the decorative arts in rediscovering and promoting the myth of New England.[171] The fascination with the colonial past was spurred by both the recent Centennial celebration and the mounting Anglo-American foreboding that the original cultural fabric of the Northeast would be displaced by

FIG. 5.22. *Childe Hassam,* The Old Fairbanks House, Dedham, Massachusetts, *c. 1884. Museum of Fine Arts, Boston, Bequest of Kate Talbot Hopkins.*

the alien culture of the immigrant masses. By aestheticizing the indigenous clapboarded or shingled dwelling, Hassam makes these prosaic forms into symbolic forms to be esteemed for their associations with a hallowed yet threatened way of life. In many of these images the foregrounding of the white picket fence with its open gate suggests an intimate space within that is accessible to the viewer, and the dappled light Hassam typically laid over the wooden facade has the effect of softening the weathered aspects and washing the structure in an atmosphere of nostalgic sentiment.

This mood in *Sunlight on an Old House, Putnam Cottage, Greenwich* (1897; private collection) or a similar etching (fig. 5.23), for example, functions to project empathy for an inanimate object that resonates with human presence and tradition. This humanizing is accorded not only to the old house but also to the ancient trees that are often prominent in such compositions. In New England lore these craggly patriarchs were invested with iconic significance as signs of liberty through their associations with the Revolutionary War.[172] Hassam invented a patriotic topography in which he alternated his focus from the old oaks, elms, and chestnuts native

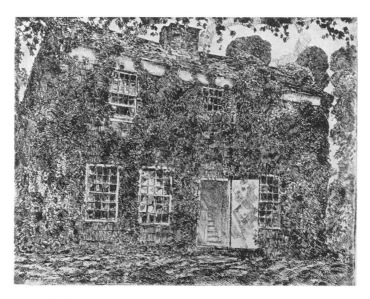

FIG. 5.23. *Childe Hassam*, Home Sweet Home Cottage, *1928, etching. From* Handbook of the Complete Set of Etchings and Drypaints of Childe Hassam, N.A. *(1933).*

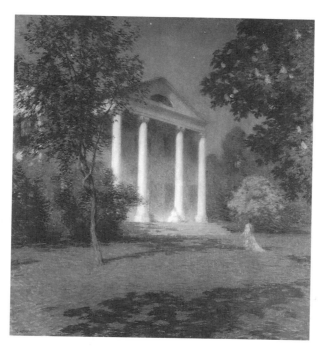

FIG. 5.24. *Willard Metcalf,* May Night, *1906. The Corcoran Gallery of Art, Museum Purchase, Gallery Fund.*

to the region to the houses that were also entwined with the lore of 1776. Putnam Cottage in Greenwich, for example, had been the headquarters of one of Washington's generals. Soon after Hassam painted it, the house was adopted by the local chapter of the Daughters of the American Revolution.[173] The house in *Home Sweet Home Cottage* was the boyhood home of Thomas Paine.

Metcalf's most obvious work in this genre, *May Night* (1906; fig. 5.24), marks his firm entrenchment in a successful pattern that lasted for the rest of his career. Highlighting the classical portico of the Griswold house in Old Lyme, Connecticut, the painting makes explicit the filiopietistic subtext not only of Metcalf's New England landscapes but also of Dewing's moonlit landscapes with female figures, in which Metcalf's composition finds its starting point. While Dewing typically weds New England nature worship with the feminine mystique, Metcalf conflates that mystique with the allure of New England's traditional culture signaled in the house as historical artifact, a reminder of its genteel roots.

Hassam, Metcalf, and Weir also worked hard to salvage the New England landscape in its preindustrial guise: their narratives essentially pre-

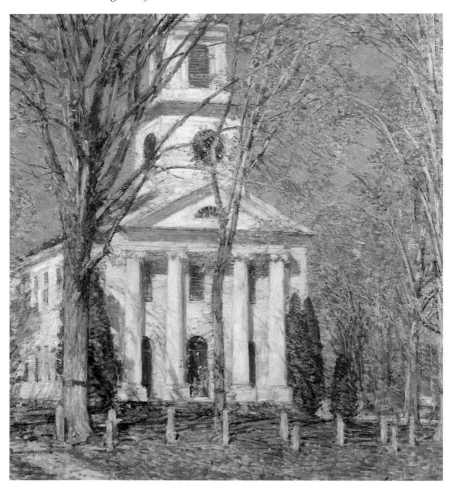

FIG. 5.25. *Childe Hassam,* Church at Old Lyme, Connecticut, *1905. Albright-Knox Art Gallery, Buffalo, New York, Albert H. Tracy Fund, 1906.*

serve the material ramifications and cultural practices of this Anglo-American world before this society had irrevocably succumbed to a more heterogeneous order. Through focusing on the country store, the old bridges, the eighteenth-century and early nineteenth-century Puritan churches, and preindustrial labor such as boat building at Provincetown (figs. 5.25 and 5.26), the past is not merely memorialized, but its viability in the present is also asserted. Weir devoted several canvases to reconciling the signs of modernity—a small dam for electric power or a steel bridge—with the natural order of the Connecticut landscape (fig. 5.27). Nature and

culture also coexist in an easy, straightforward balance in his images of the small textile mills in Willimantic, Connecticut (fig. 5.28); in these landscapes there is a tacit visual and social accommodation of the industrial order to New England cultural tradition. Viewed in a longshot, the whitewashed brick structures of the factories seem of a piece with the white clapboarded fabric of the town: they are cozily situated, almost embraced by nature, as the foliage frames the factories and the terrain dips and rises to incorporate them comfortably within the valley covered by the town.

THE ARCADIAN NICHE

In contrast to the national, public symbolism registered in the image of the village, the painted construction of New England as an arcadian prospect offered an alternative, more private experience of the same place. In the brooks and dells of Connecticut, Massachusetts, and New Hampshire, Twachtman, Weir, and Metcalf located sites of domestic intimacy and serenity. This topography, however, was also viewed by their contemporaries as a definitive American landscape that generated the American character.[174]

The structures of these landscapes encourage a close rapport between the viewer and the niche of space, an experiential model that invokes the New England cultural practice of meditation on nature, which Perry Miller traced from the Puritans to the Transcendentalists.[175] This introspective habit of mind customarily occurs in Transcendentalist writings as a trope that relates the individual's mystical apprehension of a symbolic divine order in nature. But, as reconfigured in the late nineteenth- and early

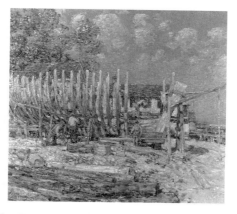

FIG. 5.26. *Childe Hassam,* Building a Schooner, Provincetown, *1900. Birmingham Museum of Art, Birmingham, Alabama, Museum Purchase.*

FIG. 5.27. J. Alden Weir, Building a Dam, Shetucket, 1908. *The Cleveland Museum of Art.*

FIG. 5.28. J. Alden Weir, The Factory Village, 1897. *The Metropolitan Museum of Art, New York. Jointly owned by The Metropolitan Museum of Art (through Gift of Cora Weir Burlingham) and The Weir Farm Heritage Trust, Inc., 1979.*

twentieth-century works of Twachtman, Metcalf, and Weir, it functions therapeutically, more to offer the urban viewer a sense of the tranquility that can be obtained by fleeing the chaos of the big city for the New England countryside. The advent of the commuter train system by the 1890s, and shortly later the automobile, meant that rural areas in Connecticut and Massachusetts served as bedroom communities or summer and weekend retreats from New York or Boston. The familiar middle-class pattern at the end of the century was that of "living in the country without being of it," as one periodical writer commented, "allowing the charms of nature to gratify and illumine but not to disturb one's cosmopolitan sense." Those who owned country places could enjoy a "metropolitan Arcadia, or an Arcadian metropolis."[176]

As he surveyed rural New England by motorcar in 1904, Henry James echoed the pattern of ambivalence to this terrain that is evidenced in the works of so many nineteenth-century writers.[177] From his distanced vantage point as a tourist, James was able to appreciate the aesthetic possibilities of the landscape and likened the undulating hills and dells of New England in the opalescent haze of autumn to the Umbrian landscape redolent with mystery or history—"the world belted afresh as with purple sewn with pearls—melting . . . into violet hills with vague white towns on their breasts."[178] The reader is indeed uncertain as to whether he is evoking Tuscany or Massachusetts here. Yet at a closer range of vision he also noted the ugliness of uncultivated prospects dotted with unkempt farms. This spectacle implied to James that history had played an insufficient role in shaping the landscape, in contrast to the romance of the English countryside, which was suffused with the vestiges of feudalistic society.[179]

Though he found the older houses full of charm and refinement, he puzzled over the homogeneity of New England villages, with their uniform white clapboarded houses, ascetic meetinghouses, and stately avenues of elms. The sameness of village life everywhere seemed to afford a paradise for the common man and woman. It was a sphere, however, that was distinguished by the "abeyance . . . of any wants, any tastes, any habits, any traditions but theirs." Moreover, this monotonous environment spoke also of a banal, and even an impoverished, moral life in which the human drama that would have lent it interest was well hidden beneath the surface of the unmodulated landscape.[180]

In moving close up to the village and then far away, James alternated between being bewitched and being bored. The gradually formed critique of New England's moral life emerged from his scrutiny of the landscape and the visual evidence of the social customs he found there. Though no

FIG. 5.29. *John Twachtman,* Winter Harmony, *c. 1890–1900. National Gallery of Art, Gift of the Avalon Foundation.*

such pattern of ambivalence can be located in the painted works of Hassam, Twachtman, Metcalf, and Weir, these painters similarly evaded and denied New England's late nineteenth-century transformation under the forces of immigration and industrialization. Like James, they looked for signs in the landscape that would only reinforce the traditional identity of the New England ethos with Americanism.

Trained in the cosmopolitan centers of New York and Paris, Twachtman, Metcalf, and Weir participated in the middle-class commuter syndrome. They kept homes in rural Connecticut or Vermont, but made their living teaching in the city. Their ties to the socioeconomic framework of the larger, urban world effectively helped to mitigate the backwardness of small-town life. This distancing phenomenon can be distinguished in their aestheticizing strategies that rendered as intimacy and provincial charm what was to James insularity and numbing sameness. Theirs was a preference for the mythology and the nostalgia of New England, not for the actual realities of rustic culture. Rather, the countryside existed for them as "inspirational resources" and as a psychological and spiritual antidote—a

place where individual identity and selfhood, depleted by the demands of the modern urban arena, could be reinstated.[181]

Twachtman (1853–1902) especially took pleasure in an intimate landscape type that functioned as a psychological refuge for the viewer.[182] Centered on still, amorphous bodies of water, his images of the brook on his property at Greenwich, just an hour outside New York City, promised that nature could offer a means to transcend personal psychological limitations. The tight, V-shaped niches of space are formed by weightless, floating configurations of water, trees, and undulating banks of earth in *Winter Harmony* (fig. 5.29) and *Winter Silence* (Mead Art Museum, Amherst College) of the early 1890s, for example. This spatial construction encourages the viewer to enter into a niche to be embraced and soothed by their ethereal masses and soft muffled textures. Meditating on the dematerialized forms of nature thus engenders not only an imaginative projection into the space but also an identification of the self with the boundlessness of nature.[183]

In other instances Twachtman centered his sights on the domestic scenery that spoke of his refuge in the emotional life of his family, such as his house on Round Hill Road or his family in the garden there (pl. 9; fig. 5.30). Through confined spaces that establish intimacy with the object of longing, such rural images of nesting and domesticity recapitulate the experiences of serenity, security, and privacy with which the artist gratified and compensated himself for the disappointments he suffered in the New York art world. The possibilities of personal reification in the rolling countryside of Connecticut are offered as an antidote to the brutalizing environment of the city, an environment Twachtman assiduously avoided in his art after 1880.

The quiescence of Twachtman's imagery was also accomplished by a suitably rarefied painterly process. Transferring his pastel technique to oil painting around 1890, his pigment was thinned out with a medium called mastic and his canvases exposed to the sun for periods of time in order to enhance the delicate dematerialized effects of his images. Whistler had also followed this procedure of exposing his canvases to the elements and bleaching them in the sun in order to maximize the dematerialization of form.[184] At times, as in *Winter Harmony,* Twachtman's surface is so nuanced and the color so layered that it becomes nearly impossible to determine the order of their application without the aid of a microscope. Overlaying muted cool and warm tones, Twachtman thus seems to work toward iridescence or opalescence—in other words, color effects that defy description and analysis, that bleed off or shift quickly into something else.

FIG. 5.30. *John Twachtman,* On the Terrace, *1890s. National Museum of American Art, Smithsonian Institution, Gift of John Gellatly.*

The fugitive color and centered niche of space, then, work to absorb the viewer into re-creating what was Twachtman's original experience in the face of his object of contemplation. For Twachtman the work of art approached its ideal purpose to the degree that it provided quiet and comfort.[185] His images of the brook or the house thus function in a manner similar to that of the Buddhist mind landscape of the Sung painter or that of Monet in his later *nymphéas* (fig. 5.31). Both Twachtman's brook and the *nymphéas* present absorptive or reflective surfaces, the silent meditation on which promotes an empathic sense of weightlessness and tranquility. In Monet's own words, he had set out in this late program to "offer an asylum of peaceful meditation" for those with "nerves overstrained by work."[186]

Beyond the possibilities of psychological repose inherent in Twachtman's paintings, the winter landscapes also seemed to hold out for his contemporaries a solace that the spirit—manifested in the dematerialized forms of nature—will be regenerated after this season when life had seemingly disappeared from the earth.[187] Given these reassurances, there can be little doubt as to why Twachtman reached a high point for sales and appreciation of his work when he was producing these "ghostly" land-

scapes in the early 1890s and installing them in "ghostly" gallery displays in white frames against walls spread with white cheesecloth.[188] As critics commented, his works not only suggested an "impressionism minus the violence" but they were also "not fit for the struggle of life in a contemporary exhibition gallery."[189]

Though Twachtman's specific religious persuasion is not known, his marriage in a Swedenborgian church and his exploration of Asian religious texts during the 1890s suggest that he typically sought solutions to private dilemmas in popular religious currents that were outside orthodox Protestantism.[190] Like Dewing's works, Twachtman's winter landscapes proposed feminized aesthetic structures that operated in the nurturing terms of mind cure. The winter landscapes positively answered the problems posed by Darwinism: they denied the finality of the death, and they conformed to the evolutionary program by insisting on a higher, more civilized, anti-animalistic destiny for human culture.

If the therapeutic paradigm set into place by Twachtman's landscapes of the early 1890s approached Monet's intentions in the *nymphéas*, Twachtman also thought of these works as advancing an antibourgeois sensibility, a form of aesthetic refinement that was inspired by the rarefied effects of the Japanese print, which he, Weir, and Robinson began to collect at this

FIG. 5.31. *Claude Monet,* Water Lilies (I), *1905. Museum of Fine Arts, Boston, Gift of Edward Jackson Holmes.*

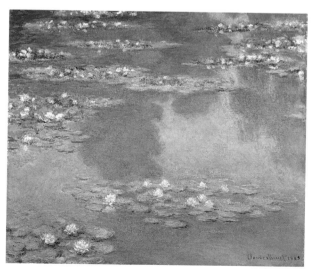

time.[191] To Twachtman and Weir, the Japanese sensibility stood for the opposite of the crass, "barbaric" element in American culture, epitomized, for example, in cacophonic, large-scale art exhibitions in which each painting jostled with the next for the viewer's attention.[192] Styling their collective exhibitions and their individual works thusly after what they perceived as an Asian subtlety and quiescence functioned as a means of distinguishing themselves as a small elite group from the all-too-numerous "mediocrities" of the Society of American Artists, as an elect few with an evolved ability to discern the higher "quality" in art from the lower. Appreciation of, and experimentation with, the parameters of this Asian aesthetic served as marks of initiation into a brahmin circle.

As the 1890s gave way to the first decade of the twentieth century, a noticeable preference for close tonal harmonies began to assert itself in the works of Twachtman, Weir, Metcalf, and usually Hassam, as well as the other members of the Ten. The signs of French impressionist cultural capital—jewel tones just squeezed out of the tube—gave way to color schemes that cohere around the middle tones and hues that are closer on the spectrum than complementaries. In search of quietism and refinement, guided by their considerable experience with pastel and by Whistler's example, as well as that of the Japanese print, they mixed a good deal of white into their palettes, so that their version of impressionist color is blond rather than high-keyed—toned down and ameliorated; that is, color harmony and tonal equilibrium predominate—not dissonances or abrupt shifts.

In their plein-air compositions of the early 1890s Tarbell especially, and at times Chase and Benson, had used the saturated, complementary hues exploited by Monet and Renoir. Tarbell's first work on this order, *Three Sisters: A Study in June Sunlight* (1890; fig. 5.32), sold immediately to the prominent Boston socialite and collector Mrs. J. Montgomery Sears. Though it was termed not too "violent" and was duly admired in exhibitions in New York and Boston, Tarbell's second endeavor in this vein, *In the Orchard* (1891; private collection), never did find a buyer.[193] The frothy confections Benson produced after 1900 hinged on white, blue, and pink, as he repeatedly posed his children dressed in summer linens against the deep blue of the bright midday sky (fig. 5.33).

The woman in the garden theme, the identification of nature with femininity and domesticity, was as much the preserve of Chase in his Shinnecock landscapes as the Boston painters. The summer art school Chase operated on Long Island in the 1890s was also made possible by the advent of the commuter railroad, which was developing the area as a resort community for affluent New Yorkers.[194] The great number of landscapes he

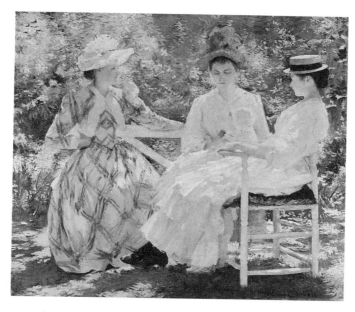

FIG. 5.32. *Edmund Tarbell,* Three Sisters: A Study in June Sunlight, *1890. Milwaukee Art Museum, Gift of Mrs. J. Montgomery Sears.*

FIG. 5.33. *Frank W. Benson,* Summer, *1909. Museum of Art, Rhode Island School of Design, Bequest of Isaac C. Bates.*

produced there during these years essentially facilitated the narrative of a middle-class rural paradise that was made all the more attractive by the need to flee from metropolitan reality to suburban playgrounds. Chase's *Near the Beach, Shinnecock* (c. 1895; fig. 5.34), one of many variations on the same theme, demonstrates his engagement with the design of the surface, as in his earlier park scenes.[195] In the Shinnecock landscapes he relentlessly played smaller rectangular shapes against the larger rectangle of the shaped canvas, geometrically partitioning the landscape components into colored oblongs and squares. Foreground expanses of greens, browns, and yellows are scumbled and rubbed into a coherent mass to provide flattened fields as appropriate backgrounds for the more intriguing presences of female figures. The figures of a mother and child, or children playing together, provide the white, pink, and red decorative accents requisite to breaking up the monotony of the flattened horizontal field. Chase's pleinairism, lacking the vibration of the high impressionist idiom, corresponds more to the naturalism of French painters such as Boudin, Daubigny, or even the very early Monet,[196] but was definitively shaped by the overriding aestheticism of Whistler to whom he paid homage on so many occasions.

If the Shinnecock landscapes of Chase present a toned-down and

FIG. 5.34. *William Merritt Chase,* Near the Beach, Shinnecock, *c. 1895. The Toledo Museum of Art, Gift of Arthur J. Secor.*

aestheticized version of naturalism, the Connecticut pastorals of Weir (1862–1919) demonstrate a self-conscious stylization that places them, with Twachtman's work, more within the sphere of symbolism, as internal landscapes made external and universal. Contemporaries often interpreted Weir's paintings, like Twachtman's, in terms of the spiritualist metaphors and as reflections of his much admired genteel character. Guy Pène du Bois, for example, read Weir's *Ploughing for Buckwheat* (1898; Carnegie Museum of Art) as "a final example of his personality . . . the soul of a modest American who intuitively shuns the vulgar side of materialism and yet makes its most successful models vivid symbols of the spirituality of the world." Understated, modest, and graceful, his personal character seemed of a piece with his silvery palette and small facture. Typically, he softened the "full light of day . . . beneath a screen of atmosphere that is lyrically suggestive," and his color was "American in the refined sense."[197] Thus, again recited was the litany of praise that tagged the American version of impressionism as a nonviolent, antibarbaric, and progressive modulation of the French idiom.

Weir's farming compositions such as *Summer Landscape* (c. 1890; fig. 5.35) translated what James had despaired over as an absence of form and cultivation—the remains of decaying structures, untidy, overgrown yards,

FIG. 5.35. *J. Alden Weir,* Summer Landscape, *c. 1890. Canajoharie Library and Art Gallery, Canajoharie, New York.*

as well as slovenly farmers—into aestheticized domains of picturesque charm. His means resembled Twachtman's in his construction of intimate space and a surface embroidered with a play of light and a muted palette. For Weir, as for Twachtman, his family (*In the Dooryard,* c. 1894; private collection) served as the focal point in constructing the New England landscape as a place of domestic tranquility. His method of flattening out feminine forms into abstracted shapes and gestures rendered symbolic the emotional intimacy of the family.

Dwelling on the glaciated terrain of Connecticut hillocks, Weir often located a feminine presence in the New England landscape, as did Dewing, Twachtman, and Henry James. The nature of *Upland Pasture* (c. 1905; pl. 12; fig. 5.36), for example, is feminized in terms of its coloristic delicacy, its tiny strokes of closely related blues, greens, and yellows and its decorative frills of boulders and sapling trees that reach up toward a high, Japanese-style horizon. Metcalf favored this therapeutic type as well (*Unfolding Buds,* 1909; The Detroit Institute of Arts), one that pleases, soothes, welcomes, and flirts with the viewer, as opposed to the masculinized, "phallic" sublime landscape that inspires fear and awe. When these landscapes are veiled in snow (fig. 5.37), not only is Whistlerian unity sug-

FIG. 5.36. *J. Alden Weir,* Upland Pasture, *c. 1905. National Museum of American Art, Smithsonian Institution, Gift of William T. Evans.*

FIG. 5.37. *Willard Metcalf,* The White Veil (No. 2), *1909. The Detroit Institute of Arts, Gift of Charles Willis Ward.*

gested as the natural order of things, but also, as in Twachtman's winter scenes, a corresponding spiritual harmony is hinted as the order underlying surface appearances.

In addition to the panoramic views of New England villages Metcalf turned out in the first twenty years of the century, he often followed Twachtman's lead in carving out intimate niches of space defined by a small brook and pool or a border of thin, spreading birches (*The Birches,* 1906; Museum of Fine Arts, Boston). For Isham and Cortissoz, Metcalf's quiescent subject and technique, the smooth, thin, still surface that lacked "the

FIG. 5.38. *Edwin H. Blashfield,* The Angel with the Flaming Sword, *1891. Church of the Ascension, New York.*

FIG. 5.39. *Frank DuMond,* Christ and the Fishermen, *1891. Private collection.*

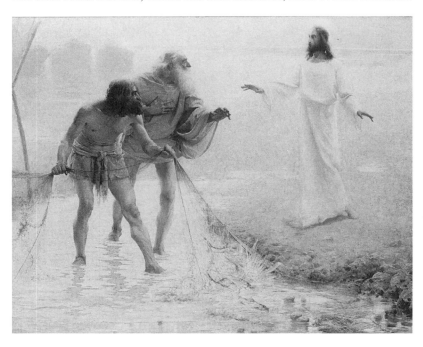

characteristic vibration . . . takes . . . [his] work out of the strict impressionist school."[198] Metcalf's work after 1905 presented a mediation between the tonal modes of the Barbizon school, Whistler, and Twachtman, and the high-keyed French idiom. The public accepted this moderated style as both modern and American, as was indicated by the numerous American art museums that purchased his work in the decade leading up to the First World War.[199]

As Elizabeth de Veer has observed, Metcalf fell back on his intense pleasure in nature in compensation for his episodes of alcoholism and marital turpitude. His late landscapes, however, must also be viewed through the interpretative framework of his spiritualist beliefs, as they pose visual analogies to the spiritualist Summerland, the afterlife that approached a perfected version of earthly life, much in the way that Inness's late landscapes function in relation to the Swedenborgian paradise.[200] Such an observation problematizes Metcalf's involvement with the impressionist idiom: his personalized translation of impressionism into a moderated and toned down quietist mode, as in the case of Twachtman, is obvious. But his landscapes also assert themselves as self-consciously constructed natural environments, in terms of their reiterated criss-crossing diagonal spaces and their hyperclear, brilliant atmospheres that at once produce diverse meticulously drawn forms and a sense of unity. In their overriding aestheticism these landscapes thus have more in common with the symbolist objectification of the subjective, the ordering of nature into a dreamlike or spiritual reality, than they do with the impressionist empirical study and notation of optical phenomena at a given moment in time and at a given site.

High-keyed color and quivering atmosphere could be employed, and were employed, in America as a pyrotechnical and theatrical strategy to heighten reality until the metaphysical dimension of the painting suggested a supranatural state. This is conveyed in the example of religious paintings executed in the early 1890s, such as Edwin Blashfield's enormous tour-de-force, *The Angel with the Flaming Sword* (1891; fig. 5.38), which displayed broken brushwork, jewel tones, and naturally observed light effects—techniques he learned from the Parisian naturalist school, in an effort to make oily impasto and eerily lit forms translate into mystical effects.

A close friend of Metcalf, Frank DuMond similarly hoped to produce a religious atmosphere in his *Christ and the Fishermen* (1891; fig. 5.39) through the strangeness of opalescent light. Observing the propensity of

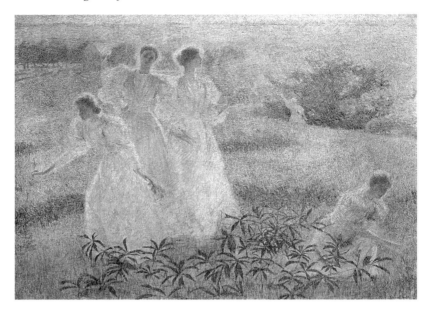

FIG. 5.40. *Philip Leslie Hale,* Girls in Sunlight, *c. 1897. Gift of Lilian Westcott Hale, Courtesy, Museum of Fine Arts, Boston.*

light to reflect off the surfaces of water and refract off moisture in the atmosphere, DuMond either manipulated the atmosphere to dissolve forms into ghostly apparitions, or he used light to clarify detail in a stark, linear fashion. In other words, the same naturalistically articulated light is called on to distinguish the earthly from the spiritual in the evocation of a supranatural moment. Even a more secularized and conventional composition, such as Philip Hale's *Girls in Sunlight* (1897; fig. 5.40), however, in its impressionist technique of broken brushwork and glaring light could achieve equally eerie (though unintended) effects, also making its interpretation problematic. Bathed in an "aureola of lemon yellow," the work was found by reviewers neither "harmonious" nor "agreeable," but some kind of an inexplicable "nebulous phantasy" in which the light decomposed the feminine figures into floating spectral forms.[201]

CONCLUSION

THE GOAL OF THIS PROJECT has been to set out the ways in which the northeastern Anglo-American elite utilized the language of evolutionary science, as it displaced the authority of religion in the 1880s and 1890s, to underwrite traditional Anglo-American ideologies. It specifically addresses artists' participation in this agenda by examining their representation of American life as a narrative of evolutionary progress to a new high point of world civilization. My study has considered both artistic idioms and personalities as socially constructed, as artists responded to and reinforced the public discourse on the evolutionary debate.

While this account is premised on the assumption that a visual language is determined by, and projects the political parameters of, a particular worldview, at certain moments—as in the cases of certain works by Metcalf, Blashfield, DuMond, and Hale, discussed at the end of chapter 5—it becomes obvious that visual language can be ambiguous and that its meaning depends on the viewer's position from within a given cultural context. This history has been focused on the hegemonic interests of the dominant class—the Anglo-American middle class of the Northeast—as that class perceived itself to be threatened by new claims for empowerment and the claims of Darwinian science. To a limited extent the book has also examined the interplay between public rhetoric and private needs, as those subjective needs inflected the representation of class and gender. If the private person in the fin-de-siècle moment despaired of universal randomness and meaninglessness, the public face he adopted was sanguine, even

if at times it was implicitly contradicted by a underlying melancholy about the unknown order of the future.

In referring here to the dominant artistic voices of the 1890s, I deliberately use the masculine pronoun, since that group, represented in the Ten and their most esteemed colleagues, such as Winslow Homer, Abbott Thayer, Thomas Eakins, and others, was uniformly male. It is thus through the medium of masculine subjectivity that we view the period, an era that was reviled by the self-consciously masculinized modernists of the next generation as overwhelming "genteel" and thusly feminized. For the most part the painters of the 1890s offered to their viewers "her/story"—the image of therapeutic leisure and domesticity—but from the masculine point of view. When the public sphere of history was essayed in images of the urban environment and the New England townscape that invoked the myths of present progress or Anglo-Saxon origins, this masculine narrative was overlaid with a gloss that bespoke the feminizing refinements of civilization.

A scenario symptomatic of the dilemma the Anglo-America artist confronted in facing American history at this moment is that of John White Alexander, who as a young man in Pittsburgh had the opportunity to paint the erupting violence of class conflict in the 1870s and 1880s, but who chose to evade that Darwinian chronicle for Spencerian images of feminine repose, in which a therapeutic state is passively effected through the viewer's adaptation to the harmonious environment of the picture space.

In contrast, the opportunity to paint the American scene as an arena of Darwinian conflict was seized in a singular work by the German-born artist Robert Koehler, whose painting *The Strike* (1886; fig. 6.1), executed in the year of "Great Upheaval," posed the antithesis to the myriad images of feminine repose and self-culture that were to proliferate in northeastern exhibitions in the 1890s. The confrontation between labor and capital depicted here resulted in four days of conflict, thirteen deaths, and at least one hundred injured when in 1877 Pittsburgh railroad workers protested the wage cuts proposed by management. From the middle-class Anglo-American point of view, such a moment was unrepresentable in the sphere of the fine arts, though artists such as Alexander reproduced the scenes of this very conflagration for the pages of *Harper's Weekly* in 1877.

Koehler's later recollection of the earlier incident was also engraved for *Harper's,* this time as a centerfold illustration for the May 1, 1886, edition, a date that had been designated by workers' groups all over the country as a day of public demonstrations for the eight-hour work day. The strike that began on this particular May Day holiday led two days later to the notorious

Haymarket Affair, in which one policeman was killed and seventy police-
men were injured by a bomb thrown into the police line, four demonstra-
tors were shot, and seven anarchists were executed afterward for a crime
in which there was no evidence of their complicity. From Koehler's subject
position in a German-American working-class family in Milwaukee, how-
ever, it was clearly possible to represent such landscapes of conflict. In
contrast to Anglo-American artists whose identification with the dominant
cultural position typically produced a position of silence, Koehler's iden-
tification with the aggrieved party, with the labor movement, led to the
pictorial protest that is clearly suggested in the representation of the ragged
madonna with her children at the lower left of *The Strike*. That there was
no market for such an image, however, is attested in the fact that the
painting had no purchaser from its exhibition at the National Academy of
Design, and it later came to rest in the public library in Minneapolis.
Koehler too acquiesced to the mainstream political position, and willingly
censored his sympathies with labor by adopting the more acceptable
domestic genres of portraiture and landscape after assuming an instructor's
post at the Minneapolis School of Art.[1]

FIG. 6.1. *Robert Koehler,* The Strike, *1886. Deutsches Historisches Museum,
Berlin.*

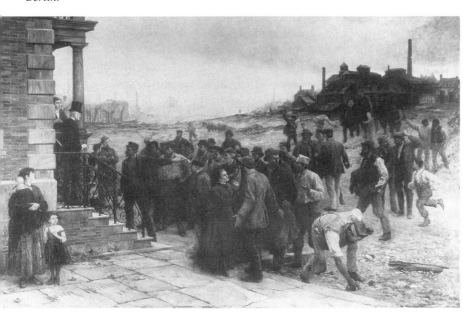

Beyond Koehler's example, Anglo-American artists almost without exception spoke in support of the status quo. As John Higham has noted, American artists and savants in the late nineteenth century lacked their European counterparts' sense of radical subjectivity, pessimism, and psychic and social disintegration, as well as their formal distortions.[2] Again, echoing the pragmatism of William James are the words of Augustus Saint-Gaudens, who in 1898 had just "flung . . . away" a volume of Schopenhauer after finding it "so deadly in its pessimism,"

> what's the use of taking that point of view? We can't remedy matters by weeping and gnashing our teeth over the misery of things! "That's the way things is" again, and although I have been told all my life it's best to put on a brave face and bear all cheerfully, it's only lately that it is really coming into my philosophy.
>
> It seems as if we are all in one open boat on the ocean, abandoned and drifting no one knows where, and while doing all we can to get somewhere, it is better to be cheerful than to be melancholy.[3]

Liberals such as Frank Lloyd Wright, William James, and Frederick Jackson Turner shared with Saint-Gaudens, Alexander, Thomas Dewing, and the Ten a therapeutic worldview, seeking unity and integration with the external world, seeking the "higher life" in both nature and the human-made world of culture.

The masculine gaze in this period was profoundly focused on the feminine object, which for the Anglo-American artist anchored the world of middle-class values and guided the way to the "higher life." Though the models for the ubiquitous female figure at her leisure were quite often the wives, daughters, or close associates of the artists, her representation on the canvas should not be confused with a flesh-and-blood woman. The figure is at all times a construction of masculine subjectivity. Masculine desire, for example, in the work of Whistler and Dewing, is the structuring principle of the image, even when the artist is trying to repress or deny that desire, while woman's desire is absent and never an issue.

The young northeastern Anglo-American woman functioned in a dual capacity for her male contemporaries. As a public symbol, her refinement to the point of bodilessness signified the evolution of American civilization to a superior state and its utopian promise, reflecting back to her masculine creators their own self-identity. In her appearance in the works of Dewing and Whistler, for example, the body is rendered musical—elongated into

rhythmic lines and cadences—or dematerialized, and thus rendered weight-less, and so finally denied, as woman is fashioned into aesthetic object. Thus neither her reproductive capacities nor her sexuality are at stake; she is neither madonna nor whore, but a desexualized symbolic construct.

At the same time, in a contradictory manner, the pliancy and amplitude of the symbolic feminine—both emotional and physical—supplied mascu-line needs for comfort and nurturance. It is not too much to assert that the extraordinary dependence of the artists of this study on the feminine—that is, on actual women, as well as the idea of woman and those cultural categories gendered feminine such as nature and art—with good reason gave rise to the typing of the era as feminized. For the masculine aggression and competition of the Darwinian marketplace could be countered and redeemed by the feminine therapeutics of the aestheticized home, the suburban garden, the symphonic Whistlerian artwork, or the performance of Wagner.

In assigning each thing and social practice to its appropriate sphere, the pervasive bifurcation of the world into the binary oppositions of masculine and feminine genders reinforced a sense of social stability at a time when the foundations of Anglo-American social order were being challenged by feminism, immigration, and Darwinian science. Geographical regions, their peoples and cultures, were also classified into social spheres: most notably, to the American Fenollosa the achievements in science and indus-try of Western Europe and its provinces suggested an essential masculinity, while the identification of Asia with mystical social, religious, and aesthetic practices typed it as feminine, and therefore another source of psychic renewal for elite men such as La Farge, Henry Adams, and other Boston brahmins.

To say that nature was gendered feminine in this period is to recall the manner in which New Englanders such as Henry James and Thomas Dewing typed their native landscape as soft, undulating, and ultimately arcadian sites of return to the "great mother." This landscape for these men was not simply maternal in its suggestion of a nurturing body of charm and mystery, but in the new-world Arcadia New Englanders figured as the nineteenth-century descendants of the ancient Greek and Roman civiliza-tions, a myth that was derived from the "Teutonic germ" theory of English philologists and regenerated in the Northeast by historian John Fiske.

If feminizing solace could be found in the hills of New England, then the brutalizing morphology of Frederick Jackson Turner's Western frontier inspired phallic dread of the typological masculine Darwinian sphere of

aggression and savagery that could also be revitalizing to the civilized male tourist, as the likes of Teddy Roosevelt discovered.[4] Roosevelt's embrace of masculine primitivism too signaled the end of the paradigm of the feminizing therapeutic environment as a model of social conduct in the early twentieth century. The feminine correlative of this movement was the New Woman, who, with her assertion of the body, and its attendant vitalism and fecundity, had already gained a foothold in the 1890s, particularly with the newly moneyed class, a social caste that in the thinking of its sharpest critic, Thorstein Veblen, was personified in Chicago's premiere clubwoman, Berthe Honoré Palmer.

This was a conflict between cultural modes, between the activist mode of the early twentieth-century Progressives and the meditational mode of the late nineteenth-century brahmins.[5] William James was perhaps one of the few who had a foot in both camps. Signaling the inability of the old elite to make the transition to the new Darwinian paradigm celebrated by industrialists and naturalists, in the 1910s Dewing's retardataire Puritan daughter literally and figuratively retreated from her expansive position in the New England landscape to the hermetic confines of therapeutic interior experience. In the terms of Henry Adams, the virgin was being replaced by the dynamo.

NOTES

INTRODUCTION

1. Letter 122, dated July 21, 1907, from Dwight Tryon to Charles Lang Freer, Freer Gallery of Art Archives [hereafter FGAA].

2. Quoted in Rose Standish Nichols, "Familiar Letters of Augustus Saint-Gaudens," *McClure's Magazine* 31 (October 1908): 608 and 616; and *McClure's Magazine* 32 (November 1908): 3.

3. Gillian Beer, *Darwin's Plots: Evolutionary Narrative in Darwin, George Eliot, and Nineteenth-Century Fiction* (London: Routledge and Kegan Paul, 1983), pp. 9, 17, and 18.

4. T. J. Jackson Lears, "The Concept of Cultural Hegemony: Problems and Possibilities," *American Historical Review* 90 (June 1985): 571, 590–591.

5. Lears, "Concept of Cultural Hegemony," 590, here paraphrases Fredric Jameson, *The Political Unconscious* (Ithaca: Cornell University Press, 1981), ch. 6.

6. See, for example, Doreen Bolger Burke et al., *In Pursuit of Beauty: Americans and the Aesthetic Movement* (New York: Metropolitan Museum of Art/Rizzoli, 1986); Wanda M. Corn, *The Color of Mood: American Tonalism, 1880–1910* (San Francisco: M. H. DeYoung Memorial Museum and the California Palace of the Legion of Honor, 1972); Charles C. Eldredge, *American Imagination and Symbolist Painting* (New York: New York University, Grey Art Gallery and Study Center, 1979); Lois Marie Fink, *American Art at the Nineteenth-Century Paris Salons* (Cambridge: Cambridge

University Press, 1990); William Gerdts, *American Impressionism* (New York: Abbeville, 1984); and H. Barbara Weinberg, *The Lure of Paris: Nineteenth-Century American Painters and Their French Teachers* (New York: Abbeville, 1991).

7. This clarified definition of cultural capital is proposed by Michèle Lamont and Annette Lareau, "Cultural Capital: Allusions, Gaps, and Glissandos in Recent Theoretical Developments," *Sociological Theory* 6 (Fall 1988): 155–158. Pierre Bourdieu, *Distinction: A Social Critique of the Judgment of Taste* (1979; Cambridge, Mass.: Harvard University Press, 1984); and "Social Space and Symbolic Power," *Sociological Theory* 7 (Spring 1989): 14–25.

8. Paul DiMaggio, "Cultural Entrepreneurship in Nineteenth-Century Boston: The Creation of an Organizational Base for High Culture in America," in *Media, Culture, and Society: A Critical Reader,* ed. Richard Collins et al. (London: SAGE Publications, 1986), pp. 194–211.

9. T. J. Jackson Lears, *No Place of Grace: Antimodernism and the Transformation of American Culture, 1880–1920* (New York: Pantheon Books, 1981); David A. Hollinger, *In the American Province: Studies in the History and Historiography of Ideas* (Bloomington: Indiana University Press, 1985); James R. Moore, *The Post-Darwinian Controversies: A Study of the Protestant Struggle to Come to Terms with Darwin in Great Britain and America, 1870–1900* (Cambridge: Cambridge University Press, 1979); Robert C. Bannister, *Social Darwinism: Science and Myth in Anglo-American Social Thought* (Philadelphia: Temple University Press, 1979); Carl N. Degler, *In Search of Human Nature: The Decline and Revival of Darwinism in American Social Thought* (New York: Oxford University Press, 1991); James Turner, *Without God, Without Creed: The Origins of Unbelief in America* (Baltimore: The Johns Hopkins University Press, 1985); Bruce Kuklick, *The Rise of American Philosophy: Cambridge, Massachusetts, 1860–1930* (New Haven: Yale University Press, 1977); William R. Hutchison, *The Modernist Impulse in American Protestantism* (Cambridge, Mass.: Harvard University Press, 1976); and Cynthia Eagle Russett, *Sexual Science: The Victorian Construction of Womanhood* (Cambridge, Mass.: Harvard University Press, 1989).

10. On this point, see the author's essay "Resisting Modernism: American Painting in the Culture of Conflict," in *American Icons: Transatlantic Perspectives on Eighteenth- and Nineteenth-Century American Art,* ed. Thomas W. Gaehtgens and Heinz Ickstadt (Santa Monica, Calif.: The Getty Center for the History of Art and the Humanities, 1992), pp. 303 and 306.

11. Thorstein Veblen, *The Theory of the Leisure Class: An Economic Study of Institutions* (1899; New York: The Modern Library, 1934).

12. See Yi-Fu Tuan, "Thought and Landscape: The Eye and the Mind's Eye," and D. W. Meinig, "Symbolic Landscapes: Models of American Community," in *The Interpretation of Ordinary Landscapes: Geographical Essays*, ed. D. W. Meinig (New York: Oxford University Press, 1979), pp. 89–102 and 164–194, respectively.

13. David Schuyler, *The New Urban Landscape: The Redefinition of City Form in Nineteenth-Century America* (Baltimore: The Johns Hopkins University Press, 1986); Peter B. Hales, *Silver Cities: The Photography of Urbanization, 1839–1915* (Philadelphia: Temple University Press, 1984).

I. THE AMERICAN RESPONSE TO DARWINISM

1. Charles Hodge, *What Is Darwinism?* (New York: Scribner, Armstrong & Co., 1874). See Frederick Gregory, "The Impact of Darwinian Evolution on Protestant Theology in the Nineteenth Century," in *God and Nature: Historical Essays on the Encounter between Christianity and Science*, ed. David C. Lindberg and Ronald L. Numbers (Berkeley: University of California Press, 1986), pp. 375–377; Edward J. Pfeifer, "United States," in *The Comparative Reception of Darwinism*, ed. Thomas F. Glick (Austin: University of Texas Press, 1974), pp. 168–206; Hutchison, *Modernist Impulse*, pp. 17–21.

2. Bowne and others are quoted in Paul F. Boller, *American Thought in Transition: The Impact of Evolutionary Naturalism, 1865–1900* (Chicago: Rand McNally, 1969), pp. 23ff.

3. Boller, *American Thought*, p. 28; J. Moore, *Post-Darwinian Controversies*, pp. 155–156 and 219; Charles Darwin, *The Descent of Man and Selection in Relation to Sex* (London: J. Murray, 1874), p. 126.

4. Cynthia Eagle Russett, *Darwin in America: The Intellectual Response, 1865–1912* (San Francisco: W. H. Freeman & Co., 1976), pp. 13–14.

5. Kuklick, *Rise of American Philosophy*, p. 26.

6. Gay Wilson Allen, *William James: A Biography* (New York: Viking Press, 1967), pp. 164ff., 172; Kuklick, *Rise of American Philosophy*, pp. 161–162 and 335; William James, "The Will to Believe" and "Is Life Worth Living?" in *The Will to Believe and Other Essays in Popular Philosophy; Human Immortality: Two Supposed Objections to the Doctrine* (New York: Dover Publications, 1956); Hollinger, "William James and the Culture of Inquiry," in *In the American Province*, pp. 3–22.

7. Dr. Robert Hooper died on April 13, 1885. Marion Hooper Adams killed herself by drinking potassium cyanide, on December 6, 1885. On Marion Adams, her relationships with her father and husband, and the circumstances of her death, see Patricia O'Toole, *The Five of Hearts: An Intimate Portrait of Henry Adams and His Friends, 1880–1918* (New York: Clarkson Potter Publishers, 1990), esp. pp. 130–157. In a letter of April 25, 1885, to Henry Adams, John Hay quoted Marion Adams on Richardson's architecture; cited in O'Toole, 142, who also notes on 154 that Marion Adams's insistence on the placement of the cross in this "Neo-Agnostic" structure was entirely against Henry Adams's wishes. In a letter of July 4, 1886, the Adamses' close friend Clarence King told John Hay that in *Esther* Adams had "exposed his wife's religious experiences and as it were made of her a clinical subject vis-a-vis of religion."; cited in O'Toole, 169. On Henry Adams and the *Adams Memorial,* see Homer Saint-Gaudens, *The Reminiscences of Augustus Saint-Gaudens* (New York: The Century Company, 1913), I:356–359, 362–366; and chapter 2 in this book.

8. Letters dated September 23, 1898, and February 17, 1897, respectively, quoted in Nichols, "Familiar Letters," *McClure's Magazine* 31:608; 32:3.

9. Milton Berman, *John Fiske: The Evolution of a Popularizer* (Cambridge, Mass.: Harvard University Press, 1961), p. 173.

10. See Neal C. Gillespie, *Charles Darwin and the Problem of Creation* (Chicago: University of Chicago Press, 1979), pp. 21–22, 55–56, 71, 78–79, 85, 119, 121.

11. Beer, *Darwin's Plots,* pp. 8, 14, 16, 43–44, 74–75.

12. J. Moore, *Post-Darwinian Controversies,* pp. 125–126; Boller, *American Thought,* p. 2; Gillespie, *Problem,* pp. 42–43. For the quote cited here, see the letter of July 13, 1856, from Darwin to J. D. Hooker, in Francis Darwin and A. C. Seward, eds., *More Letters of Charles Darwin* (New York: D. Appleton and Company, 1903), pp. 94–95. Beer, *Darwin's Plots,* 58, notes that Darwin replaced his original term *war,* which connoted a human conflict, with the less species-specific metaphor of struggle.

13. Quoted in Russett, *Darwin in America,* p. 89.

14. See Gillespie, *Problem,* pp. 49–50, esp. pp. 124ff. and 133, and ch. 8. J. Turner, *Without God, Without Creed,* p. 186; J. Moore, *Post-Darwinian Controversies,* pp. 231 and 303; and David A. Hollinger, "What Is Darwinism? It Is Calvinism!" *Reviews in American History* 8 (March 1980): 82–84.

15. On the American self-identity as an elect nation, see Sacvan Bercovitch, *The Puritan Origins of the American Self* (New Haven: Yale University Press, 1975).

16. J. Moore, *Post-Darwinian Controversies*, pp. 153–154 and 162.

17. J. Moore, *Post-Darwinian Controversies*, pp. 142–151, 219, 224–227, and 251; Degler, *In Search of Human Nature*, pp. 22–24; Pfeifer, "United States," 198–202; and George W. Stocking Jr., "Lamarckianism in American Social Science, 1890–1915," *Race, Culture, and Evolution: Essays in the History of Anthropology* (Chicago: University of Chicago Press, 1982), pp. 234–269.

18. J. Moore, *Post-Darwinian Controversies*, pp. 167–172.

19. See A. O. Lovejoy, *The Great Chain of Being: A Study of the History of an Idea* (New York: Harper and Row, 1960).

20. Herbert Spencer, *First Principles* (1862; New York: D. Appleton and Company, 1883), p. 396; and J. D. Y. Peel, *Herbert Spencer: The Evolution of a Sociologist* (New York: Basic Books, 1971), p. 136.

21. Stocking, "Lamarckianism in American Social Science"; J. Turner, *Without God, Without Creed*, pp. 205 and 250; J. Moore, *Post-Darwinian Controversies*, pp. 167–168, 240, and 250–251; Bannister, *Social Darwinism*, p. 59; Beer, *Darwin's Plots*, 23 and 37; Boller, *American Thought*, p. 28; Russett, *Darwin in America*, pp. 16–17; Kuklick, *Rise of American Philosophy*, p. 335.

22. John Dewey, *Character and Events* (1929); quoted in Bannister, *Social Darwinism*, p. 95.

23. Peel, *Herbert Spencer*, p. 133; Boller, *American Thought*, p. 50; D. H. Meyer, "American Intellectuals and the Victorian Crisis of Faith," *American Quarterly* 27 (December 1975): 600–601; and William James, *The Varieties of Religious Experience: A Study in Human Nature* (New York: Collier Books, 1961), p. 88.

24. Peel, *Herbert Spencer*, pp. 11–13; Spencer, *First Principles*, pp. 46 and 67; and J. Moore, *Post-Darwinian Controversies*, n. 146 and p. 168. On the rise of British agnosticism, see Bernard Lightman, *The Origins of Agnosticism: Victorian Unbelief and the Limits of Knowledge* (Baltimore: The Johns Hopkins University Press, 1987).

25. J. Moore, *Post-Darwinian Controversies*, pp. 167–169.

26. J. Moore, *Post-Darwinian Controversies*, p. 169. Darwin also acknowledged America as the most highly developed society but attributed this more to the unimpeded process of natural selection in the country. See Darwin, *Descent of Man*, pp. 144–145.

27. Hutchison, *Modernist Impulse*; Ann Douglas, *The Feminization of American Culture* (New York: Knopf, 1977), pp. 121–128, 180–189, and 199; J. Moore, *Post-Darwinian Controversies*, pp. 19ff.; Hollinger, "What Is Darwinism?" 80–85.

28. Douglas, *Feminization of American Culture.*

29. Douglas, *Feminization of American Culture,* pp. 100, 115–117, and 121–128; J. Turner, *Without God, Without Creed,* pp. 81, 110–112, and 188–189; Hutchison, *Modernist Impulse,* pp. 43–48.

30. Lawrence Buell, *Literary Transcendentalism: Style and Vision in the American Renaissance* (Ithaca: Cornell University Press, 1973), p. 52; and J. Turner, *Without God, Without Creed,* pp. 80, 163, 209, and 259.

31. *Scribner's Monthly* and *The Century Magazine,* which took over publication from *Scribner's* in November of 1881, published no less than seven of these articles from 1879 to 1883. See, for example, F. B. Sanborn, "The Homes and Haunts of Emerson," *Scribner's Monthly* 17 (February 1879): 496–511; Ralph Waldo Emerson, "Impressions of Carlyle in 1848," *Scribner's Monthly* 22 (May 1881): 89; "Topics of the Time: Ralph Waldo Emerson," *The Century Magazine* 24 (July 1882): 457–458; and "Topics of the Time: George Eliot and Emerson," *The Century Magazine* 23 (February 1882): 619–621; Emma Lazarus, "Emerson's Personality," *The Century Magazine* 24 (July 1882): 454–456; and Ralph Waldo Emerson, "The Superlative," *The Century Magazine* 23 (February 1882): 534–537. Richard Watson Gilder, the editor of these two publications, included in his 1885 volume of poetry a piece that described Emerson's "inward melody" as containing the "very soul" of America; see "To an English Friend with Emerson's 'Poems,' " *Lyrics and Other Poems* (New York: Charles Scribner's Sons, 1885), p. 57.

32. H. L. Kleinfield, "The Structure of Emerson's Death," in *Ralph Waldo Emerson: A Profile,* ed. Carl Bode (New York: Hill and Wang, 1969), pp. 175–199.

33. Charles William Eliot, "Emerson as Seer," *Atlantic Monthly* 91 (June 1903): 855.

34. Quoted in Pfeifer, "United States," 201.

35. Buell, *Literary Transcendentalism,* pp. 151–159; also R. A. Yoder, "The Equilibrist Perspective: Toward a Theory of American Romanticism," *Studies in Romanticism* 12 (1973): 705–709.

36. See Berman, *John Fiske,* pp. 94 and 159. D. H. Meyer, "American Intellectuals," 601.

37. Kuklick, *Rise of American Philosophy,* pp. 102–103.

38. John Fiske, *The Destiny of Man Viewed in the Light of His Origin,* in *Studies in Religion, Being The Destiny of Man; The Idea of God; Through Nature to God; Life Everlasting* (Boston: Houghton Mifflin Company, 1902), pp. 18–20 and 78. Beer, *Darwin's Plots,* p. 19.

39. Berman, *John Fiske,* p. 102.

40. Fiske, *Destiny of Man,* in *Studies in Religion,* pp. 80–81.

41. Ibid, p. 83.

42. See Herbert Spencer, *The Principles of Psychology* (New York: D. Appleton and Company, 1903), ch. 3, pp. 418–426; Fiske, *Destiny of Man*, in *Studies in Religion*, pp. 68–69; and Peel, *Herbert Spencer*, pp. 144–150. Berman, *John Fiske*, p. 98, notes that Fiske was also attentive to Wallace, who stated that with the advent of the human mind, natural selection ceased to modify man physically and selected instead for intelligence.

43. Fiske, *The Idea of God as Affected by Modern Knowledge*, in *Studies in Religion*, pp. 205–208. Hutchison, *Modernist Impulse*, pp. 99–105. On the Puritan tradition of regarding America as the site of the millennium, see Sacvan Bercovitch, *The American Jeremiad* (Madison: University of Wisconsin Press, 1978).

44. Kuklick, *Rise of American Philosophy*, p. 174.

45. J. Turner, *Without God, Without Creed*, p. 163; James, *The Varieties of Religious Experience*, p. 117. On the Transcendentalists, see Buell, *Literary Transcendentalism*.

46. Herbert Spencer, *Social Statics; or, the Conditions Essential to Human Happiness Specified, and the First of Them Developed* (1865; New York: D. Appleton and Company, 1884), pp. 73, 74, and 79.

47. James, *The Varieties of Religious Experience*, p. 119; J. Moore, *Post-Darwinian Controversies*, pp. 238–240; Berman, *John Fiske*, p. 105; Hutchison, *Modernist Impulse*, pp. 191–193.

48. Kuklick, *Rise of American Philosophy*, pp. 158, 179, and 257.

49. James, *The Varieties of Religious Experience*, pp. 117–118; and "Is Life Worth Living?" pp. 38–47.

50. Kuklick, *Rise of American Philosophy*, p. 295.

51. Kuklick, *Rise of American Philosophy*, pp. 331–336, also relates James's pluralism to Bergson's concept of duration.

52. Allen, *William James*, pp. 287, 368, and 469.

53. On Spencer's view of mind as an agent of adaptation, see his *Principles of Psychology*, ch. 2, pp. 418–426, 577ff.; Kuklick, *Rise of American Philosophy*, pp. 89–90, notes that Fiske did not publish this idea until 1899, but that he and James probably influenced each other on this issue.

54. Edward Livingston Youmans, ed., *Herbert Spencer on the Americans and the Americans on Herbert Spencer: Being a Full Report of His Interview and of the Proceedings of the Farewell Banquet of November 9, 1882* (1882; reprint ed., New York: D. Appleton and Company, 1887), pp. 29–35, gives Spencer's address.

55. Buell, *Literary Transcendentalism*, pp. 274–277; Hutchison, *Mod-*

ernist Impulse, pp. 17–22; David Robinson, *The Unitarians and the Universalists* (Westport, Conn.: Greenwood Press, 1985), pp. 32–33, 46; David Robinson, *Apostle of Culture: Emerson as Preacher and Lecturer* (Philadelphia: University of Pennsylvania Press, 1982).

56. James Freeman Clarke, *Self-Culture: Physical, Intellectual, Moral, and Spiritual* (New York: James R. Osgood and Company, 1880).

57. See George M. Beard, *American Nervousness: Its Causes and Consequences* (New York: G. P. Putnam's Sons, 1881); F. G. Gosling, *Before Freud: Neurasthenia and the American Medical Community, 1870–1910* (Urbana: University of Illinois Press, 1987), pp. 9–16, 78–98; William James, "The Gospel of Relaxation," *Scribner's Monthly* 25 (April 1899): 499–507, and *The Varieties of Religious Experience,* pp. 90–111, 377. James also recommended *Power Through Repose* (Boston, 1893) and *As a Matter of Course* (Boston, 1894), two books on the techniques of mental relaxation by Annie Payson Call. Other articles in this vein are George Romanes, "The Science and Philosophy of Recreation," *Popular Science Monthly* 15 (October 1879): 773–795; and Alfred H. Peters, "The Extinction of Leisure," *The Forum* 7 (August 1889): 683–693.

58. Prentice Mulford, *Your Forces, and How to Use Them* (New York: Red Cross Knight Library, c. 1888–1890). Ralph Waldo Trine, *In Tune with the Infinite* (1896), in *The Best of Ralph Waldo Trine* (Indianapolis: The Bobbs-Merrill Company, Inc., 1957), was another popular mind-cure text in the 1890s. For James's endorsement of mind cure, see James, *The Varieties of Religious Experience,* pp. 91–92, n. 15, 140; and Allen, *William James,* pp. 287, 368, and 469. On the history of mind cure, see Gail Thain Parker, *Mind Cure in New England from the Civil War to World War I* (Hanover, N.H.: University Presses of New England, 1973); and Donald Meyer, *The Positive Thinkers: Religion as Pop Psychology from Mary Baker Eddy to Oral Roberts* (New York: Pantheon Books, 1980).

59. John Higham, "The Reorientation of American Culture in the 1890's," in *The Origins of Modern Consciousness,* ed. John Weiss (Detroit: Wayne State University Press, 1965), pp. 25–48. Kleinfield, "Structure of Emerson's Death," 196, somewhat condescendingly describes the "Genteel Tradition" as predominantly a culture of "self-help." The same attitude is also evident in Howard Mumford Jones, "The Genteel Tradition," *The Age of Energy: Varieties of American Experience, 1865–1915* (New York: Viking Press, 1971), pp. 216–258; Lears, *No Place of Grace,* passim; and Alan Trachtenberg, *The Incorporation of America: Culture and Society in the Gilded Age* (New York: Hill and Wang, 1982), esp. ch. 5.

60. Kuklick, *Rise of American Philosophy,* pp. 309–313.

61. Ibid., p. 306.

62. Beer, *Darwin's Plots,* pp. 6 and 17.

63. These escalating figures peaked in the eight years from 1907 to 1914, when an average of 650,000 people entered the country annually. Paul Boyer, *Urban Masses and Moral Order in America, 1820–1920* (Cambridge, Mass.: Harvard University Press, 1978), pp. 123–124; Trachtenberg, *Incorporation of America,* p. 88; and John Higham, *Strangers in the Land: Patterns of American Nativism, 1860–1925* (New York: Athenaeum, 1965), pp. 137–140 and 159.

64. On the rhetorical strategies nineteenth-century Americans employed to regenerate Puritan ideology, see Bercovitch, *American Jeremiad.* Darwin, *Descent of Man,* pp. 144–145, here quotes Foster Barhum Zincke, *Last Winter in the United States* (London: J. Murray, 1868), p. 29.

65. Youmans, *Herbert Spencer,* pp. 19–20.

66. Berman, *John Fiske,* pp. 210–211; Bercovitch, *American Jeremiad,* 40–44; James R. Moorhead, "Between Progress and Apocalypse: A Reassessment of Millennialism in American Religious Thought, 1800–1880," *Journal of American History* 71 (December 1984): 524–525; "The Erosion of Postmillennialism in American Religious Thought, 1865–1925," *Church History* 53 (March 1984): 61–62; and J. Turner, *Without God, Without Creed,* pp. 87–88. For the ideas of Freeman and other British theorists, as well as the American appropriation of Anglo-Saxonism, see Reginald Horsman, *Race and Manifest Destiny: The Origins of American Racial Anglo-Saxonism* (Cambridge, Mass.: Harvard University Press, 1981), pp. 63–77 and 177–186; and Edward N. Saveth, *American Historians and European Immigrants, 1875–1925* (New York: Columbia University Press, 1948).

67. Fiske reflected later that "the very cream of Boston . . . [drank] in every word and tone with hushed breath and keen relish"; Berman, *John Fiske,* pp. 126, n. 29, 127–137 and 139.

68. John Fiske, "Manifest Destiny," *Harper's New Monthly Magazine* 70 (March 1885): 578–590, and his book, *The Beginnings of New England* (1889).

69. Berman, *John Fiske,* pp. 251, 265; Theodore Roosevelt, *The Strenuous Life: Essays and Addresses* (New York: The Century Company, 1901); Gail Bederman, *Manliness and Civilization: American Debates about Race and Gender, 1880–1917* (Chicago: University of Chicago Press, 1995).

70. Fiske, "Manifest Destiny," 583 and 588.

71. Fiske, like Spencer and most Americans, used the word *race* as a category defined by linguistic and cultural traits, as well as biological differences, until about 1910, when the eugenics controversy was intro-

duced into the country. See Berman, *John Fiske,* pp. 267 and 269; and Higham, *Strangers in the Land,* p. 122.

72. Barbara Miller Solomon, *Ancestors and Immigrants: A Changing New England Tradition* (Cambridge, Mass.: Harvard University Press, 1956), pp. 10–22.

73. Stocking, "The Dark-Skinned Savage: The Image of Primitive Man in Evolutionary Anthropology," in *Race, Culture, and Evolution,* pp. 116–128. Herbert Spencer, *The Principles of Sociology,* 3d edition (New York: D. Appleton & Company, 1896) I, chs. 6 and 7, pp. 71 and 92–93.

74. Stocking, "Lamarckian in American Social Science," pp. 242–244; Peel, *Herbert Spencer,* pp. 144–155, notes also that Spencer and other nineteenth-century anthropologists moved between race and environment, according to which view was "ideologically useful," and that Spencer's gravitation toward racial determinism away from environmentalism occurred as he became more politically conservative at the end of his career; Lester Frank Ward, "Eugenics, Euthenics, Eudemics," *American Journal of Sociology* 27 (May 1913): 741–750, quoted in Degler, *In Search of Human Nature,* pp. 21–22.

75. For a few examples, see "Editor's Easy Chair: Does the Puritan Still Survive?" *Harper's New Monthly Magazine* 72 (March 1886): 641–643; John H. Denison, "The Survival of the American Type," *Atlantic Monthly* 75 (1895): 16–28; and Albert Bushnell Hart, "Is the Puritan Race Dying Out?" *Munsey's Magazine* 45 (1911): 252–255.

76. Higham, *Strangers in the Land,* pp. 120–121, 138–144, 159–163.

77. David Montgomery, *The Fall of the House of Labor: The Workplace, the State, and American Labor Activism, 1865–1925* (Cambridge: Cambridge University Press; Paris: Editions de la maison des sciences de l'homme, 1987), esp. pp. 284–285.

78. Melvyn Dubofsky, *Industrialism and the American Worker, 1865–1920* (Arlington Heights, Ill.: Harlan Davidson, Inc., 1985), ch. 2, pp. 33ff. Trachtenberg, *Incorporation of America,* pp. 89 and 99.

79. See Robert H. Wiebe, *The Search for Order, 1877–1920* (New York: Hill and Wang, 1967); David Montgomery, *Workers' Control in America: Studies in the History of Work, Technology, and Labor Struggles* (Cambridge: Cambridge University Press, 1979), pp. 34ff.; and Dubofsky, *Industrialism,* ch. 1; Trachtenberg, *Incorporation of America,* ch. 3, esp. pp. 79–91.

80. Boyer, *Urban Masses,* p. 126; Dubofsky, *Industrialism,* pp. 48–53.

81. Though not wholly acquitting Spencer of these charges, Lester Frank Ward noted that though Spencer's writings "possess this tone [of *laissez-faire*] throughout, his disciples, particularly in America, delight in

going even farther than their master"; see "Mind as a Social Factor," *Mind* 4 (October 1884): 563–573; reprinted in David A. Hollinger and Charles Capper, *The American Intellectual Tradition: A Sourcebook, Volume II: 1865 to the Present* (New York: Oxford University Press, 1989), pp. 32–41. Spencer's influence on Darwin can even be discerned in the latter's discussion of highly civilized societies, in which Darwin agreed with Spencer that there the moral and altruistic values of the society and the inherited effects of environment and habit predominated over natural selection. Peel, *Herbert Spencer*, pp. 146–150, disputes the traditional interpretations of Spencer's thought as social Darwinism, arguing that Spencer's view of the "early stages of social evolution," in which societies were militaristic, involved a crude version of Darwinism, but that Spencer labeled them " 'barbarous' and 'cannibal' and saw them not as a means of advance, but as a symptom of regression"; and finally that this was not Spencer's prescription for the more advanced stages of industrialized societies. On Darwin's racism, see Degler, *In Search of Human Nature*, p. 15. Bannister, *Social Darwinism*, ch. 2, treats Spencer's vacillation on social issues.

82. See Irvin G. Wyllie, "Social Darwinism and the Businessman," *Proceedings of the American Philosophical Society* 103 (October 1959): 629–635. Merle E. Curti, *The Growth of American Thought* (New York: Harper & Brothers, 1951), and Richard Hofstadter, *Social Darwinism in American Thought, 1860–1915* (Philadelphia: University of Pennsylvania Press, 1945), link Spencer and the "robber barons." Donald C. Bellomy, " 'Social Darwinism' Revisited," *Perspectives in American History* 1 (1984): 1–29, provides a more recent evaluation of the problem.

83. On nativism, see Higham, *Strangers in the Land*, pp. 137–138; and Trachtenberg, *Incorporation of America*, pp. 79 and 87.

84. Boyer, *Urban Masses*, pp. 127–131; Francesco Dal Co, "From Parks to the Region: Progressive Ideology and the Reform of the American City," in *The American City: From the Civil War to the New Deal*, ed. Giorgio Ciucci, Francesco Dal Co, Mario Manieri-Elia, and Manfredo Tafuri (Cambridge, Mass.: The MIT Press, 1979), p. 196.

85. Boyer, *Urban Masses*, pp. 175–187.

86. Ward, "Mind as a Social Factor"; Stocking, "Lamarckianism in American Social Science," 243–245, 251, and 256, explains that these Lamarckian social theorists could remain both "racialist and egalitarian" in their views of cultural development, as did Ward, because they used biological terms to describe social processes, assuming that social characteristics were transmitted biologically.

87. On "positive environmentalism," see Schuyler, *New Urban Land-*

scape, pp. 185ff.; and Thomas Bender and William R. Taylor, "Culture and Architecture: Some Aesthetic Tensions in the Shaping of Modern New York City," in *Visions of the Modern City: Essays in History, Art, and Literature*, ed. William Sharpe and Leonard Wallock (New York: Columbia University Press, 1983), pp. 200–203.

88. Herbert Spencer, *Education: Intellectual, Moral, and Physical* (New York: D. Appleton and Company, 1881), esp. pp. 156–160, had sanctioned a healthy component of pleasure in the educational process and in the formation of cultural mores, by advancing the observation that learning is more successful the more it gratifies the instinct of pleasure; Boyer, *Urban Masses*, pp. 179–187.

89. Dal Co, "Parks to the Region," 164; and Henry Hope Reed and Sophia Duckworth, *Central Park: A History and a Guide* (New York: Clarkson N. Potter, Inc., 1967), pp. 34–35 and 41.

90. Harvey Green, "Popular Science and Political Thought Converge: Colonial Survival Becomes Colonial Revival, 1830–1910," *Journal of American Culture* 6 (Winter 1983): 3–24; and William B. Rhoads, "The Colonial Revival and the Americanization of Immigrants," in *The Colonial Revival in America*, ed. Alan Axelrod (New York: W. W. Norton, 1985), pp. 341–361.

91. Charles Eliot Norton, "The Educational Value of the History of the Fine Arts," *Educational Review* (April 1895); quoted in Jones, *The Age of Energy*, p. 240. On Norton, see Kermit Vanderbilt, *Charles Eliot Norton: Apostle of Culture in a Democracy* (Cambridge, Mass.: The Belknap Press of Harvard University Press, 1959).

92. On the Aesthetic Movement, see Detroit Institute of Arts, *The Quest for Unity: American Art between World's Fairs, 1876–1893* (Detroit: Detroit Institute of Arts, 1983); and Burke et al., *In Pursuit of Beauty*. On Wilde, see Richard Ellmann, *Oscar Wilde* (New York: Vintage Books, 1988).

93. Eileen Boris, *Art and Labor: Ruskin, Morris, and the Craftsman Ideal in America* (Philadelphia: Temple University Press, 1986), p. 78, quotes Candace Wheeler; and 88–89, and 92–93.

94. Boris, *Art and Labor*, pp. 40–51.

95. Boris, *Art and Labor*, pp. 62ff.; Margaret Marsh, "Suburban Men and Masculine Domesticity, 1870–1915," *American Quarterly* 40 (June 1988): 165–186.

96. Boris, *Art and Labor*, pp. 84–89, 92–96; Garry Wills, "Sons and Daughters of Chicago," *The New York Review of Books* 41 (June 9, 1994): 57–58.

97. Henry Adams, *The Education of Henry Adams: An Autobiography* (Boston: Houghton Mifflin Company, 1918), pp. 340–343, remarked that

the fair was "the first expression of American thought as a unity" and contrasted it to America's more traditional approach to such large enterprises as "a Babel of loose and ill-joined . . . thoughts and half-thoughts and experimental outcries."

98. David F. Burg, *Chicago's White City of 1893* (Lexington: University Press of Kentucky, 1976), ch. 7; Trachtenberg, *Incorporation of America,* pp. 217–219; Mario Manieri-Elia, "Toward an Imperial City: Daniel H. Burnham and the City Beautiful Movement," in *The American City: From the Civil War to the New Deal,* p. 36.

99. Robert Rydell, "The Chicago World's Columbian Exposition of 1893: 'And Was Jerusalem Builded Here?'" *All the World's a Fair: Visions of Empire at American International Expositions, 1876–1916* (Chicago: University of Chicago Press, 1984), pp. 38–71; and "Rediscovering the 1893 Chicago World's Columbian Exposition," in *Revisiting the White City: American Art at the 1893 World's Fair* (Washington, D.C.: National Museum of American Art and National Portrait Gallery, 1993), pp. 18–61.

100. See Burg, *Chicago's White City,* pp. 102 and 108, for the texts of the speeches made by Col. George R. Davis, director general of the fair, and Chauncey Depew, who delivered the "Columbian Oration" on opening day. Manieri-Elia, "Toward an Imperial City," 35–46, also provides eyewitness responses to the fair.

101. Manieri-Elia, "Toward an Imperial City," 48–81; Richard Guy Wilson, "Architecture, Landscape, and City Planning," in *The American Renaissance, 1876–1917* (Brooklyn: The Brooklyn Museum, 1979), pp. 87ff.; and William H. Wilson, *The City Beautiful Movement* (Baltimore: The Johns Hopkins University Press, 1989).

102. On the omnipresence of progressive environmentalism among American architects by the turn of the century, see Gwendolyn Wright, *Moralism and the Model Home* (Chicago: The University of Chicago Press, 1981), pp. 199–211.

103. Frank Lloyd Wright, "The Architect," *The Brickbuilder* 9 (June 1900): 126; quoted in Robert C. Twombly, *Frank Lloyd Wright: His Life and His Architecture* (New York: John Wiley and Sons, 1979), p. 50.

104. Frank Lloyd Wright, *The Natural House* (1954; New York: Mentor Book; New American Library, 1963), pp. 29, 123, and 166–167.

105. Robert Fishman, *Urban Utopias in the Twentieth Century: Ebenezer Howard, Frank Lloyd Wright, and Le Corbusier* (Cambridge, Mass.: The MIT Press, 1982), pp. 142–144.

106. On the social function of paradigms, see Thomas S. Kuhn, *The Structure of Scientific Revolutions* (Chicago: University of Chicago Press,

1970); and on the application of the Kuhnian paradigm to historical discourse, see David A. Hollinger, "T. S. Kuhn's Theory of Science and Its Implications for History," in *In the American Province,* pp. 105–129.

2. JOHN LA FARGE AND THE SENSUOUS ENVIRONMENT

1. Henry Adams (Frances Snow Compton), *Esther,* intro. by Robert E. Spiller (1884; New York: Scholars' Facsimiles and Reprints, 1976), pp. 22–23.

2. Adams, *Esther,* p. 255.

3. John La Farge, *Considerations on Painting: Lectures Given in the Year 1893 at the Metropolitan Museum of New York* (1895; New York: The Macmillan Company, 1908), pp. 255–256; and Anna Bowman Dodd, "John La Farge," *The Art Journal* (London) 47 (1886): 264.

4. John La Farge, *An Artist's Letters from Japan* (New York: The Century Company, 1897), p. 158. La Farge's notes on Japan were first published in installments in *The Century Magazine* between February 1890 and August 1893. Wills, "Sons and Daughters," 57, makes a similar point, that this generation understood aesthetic practices as universally viable regardless of class.

5. The artist's son, John La Farge, S. J., "The Mind of John La Farge," *Catholic World* 140 (March 1935): 706, notes that these humanistic values justified "man as the measure of all things" in art, especially in interpreting the art object. Linnea H. Wren, "John La Farge: Aesthetician and Critic," in *John La Farge: Essays,* ed. Henry Adams et al. (Pittsburgh and Washington, D.C.: Carnegie Museum of Art and National Museum of American Art, Smithsonian Institution, 1987), pp. 229–230, takes issue with the foregoing assertion.

6. Royal Cortissoz, *John La Farge: A Memoir and a Study* (Boston: Houghton Mifflin Company, 1911).

7. Cortissoz, *Memoir,* pp. 74–100, recounts the events of this European trip.

8. Helene Barbara Weinberg, "John La Farge, the Relation of His Illustrations to His Ideal Art," *American Art Journal* 5 (May 1973): 60–61; James L. Yarnall, "John La Farge's 'Paradise Valley Period,'" *Newport History* 55 (Winter 1982): 6–25.

9. For an example of this kind of criticism, see Charles H. Caffin, *American Masters of Painting: Being Brief Appreciations of Some American Painters* (New York: Doubleday, Page and Co., 1902), pp. 23–24.

10. La Farge, S. J., "The Mind of John La Farge," 706; La Farge, *Considerations on Painting,* p. 211; and *An Artist's Letters,* p. 113.

11. La Farge, *Considerations on Painting*, pp. 112–113.

12. Cecilia Waern, *John La Farge, Artist and Writer* (London: Seeley and Company, Limited, 1896), p. 16.

13. See La Farge, *Considerations on Painting*, pp. 103 and 112–113; and Yarnall, "'Paradise Valley Period,'" 19–20. Henry Adams, *John La Farge, 1830–1870: From Amateur to Artist*, Ph.D. diss., Yale University (Ann Arbor: University Microfilms, Inc., 1980), esp. pp. 293–303.

14. Wolfgang Born, *Still-Life Painting in America* (New York: Oxford University Press, 1947), p. 41.

15. See Henry Adams, "A Fish by John La Farge," *Art Bulletin* 62 (June 1980): 269–280; Henry Adams, "John La Farge and Japan," *Apollo* 119 (February 1984): 120–129; and Henry Adams, "John La Farge's Discovery of Japanese Art: A New Perspective on the Origins of *Japonisme*," *Art Bulletin* 67 (September 1985): 450–453.

16. Adams, "John La Farge's Discovery of Japanese Art," 478, 480–481, n. 155.

17. John La Farge, S. J., *The Manner Is Ordinary* (New York: Harcourt, Brace & Co., 1954), pp. 24–25; Adams, *John La Farge, 1830–1870*, p. 204. La Farge's list of books at the 1866 sale of his library includes such titles as Peter Hardeman Burnett, *The Path Which Led a Protestant Lawyer to the Catholic Church* (New York, 1860), *Cyclopedia of Religious Denominations; or, Authentic Accounts of the Different Creeds and Systems Prevailing Throughout the World, by Members of the Respective Bodies* (London, 1853), Kelnem Digby, *Mores Catholici; or, Ages of Faith* (London, 1844), F. D. Maurice, *Sequel to the Inquiry, What is Revelation?* (Cambridge, England, 1860) and *Theological Essays* (New York, 1854), Rev. Robert Owen, *Introduction to the Study of Dogmatic Theology* (London, 1858) and *Footfalls on the Boundary of Another World* (Philadelphia, 1860), Richard Whateley, *Paley's Evidences of Christianity* (New York, 1860), Rev. R. W. Morgan, *St. Paul in Britain; or, the Origin of British as Opposed to Papal Christianity* (Oxford, England, 1861), Emanuel Swedenborg, *Treatise on Heaven and Hell* (London, 1800), Robert A. Vaughan, *Hours with the Mystics, A Contribution to the History of Religious Opinion* (London, 1860), Cardinal Wiseman, *Lectures on Science and Revealed Religion* (London, 1853), Francois Pierre Guillaume Guizot, *L'Eglise et la Société Chrétiennes* (1861), E. About, *La Question Romaine* (Brussels, 1859), and many more that indicate his interests in Catholic/Protestant doctrinal differences, as well as the liberalized theology emanating from England.

18. Sidney E. Ahlstrom, *A Religious History of the American People* (New Haven: Yale University Press, 1972), pp. 552–554, 556, 564–565, and 629.

19. Ella M. Foshay, *Reflections of Nature: Flowers in American Art* (New

York: Whitney Museum of American Art, 1984), pp. 58–59, implies that Darwin's scientific attitude influenced La Farge to study natural forms in their own habitats, ostensibly because he had a copy of Darwin's *Expression of the Emotions in Men and Animals* (London, 1872) in his library by 1881. La Farge's pursuit of natural law in this respect, however, might be more properly deemed Ruskinian, and expressive of the ubiquitous impulse in the mid-nineteenth century English-speaking world to study nature empirically. La Farge also owned a set of the complete writings of John Fiske, as well as a biography of Fiske; see *Catalogue of a Portion of the Library of John La Farge,* March 24 and 25, 1909, Anderson Auction Company, New York (La Farge Family Papers, Yale University Library), no. 200; and *Catalogue of the Private Library of the Late John La Farge,* February 20, 21, and 23, 1911, Merwin-Clayton Sales Company, New York (La Farge Family Papers, Yale University Library).

20. Cortissoz, *Memoir,* pp. 134–136; and Dodd, "La Farge," 262.

21. La Farge, S. J., "The Mind of John La Farge," 707; La Farge, *Considerations on Painting,* pp. 131, 141, 203; Ruth Berenson Katz, "John La Farge, Art Critic," *Art Bulletin* 33 (June 1951): 115.

22. John La Farge, *Considerations on Painting,* pp. 129–131, 169, and *An Artist's Letters,* p. 145. Recalling Swedenborg's correspondences, La Farge wrote that expression in art was "based on a correspondence between the sensations of the soul and the sensations of the body."

23. Cortissoz, *Memoir,* pp. 14, 23–25, and 209.

24. Dodd, "La Farge," 261.

25. George Parsons Lathrop, "John La Farge," *Scribner's Monthly* 21 (February 1881): 509–510. It is interesting to note that La Farge made a drawing (1862) similar in description to *Spirit of the Waterlily,* presumably intended as an illustration for a volume of Emerson, which, again, underlines the connection between Emerson and the Orient in the minds of many late nineteenth-century Americans. See H. Barbara Weinberg, *The Decorative Work of John La Farge* (New York: Garland, 1977), p. 57, n. 3.

26. James Jackson Jarves, *The Art-Idea: Sculpture, Painting, and Architecture in America* (New York: Hurd and Houghton, 1865), pp. 224–225.

27. Jarves, *Art-Idea,* p. 226.

28. Caffin, *American Masters of Painting,* p. 34, also comments on La Farge's reach for the spiritual through material luxury.

29. Kathleen A. Foster, "John La Farge and the American Watercolor Movement: Art for the 'Decorative Age,'" in *John La Farge: Essays,* pp. 138, 144, 150–151; and James Yarnall, *John La Farge: Watercolors and Drawings* (Westchester, N.Y.: Hudson River Museum, 1990), p. 35, comments that

the floral watercolors he began to sell in 1879 to great success "fed into and [were] fed by his decorative work, particularly stained glass."

30. La Farge, *An Artist's Letters*, p. 158.

31. See Cortissoz, *Memoir*, pp. 44–61, and Henry Adams, "The Mind of John La Farge," in *John La Farge: Essays*, pp. 18–19.

32. Henry T. Tuckerman, *Book of the Artists: American Artist Life* (New York: G. P. Putnam & Son, 1867), p. 208.

33. Berman, *John Fiske*, pp. 191–192, relates that the only Catholic priests interested in evolutionary thought were those who, like Hecker, were committed to converting Protestants and enhancing the "modernity" of the Church. In 1897 the Pope condemned "Americanism," i.e., the modernist evolutionary discourse, and excommunicated many of those who had been involved with such topics. Boller, *American Thought*, pp. 38–39, recounts that the Roman Catholic Church was essentially hostile toward evolution, but then by the 1890s tried to diminish any sense of conflict. When Father John A. Zahm of the University of Notre Dame in 1895 attempted to reconcile evolutionary theory with theology, however, his tract, *Evolution and Dogma*, was condemned by the Holy See, and Zahm promptly "withdrew it from circulation." On Zahm, see John Rickards Betts, "Darwinism, Evolution, and American Catholic Thought, 1860–1900," *The Catholic Historical Review* 45 (July 1959): 161–185; and Thomas J. Schlereth, introduction, *Evolution and Dogma*, by J[ohn]. A[ugustine]. Zahm (1896; New York: Arno Press, 1978).

34. Letter from La Farge to Margaret Perry, February 20, 1860, quoted in La Farge, S. J., *The Manner Is Ordinary*, p. 24.

35. Dodd, "La Farge," 263.

36. Ahlstrom, *Religious History*, pp. 628–631.

37. Lears, *No Place of Grace*, ch. 5, esp. pp. 192–193; and William B. Chisholm, "Open Letters: Christmas and Modern Ritualism," *The Century Magazine* 47 (December 1893): 314.

38. Hutchison, *Modernist Impulse*, p. 15.

39. Saint-Gaudens, *Reminiscences*, I:190–191.

40. The three Episcopal churches La Farge decorated in New York were St. Thomas Church (1878), the Church of the Incarnation (1882–1885), and the Church of the Ascension (1886–1888). In contrast to the scholastic figural style La Farge developed in the Episcopal churches, which was based on quotations from celebrated Old Master paintings, he used floral and geometric motifs adopted from Byzantine and Romanesque (i.e., early Christian) sources at the United Congregational Church in Newport, Rhode Island (1880), and the Brick Presbyterian Church in New York

(1883). Symbols of the liturgy, animals for example, were also employed in designs that enhanced the liturgical functioning of the churches. Weinberg, *Decorative Work,* part II, gives a complete and detailed account of La Farge's church decorations; and in "John La Farge: Pioneer of the American Mural Movement," in Adams et al., *John La Farge: Essays,* p. 164.

41. Adams, *Esther,* pp. 5, 10–11, and 101.

42. Raymond W. Albright, *Focus on Infinity: A Life of Phillips Brooks* (New York: The Macmillan Co., 1961), pp. 155–156, 162–163, 176, and 195.

43. Dodd, "La Farge," 264. Dodd did not use quotation marks in the passages quoted here and thus might be paraphrasing La Farge's exact words. That they represent La Farge's viewpoint and not Dodd's, however, is made clear because she takes issue with his line of reasoning.

44. See John La Farge, *The Higher Life in Art* (New York: The McClure Company, 1908), which volume contains the artist's lectures at the Art Institute of Chicago in 1903; see also Katz, "Art Critic,"; 108.

45. See H. Barbara Weinberg, "John La Farge: Pioneer of the American Mural Movement," and Henry La Farge, "Painting with Colored Light: The Stained Glass of John La Farge," in *John La Farge: Essays.* Among the other capitalists and financiers who gave La Farge commissions were Frederick Lothrop Ames, Henry G. Marquand, James J. Hill, and Darius Ogden Mills. La Farge's *Fortune Window* (1902) graced the Frick Building in Pittsburgh, a structure named for Henry Clay Frick, the chief lieutenant of Andrew Carnegie's steel mills. Carnegie's corporation was notorious for the poor wages and living conditions of thousands of men in its employ. The fee La Farge commanded to decorate the New York residence of Cornelius Vanderbilt II in 1878 reached the six-figure sum of $100,000, signaling La Farge's stature in the field; see Henry La Farge, "John La Farge's Work in the Vanderbilt Houses," *American Art Journal* 16 (Autumn 1984): 30–70. For La Farge's prices (and their 1994 approximations), see Julie L. Sloan and James L. Yarnall, "Art of an Opaline Mind: The Stained Glass of John La Farge," *American Art Journal* 24 (Winter and Spring/Summer 1994): 17, 34–35, 43.

46. On the relationships between lower-class and immigrant audiences and the cultural forms targeted as pedagogical vehicles, see Michele H. Bogart, *Public Sculpture and the Civic Ideal in New York City, 1890–1930* (Chicago: The University of Chicago Press, 1989); and "In Search of a United Front: American Architectural Sculpture at the Turn of the Century," *Winterthur Portfolio* 19 (Summer/Autumn 1984): 151–176; Harvey

Green, "Popular Science and Political Thought Converge," 3–24; and Rhoads, "The Colonial Revival," 341–361.

47. Lears, *No Place of Grace*, pp. 159–171.

48. Letter of May 12, 1911, to Royal Cortissoz (Yale University Library); quoted in Worthington Chauncey Ford, ed., *Letters of Henry Adams (1892–1918)* (Boston: Houghton Mifflin Company, 1938), p. 567.

49. Hutchison, *Modernist Impulse*, pp. 98–105.

50. "Mr. La Farge on Useless Art," *Architectural Record* 17 (April 1905): 346, quotes La Farge's speech.

51. Katz, "Art Critic," 111–112, n. 44, notes that La Farge owned a volume of Spencer's *Essays: Moral, Political, and Aesthetic* (London, 1871) at the time of his 1881 library sale, as well as several volumes by Spencer's French followers.

52. La Farge, *An Artist's Letters*, p. 113; Lois Fink, "The Innovation of Tradition in Late Nineteenth-Century American Art," *American Art Journal* 10 (November 1978): 63–71.

53. For a detailed discussion of the mural's creation and sources, see La Farge, *An Artist's Letters*, pp. 113 and 170–174; Weinberg, *Decorative Work*, pp. 179–193; and Adams, "La Farge and Japan," 125–129, who commented on the artist's conservative use of Japanese art as well in the late 1870s.

54. La Farge, *An Artist's Letters*, pp. 145–147; and a typescript of La Farge's lecture delivered in Boston in 1906, Isabella Stewart Gardner Papers, Archives of American Art, Smithsonian Institution [herafter AAA], microfilm 401, frame 540.

55. Letter dated September 20, 1867, Cambridge, to Thomas Sergeant Perry (La Farge's brother-in-law); quoted in Leon Edel, *Henry James, 1843–1870: The Untried Years* (Philadelphia: Lippincott, 1953), pp. 264–265. When Henry James was introduced to La Farge only a few years earlier at Newport, he had been tremendously impressed by the older man's erudition, and in reading this passage, one cannot help but wonder if La Farge had not contributed to such reasoning, similar as it is to the themes of James's late novels. For an account of La Farge's influence on Henry James, see Edel, pp. 142–144 and 162–166, and Henry Adams, "William James, Henry James, John La Farge, and the Foundations of Radical Empiricism," *American Art Journal* 17 (Winter 1985): 63–65.

56. La Farge, *An Artist's Letters*, pp. 170 and 173.

57. Rydell, "The Chicago World's Columbian Exposition," 50–51.

58. La Farge, *An Artist's Letters*, pp. 117–118.

59. Adams, "Foundations of Radical Empiricism," 63; Cortissoz, *Memoir*, pp. 14–16, wrote of La Farge's "serene eloquence," meditative manner, and "self-centered calm," which lent him an affinity with the East; according to Cortissoz, the artist spoke slowly, with an "oracular deliberation," and his spell-binding monologues created an anticipation in the listener, who waited for the next mental picture to unfold.

60. See M. H. Abrams, *Natural Supernaturalism: Tradition and Revolution in Romantic Literature* (New York: W. W. Norton, 1971), particularly pp. 228–237, 292–299, 338, 431–436; also Sigmund Freud, *Civilization and Its Discontents*, ed. and trans. James Strachey (New York: W. W. Norton, 1961), pp. 11–13; and James, *The Varieties of Religious Experience*, p. 377.

61. La Farge, *An Artist's Letters*, pp. 116–118 and 173, alludes to Shingon meditational practices. Bigelow continued to practice Shingon meditation after returning to Boston; see Akiko Murukata, ed., *Selected Letters of Dr. William Sturgis Bigelow*, Ph.D. diss., George Washington University, 1971, letter 47, April 1895 to Rt. Rev. Kwanryo Naobayashi from Bigelow, which refers to his invocation of the "three mysteries" of Shingon practice. Satoko Fujita Tachiki, *Okakura Kakuzo (1862–1913) and Boston Brahmins*, Ph.D. diss., University of Michigan (Ann Arbor: University Microfilms, Inc., 1986), p. 40, recounts that Okakura, Bigelow, and Fenollosa received the Buddhist precepts of the Tendai sect from Ajari Sakurai on September 21, 1885.

62. Lawrence W. Chisolm, *Fenollosa: The Far East and American Culture* (New Haven: Yale University Press, 1963), pp. 22–28 and 41–42; Murakata, *Selected Letters*, 61, letter of September 3, 1883, from Bigelow to Edward S. Morse reports that Fenollosa is again reading Emerson, and 83, letter of August 19, 1889 (Nikko), to Phillips Brooks.

63. O'Toole, *Five of Hearts*, pp. 174, 248–249, and 256, quotes King's letter of January 1892 to John Hay.

64. Spencer, *Principles of Sociology*, vol. 1, chs. 5, 6, and 7, esp. pp. 90–92; and Stocking, "The Dark-Skinned Savage," 126.

65. Letter of May 12, 1911, from Adams to Royal Cortissoz; quoted in Ford, *Letters of Henry Adams*, p. 568.

66. Cortissoz, *Memoir*, pp. 245–247. La Farge respected Gauguin's sincere attempt to find regeneration in the primitivism of Samoan life but could not tolerate the degree of distortion Gauguin produced in his *synthétisme*.

67. La Farge, *An Artist's Letters*, pp. 157–158. La Farge's dichotomy between the East as mystical and aesthetic and the West as rational and

scientific is consistent with Fenollosa's analysis of the evolution of world civilization: see Chisolm, *Fenollosa,* pp. 96–97. Carl T. Jackson, "The New Thought Movement and the Nineteenth-Century Discovery of Oriental Philosophy," *Journal of Popular Culture* 9 (Winter 1975): 523–548, points out that the principle of release into the subconscious through meditation and the idea of psychic revitalization attendant upon that release were probably appropriated by mind-cure theorists from this Eastern religious practice. At the 1909 sale of his library, La Farge had two mind-cure texts by Ralph Waldo Trine (*In Tune with the Infinite* [1897] and *What All the World's A-Seeking* [1899]); by the time of his death he had accumulated a sizeable number of books on spiritualism, Hinduism, Buddhism, and Taoism, including volumes by Elizabeth Stuart Phelps, Rhys Davids, Bigelow, Percival Lowell, the Swami Vivekananda, Lao-Tzu, and Confucius.

68. La Farge, *An Artist's Letters,* p. 242.

69. Isabella Stewart Gardner Papers, AAA, microfilm 401, frame 540. In *Considerations on Painting,* pp. 117–118, again, paraphrasing Delacroix, La Farge conveyed his belief that an art form evocative of the mystery found in silence was superior to that of literary expression. Such a visual image was "infinitely more expressive [than literature], since, independently of the idea, its sign, its living hieroglyph, fills the soul of the painter with the splendour that things give; their beauty, their contrast, their harmony, their colors,—all the undivided order of the external universe."

70. Adams, *Esther,* pp. 59–60, had La Farge's stand-in, the painter Wharton, respond, to a question about the darkness of his work, that the "merit of a painting was not so much in what it explained as in what it suggested."

71. Okakura Kakuzo, *The Book of Tea* (1906; New York: Duffield and Green, 1932). Okakura was employed as curator of Japanese art at the Boston Museum after Fenollosa's tenure there. See Tachiki, *Okakura Kakuzo,* pp. 114–116, 124–127; and Okakura Kakuzo, "Religions in East Asiatic Art," in *Okakura Kakuzo: Collected English Writings* (Tokyo: Heibonsha Limited, Publishers, 1984) II:134 and 142.

72. Okakura Kakasu, *The Ideals of the East, with Special Reference to the Art of Japan* (London: John Murray, 1903), pp. 172, 184, and 228.

73. Okakura, *Tea,* pp. 60–61.

74. Okakura, *Tea,* pp. 112, 123; and *Ideals,* pp. 28, 181, and 184.

75. Okakura, *Tea,* p. 111; and *Ideals,* pp. 37–38 and 169.

76. Adams, *John La Farge,* p. 309. His visual source for the painting was probably Thomas Couture's *Reverie,* which was sold in New York in 1863 for a large sum. On Courbet's sleeping women and the unconscious, see

Aaron Sheon, "Courbet, French Realism, and the Discovery of the Unconscious," *Arts Magazine* 55 (February 1981): 114–128.

77. Adams, *John La Farge*, p. 315.

78. Lears, *No Place of Grace*, ch. 4, pp. 142–181 and 218–224; Bederman, *Manliness and Civilization;* and Charles S. Rosenberg, "Sexuality, Class, and Role in 19th-Century America," *American Quarterly* 25 (May 1973): 131–153. David James Fisher, "Reading Freud's *Civilization and Its Discontents,*" in *Modern European Intellectual History: Reappraisals and New Perspectives,* ed. Dominick La Capra and Stephen L. Kaplan (Ithaca: Cornell University Press, 1982), particularly pp. 255–257, discusses Freud's notion of the "oceanic experience" as the source of all religious feeling, "the force responsible for the individual's amorous bonds with other humans and the environment," and the reservoir of artistic inspiration and creative ability.

79. La Farge, *An Artist's Letters*, pp. 83, 98, and 191–192.

80. Lears, *No Place of Grace*, p. 224.

81. Lydia M. Child, "Resemblances Between the Buddhist and the Roman Catholic Religions," *Atlantic Monthly* 26 (December 1870): 660–665. See Lears, *No Place of Grace*, ch. 4.

82. Okakura, *Tea*, pp. 37 and 151–152.

83. Okakura, *Tea*, p. 24, quoted in Tachiki, *Okakura Kakuzo*, p. 118. On the attraction of Teaism for agnostics in Boston as a religious way of life, and its compatibility with evolutionary theory, see Tachiki, pp. 115–127, and 141; Tachiki, 20, notes also that Fenollosa had tutored Kakuzo in evolutionary theory.

84. For a historical account of the *Adams Memorial,* see Louise Hall Tharp, *Saint-Gaudens and the Gilded Era* (Boston: Little, Brown and Co., 1969), pp. 222–225, and Saint-Gaudens, *Reminiscences,* I:356–366. La Farge, *An Artist's Letters*, pp. vii and 174–175.

85. La Farge, *An Artist's Letters*, p. 175.

86. For the origins of image of the Kannon near a waterfall, see Alice Getty, *The Gods of Northern Buddhism, Their History, Iconography, and Progressive Evolution Through the Northern Buddhist Countries* (Oxford: The Clarendon Press, 1928), p. 97; and Hugo Munsterberg, *Dictionary of Chinese and Japanese Art* (New York: Hacker Art Books, 1981), p. 167. La Farge, *An Artist's Letters*, p. 96, reproduces the image of the Kannon by Okyo.

87. Lafcadio Hearn, "Nirvana: A Study in Synthetic Buddhism," in *Gleanings in Buddha-Fields: Studies of Hand and Soul in the Far East* (Boston: Houghton Mifflin and Company, 1897), pp. 211–266. Guy Richard Welbon,

The Buddhist Nirvana and Its Western Interpreters (Chicago: University of Chicago Press, 1968), p. 228, relates the similar interpretation of nirvana by Thomas William Rhys Davids, one of the great popularizers of Buddhism in the late nineteenth-century English-speaking world.

88. O'Toole, *Five of Hearts,* pp. 249–250, observes that John Hay and Charles Adams connected the idea of repose after suffering with the sculpture, and that Clarence King interpreted it in terms of Marion Adams's despair; see also Saint-Gaudens, *Reminiscences,* I:362.

89. Saint-Gaudens, *Reminiscences,* I:356–359, 362–366, wrote that Adams suggested the Kannon and the sibyls of the Sistine as sources, as well as Raphael's *Sistine Madonna.* The sculptor noted on his preliminary sketch for the figure, "Adams/Buhda [sic] Mental Repose/Calm reflection/in contrast with/the violence or/ force in nature."

90. Weinberg, *Decorative Work,* pp. 441–442; and Maria Oakey Dewing, "Abbott Thayer–A Portrait and an Appreciation," *International Studio* 74 (August 1921): 7.

91. La Farge exhibited his small easel paintings at the Society of American Artists from 1878 to 1892, the American Society of Water-color Painters, the National Academy of Design, from 1862 to 1879, and even monthly throughout the 1880s and 1890s at the socially prominent Century Club. Theodore Robinson's entry for December 12, 1893, in vol. 1 of his Diaries (Frick Art Reference Library, New York) suggests the great impression the appearance of La Farge's *Paradise Valley, Newport* made on younger painters at the 1893 Fine Arts Society Retrospective Exhibition.

92. Journal for April 16, 1875, and December 12ff., 1877, Helena de Kay Gilder, Richard Watson Gilder and Helena de Kay Gilder Papers, AAA, microfilm 285.

3. JAMES MCNEILL WHISTLER AND THE RELIGION OF ART

1. Carl Dahlhaus, *Between Romanticism and Modernism: Four Studies in the Music of the Later Nineteenth Century* (Berkeley: University of California Press, 1980), pp. 7–10.

2. Dahlhaus, *Between Romanticism and Modernism,* pp. 7–10.

3. Jürgen Habermas, "Modernity versus Postmodernity," *New German Critique* 22 (Winter 1981): 10.

4. Gabriel P. Weisberg and Petra ten-Desschate Chu, *The Realist Tradition: French Painting and Drawing, 1830–1900* (Cleveland: Cleveland Museum of Art, 1980). Several of the standard reconstructions of Whistler's life and art are as follows: E. R. Pennell and J. Pennell, *The Life of James*

McNeill Whistler (rev. 6th ed.; Philadelphia: J. B. Lippincott Company, 1919), and *The Whistler Journal* (Philadelphia: J. B. Lippincott Company, 1921); Denys Sutton, *Nocturne: The Art of James McNeill Whistler* (London: Country Life Limited, 1963), and *James McNeill Whistler: Paintings, Etchings, Pastels, and Watercolours* (London: Phaidon, 1966); and Gordon Fleming, *The Young Whistler, 1834–1866* (London: George Allen & Unwin, 1978).

5. Michael Fried, *Absorption and Theatricality: Painting and Beholder in the Age of Diderot* (Berkeley: University of California Press, 1980); and *Courbet's Realism* (Chicago: University of Chicago Press, 1990).

6. Sheon, "French Realism," 114–128; and Katharine A. Lochnan, *The Etchings of James McNeill Whistler* (New Haven: Yale University Press, in association with the Art Gallery of Ontario, 1984), pp. 27–66.

7. Horace Lecoq de Boisboudran, *The Training of Memory in Art* (Paris: 1847); Douglas Druick and Michel Hoog, *Fantin-Latour* (Ottawa: National Gallery of Canada, 1983), pp. 65–66.

8. Charles Dickens, *Our Mutual Friend* (1864–1865; London: Dent; New York: Dutton/Everyman's Library, 1963), p. 19. Whistler's letter to Fantin-Latour of July 1861, Pennell-Whistler Collection of the Papers of Joseph Pennell, Elizabeth Robins Pennell, and James A. McNeill Whistler, Manuscripts Division, Library of Congress [hereafter Pennell-Whistler Collection, LC], describes the earlier state of the painting before Jo's dress was changed; quoted in Léonce Bénédite, "Artistes Contemporains: Whistler," *Gazette des Beaux-Arts* 33 (1905): 496.

9. E. R. Pennell and J. Pennell, *Life,* pp. 69–70.

10. Elizabeth Broun, "Thoughts That Began with the Gods: The Context of Whistler's Art," *Arts Magazine* 62 (October 1987): 36–43, connected the bearskin with Whistler, in interpreting the painting as an unconscious projection of Whistler's complex emotions for his mistress.

11. Andrew McLaren Young, Robin Spencer, and Margaret MacDonald, with the assistance of Hamish Miles, *The Paintings of James McNeill Whistler* (New Haven: Yale University Press, 1980), I:17–22; and Fleming, *Young Whistler,* pp. 184–190. Lee McKay Johnson, *The Metaphor of Painting: Essays on Baudelaire, Ruskin, Proust, and Pater* (Ann Arbor: University Microfilms, Inc., 1980), pp. 3–7.

12. Dennis Farr, "James McNeill Whistler–His Links with Poetry, Music, and Symbolism," *The Royal Society for the Encouragement of Arts, Manufactures, and Commerce Journal* 122 (April 1974): 267–284; Ronald W. Johnson, "Whistler's Musical Modes: Symbolist Symphonies," *Arts* 55 (April 1981):

166. Baudelaire's approval of the painting was related to Whistler by Fantin-Latour in a letter (after May 1863), Rosalind Birnie Philip Papers, University of Glasgow. At its 1863 exhibition Whistler simply called this composition *The White Girl,* while the critic Paul Mantz referred to it as a "symphonie en blanc." Charles Baudelaire, *Salon de 1846,* ed. David Kelley (Oxford: The Clarendon Press, 1975); Paul Mattick Jr., "The Beautiful and Sublime: Gender Totemism in the Constitution of Art," *Journal of Aesthetics and Art Criticism* 48 (Fall 1990): 300–301.

13. Rosenberg, "Sexuality, Class, and Role," esp. 140–151.

14. Fleming, *Young Whistler,* p. 174, notes that the association of Whistler's *White Girl* with Collins's novel *The Woman in White* stuck until "as late as 1867."

15. The *Athenaeum* review and Desnoyers's comments (in translation) and others are quoted in Fleming, *Young Whistler,* pp. 173–174 and 189–191.

16. Bénédite, "Artistes," 509–511, quotes Castagnary among other reviewers, and discusses Whistler's admiration for Millais's *Eve of St. Agnes* (1863; Collection of Her Majesty Queen Elizabeth the Queen Mother) exhibited in London in 1863.

17. McLaren Young et al., *Paintings,* I:19–20.

18. Bénédite, "Artistes," 232–233, quotes Whistler's letter to Fantin-Latour (no. 24, August 1867), Pennell-Whistler Collection, LC.

19. In 1863 Whistler took Swinburne to Paris to introduce him to Baudelaire, with whom Swinburne then struck up a correspondence. Throughout the mid-1860s Swinburne was deeply involved in assimilating Baudelaire's and Poe's concepts of synaesthesia and musicality to the visual arts. See Eric Warner and Graham Hough, eds., *Strangeness and Beauty: An Anthology of Aesthetic Criticism, 1840–1910; Vol. I: Ruskin to Swinburne* (Cambridge: Cambridge University Press, 1983), pp. 221–225.

20. John Sandberg, "Whistler Studies," *Art Bulletin* 50 (March 1968): 63–64; and Alastair Grieve, "Whistler and the Pre-Raphaelites," *The Art Quarterly* 34 (1971): 219–221.

21. McLaren Young et al., *Paintings,* I: 29. Another possible source for Whistler's *Little White Girl* is a photograph of Fanny Cornforth before a mirror (Jeremy Maas Collection), an image staged in Rossetti's Chelsea garden just a few months after Whistler moved nearby in 1863.

22. Swinburne's poem was published in his *Poems and Ballads* (London: John Camden Hotten, 1868). The title of Swinburne's poem strengthens the relation between Whistler's "white girl" and Millais's etching. On

Freud's conception of feminine narcissism, see Sarah Kofman, *The Enigma of Woman: Women in Freud's Writings,* trans. Catherine Porter (Ithaca: Cornell University Press, 1985), pp. 39–71.

23. Letter from Swinburne to Whistler, dated April 2, 1865, quoted in Cecil Y. Lang, ed., *The Swinburne Letters* (New Haven: Yale University Press, 1959), I:119–120.

24. For Whistler's statements on his belief in and practice of spiritualism, see E. R. Pennell and J. Pennell, *Whistler Journal,* pp. 156–158; and *Life,* I:115 and 189.

25. E. R. Pennell and J. Pennell, *Whistler Journal,* p. 157.

26. Letter from Fantin-Latour to Whistler, after May 1863 (Rosalind Birnie Philip Papers, University of Glasgow); cited in Bénédite, "Artistes," 509; Fernand Desnoyers shared Courbet's response, calling *The White Girl, No. 1* "le portrait d'une spirite, d'un medium."

27. On Courbet's spiritualist practices, see Sheon, "French Realism," 22; and Michael Fried, "Courbet's Metaphysics: A Reading of *The Quarry,*" *Modern Language Notes* 99 (1984): 808–810. Courbet repeated this composition of Jo staring into a mirror three times after painting the original; see Ann Dumas in *Courbet Reconsidered,* by Sarah Faunce and Linda Nochlin (Brooklyn, New York: The Brooklyn Museum, 1988), p. 162.

28. R. Laurence Moore, *In Search of White Crows: Spiritualism, Parapsychology, and American Culture* (New York: Oxford University Press, 1977), esp. 62–66 and 138–146; and Janet Oppenheim, *The Other World: Spiritualism and Psychical Research in England, 1850–1914* (Cambridge: Cambridge University Press, 1985).

29. Maurice Bloch and Jean H. Bloch, "Women and the Dialectics of Nature in Eighteenth-Century French Thought," *Nature, Culture, and Gender,* ed. Carol P. Mac Cormack and Marilyn Strathern (Cambridge: Cambridge University Press, 1980), pp. 33–40; and Ludmilla Jordanova, "Natural Facts: An Historical Perspective on Science and Sexuality," in *Sexual Visions: Images of Gender in Science and Medicine Between the Eighteenth and Twentieth Centuries* (Madison: University of Wisconsin Press, 1989). Jeffrey Weeks, *Sex, Politics, and Society: The Regulation of Sexuality Since 1800* (London: Longman Group Limited, 1981), ch. 2. Leonore Davidoff and Catherine Hall, *Family Fortunes: Men and Women of the English Middle Class, 1780–1850* (Chicago: University of Chicago Press, 1987); and Mary Poovey, *Uneven Developments: The Ideological Work of Gender in Mid-Victorian England* (Chicago: University of Chicago Press, 1988), esp. ch. 1.

30. Londa Schiebinger, "Skeletons in the Closet: The First Illustrations

of the Female Skeleton in Nineteenth-Century Anatomy," *Representations* 14 (Spring 1986): 63–72; Jordanova, *Sexual Visions,* pp. 19–42.

31. Nancy F. Cott, "Passionlessness: An Interpretation of Victorian Sexual Ideology, 1790–1850," *Signs* 4 (Winter 1978): 234–235; Schiebinger, "Skeletons," 63–65; and Ruth H. Bloch, "Untangling the Roots of Modern Sex Roles: A Survey of Four Centuries of Change," *Signs* 4 (Winter 1978): 237–252.

32. Cott, "Passionlessness," 227; and Christine Buci-Glucksmann, "Catastrophic Utopia: The Feminine as Allegory of the Modern," *Representations* 14 (Spring 1986): 223, discusses the importance of the figure of the prostitute to Baudelaire's concept of modernity. G. Robert Stange, "The Frightened Poets," in *The Victorian City: Images and Realities,* ed. H. J. Dyos and Michael Wolff (London: Routledge and Kegan Paul, 1973), vol. 2, pp. 479–493, argued that the connection between sexual exploitation and the urban environment intimidated English artists and writers, unlike their French counterparts, and kept them from developing a poetics of the city.

33. Mattick, "Beautiful and Sublime," 300, commented briefly on the types of the bad sublime. Bram Dijkstra, *Idols of Perversity: Fantasies of Feminine Evil in Fin-de-Siècle Culture* (New York: Oxford University Press, 1986); Mario Praz, *The Romantic Agony,* trans. Angus Davidson (London: Oxford University Press, 1951).

34. On Freud's theory of feminine sexuality, see Kofman, *Enigma of Woman.*

35. Albert Parry, *Whistler's Father* (Indianapolis: Bobbs-Merrill Company, 1939).

36. See, for example, Sutton, *Nocturne,* p. 40.

37. John Sandberg, "'Japonisme' and Whistler," *Burlington Magazine* 106 (November 1964): 500–505 and 507; McLaren Young et al., *Paintings,* I: 32.

38. Warner and Hough, *Strangeness and Beauty,* pp. 221–222. Walter Pater's essay "The School of Giorgione" was probably written in the late 1860s and was later included in the 1883 edition of *The Renaissance* (1873). Michael Levey, *The Case of Walter Pater* (London: Thames and Hudson, 1978), pp. 105 and 108–110, recounts that Swinburne's influence on Pater was as important as Rossetti's and Baudelaire's, especially in the essays that were later collected into *The Renaissance.*

39. Swinburne knew the works of Gautier and Baudelaire through Rossetti before meeting Whistler, and both struggled to develop musical modes throughout the 1860s, with Whistler reaching a breakthrough in the *Six Projects* and appending musical titles to his works only in 1867.

Further, in his study of Blake, Swinburne had already arrived at several of the dicta Whistler put forth in his "Ten O'Clock" lecture of 1886. Swinburne set out these ideas in several short pieces in the 1860s, which were collected and published in 1870 as *Essays and Studies*. The relationship between Swinburne and Whistler deserves further study. See also Grieve, "Pre-Raphaelites," and Sandberg, "Whistler Studies."

40. In the year *The Balcony* was painted, Fantin-Latour executed his *Homage à Delacroix* (1864; Musée du Louvre), a group portrait that depicted those artists and writers—Whistler, Fantin-Latour, Alphonse Legros, Felix Bracquemond, Manet, and Baudelaire, among others—who were disciples of Baudelaire's aestheticism. E. R. Pennell and J. Pennell, *Life*, p. 91, relate that Whistler significantly wanted Rossetti and Swinburne to be included also in this portrait.

41. Richard Jenkyns, *The Victorians and Ancient Greece* (Cambridge, Mass.: Harvard University Press, 1980), pp. 264–270; David C. Huntington, "The Quest for Unity: American Art Between World's Fairs, 1876–1893," in *The Quest for Unity*.

42. See Whistler's letter to Fantin-Latour of 1867, quoted in Bénédite, "Artistes," 232–233. Whistler's *Symphony in White: Three Girls*, as well as *Tanagra* (c. 1869, Randolph-Macon Woman's College Art Gallery, Lynchburg, Virginia), makes it obvious that he was keenly aware of Moore's work. See Deborah Fenton Shepherd, cat. no. 67, in *The Quest for Unity*, pp. 141–142. My discussion of the mysterious feminine beauty as the type for the antidiscursiveness of the work of art is indebted to Frank Kermode, *The Romantic Image* (New York: The Macmillan Company, 1957), "The Dancer," esp. 52–67.

43. H. B. Walters, *Catalogue of the Terracottas in the Department of Greek and Roman Antiquities, British Museum* (London: Trustees of the British Museum, 1903), parts C and D, esp. pp. 184–288 and 297–378. Produced all over the Greek world during the Hellenistic period, these small figurines (see fig. 3.11) were first excavated at sites in North Africa, Italy, and Asia Minor by British and French archaeologists, beginning in the 1850s.

44. While Tanagras were valued for reasons as simple as their resemblance to eighteenth-century porcelain figurines, other appreciations stressed the melancholy, transient qualities that seemed to emanate from their tilted heads and physical fragility. See Henri Lechat, "Tanagra," *Gazette des Beaux-Arts* 10 (1 August 1893): pt. II, 130 and 138; Otto Rayet, "Les figurines de Tanagra au Musée du Louvre," *Gazette des Beaux-Arts* 11 (1 July 1875): pt. IV, 58.

45. Lechat, "Tanagra," 130–131. Probably after c. 1879, Whistler kept

a set of photographs of Alexander Ionides's figurines for reference as he worked. In the 1860s, however, artists such as Leighton, Moore, Whistler, and Degas were already seeking these terracottas in the British Museum and the Louvre. David Park Curry, *James McNeill Whistler at the Freer Gallery of Art* (New York: Freer Gallery of Art, Smithsonian Institution, in association with W. W. Norton, 1984), p. 49, suggested a correlation between the tactile, coloristic qualities of the figurines and Whistler's pastels.

46. Sutton, *Nocturne,* pp. 56–60.

47. Walter Pater, "The School of Giorgione," in *The Renaissance: Studies in Art and Poetry. The 1893 Text,* edited, with textual and explanatory notes, by Donald L. Hill (Berkeley and Los Angeles: University of California Press, 1980), p. 109.

48. Margaret F. MacDonald, "Maud Franklin," in *James McNeill Whistler: A Re-Examination,* Center for Advanced Studies in the Visual Arts Symposium Papers VI, *Studies in the History of Art* 19 (Washington, D.C.: National Gallery of Art, 1987), pp. 21–23, also questioned the extremism of Whistler's formalist polemic against subject matter and associative values. On the social implications of the aesthetic disposition, see Pierre Bourdieu, "The Aristocracy of Culture," in *Media, Culture, and Society,* ed. Collins et al., pp. 164–193.

49. Algernon Charles Swinburne, "Notes on Some Pictures of 1868," in *Essays and Studies* (2d ed.; London: Chatto and Windus, Piccadilly, 1876), pp. 373–374 .

50. See Kermode, *Romantic Image,* p. 66, on Pater's aesthetics.

51. Sutton, *Nocturne,* p. 59; Swinburne, "Notes on Some Pictures of 1868," 373–374.

52. Kermode, *Romantic Image,* pp. 50–79, discusses the romantic and symbolist equivalence of the work of art with the body of a woman.

53. Sutton, *Nocturne,* pp. 59–60.

54. Whistler would have been well acquainted with Watteau, whose reputation was enjoying a revival in Paris in the 1850s and 1860s; moreover, the eighteenth-century ambience of St. Petersburg made a lasting impression on him as a boy. Curry, *Freer Gallery,* ch. 2, connected Whistler's art and sensibility with Watteau's in their melancholy and musical qualities. Norman Bryson, *Word and Image: French Painting of the Ancien Régime* (Cambridge: Cambridge University Press, 1981), pp. 65–84, has written about a similar mechanics of the semantic void in Watteau's work, which has engendered a perception of Watteau in terms of musicality, melancholy, and psychological penetration—qualities that have a familiar reso-

nance in literature on Whistler's work. Even the charge of a fragile, nervous constitution was similarly leveled at Whistler by George Moore, *Modern Painting* (1893; New York: Carra, 1923), p. 5, who described the "nocturnes" as "the outcome of a highly-strung, bloodless nature whetted on the whetstone of its own weakness to an exasperated sense of volatile colour and evanescent light."

55. Bryson, *Word and Image*, pp. 61–63.

56. Letter no. 24 from Whistler to Fantin-Latour, after August 1867, Pennell-Whistler Collection, LC. This English translation is based on a typescript (c. 1900–1910), Library, Freer Gallery of Art, with the author's corrections and emendations. The original French text is as follows: "La couleur—c'est vrai, c'est le vice! Certainement qu'elle peut être et a le droit d'être une des plus belles vertus. Bien tenue avec main forte, bien guidée par son maître le dessin, la couleur alors est ## une fille splendide avec un epoux digne d'elle (son amant) mais aussi son maître, la maîtresse la plus magnifique possible! Et le résultat se voit dans toutes les belles choses produisant par leur union. Mais accolée avec l'incertitude—un dessin faible, craintif, vicieux—qui se contente facilement, la couleur devient une crasse putain! se moque pas mal de 'son petit homme,' n'est-ce pas vrai! Et se galvaude comme bon lui semble prenant légèrement la chose pourvu que tout soit pour elle charmant! Traitant son malheureux compagnon comme un bêta qui la gêne! Ce qui du reste est vrai aussi! Et le résultat se voit: un chaos de ###, de fricheries, de regrets, de choses incomplètes."

57. Mattick, "Beautiful and Sublime."

58. Mattick, "Beautiful and Sublime," 301.

59. E. R. Pennell and J. Pennell, *Life*, p. 115, recounted Walter Greaves's version of this medium, although Whistler stated it as "copal, mastic, and turpentine."

60. Margaret F. MacDonald, "Whistler: The Painting of the 'Mother,'" *Gazette des Beaux-Arts* 85 (February 1975): 73–88, related the Catholicism of Legros's *Women Praying* (Tate Gallery, London) to the Calvinism of Whistler's characterization of Anna Whistler here.

61. G. Moore, *Modern Painting*, pp. 3–5; see also n. 54 above.

62. Whistler's patron, Frederick Leyland, proposed the musical term *nocturne*, where Whistler had been using *moonlight*.

63. Parry, *Whistler's Father*, pp. 228 and 315.

64. Ann Bermingham, *Ideology and Landscape: The English Rustic Tradition, 1740–1860* (Berkeley: University of California Press, 1986), pp. 68–69; and Raymond Williams, *The Country and the City* (New York: Oxford University Press, 1973), pp. 60ff., 96–105, 122; Lochnan, *Etchings*, pp. 33–

48. It should be noted that both French realists and their British contemporaries were employing the conventions of Dutch artists for depicting rural poverty.

65. For commentary on the illustrators T. S. Boys and Thomas Shepherd, in addition to others, see the following: Donald J. Gray, "Views and Sketches of London in the Nineteenth Century," 47–50, and Will Vaughn, "London Topographers and Urban Change," 60–63 in Ira Bruce Nadel and F. S. Schwarzbach, *Victorian Artists and the City: A Collection of Critical Essays* (New York: Pergamon Press, 1980); E. D. H. Johnson, "Victorian Artists and the Urban Milieu," 462–465, and Michael Wolff and Celina Fox, "Pictures from the Magazines," in Dyos and Wolff, *Victorian City,* pp. 561–573; and Alex Potts, "Picturing the Modern Metropolis: Images of London in the Nineteenth Century," *History Workshop,* issue 26 (Autumn 1988): 32–43.

66. Vaughn, "London Topographers," 68, and Johnson, "Victorian Artists," 462. "Mr. Whistler's Etchings," *Saturday Review* (August 12, 1871), quoted in Robin Spencer, ed., *Whistler: A Retrospective* (New York: Hugh Lauter Levin Associates, Inc., 1989), p. 100.

67. Dickens's novel describes the practice of looting dead bodies floating in the river as a means by which the residents of this area made a living. Fantin-Latour described his tour of Rotherhithe in a letter to his parents, July 24, 1859 (Collections, Bibliothèque d'Etude et d'Information, Grenoble). See the author's "Whistler and the Politics of the Urban Picturesque," *American Art* 8 (Summer/Fall 1994): 61–77.

68. Henry Mayhew, *Mayhew's London: Being Selections from "London and the London Poor"* (1851; London: Spring Books, 1951), esp. pp. 537–548, 553–557.

69. "Mr. Whistler's Etchings," *The Saturday Review* (August 12, 1871), and Frederick Wedmore, "Mr. Whistler's Theories and Mr. Whistler's Art," *The Nineteenth Century* (August 1879); both reprinted in R. Spencer, *Whistler: A Retrospective,* pp. 86–100, and 143–151. For other favorable reviews of these etchings, see "Mr. Whistler's Paintings and Drawings," *Art Journal* 36 (August 1874): 230; and Frederick Wedmore, "Some Tendencies in Recent Painting," *Temple Bar* 53 (July 1878): 346; in John Charles Olmstead, ed., *Victorian Painting: Essays and Reviews; Vol. Three: 1861–1880* (New York: Garland, 1985), pp. 408 and 461. For Ruskin's attack on the picturesque, see Robert Hewison, *John Ruskin: The Argument of the Eye* (London: Thames and Hudson, 1976), pp. 46–49.

70. His letter to Fantin-Latour of August 1867 renouncing realism as a mode that appealed to his vain egotism also makes apparent this lack of

commitment. On the political tenets of the realist movement, see Weisberg, "Introduction," in *The Realist Tradition*. Baudelaire's praise for the Thames etchings published in the April 1862 issue of *Revue Anecdotique* is quoted in Fleming, *Young Whistler*, p. 174, who also noted Whistler's disappointment in Baudelaire's greater interest in the subject than the artistic properties of the etchings.

71. William Gaunt, *Chelsea* (London: B. T. Batsford, Ltd., 1954); Harold P. Clunn, *The Face of London* (rev. ed.; London: Phoenix House Limited, 1951).

72. Joseph Pennell, *The Graphic Arts: Modern Men and Modern Methods* (Chicago: University of Chicago Press, 1921), p. 170; Fleming, *Young Whistler*, pp. 181–182.

73. Arthur Symons, *London: A Book of Aspects* (London, 1909), pp. 12–13; quoted in Gray, "Views and Sketches," 52. On Doré's contribution to Blanchard Jerrold's *London: A Pilgrimage* (London: Grant and Company, 1872), see Johnson, "Victorian Artists," 461; Vaughn, "London Topographers," 66; and Potts, "Modern Metropolis," 50.

74. Johnson, "Victorian Artists," 458, observed that such areas of London had become associated in the minds of the public with the "moral degradation associated with urban life." Curry, *Freer Gallery*, pp. 80ff., argues for similarities between Whistler's involvement in the "pleasures of *flâneurie*" and those of Degas and Manet, and sees the "darker side of the pleasure garden" suggested in the "bituminous and rather sinister palette" of Whistler's images of Cremorne Gardens, a scene of licentious behavior in the 1860s and 1870s.

75. James A. McNeill Whistler, *Ten O'Clock, a Lecture* (Portland, Maine: Thomas Bird Mosher, 1920), p. 13. G. Moore, *Modern Painting*, pp. 18–19, echoed Whistler's sentiments, observing that the plaintive mood of the evening along the river unified "the jaded and the hungry and the heavy-hearted" in releasing them from their daytime troubles into a limitless nocturnal world.

76. The general panoramic viewpoint and topographical disposition of the shoreline in several of Whistler's "nocturnes"—squeezed between vast bands of water and sky—are very close to the contemporary topographical views of London, proliferated in illustrated journals—for example, Thomas Shotter Boys, "London Bridge from Southwark Bridge," from *Original Views of London As It Is* (1842); Nadel and Schwarzbach, *Victorian Artists*, p. 17; Wolff and Fox, "Pictures," 561.

77. Johnson, "Victorian Artists," 457; Wolff and Fox, "Pictures," 561 and 570–573; Gray, "Views and Sketches," 50; and Vaughn, "London Topographers," 59.

78. Stanley Weintraub, *Whistler* (New York: Weybright & Talley, 1974), pp. 31, 35, 38–39, 66–67, 74, 89, recounted Whistler's suppressed revolt against his mother's Calvinism. E. R. Pennell and J. Pennell, *Whistler Journal,* pp. 158ff., reiterate Whistler's dependency on women.

79. Erich Neumann, *The Great Mother: An Analysis of the Archetype,* trans. Ralph Manheim (New York: Pantheon Books; Bollingen Series XLVII, 1963), provides a classic account of the historical connection between transformation processes, natural elements such as air and water, and feminine goddesses and archetypes.

80. Sidney Colvin, "The Grosvenor Gallery," *Fortnightly Review* 26 (June 1877): 832; reprinted in Olmstead, *Victorian Painting,* p. 445; Richard Muther, *The History of Modern Painting* (London: Henry and Company, 1895–1896), III, 662.

81. Walter Sickert, quoted in Sutton, *Whistler: Paintings,* pp. 42–43.

82. Henry James, "London Portraits" (1882), in *The Painter's Eye: Notes and Essays on the Pictorial Arts,* selected and edited with an introduction by John L. Sweeney (Cambridge, Mass.: Harvard University Press, 1956), p. 209.

83. See Whistler's "Proposition No. 2" of 1884. The discrepancies between Whistler's public persona (the dandy) and his private demeanor in the studio were humorously noted by many in his lifetime. See, for example, William M. Chase, "The Two Whistlers: Recollections of a Summer with a Great Etcher," *The Century Magazine* 80 (June 1910): 218–226. Sarah Burns, "Old Maverick to Old Master: Whistler in the Public Eye in Turn-of-the-Century America," *American Art Journal* 22 (1990): 28–49, exhaustively examined Whistler's strategies in self-mythologizing.

84. E. R. Pennell and J. Pennell, *Life,* pp. 381–382. The emphasis at the academy was also on color, on the systematic arrangement of the palette, while the more intellectual exercise of composition was omitted from classes altogether.

85. For a discussion of Pater's aesthetics and metaphysics, especially as developed in *Marius, the Epicurean,* see Johnson, *Metaphor of Painting,* pp. 199–226.

86. Arthur J. Eddy, *Recollections and Impressions of James A. McNeill Whistler* (Philadelphia: J. B. Lippincott Company, 1903), p. 214.

87. Lechat, "Tanagra," 130 and 138, found the faces of Tanagras possessed of a quality equally serious and sweet, which nearly eluded description. Rayet, "Figurines," pt. IV, 58, described them as evoking "une douleur plus douce et plus calme . . . une tranquille melancolie." Interestingly, while Edmond Duranty ("La Curiosité, les statuettes de Tanagra," *La Vie Moderne* [April 17, 1879]: 32) found the elegant movement of the figurines

comparable to the coquettes of Paris, he associated the expression of their heads with an unnamed English quality.

88. On feminine typology see Cott, "Passionless," 227 and 235–236; and Bloch, "Untangling the Roots," 249–251. Erik H. Erickson, "Inner and Outer Space: Reflections on Womanhood," *Daedalus* 93 (1964): esp. 592–599, explored from a neo-Freudian essentialist viewpoint the experience of womanhood as an inner space or void in both the negative and positive senses, and how artistic men (e.g., the *Sarasate*) also might harbor this sense of inwardness. Whistler's construction of feminine mystery as a dark, nurturing space has obvious correspondences with Courbet's more naturalistic association of womanly fecundity with the image of the mouth of a cave from which issues a river, the source of life. For examples of Courbet's construction of feminine mystery as a womblike interior space, see Werner Hofmann, "Uber die 'Schlaffende Spinnerin,'" in *Realismus als Widerspruch: Die Wirklichkeit in Courbets Malerei*, ed. Klaus Herding (Frankfurt am Main: Suhrkamp, 1978), pp. 212–222.

89. Alfred Stieglitz, "Woman in Art," in Dorothy Norman, *Alfred Stieglitz: An American Seer* (New York: Random House, 1973), p. 137.

90. See Jordanova, "Natural Facts," "Body Image and Sex Roles," and "Nature Unveiling before Science," in *Sexual Visions;* and Elaine Showalter, *Sexual Anarchy: Gender and Culture at the Fin de Siècle* (New York: Viking Press, 1990), pp. 134 and 145, makes a similar point.

91. Bénédite, "Artistes," 243–246.

92. Jordanova, *Sexual Visions,* p. 59; Burns, "Old Maverick," 36–41.

93. Letter from Whistler to Mrs. Anna Whistler, c. April 1880, FGAA.

94. Joris-Karl Huysmans, "Wisthler [sic]," *Certains* (1889), in R. Spencer, *Whistler: A Retrospective,* pp. 257–258 and 267–268. Alfred de Lostalot, "Salon de 1886," *Gazette des Beaux-Arts* 33 (June 1886): 464; Edmond Pottier, "Les Salons de 1892: La Peinture," *Gazette des Beaux-Arts* 7 (June 1892): 455. Octave Maus, "Whistler in Belgium," *The Studio* (June 1904), in Spencer, p. 208, responded to Whistler as a painter who made manifest "the psychical glow of a human soul shining through, . . . the spiritual reflection of his own soul." Camille Mauclair [Camille L. C. Fausti], "James Whistler et le Mystère dans la peinture," *Revue Politique et Littéraire: Revue Bleue* 20 (October 3, 1903): 440–444; an English translation of this article is preserved in a typescript in the FGAA. Burns, "Old Maverick," 39, commented on the tendency of American critics in the 1880s and 1890s to read Whistler's images as expressions of essence and spirit. On the reverence of Belgian painters and critics for Whistler, see Francine-Claire Legrand, "The Symbolist Movement," in *Belgian Art, 1880–1914* (Brook-

lyn: The Brooklyn Museum, 1980), p. 63. Whistler exhibited three times with "Les XX."

95. William Ernest Henley, "XIII. To James McNeill Whistler," from *Rhymes and Rhythms* (1889–1892) in *Poems* (New York: Charles Scribner's Sons, 1926), pp. 247–248. G. Moore, *Modern Painting*, pp. 18–19.

96. Sutton, *Nocturne,* pp. 136–137; Eddy, *Recollections,* p. 49. Burne-Jones, quoted in Gertrude Himmelfarb, *Marriage and Morals Among the Victorians* (New York: Knopf, 1986), pp. 160–161.

97. Eric Trudgill, *Madonnas and Magdalens: The Origins and Development of Victorian Sexual Attitudes* (London: Heinemann, 1976), pp. 28–29, 40, and 76–77.

98. Parry, *Whistler's Father,* pp. 175–176, 179–180.

99. Whistler's sense of art as a religion conducted by elect spirits approaches Stéphane Mallarmé's statement in *L'Art pour tous* (1862) that "art was a sublime accessible only to the few"; see his letter to Mallarmé of October 1896 (?), in C. P. Barbier, *Correspondance: Mallarmé—Whistler, histoire de la grande amité de leurs dernières années* (Paris: A. G. Nizet, 1964), p. 257. Originally delivered on February 20, 1885, at the Prince's Hall in London, the "Ten O' Clock" was repeated in March of 1885 at Cambridge and six weeks later at Oxford. The view of art Whistler presented in this lecture approaches the quasi-religious value Pater assigns to the experience of art.

100. For contentious responses to Whistler's hyperbolic rhetoric in the "Ten O'Clock," see Algernon Charles Swinburne, "Mr. Whistler's Lecture on Art," *Fortnightly Review* (June 1888); and Oscar Wilde, "Mr. Whistler's Ten O'Clock," *The Pall Mall Gazette* (February 21, 1885), reprinted in R. Spencer, *Whistler: A Retrospective,* pp. 252–254; and 228–229, respectively.

101. "Mr. Whistler," *The Athenaeum* (July 25, 1903): 133–134; and A. J. Finberg, "Mr. Whistler and Artistic Solipsism," *The Athenaeum* (August 8, 1903): 198.

102. On the Whistler/Ruskin conflict, see Linda Merrill, *A Pot of Paint: Aesthetics on Trial in Whistler v Ruskin* (Washington, D.C.: Smithsonian Institution Press, 1992), esp. pp. 48–50; also David Craven, "Ruskin vs. Whistler: The Case against Capitalist Art," *Art Journal* 37 (Winter 1977/78): 140–143.

103. Mrs. Julian Hawthorne, "Mr. Whistler's New Portraits," *Harper's Bazaar* (October 15, 1881): 658; and Frank Stephen Granger, "The Purpose of Art," *Notes on the Psychological Basis of Fine Art* (1887); reprinted in R. Spencer, *Whistler: A Retrospective,* pp. 178 and 232, respectively.

104. Richard Stein, *The Ritual of Interpretation: The Fine Arts as Literature in Ruskin, Rossetti, and Pater* (Cambridge, Mass.: Harvard University Press, 1967), pp. 31–32. The importance Whistler gave to the designed environment, in its potential for the refinement of human nature and the conduct of life, is similar to the role Josef Hoffman conceived for the Palais Stoclet, as articulated by Carl Schorske, "Revolt in Vienna," *New York Review of Books* 33 (May 29, 1986): 25. Schorske wrote that the typical client of the Secessionist architect "was expected to define himself from within, to refine his own psyche into art. The forms of living—the house, its furnishings, its art—were to be personal expressions of each man's soul and beauty. . . . The aim [of the Palais Stoclet] was to provide both a scene for and a symbol of the life-beautiful."

105. James Jackson Jarves, "Art of the Whistler Sort," *New York Times* (January 12, 1879): 10e–f (the author thanks Linda Merrill for this reference); and William Howe Downes, "Whistler and His Work," *National Magazine* 20 (April 1904): 15.

106. See Ernest Francisco Fenollosa, "Chinese and Japanese Traits," *Atlantic Monthly* 69 (June 1892): 769–774; "The Symbolism of the Lotos," *Lotos* 8 (February 1896): 577–583; *East and West: The Discovery of America and Other Poems* (New York: Thomas Y. Crowell, 1893); and "The Coming Fusion of East and West," *Harper's New Monthly Magazine* 98 (December 1898): 115–122. Chisolm, *Fenollosa*, pp. 97, 123–124, 155–156, 159.

107. In *Composition* (1899), a textbook by Arthur Dow, who was Fenollosa's assistant curator at the Museum of Fine Arts, these design principles were explicated as line, color, and notan (the relationship of positive to negative space and of light to dark values). Fenollosa took the images for his lectures from this textbook's illustrations, which were in turn based on Japanese prints. See Fenollosa's "The Collection of Mr. Charles L. Freer," *Pacific Era* 1 (November 1907): 57–66; "The Place in History of Mr. Whistler's Art," *The Lotus: In Memoriam: James McNeill Whistler* (Special Holiday Number, December 1903): 14–17; and "The Symbolism of the Lotos," 581. On Freer's gift of his collections to the Smithsonian Institution, see Agnes E. Meyer, *Charles Lang Freer and His Gallery* (Washington, D.C.: Freer Gallery of Art, 1970); Aline B. Saarinen, *The Proud Possessors: The Lives, Times, and Tastes of Some Adventurous American Art Collectors* (New York: Random House, 1958), pp. 132–142; and Thomas Lawton and Linda Merrill, *Freer: A Legacy of Art* (Washington, D.C.: Freer Gallery of Art, Smithsonian Institution; New York: Abrams, 1993).

108. Charles H. Caffin, *The Story of American Painting: The Evolution of*

Painting in America from Colonial Times to the Present (New York: Charles Scribner's Sons, 1907); and *American Masters of Painting: Being Brief Appreciations of Some American Painters* (New York: Doubleday, Page, and Company, 1902). Sarah Lee Underwood, *Charles H. Caffin: A Voice for Modernism, 1897–1918* (Ann Arbor: UMI Research Press, 1983); John Loughery, "Charles Caffin and Willard Huntington Wright, Advocates of Modern Art," *Arts Magazine* 59 (January 1985): 103–104, recounted that Caffin, the son of an Anglican minister, was sent to Oxford with the express intent that he would enter the clergy as well. Caffin, however, converted to the religion of art. He became more enamored of the stage and began to write on the theater, then in 1892 came to Chicago to work on the decoration of the World's Columbian Exposition. In the 1890s in New York he was befriended by Alfred Stieglitz and began writing about art for the popular press. Loughery notes that his vocabulary, like Stieglitz's, was characteristic of late nineteenth-century liberal culture and drew heavily on concepts such as "Spirit, Will, and Beauty." Caffin later continued his efforts to bring the gospel of art to a middle-brow public by joining the Chautauqua movement.

109. Caffin, *Story of American Painting,* pp. 285–303; *American Masters of Painting,* pp. 38–47; and "The Art of James McNeill Whistler," (a lecture by Mr. Charles H. Caffin at the Detroit Museum of Art, April 23, 1909), pp. 30–31, typescript at the Library, Freer Gallery of Art.

110. Charles H. Caffin, *Art for Life's Sake: An Application of the Principles of Art to the Ideals and Conduct of Individual and Collective Life* (New York: The Prang Company, 1913), passim.

111. See, for example, Royal Cortissoz, "Egotism in Contemporary Art," *Atlantic Monthly* 73 (May 1894): 648; Sadakichi Hartmann, *A History of American Art* II (Boston: L. C. Page and Company, 1902), pp. 163–173; and *The Whistler Book* (Boston: L. C. Page and Company, 1910), pp. 79–80. Also in this antimaterialist vein, Burns, "Old Maverick," 39, cited Theodore Child, "American Artists at the Paris Exposition," *Harper's Monthly Magazine* 79 (September 1889): 492; John C. Van Dyke, "What Is All This Talk about Whistler?" *Ladies' Home Journal* 21 (March 1904): 10; and Christian Brinton, "Whistler from Within," *Munsey's Magazine* 36 (October 1906): 16. Hartmann's version of spiritualism is set down in *My Theory of Soul-Atoms* (New York: The Stylus Publishing Company, 1910). Other favorable critical pieces in major publications, some of which comment on Whistler's impact on American painters, are: William C. Brownell, "Whistler in Painting and Etching," *Scribner's Monthly* 18 (August 1879): 481–495; Charles de Kay, "Whistler: The Head of the Impressionists," *The Art*

Review 1 (November 1886): 1–3; Clarence Cook, *Art and Artists of Our Time* (New York: Selmar Hess, 1888), vol. 3, pp. 258–260; "American Painting. IV. Whistler, Dannat, Sargent," *The Art Amateur* 29 (November 1893): 134; Lucy Monroe, "Chicago Letter," *The Critic* 22 (May 27, 1893): 351.

112. Fenollosa, "The Place in History of Mr. Whistler's Art," 16–17; and "The Collection of Mr. Charles L. Freer," 58–62.

113. Roger B. Stein, *John Ruskin and Aesthetic Thought in America, 1840–1900* (Cambridge, Mass.: Harvard University Press, 1967), pp. 186–191; Kuklick, *Rise of American Philosophy,* esp. pp. 138 and 149–158; William James, "On Some Hegelisms," *Mind* 7 (April 1882): 186–208.

114. See letter 177 from Maud Franklin and Whistler in London to Otto Bacher in Venice, c. 1880, FGAA.

115. Frances Grimes, "Reminiscences," frame 367, microfilm 3565r, #36, The Papers of Augustus Saint-Gaudens, Special Collections, Dartmouth College Library.

116. William Innes Homer, *Alfred Stieglitz and the American Avant-Garde* (Boston: New York Graphics Society, 1977), pp. 20, 33, 68, 148.

4. AESTHETIC STRATEGIES IN THE "AGE OF PAIN": THOMAS DEWING AND THE ART OF LIFE

1. K. K. [Kenyon Cox], "An Out-door Masque in New England," *The Nation* 80 (June 29, 1905): 519–520. The masque was scripted by the playwright Louis Shipman, who was also a resident of the colony.

2. Philip Littell, "A Look at Cornish," *The Independent* 74 (June 5, 1913): 1297; Herbert Croly, "The Architectural Work of Charles A. Platt," *The Architectural Record* 15 (March 1904): 185; Maud Howe Elliott, *John Elliott: The Story of an Artist* (Boston: Houghton Mifflin Company; Cambridge, Mass.: The Riverside Press, 1930), p. 143. On the utopian paradigm, see Philip W. Porter and Fred E. Lukermann, "The Geography of Utopia," in *Geographies of the Mind: Essays in Historical Geosophy in Honor of John Kirtland Wright,* ed. David Lowenthal and Martyn J. Bowden (New York: Oxford University Press, 1976), pp. 204–217.

3. Elliott, *John Elliott,* pp. 143–145; Cox, "Out-door Masque," 520.

4. Woodrow Wilson made Cornish his summer home in 1913. James L. Farley, "The Cornish Colony," *Dartmouth College Library Bulletin* 14 (November 1973): 6–15; and John H. Dryfhout, "The Cornish Colony," in *A Circle of Friends: Art Colonies of Cornish and Dublin* (Durham, N.H.: University Art Galleries, University of New Hampshire, 1985), pp. 33–57.

5. *New York Daily Tribune* (August 11, 1907); cited in Dryfhout, "Cornish Colony," 39–40.

6. Grimes, "Reminiscences," frame 367, microfilm 3565r, #36; Littell, "A Look at Cornish," 1297.

7. Frances Duncan, "The Gardens of Cornish," *The Century Magazine* 72 (May 1906): 4, enumerated the Cornish "elect" who had come to the "Promised Land," and (7) wrote of the "rare, wild beauty [of Cornish] as yet unspoiled by the Philistines." Duncan was a member of the community at this time. Grimes, "Reminiscences," frames 352, 358–359.

8. Pierre Bourdieu, "Aristocracy of Culture," 178, 182–185, 189, and 192.

9. Littell, "A Look at Cornish," 1298; and Croly, "Architectural Work," 185.

10. Mary French, *Memories of a Sculptor's Wife* (New York: Houghton Mifflin Company, 1928), pp. 182–183; Grimes, "Reminiscences," frame 355; Duncan, "Gardens of Cornish," 8–18. On Platt's architecture at Cornish, see Croly, "Architectural Work"; and also Keith N. Morgan, *Charles A. Platt: The Artist as Architect* (Cambridge, Mass.: The MIT Press; New York: The Architectural History Foundation, 1985).

11. Letter 158 of July 5, 1890, to Eleanor Hardy, folio 504, vol. IV, Dennis Bunker Papers, AAA, microfilm 2773; Margaret French Cresson, *Journey into Fame: The Life of Daniel Chester French* (Cambridge, Mass.: Harvard University Press, 1947), p. 167.

12. Grimes, "Reminiscences," frames 366, 359, and 363.

13. Grimes, "Reminiscences," frames 351–353.

14. Grimes, "Reminiscences," frames 351–353. Dewing's entry sheet for April of 1919 in *Who's Who in Art*, Elizabeth Dewing Kaup Papers, AAA, microfilm D22, frame 170, has a note in Maria Oakey Dewing's hand on the performance of the Kneisel Quartette in their home. The Dewing Papers, AAA, microfilm 2077, frames 383–427, contain the program and script for Maria Dewing's masque "The Diplomat," which was performed at High Court on August 14, 1894, with accompanying music by Dvořák. For other accounts of masques and musical performances, see *A Circle of Friends;* and Lucia Fairchild Fuller Papers, Diary for 1903, AAA, microfilm 3825.

15. On pageantry, see Percy MacKaye, "American Pageants and Their Promise," *Scribner's Magazine* 46 (July 1909): 34; *The Civic Theatre in Relation to the Redemption of Leisure: A Book of Suggestions* (New York: Mitchell Kennerley, 1912); and Anne Throop Craig, "The Poetic Theme in the Modern Pageant," *The Forum* 54 (September 1915): 350; Trudy Baltz,

"Pageantry and Mural Painting: Community Rituals in Allegorical Form," *Wintherthur Portfolio* 15 (Autumn 1980): 211–228; David Glassberg, *American Historical Pageantry: The Uses of Tradition in the Early Twentieth Century* (Chapel Hill: University of North Carolina Press, 1990), esp. pp. 32–33, 52–53, and 128–149.

16. MacKaye, *Civic Theatre*, p. 29; J. Turner, *Without God, Without Creed*, p. 252; and Craig, "Poetic Theme," 350.

17. Elliott, *John Elliott*, pp. 143–144.

18. Elliott, *John Elliott*, p. 146; Walter Pater, "Conclusion," in *The Renaissance; The 1893 Text*, p. 190.

19. Walter Pater, *The Renaissance* (New York, 1877). The Dewings' familiarity with Pater's *The Renaissance* is evidenced in Maria Oakey Dewing's letter to Royal Cortissoz of May 5, 1919, Royal Cortissoz Papers, Yale University Library.

20. Maria Oakey Dewing, *Beauty in the Household* (New York: Harper and Brothers, 1882).

21. I thank Mark Jordan for the translation given here.

22. Grimes, "Reminiscences," frame 370; Henry James, *The American Scene*, introduction by Irving Howe (New York: Horizon Press, 1967), 14–17, writing about the landscape at Chocura, New Hampshire, not far from Cornish.

23. James, *American Scene*, pp. 19–20.

24. Grimes, "Reminiscences," frame 411; Frances Duncan, "An Artist's New Hampshire Garden," *Country Life in America* 11 (March 1907): 518; and John Elliott's letter of October 1903 to his wife in Elliott, *John Elliott*, p. 137.

25. John Burroughs, *Wake-Robin* (1871; Boston: Houghton Mifflin Company, 1913), p. 22; F. Schuyler Mathews, *Field Book of Wild Birds and Their Music: A Description of the Character and Music of Birds* (1904; New York: G. P. Putnam's Sons, 1921), pp. xlii and 266–267. The hermit thrush was identified with the spirit of Cornish as a special place. In 1913 the Cornish colony attempted to help found a bird sanctuary in the region, and staged a "bird masque" written by MacKaye, with President Wilson and his wife in attendance and their two daughters in lead roles. Even Theodore Roosevelt contributed to this nature chauvinism, asserting the superior beauty of the thrush's song—which was "typical of American nature"—over that of the English nightingale. Dryfhout, "Cornish Colony," 54–55. Roosevelt is quoted in the introduction to Mathews, p. xxxvii.

26. Burroughs, *Wake-Robin*, pp. 22–23 and 46–47; Mathews, *Field Book*, p. xxxvii. F. Schuyler Mathews, who lived not far from Cornish at

Campton, New Hampshire, compared the thrush's song to the bird motif Wagner wrote for "Siegfried" and characterized the bird as a "transcendentalist" performing a delicate spiral weaving of song with a "spirituality of tone and . . . depth of expression." See Mathews, pp. 261–267.

27. Peter J. Schmitt, *Back to Nature: The Arcadian Myth in Urban America* (New York: Oxford University Press, 1969), pp. 36 and 53, cites William Long's approach to nature as symptomatic of most naturalists' attitudes in the view of nature as a revelation of "man's own soul"; and 141, quotes Lyman Abbott on nature as the "playground of the soul." See also William J. Long, *Northern Trails: Some Studies of Animal Life in the Far North* (Boston: Ginn and Company, 1905), p. 217. Demonstrating the pervasiveness of these beliefs in the period, Mary Hallock Foote's illustrations for "Bird Songs," *The Century Magazine* 46 (May–July 1893): 236, and particularly the drawing of the "Hermit Thrush," tranlsate Dewing's "high art" version for elect spirits into a format for a wider audience uninitiated into the semi-abstract idiom of his works.

28. Darwin, *Descent of Man.* D. H. Meyer, "American Intellectuals," 584–603. J. Turner, *Without God, Without Creed,* pp. 252–255.

29. Sylvester R. Koehler, *American Art* (New York: Cassell and Company Limited, 1886), pp. 13, 18, and 40.

30. Sarah Lea Burns, *The Poetic Mode in American Painting: George Fuller and Thomas Dewing,* Ph.D. diss., University of Illinois at Urbana-Champaign (Ann Arbor: University Microfilms, Inc., 1979), p. 212, related this composition to Burne-Jones's *The Fifth Day of Creation* and *The Sixth Day of Creation* (1870–1876; Fogg Art Museum), which were exhibited at the Grosvenor Gallery in 1877.

31. Koehler, *American Art,* pp. 42–44.

32. Susan Hobbs, "Thomas Wilmer Dewing: The Early Years, 1851–1885," *American Art Journal* 13 (Spring 1981): 4–35.

33. See Dewing's sketchbook in the Thomas and Maria Dewing Papers, AAA, microfilm 2077, frame 480.

34. Doreen Bolger Burke, *American Paintings in the Metropolitan Museum of Art; Vol. III: A Catalogue of Works by Artists Born between 1846 and 1864,* ed. Kathleen Luhrs (New York: The Metropolitan Museum of Art, 1980), pp. 120–122. In a letter to Koehler of July 19, 1886, Dewing mentions this painting in his Cornish studio; Sylvester R. Koehler Papers, AAA, microfilm D184, frame 145.

35. Catherine Beach Ely, "Thomas W. Dewing," *Art in America* 10 (August 1922): 229.

36. Robert Goldwater, *Symbolism* (New York: Harper and Row, 1979), p. 9.

37. For illustrations of their works, see Michael Quick, *American Expatriate Painters of the Late Nineteenth Century* (Dayton, Ohio: Dayton Art Institute, 1976).

38. Jane Dillenberger, "Between Faith and Doubt: Subjects for Meditation," in *Perceptions and Evocations: The Art of Elihu Vedder* (Washington, D.C.: National Collection of Fine Arts, 1979), pp. 127, 142, 148–149, 157–159.

39. Koehler, *American Art*, pp. 26–27.

40. Freer and Dewing had evidently discussed the program for the picture. See Dewing to Freer, letter 145, dated October 19, 1892, Charles Lang Freer Papers, FGAA 77. Burns, *Poetic Mode*, p. 337, suggested that the Rossetti sonnet Dewing referred to as "the Ode to Hope" might be "The One Hope."

41. Rossetti, cited in Stein, *Ritual of Interpretation*, p. 202.

42. On "The One Hope," see William Michael Rossetti, *Dante Gabriel Rossetti as Designer and Writer* (London: Cassell and Company, Ltd., 1889), p. 261; and Stein, *Ritual of Interpretation*, pp. 202–203.

43. David G. Riede, *Swinburne: A Study of Romantic Mythmaking* (Charlottesville: University Press of Virginia, 1978), pp. 75–80, 137–141, 146ff.

44. Burns, *Poetic Mode*, p. 338.

45. On the "oceanic feeling," see Freud, *Civilization and Its Discontents*, pp. 12–15, 19–20, 29–30; Fisher, "Reading Freud's *Civilization and Its Discontents*," 251–279; Irving B. Harrison, "On the Maternal Origins of Awe," *The Psychoanalytic Study of the Child* 30 (1975): 181–195; and Irving B. Harrison, "On Freud's View of the Infant-Mother Relationship and of the Oceanic Feeling—Some Subjective Influences," *Journal of the American Psychoanalytic Association* 27 (1979): 399–421.

46. Carl E. Schorske, "The Quest for the Grail: Wagner and Morris," in *The Critical Spirit: Essays in Honor of Herbert Marcuse*, ed. Kurt H. Wolff and Barrington Moore Jr. (Boston: Beacon Press, 1967), pp. 225 and 229. Jennifer Martin, "Portraits of Flowers: The Out-of-Door Still-Life Paintings of Maria Oakey Dewing," *American Art Review* 4 (December 1977): 117, n. 11, notes the death of a son in 1882; "Fine Arts: News of Studio and Galleries at Home and Abroad," *The New York Herald* (June 24, 1883), sextuple sheet, gives the Dewings' destination on their European trip as Bayreuth. On Americans' use of Wagner's music as therapy, see Lears, *No Place of Grace*, pp. 170–172.

47. Joseph A. Mussulman, *Music in the Cultured Generation: A Social History of Music in America, 1870–1900* (Evanston, Ill.: Northwestern

University Press, 1971), esp. pp. 30–41 and 142–168; and Joseph Horowitz, *Wagner Nights: An American History* (Berkeley: University of California Press, 1994). J[ohn]. T[asker]. H[oward]., "Seidl, Anton," in *Dictionary of American Biography*, ed. Dumas Malone (New York: Charles Scribner's Sons, 1935), vol. 8, part 1, pp. 561–562; Hans-Hubert Schönzeler, "Seidl, Anton," in *The New Grove Dictionary of Music and Musicians*, ed. Stanley Sadie (London: Macmillan Publishers, Ltd., 1980), vol. 17, 113. Ernest Samuels, *Bernard Berenson: The Making of a Connoisseur* (Cambridge, Mass.: The Belknap Press of Harvard University Press, 1979), p. 77.

48. See Beard, *American Nervousness*; Russett, *Sexual Science*, pp. 110–115. On the "husbanding of resources" as a metaphor central to nineteenth-century American culture, see Barbara Sicherman, "The Paradox of Prudence: Mental Health in the Gilded Age," *Journal of American History* 62 (March 1976): 890–912.

49. D. Meyer, *Positive Thinkers*; and Parker, *Mind Cure in New England*.

50. Peel, *Herbert Spencer*, pp. 139–140. Spencer compared vital physical and mental forces, or energies (the two terms were used interchangeably), to an electrical current flowing through nature that, although redistributed, remains at a constant level.

51. Peel, *Herbert Spencer*, p. 140, notes that for Spencer "the key concept, uniting mind, matter and motion, was Force, the basic element of consciousness, the 'ultimate of ultimates,' which 'can be regarded . . . as the relative reality indicating to us an Absolute Reality by which it is immediately produced.'" See also Ronald E. Martin, *American Literature and the Universe of Force* (Durham, N.C.: Duke University Press, 1981), pp. 37–40; Russett, *Sexual Science*, pp. 109–110; Nina Baym, "From Metaphysics to Metaphor: The Image of Water in Emerson and Thoreau," *Studies in Romanticism* 5 (Summer 1966): 232–237.

52. In her Diary entry for August 31, 1924, Maria Dewing noted "Tom's usual restlessness about autumn"; Dewing Papers, AAA, microfilm 2077.

53. Grimes, "Reminiscences," frame 347, recalls this as one of her "happiest" moments at Cornish.

54. Grimes, "Reminiscences," frame 335.

55. Pater, "The School of Giorgione," *The Renaissance*, pp. 119–120.

56. On the synaesthesia of *Summer* and *Spring* (c. 1890; National Museum of American Art, Smithsonian Institution, Gift of John Gellatly), see Burns, *Poetic Mode*, pp. 267–268.

57. Dewing's letter 21, January 4, 1893, to Freer states, "Stanford and I do a turn at the theatres occasionally." White's letters for 1890–1892 to Dewing make numerous references to their evenings at the theater in New

York. See Letterpress Books 3–6, Stanford White Papers, Avery Architectural and Fine Arts Library, Columbia University.

58. Russett, *Sexual Science,* pp. 42–48 and 86–88; Jordanova, *Sexual Visions,* pp. 19–42; and Nancy Chodorow, "Family Structure and Feminine Personality," in *Woman, Culture, and Society,* ed. Michelle Zimbalist Rosaldo and Louise Lamphere (Stanford: Stanford University Press, 1974), pp. 43–66.

59. Lears, *No Place of Grace,* pp. 218–224; Carl E. Schorske, *Fin-de-Siècle Vienna: Politics and Culture* (New York: Knopf, 1980), pp. 223–225.

60. Charles de Kay, "The Ceiling of a Café," *Harper's Weekly* 36 (March 12, 1892): 257–258. Robert Rosenblum, "Painting: 1870–1900," in *19th-Century Art* (New York: Abrams; Englewood Cliffs, N.J.: Prentice-Hall, Inc., 1984), p. 456, compared *Summer* of 1893 to the eroticized landscapes of Edvard Munch.

61. Schmitt, *Back to Nature,* p. 167. Mind-cure writers often referred to nature as the "great mother."

62. Susan Hobbs, "Thomas Dewing in Cornish, 1885–1905," *American Art Journal* 17 (Spring 1985): 30, n. 13, noted that the dates of *The Hermit Thrush* and *Summer* (National Museum of American Art, Smithsonian Institution), penciled in below the oil signatures, were probably added at Dewing's 1900 retrospective at the Montross Gallery, New York. Based on their close technical and stylistic similarities, these paintings should be considered contemporaneous with Freer's *After Sunset* and *Summer* (Detroit Institute of Art), both of which are firmly dated 1892 and 1893, respectively.

63. Freer met Whistler in 1890 and Dewing in 1891 when he purchased *The Piano* from the latter; see Freer's Diary, March 2–4, 1890, FGAA. Dewing was working in pastel by 1893; see letters 38 and 39 to Freer, dated December 21 and 26, 1893, FGAA.

64. For Dewing's and Freer's interests in the Tanagra, see Dewing's letters to Freer, no. 19, December 23, 1892, and no. 36, November 16, 1893, FGAA. On the cult of Corot and Puvis de Chavannes in Boston and New York, see Henry C. Angell, *Records of William M. Hunt* (Boston: James R. Osgood and Company, 1881), and Maureen C. O'Brien, "European Paintings at the Pedestal Fund Art Loan Exhibition: An American Revolution in Taste," in her *In Support of Liberty: European Paintings at the 1883 Pedestal Fund Art Loan Exhibition* (Southampton, N.Y.: The Parrish Art Museum, 1986); Burns, *Poetic Mode,* pp. 256–258; Charlotte Adams, "Puvis de Chavannes," *The Art Interchange* 30 (February 1893): 46 and 50; and Theodore Child, "Salon of the Champ de Mars," *The Art Amateur* 25

(1891): 25. Chinese ink paintings were not accessible for study in America until after 1900; see Chisolm, *Fenollosa.*

65. Quoted in Henry C. White, *The Life and Art of Dwight William Tryon* (Cambridge, Mass.: The Riverside Press, 1930), p. 82.

66. Kathleen Pyne, "Classical Figures, a Folding Screen by Thomas Dewing," *Bulletin of the Detroit Institute of Arts* 59 (Spring 1981): 9–12; and in *The Quest for Unity,* pp. 222–224.

67. Linda Merrill, *An Ideal Country: Paintings by Dwight William Tryon in the Freer Gallery of Art* (Washington, D.C.: Freer Gallery of Art, Smithsonian Institution, 1990), pp. 71 and 73.

68. M. Dewing, *Beauty in the Household,* pp. 32–34; Martin, "Flowers," 55; William R. Hutchison, "To Heaven in a Swing: The Transcendentalism of Cyrus Bartol," *Harvard Theological Review* 56 (October 1963): 275–295; Greville MacDonald, *George MacDonald and His Wife* (London: George Allen and Unwin, Ltd., 1924), p. 440.

69. M. Dewing, *Beauty in the Household,* pp. 32–34 and 38.

70. M. Dewing, *Beauty in the Household,* pp. 36–37; and M[aria]. R[ichards]. Oakey [Dewing], *Beauty in Dress* (New York: Harper and Brothers, 1881), pp. 49 and 170.

71. Merrill, *Freer: A Legacy,* pp. 60–61; White, *Life and Art,* pp. 81–84; Thomas W. Brunk, "The House That Freer Built," *Dichotomy* 3 (Spring 1981): 17 and 22.

72. Alexander Oakey, "A Trial Balance of Decoration," *Harper's New Monthly Magazine* 64 (April 1882): 739–740.

73. Oakey, "Trial Balance," 735.

74. Dewing to Freer, letter no. 2 of February 15, 1892, AAA, microfilm 77; M. Dewing, *Beauty in the Household,* p. 6.

75. On Freer, see Saarinen, *Proud Possessors;* Helen Nebeker Tomlinson, *Charles Lang Freer: Pioneer Collector of Oriental Art,* Ph.D. dissertation, Case Western Reserve University (Ann Arbor: University Microfilms, Inc., 1979); and Lawton and Merrill, *Legacy of Art.*

76. Maria Dewing, letter of February 20, 1921, to Royal Cortissoz; Royal Cortissoz Papers, Yale University Library. For Wilde's New York lecture, see Richard Ellmann, *Oscar Wilde* (New York: Knopf, 1988), pp. 157–166.

77. On the euthenics movement, see Laura Shapiro, *Perfection Salad: Women and Cooking at the Turn of the Century* (New York: Farrar, Straus, and Giroux, 1986).

78. M. Dewing, *Beauty in the Household,* preface, pp. 5–6.

79. M. Dewing, *Beauty in the Household,* pp. 32–37 and 57.

80. M. Dewing, *Beauty in the Household,* pp. 52–55, 78, 80, 98, 105–106, 118, 121–122, 130.

81. M. Dewing, *Beauty in the Household,* p. 168.

82. M. Dewing, *Beauty in the Household,* pp. 173 and 182–183. For Spencer's belief in the increasing intelligence of humankind, see Spencer, *The Principles of Psychology,* ch. 3, pp. 418–426.

83. Letter of August 30, 1927, from Maria Dewing to Nelson White; cited in Martin, "Flowers," 116.

84. In his letters to Freer, Dewing often commiserated with the beleaguered and exhausted Freer; see, for example, letter 9, July 18, 1892; letter 30, dated June 16, 1893; letter 32a, of July 22, 1893; and letter 33 of August 18, 1893, FGAA. On Freer's early life, see Tomlinson, *Charles Lang Freer,* ch. 1; on his response to immigrants, pp. 40; on the impact of the depression on Freer's company and its conflict with Pingree, pp. 158–160; on his nervous collapse of 1898–1899, pp. 188–189.

85. Melvin G. Holli, *Reform in Detroit: Hazen S. Pingree and Urban Politics* (New York: Oxford University Press, 1969), pp. 56–73; Robert Conot, *American Odyssey* (New York: William Morrow & Company, 1974), pp. 100–105.

86. Letter of July 28, 1902, from Freer to Hecker, FGAA.

87. Dewing to Freer, letter 9, July 18, 1892; 28, May 2, 1893; 29, May 21, 1893; 30, June 16, 1893; 31, June 26, 1893; 32a, July 22, 1893; 57, June 29, 1894; 66, September 22, 1895; 67, September 30, 1895; 73, June 4, 1896, FGAA. On Freer's house at Sheffield, Massachusetts, and his farm at Great Barrington, Vermont, which he described as a "small garden spot" with "a view stretching straight to Nirvana," see Tomlinson, *Charles Lang Freer,* pp. 205–206 and 682–685.

88. Letter of March 18, 1893, from Freer to Dewing; letter of March 2, 1898, from Freer to Tryon, FGAA.

89. Freer to John Gellatly, letter dated March 30, 1904; Freer to Whistler, July 21, 1897, FGAA. Freer found Whistler "wonderfully superstitious" and admired the "weird mental pictures" Whistler composed in terms of recollections of events "just prior to Mrs. Whistler's death"; see Freer to Hecker, June 30, 1902, FGAA.

90. See the disposition lists of Freer's personal library, "Distribution of Mr. Charles L. Freer's Personal Property, Vol. II," FGAA. Among these entries were the following volumes: multiple volumes of the *Rubáiyát of Omar Khayyám,* William Ernest Henley, and Arthur Symons; the complete works and many duplicate volumes of Rossetti's poems; eight volumes by Pater, sixteen volumes by Wilde, several by Swinburne; multiples of

Emerson's works; writings by Thoreau, Carlyle, Wordsworth, Arnold, William Morris, Whitman, Maeterlinck, Keats, Shelley, Stevenson, John Fiske, Bliss Carman, John Burroughs; Mary Conan Doyle, *Visit to Heaven;* Kandinsky, *The Art of Spiritual Harmony; The Yellow Book;* Ralph Waldo Trine, *In Tune with the Infinite;* Paul Carus, *The Gospel of Buddha;* Thomson Jay Hudson, *The Law of Psychic Phenomena;* William James, *Principles of Psychology;* Rama Prasad, *Nature's Finer Forces;* Boris Sidis, *The Psychology of Suggestion;* E. D. Walker, *Re-incarnation;* H. P. Blavatsky, *Isis Unveiled;* and G. T. W. Patrick, *Psychology of Relaxation.*

91. Letter from Freer to Tryon, dated June 17, 1895, from Ama-no-Hashidate, FGAA.

92. Miscellaneous file, FGAA. Tomlinson, 581ff., recounts Freer's stroke on May 28, 1911, his medical treatment, and gradual demise thereafter.

93. Tomlinson, *Charles Lang Freer,* pp. 161, 271. A. Meyer, *Freer and His Gallery,* pp. 18–19.

94. Tomlinson, *Charles Lang Freer,* p. 17, notes his recuperation in the Canadian woods in 1879; pp. 88–89, his habitual hikes through the Catskill Mountains with the "manly" F. S. Church; pp. 587, 591–593, and 682, his retreats to Great Barrington, Vermont.

95. To this effect Freer also spoke of the dying Whistler "communing" with his artworks that lay around him. Freer to Hecker, July 5, 1903, FGAA. Agnes E. Meyer, "The Charles L. Freer Collection," *The Arts* 12 (August 1927): 65 and 80; Meyer, *Freer and His Gallery,* p. 11.

96. Freer purchased Japanese screens (FGA acc. nos. 96.82 and 97.27–28), as well as many *kakemono* in this same period. On the commissioning and chronology of Dewing's screens, see Pyne, "*Classical Figures,*" 9; Hobbs, "Thomas Dewing in Cornish," 18–21; also Dewing to Freer, letters 72, January 10, 1896; 73, June 4, 1896; 74, August 12, 1896; 75, October 3, 1896; 82, May 19, 1897, FGAA.

97. Hobbs, "Thomas Dewing in Cornish," 21.

98. John La Farge, *An Artist's Letters,* p. 173.

99. See Freer's letter to Scribner's of August 3, 1896, in which he ordered a copy of Hearn's *Glimpses of Unfamiliar Japan* for Emma Thayer; and his letter to Edward S. Hull, a New York dealer of Asian artifacts, from whom he borrowed a "handbook" on Buddhism, December 8, 1898, FGAA, possibly T. W. Rhys Davids's *Buddhism: Its History and Literature* (New York: G. P. Putnam's, 1896).

100. On February 27, 1893, Freer wrote to "The Path," which functioned as the central publication of the Aryan Theosophical Society of New York, to order a number of Theosophic tracts by Madame Blavatsky, Annie

Besant, and Rama Prasad (Pandit Rama Prasad Kasyapa). For Freer's subscriptions to *The Bramhamvadin* in 1896 and *Far East* in 1897, see his letters to Walter Goodyear, September 11, 1896; to Tozo Takayanagi, March 1, 1897, and December 8, 1898, FGAA.

101. Hamilton Wright Mabie, *Essays on Nature and Culture* (New York: Dodd, Mead, and Company, 1896), pp. 236, 243–244, 249–250.

102. Dewing to Royal Cortissoz, July 28 [c. 1921], Royal Cortissoz Papers, Yale University Library.

103. Mabie, *Essays,* pp. 170–171.

104. Bliss Carman, *The Kinship of Nature* (Boston: L. C. Page and Company, 1903), pp. 149–151, 186–190. Of Carman's published volumes of poetry and essays Freer owned *Behind the Arras, Songs of Vagabondia, Last Songs of Vagabondia* (with Richard Harvey), *Low Tide on the Grande Pre, A Seamark,* and *The Pipes of Pan.*

105. Meyer, "The Charles Lang Freer Collection," 69.

106. Mabie, *Essays,* pp. 208–211, 257–258.

107. The date at which Freer became acquainted with Fenollosa's predictions of an approaching symbiosis of world civilizations is unknown, but by 1893 he had come to a conclusion that the art of Whistler, Tryon, Dewing, and Abbott Thayer represented an evolutionary pinnacle; see Freer's letter to Dewing, July 19, 1893, FGAA written after viewing the international art exhibitions at the Chicago World's Columbian Exposition. For Fenollosa's views on the evolution of world civilization, see Ernest Francisco Fenollosa, "Chinese and Japanese Traits," 770–774; his poem delivered before the Phi Beta Kappa Society at Harvard, "East and West," in *East and West*; and "The Collection of Mr. Charles L. Freer," 57–66.

108. Carman, *Kinship,* pp. 116–118 and 143.

109. Letter of July 28, [c. 1923–1924], Dewing to Cortissoz, Royal Cortissoz Papers, Yale University Library.

110. Letter 122, Tryon to Freer, July 21, 1907, FGAA.

111. Letter of September 2, 1898, to Rose Standish Nichols, excerpted in Nichols, "Familiar Letters," *McClure's Magazine* 31 (October/November 1908): 616.

112. I thank Louise Cort and Henry Hawley for their opinions on the provenance of this vase.

113. Dewing's other compositions that utilize these motifs are *The Mirror, The Spinet,* and *The Letter.*

114. "Two Small Art Shows," *New York Times* (February 28, 1907); see the Press Cuttings Book, vol. 1, p. 25, FGAA.

115. Biographical sketch written by Clara B. F. Taylor (Fuller's daugh-

ter), dated April 15, 1976, Port Clyde, Maine, Lucia Fairchild Fuller Papers, AAA, microfilm 3825, frame 6.

116. Francis Albert Doughty, "A Southern Woman's Study of Boston," *The Forum* 18 (October 1894): 238–244.

117. Martha Banta, *Henry James and the Occult: The Great Extension* (Bloomington: Indiana University Press, 1972), pp. 157–158, 159.

118. W. James, "What Psychical Research Has Accomplished," in *The Will to Believe and Other Essays*, pp. 301–302; Banta, *Henry James and the Occult*, p. 156.

119. R. Moore, *In Search of White Crows*, pp. 105–125.

120. R. Moore, *In Search of White Crows*, p. 127.

121. Carman, *Kinship*, particularly "On Being Strenuous," "The Crime of Ugliness," "Haste and Waste," "The Cost of Beauty," and "Of Serenity."

122. Mulford, *Your Forces, and How to Use Them:* vol. II, "The Religion of Dress"; vol. IV, "The Use of Sunday"; vol. IV, "The Use and Necessity of Recreation"; vol. IV, "The Drawing Power of Mind"; and vol. VI, "Cultivate Repose."

123. Beard, *American Nervousness*, pp. vi–ix, 66–73ff., 173–192; Charles E. Rosenberg, "The Place of George M. Beard in Nineteenth-Century Psychiatry," *Bulletin of the History of Medicine* 36 (1962): 245–259. F. G. Gosling, *Before Freud*, pp. 9–16, 78–98; Russett, *Sexual Science*, pp. 113ff.

124. See Carol Christ, "Victorian Masculinity and the Angel in the House," in *A Widening Sphere: Changing Roles of Victorian Women*, ed. Martha Vicinus (Bloomington: Indiana University Press, 1977), pp. 146–162; and Barbara Charlesworth Gelpi, "The Feminization of D. G. Rossetti" in *The Victorian Experience: The Poets*, ed. Richard A. Levine (Athens: Ohio University Press, 1982), pp. 94–114.

125. On the crisis of American masculinity in this period, see Bederman, *Manliness and Civilization;* and Michael S. Kimmel, "The Contemporary 'Crisis' of Masculinity in Historical Perspective," in *The Making of Masculinities*, ed. Harry Brod (Boston: Allen & Unwin, 1989), pp. 121–153. Poovey, *Uneven Developments*, describes the double construction of nineteenth-century femininity.

126. Stanford White Papers, Avery Architectural and Fine Arts Library, Columbia University, Letterpress Books 1:372a; 2:315; 3:412, 412a, 413, 424; 4:135; 5:260; 21:403; 23:247; 24:407. Dewing to White, letters of July 2, 1894, and December 1, 1894, Stanford White Papers, New York Historical Society.

127. On Dewing's and White's extramarital activities, see Dewing to White, June 11, 1895, Box 39; and White to Augustus Saint-Gaudens,

March 2, 1989, Copy Book 19:397–398, Stanford White Papers, Avery Architectural and Fine Arts Library, Columbia University. Paul R. Baker, *Stanny: The Gilded Life of Stanford White* (New York: The Free Press; London: Collier Macmillan Publishers, 1989), pp. 275, 280–281, 283, 287–290. Saint-Gaudens's double life is described in Burke Wilkinson, *Uncommon Clay: The Life and Works of Augustus Saint-Gaudens* (San Diego: Harcourt Brace Jovanovich, 1985). Meyer, *Charles Lang Freer,* p. 18, discusses these casual relationships in opposition to love relationships, an emotion that Freer claimed he had only borne for two respectable (married) middle-class women—Meyer herself being one of these women. Meyer's manuscript for this publication in the Eugene and Agnes Meyer Papers, Library of Congress, pp. 40–42, also includes passages on Freer's view of feminine sexuality that were edited out of the publication.

128. Nelson White, "Introduction," *A Loan Exhibition: Thomas W. Dewing, 1851–1938* (New York: Durlacher Brothers, 1963), unpag.

129. Baker, *Stanny,* pp. 244–245.

130. Ezra Tharp, "T. W. Dewing," *Art and Progress* 5 (March 1914): 157; Sadakichi Hartmann, "Portrait Painting and Portrait Photography," in *The Valiant Knights of Daguerre,* ed. Harry W. Lawton and George Knox (Berkeley: University of California Press, 1978), p. 41; Charles H. Caffin, "The Art of Thomas W. Dewing," *Harper's Monthly Magazine* 116 (April 1908): 721; Lynn Nead, "Representation, Sexuality, and the Female Nude," *Art History* 6 (1983): 232–233.

131. Tharp, "Dewing," 159.

132. Ibid.," 156; Susan Hobbs, "A Connoisseur's Vision: The American Collection of Charles Lang Freer," *American Art Review* 4 (August 1977): 89, 101, n. 27; and Judith Elizabeth Lyczko, "Thomas Wilmer Dewing's Sources: Women in Interiors," *Arts Magazine* 54 (November 1979): 152–157.

133. Caffin, "Art of Thomas W. Dewing," 724. Penelope Redd, "Canvases of Dewing/One of the Exhibits Now Attracting Attention," *Pittsburgh Post* (February 24, 1922); AAA, microfilm 1124, frame 579. Ely, "Dewing," 225–229.

134. Martha Banta, *Imaging American Women: Ideas and Ideals in Cultural History* (New York: Columbia University Press, 1987), pp. 104, 124–125.

135. Letter of December 30, 1984, to the author from Elizabeth Gunter, Dewing's great-granddaughter.

136. On Annie Lazarus, see Hobbs, "Thomas Dewing in Cornish," 8–9; on Maria Dewing's career, see Martin, "Flowers," 48–55 and 114–118.

137. Grimes, "Reminiscences," 64, frame 357, recalls Maria Dewing as "a personage, remote with a truly grand manner. I cannot imagine anyone

talking intimately with her; everything would escape the small and immediate and take the size of general truths and aphorisms. True she sometimes told details of her housekeeping, but these details took on an Olympian character or became rules for housekeepers."

138. Spencer, *The Principles of Sociology,* vol. 1, part 3, ch. 1, pp. 734ff.; Russett, *Sexual Science,* pp. 83, 122, 124–125, 131, 143–146.

139. Oakey [Dewing], *Beauty in Dress,* p. 31.

140. Oakey [Dewing], *Beauty in Dress,* pp. 43–45.

141. Oakey [Dewing], *Beauty in Dress,* p. 162.

142. Oakey [Dewing], *Beauty in Dress,* p. 135–139 and 165–166.

143. See Wiliam L. O'Neill, "The Origins of American Feminism," *Everyone Was Brave: A History of Feminism in America* (New York: Quadrangle/The New York Times Book Company, 1976), esp. pp. 32–40.

144. Kate Gannett Wells, "The Transitional American Woman," *Atlantic Monthly* 46 (December 1880): 817–823. For a more reactionary response, see David J. Hill, "The Emancipation of Woman," *The Cosmopolitan* 1 (March 1886): 96–99. Anna Bowman Dodd's dystopia of about the same date, *The Republic of the Future; or, Socialism a Reality* (New York: Cassell and Company, 1887), links feminism with socialism in disintegrating effects of these movements on the social fabric.

145. M[arianna]. G. van Rensselaer, "The Waste of Women's Intellectual Force," *Forum* 13 (July 1892): 616–628.

146. Hartmann, "Portrait Painting and Portrait Photography" in *The Valiant Knights of Daguerre,* pp. 41, 320, n. 16, relates his familiarity (an earlier romantic link) with the model Dewing used for *In the Garden;* Ely, "Dewing," 225–226; Tharp, "Dewing," 160.

147. Lois W. Banner, *American Beauty* (New York: Knopf, 1983), pp. 122–146. On Delsarte's exercises, see Genevieve Stebbins, *Society Gymnastics: Voice-Culture, Adapted from the Delsarte System* (New York: Edgar S. Werner, 1889).

148. Sadakichi Hartmann, "On the Elongation of Form," *Camera Work* 10 (April 1905): 34–35.

149. Hartmann, "On the Elongation of Form," 33.

150. Hartmann, "On the Elongation of Form," 33, 35.

151. See Spencer, *The Principles of Psychology,* ch. 3, pp. 418–426; John Fiske, *The Destiny of Man,* in *Studies in Religion,* pp. 14, 18–19, 72, 78, 205–209.

152. Royal Cortissoz, "Some Imaginative Types in American Art," *Harper's New Monthly Magazine* 91 (July 1895): 165–179; Caffin, "Art of Thomas W. Dewing," 716–717.

153. Doughty, "Southern Woman's Study," 241 and 245–246; Saveth, *American Historians;* Solomon, *Ancestors and Immigrants,* ch. 4; and Higham, *Strangers in the Land,* esp. pp. 120–159. On the New England woman as representative of the whole country, see Wells, "Transitional American Woman," 818; Banta, *Imaging American Women,* p. 91.

154. Kate Stephens, "The New England Woman," *Atlantic Monthly* 88 (July 1901): 63, 65–66.

155. Ely, "Dewing," 229; Tharp, "Dewing," 160; Hartmann, "Thomas W. Dewing," 35, and "On the Elongation of Form," 34; Caffin, "Art of Thomas W. Dewing," 723; and *Story of American Painting,* p. 189.

156. Banner, *American Beauty,* pp. 156–158ff., 169.

157. M. E. W. Sherwood, "New England Women," *Atlantic Monthly* 42 (August 1878): 230–237; Doughty, "Southern Woman's Study," 238–249; Stephens, "New England Woman" 60–66.

158. Doughty, "Southern Woman's Study," 240; Wells, "Transitional American Woman," 820–821.

159. O'Neill, "Origins," 48.

160. Lucia Fairchild Fuller, Diary for 1890, p. 22, frame 39, Lucia Fairchild Fuller Papers, AAA, microfilm 3825.

161. Theodore Robinson, Diary, vol. 4, entry for March 8, 1896 (Frick Art Reference Library), in reference to Dewing's *Before Sunrise (Dawn)* (1895; Freer Gallery of Art).

162. Grimes, "Reminiscences," 64, frame 357.

163. Hartmann, "On the Elongation of Form," 34; "Thomas W. Dewing," 35; and *A History of American Art* (Boston: L. C. Page and Company, 1902) I, 307; Caffin, "Art of Thomas W. Dewing," 721–723.

164. W. K. Brooks, *The Law of Heredity* (1883), pp. 82–83, 160; Joseph LeConte, "The Woman Question," both cited in Russett, *Sexual Science,* pp. 94–95, 144–145, who also draws on Edward Drinker Cope, "The Marriage Problem" (1888).

165. Van Rensselaer, "Waste," 620; Russett, *Sexual Science,* p. 97.

166. Pyne, "*Classical Figures*" and "Evolutionary Typology and the American Woman in the Work of Thomas Dewing," *American Art* 7 (Winter 1993): 12–29.

167. Henry James also invoked this version of American evolution, for example in *The Golden Bowl* (1904; Middlesex: Penguin Books, 1978), pp. 33–34 and 36, as embodied in Maggie Verver. Berman, *John Fiske,* pp. 46, 126, 137–143, 205–209; and Fiske, "Manifest Destiny," 578–590.

168. Matthew Arnold, *Civilization in the United States: First and Last Impressions of America* (1888; Boston: De Wolfe, Fiske, and Company,

1900), pp. 168–169; Paul Bourget, *Outre-Mer* (New York: Charles Scribner's Sons, 1895), p. 109; Charles William Eliot, "The Working of the American Democracy," *American Contributions to Civilization and Other Essays and Addresses* (New York: The Century Company, 1897), pp. 97–98.

169. On Hartmann, see Jane Calhoun Weaver, ed. *Sadakichi Hartmann: Critical Modernist; Collected Art Writings* (Berkeley: University of California Press, 1991).

170. Hartmann, "On the Elongation of Form," 34.

171. Hartmann, "On the Elongation of Form," 27 and 34. Of Puritan stock himself, Dudley A. Sargent numbered among many scientists whose inquiries were clearly shaped by their interests in seeing the hegemony of Anglo-Americans preserved; *The National Cyclopaedia of American Biography* 7 (New York: James T. White and Company, 1897), p. 97.

172. Henry James, "Preface," *The Wings of a Dove* (1902; New York: Random House/The Modern Library, 1946), p. xi.

173. David W. Levy, *Herbert Croly of "The New Republic": The Life and Thought of an American Progressive* (Princeton: Princeton University Press, 1985), pp. 78–80; Deborah Elizabeth Van Buren, *The Cornish Colony: Expressions of Attachment to Place, 1885–1915,* Ph.D. diss., George Washington University (Ann Arbor: University Microfilms, Inc., 1987), pp. 48–51; Saint-Gaudens, *Reminiscences,* I:318–321; Wiebe, *Search for Order,* pp. 133–140.

174. Grimes, "Reminiscences," frames 367ff.; Hobbs, "Thomas Dewing in Cornish," 28. Dewing to Freer, letter 83, July 16, 1897, FGAA, claims that Cornish is becoming too expensive, but whether this concerned property taxes or an outlay for the rather extensive entertaining now required to maintain social status in the community is unclear. The Fuller Diary for 1903 gives a clear picture of work and social routines at Cornish at the end of the Dewings' residence there.

175. Glassberg, *Historical Pageantry;* and Baltz, "Pageantry and Mural Painting," 211–228. The Dewings' daughter, Elizabeth Bartol Dewing, was in the 1920s involved in writing and producing plays for the Little Theatre Movement; see the Dewing Papers, AAA, microfilm 2077, frames 128ff.; Maria Dewing's Diary for 1924; and "Plan of the Manhattan Little Theater Club," proposed by Carl Bender, written and planned by E. B. Dewing, frames 437–452; Sheldon Cheney, *The Art Theater: Its Character as Differentiated from the Commercial Theater; Its Ideas and Organization; and a Record of Certain European and American Examples* (New York: Knopf, 1925); Alexander Dean, *Little Theatre Organization and Management for Community, University, and School* (New York: D. Appleton and Company,

1926). For the prewar challenges launched to Anglo-American culture, see Henry F. May, *The End of American Innocence: A Study of the First Years of Our Own Time, 1912–1917* (Chicago: Quadrangle Books/Quadrangle Paperbacks, 1964), pp. 220ff.

176. *New York American* (March 13, 1916): 12; quoted in John Loughery, "Charles Caffin," 105; Caffin, *The Story of American Art*, p. 382.

177. Loughery, "Charles Caffin," 105.

178. Dewing to Freer, letter 30, June 16, 1893; and letter 37, December 20, 1893, FGAA. Dewing's disappointment in the lack of appreciation for his work eventually led to a failed attempt to establish himself in London in 1894–1895.

179. Dewing to Freer, letter 110, February 16, 1901; Church to Freer, letter 134, April 1, 1893, FGAA. Freer to William Bixby, February 9, 1900, FGAA, relates Dewing's bad experiences with potential clients uneducated in his aesthetics.

180. *Art Amateur* 31 (November 1894): 114; De Kay, "The Ceiling of a Café," 257. For information on Dewing's clients who could trace their ancestry back to seventeenth-century English settlements, see entries in the *National Cyclopaedia of American Biography* for Robert G. Cheney (19:76), a silk manufacturer whose sisters owned Dewing's *The Days;* Edward Adams (10:419), a financier of railroads who owned *Tobit and the Angel;* Marvin Hughitt (20:22), a railroad executive who owned *The Rose Garden;* John Newell (39:227), a railroad executive who owned *The Palm Leaf Fan;* James B. Williams (6:245), a manufacturer of drugs who owned Yale University's *Summer;* Thomas F. Oakes (19:63), the president of the Northern Pacific Railroad, who probably owned *The Recitation;* William K. Bixby (27: 23), who purchased Freer's company and owned *Silver Birches, Brocart de Venise,* and *The Fortune Teller;* Frank J. Hecker, Freer's business partner, who owned Detroit's *Summer;* and John Gellatly, a New York businessman of Scottish origins with interests in pharmaceuticals and real estate. William G. Mather (41:56), a Cleveland industrialist, owned a pastel by Dewing, as did Edward Whittemore (22:306), an iron company executive.

181. Cortissoz, "Some Imaginative Types in American Art," 165–166. Letter of August 19, 1895, from Dewing to Cortissoz, Royal Cortissoz Papers, Yale University Library.

182. "The Art World, Paintings by Thomas W. Dewing," *New York Commercial Advertiser* (March 2, 1900); "Art Notes: Thomas W. Dewing's Paintings at the Montross Gallery," *New York Mail and Express* (March 8, 1900); for these and the numerous other reviews of the Montross exhibition, see the Press Cuttings Book, vol. 1, pp. 2–3, FGAA.

183. "Fine Arts: Paintings by Tryon and Dewing at the Montross Gallery," *Brooklyn Daily Eagle* (January 6, 1906); "Annual Exhibition at the Academy," *Pennsylvania Press* (January 21, 1906); "Pictures by 'The Ten,'" *Evening Post* (March 26, 1910); unidentified review, c. March 1910, regarding Dewing's Montross exhibition of that year; Press Cuttings Book, vol. 1, pp. 20, 21, and 36, FGAA. For reviews of Dewing's other exhibitions at Montross from 1906 to 1914, at the Pennsylvania Academy of the Fine Arts in 1906, the Ten American Painters at the Pennsylvania Academy and the Carnegie International Exhibition in 1908, also see the Press Cuttings Book, vol. 1.

184. Rebecca Zurier, *Art for "The Masses": A Radical Magazine and Its Graphics, 1911–1917* (Philadelphia: Temple University Press, 1988), pp. 143–147.

185. Guy Pene du Bois, "Whistler, Troyon [sic], Dewing, and Thayer Contribute to a Remarkable Collection . . . ," *New York American* (February 14, 1904); Press Cuttings Book, vol. 1, p. 3, FGAA.

186. Ira Glackens, *William Glackens and the Ashcan Group: The Emergence of Realism in American Art* (New York: Crown Publishers, Inc., 1957), pp. 89–90; William Innes Homer, *Robert Henri and His Circle* (Ithaca: Cornell University Press, 1969), pp. 126–156.

187. Charles de Kay, "French and American Impressionists," *New York Times* (January 31, 1904): 23.

188. "A Quintet of Painters," New York *Sun* (February 2, 1908); "Art Notes," New York *Sun* (February 12, 1909); Press Cuttings Book, vol. 1, pp. 26 and 31, FGAA.

189. Adeline Adams, "The Secret of Life," *Art and Progress* 4 (April 1913): 925–932.

190. Letter from Dewing to Macbeth of May 15, [1920s], AAA, NMc42, frame 640; see also Dewing to Freer, letters no. 132, May 7, 1916; and 138, May 22, 1917, FGAA.

191. May, *End of American Innocence*, pp. 282–284. Forbes Watson Papers, AAA, microfilm D55, frame 506.

192. Ernest Fenollosa, "The Place in History of Mr. Whistler's Art," 14–17; and "The Symbolism of the Lotos," 581.

193. Merrill, *An Ideal Country*, pp. 84–87.

194. It was thought that this was true until the museum's curator, John E. Lodge, placed the paintings of Dewing, Tryon, and Thayer in storage in order to give more gallery space to Whistler. Maria Dewing's Diary for January 31, 1924, records the dismay of the Dewings and their allies John Gellatly and Royal Cortissoz, as well as efforts to get the paintings back on the gallery walls.

195. In January 1918 the Dewings were encouraging the Worcester Art Museum to buy a Dewing painting from Gellatly's collection. Maria Dewing's Diary indicates that she wrote letters for her husband to the museums in Rochester, New York, Connecticut, and elsewhere on October 17 and 21, 1924, offering his paintings.

196. See Dewing's Diary of 1917, Dewing Papers, AAA, microfilm 2077, frames 63–127. Maria Dewing's Diary for 1924, AAA, microfilm 2077, frames 128–324, details her husband's breakdown as well as his slow, partial recovery. For a picture of Dewing's production in pastel and silverpoint in these years, see Dewing's correspondence in the Macbeth Galleries Papers, AAA, NMc42.

197. Lewis Mumford, *The Brown Decades: A Study of the Arts in America, 1865–1895* (1931; New York: Dover Publications, Inc., 1955), pp. 42 and 150, draws on Veblen's critique of higher education, "The Higher Learning," in discussing educational reforms in the late nineteenth century; and Veblen's *Theory of Business Enterprise* to condemn the vulgarity of Chicago's high-rise structures built by the city's capitalists, in contrast to the "radical modernity" of Sullivan that Mumford is championing here. For examples of art historians who read the paintings of the Ten as attempts to hallow the conspicuous consumerism of nouveau-riche America, see Patricia Hills, *Turn-of-the-Century America: Paintings, Graphics, and Photographs, 1890–1910* (New York: Whitney Museum of American Art, 1977), p. 74; Linda Ayres, "The American Figure: Genre Paintings and Sculpture," in John Wilmerding, Linda Ayres, and Earl Powell, *An American Perspective: Nineteenth-Century Art from the Collection of Jo Ann and Julian Ganz Jr.* (Washington, D.C.: National Gallery of Art, 1981), pp. 70–71; and Linda Nochlin, "Seeing through Women," *Woman* (Evanston, Ill.: Terra Museum of American Art, 1984), pp. 7–8.

198. Lev E. Dobriansky, *Veblenism: A New Critique* (Washington, D.C.: Public Affairs Press, 1957), pp. 7–10; David W. Noble, "The Sacred and the Profane: The Theology of Thorstein Veblen," in *Thorstein Veblen: The Carleton College Veblen Seminar Essays*, ed. Carlton C. Qualey (New York: Columbia University Press, 1968), p. 89; Joseph Dorfman, "Background of Veblen's Thought," in *Carleton College*, pp. 111–119.

199. Dorfman, "Background," 127; Noble, "Sacred and Profane," 79 and 82.

200. Noble, "Sacred and Profane," 79–82, and 89.

201. Veblen, *Theory of the Leisure Class*, p. 121.

202. Ibid., pp. 43 and 179.

203. Garry Wills, "Sons and Daughters," 52–54.

204. Veblen, *Theory of the Leisure Class,* pp. 179–182.

205. Ibid., pp. 357–359.

206. On the Mencken-Veblen dispute, see John P. Diggins, *The Bard of Savagery: Thorstein Veblen and Modern Social Theory* (New York: A Continuum Book; The Seabury Press, 1978), pp. 162–165.

207. See Veblen, *Theory of the Leisure Class,* ch. IX, pp. 212–245; Noble, "Sacred and Profane," 84–86.

208. "Ten American Painters," *New York Times* (April 19, 1908), Press Cuttings Book, I, 27, FGAA.

209. Veblen, *Theory of the Leisure Class,* p. 43.

210. Bernice Kramer Leader, "Antifeminism in the Paintings of the Boston School," *Arts Magazine* 56 (January 1982): 112–119.

211. Minna Smith, "The Work of Frank W. Benson," *International Studio* 35 (October 1908): 99; Anna Seaton-Schmidt, "Frank W. Benson," *American Magazine of Art* 12 (November 1921): 365–372; entry for Benson, *National Cyclopaedia of American Biography,* 41:66–67; entry for Tarbell, *National Cyclopaedia of American Biography,* 41:563.

212. "Joseph DeCamp Shows at Guild," *Christian Science Monitor* (December 29, 1916): 5.

213. Kenyon Cox, "The Recent Work of Edmund C. Tarbell," *Burlington Magazine* 14 (January 1909): 254 and 259.

214. Mary Anne Goley, *John White Alexander (1856–1915)* (Washington, D.C.: National Collection of Fine Arts, Smithsonian Institution, 1976), unpag.

215. Alexander's illustrations of the Pittsburgh railroad strike appeared in *Harper's Weekly* 21 (August 11, 1877).

5. THE IDEOLOGIES OF AMERICAN IMPRESSIONISM

1. Quoted in Barbara Ehrlich White, ed., *Impressionism in Perspective* (Englewood Cliffs, N.J.: Prentice-Hall, Inc.; A Spectrum Book, 1978), p. 18.

2. On the dynamics of intraprofessional politics among groups of intellectuals and artists, see Pierre Bourdieu, "The Production of Belief: Contribution to an Economy of Symbolic Goods," trans. by Richard Nice, in *Media, Culture, and Society,* ed. Collins et al., esp. pp. 139, 146–148, 154–155, 158–161.

3. Gerdts, *American Impressionism;* Richard J. Boyle, *American Impressionism* (Boston: New York Graphic Society, 1974); Ulrich W. Hiesinger, *Impressionism in America: The Ten American Painters* (Munich: Prestel

Verlag, 1991); H. Barbara Weinberg, Doreen Bolger, and David Park Curry, *American Impressionism and Realism: The Painting of Modern Life, 1885–1915* (New York: Metropolitan Museum of Art; Abrams, 1994).

4. H. Barbara Weinberg, "American Impressionism in a Cosmopolitan Context," *Arts Magazine* 55 (November 1980): 160–165.

5. Kirk Varnedoe, *Northern Light: Nordic Art at the Turn of the Century* (New Haven: Yale University Press, 1988), pp. 13–36.

6. Bercovitch, *American Jeremiad,* p. 160, writes that American political rhetoric, structured in the ritualized form of the Puritan jeremiad, rendered conflict as a "mode of control: a means of facilitating process through which process became an aid to socialization," and that the American consensus habitually absorbs radical movements in so far as they "lead into the middle-class American Way."

7. Linda Nochlin, *Realism* (Harmondsworth, Middlesex: Penguin, 1978), pp. 42–43, 53–54, 143–145.

8. Richard Shiff, "The End of Impressionism," in *The New Painting: Impressionism, 1874–1886* (San Francisco: The Fine Arts Museum of San Francisco, 1986), pp. 71–74.

9. Joel Isaacson, "Observation and Experiment in the Early Work of Monet," in *Aspects of Monet: A Symposium on the Artist's Life and Times,* ed. John Rewald and Frances Weitzenhoffer (New York: Abrams, 1984), pp. 16–35.

10. Joel Isaacson, *The Crisis of Impressionism, 1878–1882* (Ann Arbor: The University of Michigan Museum of Art, 1980), pp. 14 and 27.

11. T. J. Clark, *The Painting of Modern Life: Paris in the Art of Manet and His Followers* (New York: Knopf, 1984); Robert L. Herbert, *Impressionism: Art, Leisure, and Parisian Society* (New Haven: Yale University Press, 1988).

12. Kathleen A. Pyne, "John Twachtman and the Therapeutic Landscape," in Deborah Chotner, Lisa N. Peters, and Kathleen A. Pyne, *John Twachtman: Connecticut Landscapes* (Washington, D.C.: National Gallery of Art, 1989), pp. 48–69.

13. Wanda Corn and John Wilmerding, "The United States," in *Post-Impressionism: Cross-Currents in European and American Painting, 1880–1906* (Washington, D.C.: National Gallery of Art, 1980), pp. 219–222.

14. Robert Herbert, "Method and Meaning in Monet"; Joel Isaacson, *Observation and Reflection: Claude Monet* (Oxford: Phaidon, 1978); John House, *Monet: Nature into Art* (New Haven: Yale University Press, 1986), esp. pp. 223–225; and Shiff, "The End of Impressionism."

15. In reality, this view can be situated within the essentialist modernist discourse that values formal abstraction as a "higher" aesthetic in the

"progressive" evolution of art toward an essential condition. It also lends itself to the discourse that seeks to formulate an American impressionism as part of a usable American past, as a prologue to American abstraction in the first half of the twentieth century.

16. Bourdieu, "The Production of Belief," 154–155, for example, has observed: "Specifically aesthetic conflicts about the legitimate vision of the world, . . . about what deserves to be represented and the right way to represent it, are political conflicts (appearing in their most euphemized form) for the power to impose the dominant definition of reality, and social reality in particular."

17. Hans Huth, "Impressionism Comes to America," *Gazette des Beaux-Arts* 29 (April 1946): 225–252.

18. Monet to Durand-Ruel, July 28, 1885; quoted in translation by Frances Weitzenhoffer, "The Earliest American Collectors of Monet," in *Aspects of Monet,* p. 75.

19. *Works in Oil and Pastel by the Impressionists of Paris* (New York: The American Art Association, 1886).

20. "The Impressionists' Exhibition at the American Art Galleries," *The Art Interchange* 16 (April 24, 1886): 130–131.

21. Huth, "Impressionism Comes," 244, determined these figures from the customs duties on sales paid by Durand-Ruel. Weitzenhoffer, "Earliest American Collectors," 79–82, counts thirty-six Monets from this venture purchased by four different collectors, two of whom (Erwin Davis and Alden Wyman Kingman) seemed to be buying and selling pictures for speculative reasons; Huth, 244, n. 31, traced the sales of two Manets from the exhibition.

22. For positive reviews, see Lionello Venturi, ed., *Les Archives de l'Impressionisme* (New York: Durand-Ruel, 1939), p. 78; and Huth, "Impressionism Comes," 241–242.

23. R[oger]. R[iordan]., "Second Notice: The Impressionist Exhibition," *The Art Amateur* 15 (June 1886): 4.

24. "The Fine Arts: The French Impressionists," *The Critic* 5 (April 17, 1886): 195.

25. "The Impressionists' Exhibition at the American Art Galleries," 130–131.

26. *The Churchman* (June 12, 1886): 672–673; and *New York Times* (April 10, 1886): 5, and (May 28, 1886): 5.

27. Lucy H. Hooper, "Art-Notes from Paris," *The Art Journal* (New York) 6 (1880): 189–190.

28. J[ohn]. C. Van Dyke, "The Bartholdi Loan Collection," *The*

Studio 2 (December 8, 1883): 262–263; William Howe Downes, "Impressionism in Painting," *New England Magazine* 6 (July 1892): 600.

29. For responses to Degas, see "The Fine Arts," *The Critic,* 195; and Clarence Cook, "The Impressionist Pictures—The Art-Association Galleries," *The Studio* (April 17, 1886): 250; and "The Impressionists," *The Art Interchange* 29 (July 1892): 6. Theodore Child, "Some Modern French Painters," *Harper's New Monthly Magazine* 80 (May 1890): 840; W[illiam]. C. Brownell, *French Art: Classic and Contemporary Painting and Sculpture* (1892; New York: Charles Scribner's Sons, 1901), pp. 112–113.

30. "The Impressionists," *The Art Age* 3 (April 1886): 166.

31. "The Impressionists' Exhibition at the American Art Galleries," 130; and "The Impressionists," *The Art Interchange,* 6.

32. Shiff, *The New Painting,* p. 412.

33. See Downes, "Impressionism in Painting," 601; and Huth, "Impressionism Comes," 229, n. 6.

34. L. Lejeune, "The Impressionist School of Painting," *Lippincott's Magazine of Popular Literature and Science* 24 (December 1879): 725.

35. Meyer Schapiro, "The Nature of Abstract Art," *Modern Art, 19th and 20th Centuries: Selected Papers* (New York: George Braziller, 1978), p. 192, commented on the impressionists' "implicit criticism of symbolic social and domestic formalities."

36. Hooper, "Art-Notes," 189–190.

37. Wiebe, *Search for Order,* pp. 9–10, and 77.

38. John L. Thomas, *Alternative America: Henry George, Edward Bellamy, Henry Demarest Lloyd, and the Adversary Tradition* (Cambridge, Mass.: The Belknap Press of Harvard University Press, 1983), p. 234.

39. Wiebe, *Search for Order,* p. 76.

40. Wiebe, *Search for Order,* pp. 44–52.

41. Trachtenberg, *Incorporation of America,* pp. 90 and 99.

42. Wiebe, *Search for Order,* pp. 12ff., 44.

43. Paul Avrich, *The Haymarket Tragedy* (Princeton: Princeton Univeristy Press, 1984), pp. 197ff.; Henry David, *The History of the Haymarket Affair* (New York: Russell & Russell, 1958), p. 528; Trachtenberg, *Incorporation of America,* pp. 88–89.

44. Wiebe, *Search for Order,* p. 54.

45. Wiebe, *Search for Order,* pp. 63 and 77–79.

46. Josiah Strong, *Our Country: Its Possible Future and Its Present Crisis,* ed. Jurgen Herbst (1886; Cambridge, Mass.: The Belknap Press of Harvard University Press, 1963), pp. 42ff., states that 5,248,000 immigrants settled in the United States between 1880 and 1886.

47. Higham, *Strangers in the Land,* pp. 135–140.

48. J. Moore, *Post-Darwinian Controversies,* ch. 1.

49. Henry Bacon, "Glimpses of Parisian Art," *Scribner's Monthly* 21 (December 1880): 170.

50. See Lejeune, "Impressionist School," 727; also *New York Herald* (April 10, 1886), cited in Huth, "Impressionism Comes," 242; Greta, "Art in Boston: The Wave of Impressionism," *The Art Amateur* 24 (May 1891): 141; and R[oger]. R[iordan]., "The Impressionist Exhibition," *The Art Amateur* 14 (May 1886): 121.

51. "The Point of View," *Scribner's Magazine* 9 (May 1891): 657.

52. Edward Rudolf Garczanski, "Jugglery in Art," *The Forum* 1 (August 1886): 594, 598–601.

53. See her translation of Alfred Stevens, *Impressions on Painting* (New York: George J. Coombes, 1886), pp. xi–xii.

54. Theodore Child, "Impressionist Painting," *Art and Criticism: Monographs and Studies* (New York: Harper and Brothers, 1892), pp. 164.

55. "The Impressionists," *The Art Interchange,* 4–7, quotes André Michel's publication, and elsewhere describes their aesthetic as brutal, unrefined, violent, and indifferent to harmony both in nature and in the art object.

56. See Oscar Reutersvärd, "Journalists (1876–1883) on 'Violettomania,'" in White, *Impressionism in Perspective,* pp. 38–43; and "Journalists (1874–1896) on the Accentuated Brush Stroke," also in White, pp. 44–50. Paul Tucker, "The First Impressionist Exhibition in Context," in *The New Painting,* pp. 92–117.

57. "The Impressionists," *The Art Age,* pp. 165–166, also added that the landscapes of Monet, "full of a heavenly calm," were in a different category altogether from the figure subjects, which were full of the "cries of uneasy souls."

58. William Howe Downes, "Boston Painters and Paintings," *Atlantic Monthly* 62 (December 1888): 782; the *New York Times* (April 10, 1886): 5, and (May 28, 1886): 5, called the impressionist paintings "unnatural" and "devoid of honesty"; *The Churchman* (June 12, 1886): 672–673, added the accusations of "Zola-ism," "sensualism and voluptousness," and "sheer atheism"; Hooper, "Art-Notes," 189–190; and "The Impressionists," *The Art Age,* 166.

59. Isaacson, "The Crisis of Impressionism," 25, uses the term *pure impressionism* to differentiate the landscapists' interest in experimentation with color and brushwork from the figure painters' interest in social subjects. Further objections to impressionist color and distortion can be

found in Garczynski, "Jugglery" 600; Luther Hamilton, "The Work of the Paris Impressionists in New York," *The Cosmopolitan* 1 (June 1886): 241; Downes, "'Impressionism in Painting," 600 and 603; "The Field of Art—Colored Shadows," *Scribner's Magazine* 19 (April 1896): 522; and Birge Harrison, *Landscape Painting* (1909; New York: Charles Scribner's Sons, 1911), pp. 37–38.

60. Brownell, *French Art: Classic and Contemporary*, pp. 104–112.

61. The preference among American collectors in the 1880s for the Barbizon vision can be clearly discerned from the display at the 1883 New York Pedestal Fund Art Loan Exhibition; see O'Brien, *In Support of Liberty*. Unfavorable comparison of impressionist works to the superior poetic qualities of Barbizon painting was also a standard feature of the critical literature of the period; see, for example, Lejeune, "Impressionist School," 725–726.

62. "The Point of View," 657–658. See also Adeline Adams's review of the Armory Show, "The Secret of Life," *Art and Progress* 4 (April 1913): 925–932.

63. Theodore Child, "Some Modern French Painters," 826–827. Others who voiced these objections include: "The Impressionists," *The Art Interchange*, 7; "Impressionism and Impressions," *The Collector*, 213; "The Point of View," 657–658; the tonalist painter Harrison, *Landscape Painting*, pp. 171–172, 203–205, 208–217, 232–233; W. H. W., "What Is Impressionism? Part II," *The Art Amateur* 27 (December 1892): 5; Greta, "Art in Boston: The Wave of Impressionism," 141; "Colored Shadows," *Scribner's Magazine*, 233; and Brownell, *French Art: Classic and Contemporary*, pp. 107–111.

64. Brownell, *French Art: Classic and Contemporary*, p. 108; "Impressionism and Impressions," *The Collector*, 213; Duncan Phillips, "What Is Impressionism?" *Art and Progress* 3 (September 1912): 702–704.

65. Clarence Cook, "The Impressionist Pictures," 245–254; Brownell, *French Art: Classic and Contemporary*, pp. 104–107; R[oger]. R[iordan]., "From Another Point of View," *The Art Amateur* 27 (December 1892): 5; "Claude Monet (The Field of Art)," *Scribner's Magazine* 19 (January 1896): 125; "The Impressionists," *The Art Age*: 166.

66. Cecilia Waern, "Notes on French Impressionism," *Atlantic Monthly* 69 (April 1892): 535–541.

67. T[heodore]. C. Steele, "Impressionalism," *Modern Art* 1 (Winter 1893): unpag.

68. "Impressionism and After—The Field of Art," *Scribner's Magazine* 21 (March 1897): 391. For other equivocating opinions along these lines, see Brownell, Harrison, and Phillips, cited above; also Theodore Child, "The King of the 'Impressionists,'" *The Art Amateur* 14 (April 1886): 101–

102; "Fine Arts: Society of American Artists," *The Nation* 1 (May 8, 1890): 381–382; Henry G. Stephens, "'Impressionism': The Nineteenth Century's Distinctive Contribution to Art," *Brush and Pencil* 11 (January 1903): 296–297; Desmond FitzGerald, "Claude Monet—Master of Impressionism," *Brush and Pencil* 15 (March 1905): 188; and Charles H. Moore, "Modern Art of Painting in France," *Atlantic Monthly* 68 (December 1891): 805–816.

69. Celen Sabbrin [Helen Abbott Michael], *Science and Philosophy in Art* (Philadelphia: William F. Fell, 1886). For a biographical sketch, see Nathan Haskell Dole in Helen Abbott Michael, *Studies in Plant and Organic Chemistry and Literary Papers* (Cambridge, Mass.: The Riverside Press, 1907), pp. 3–104; cited in Weitzenhoffer, "Earliest American Collectors," 77 and n. 11.

70. Sabbrin, *Science and Philosophy*, pp. 3–4; on the laws of motion, force, and dissymmetry in Monet, on 5–10; on his color and human emotions, on 11–17. She contrasts Monet's color harmonies with Renoir's taste for "color discords."

71. Sabbrin, *Science and Philosophy*, p. 17.

72. Sabbrin, *Science and Philosophy*, pp. 19–20.

73. See James's essays such as "The Will to Believe," "Is Life Worth Living?" and "The Dilemma of Determinism," in *The Will to Believe and Other Essays.*

74. Hamlin Garland, *Crumbling Idols: Twelve Essays on Art Dealing Chiefly with Literature, Painting, and the Drama*, ed. Jane Johnson (1894; Cambridge, Mass.: The Belknap Press of Harvard University Press, 1960), ch. IX.

75. Garland, *Crumbling Idols*, pp. 106–110; Donald Pizer, *Realism and Naturalism in Nineteenth-Century American Literature* (Carbondale, Ill.: Southern Illinois University Press, 1984), pp. 96–141.

76. Pizer, *Realism and Naturalism*, pp. 88–89.

77. On the American market for French Barbizon painting, see Peter Bermingham, *American Art in the Barbizon Mood* (Washington, D.C.: National Collection of the Fine Arts/Smithsonian Institution Press, 1975).

78. Garland, *Crumbling Idols*, pp. 100–102, 105–106.

79. Garland, *Crumbling Idols*, pp. 100–104.

80. Garland, *Crumbling Idols*, pp. 99–100; the editor of the 1960 edition, Jane Johnson, has identified this painting as Wentzel's *Confirmation Banquet*, a work Wentzel exhibited in Chicago.

81. On Garland and Taine, see Pizer, *Realism and Naturalism*, pp. 88, 100.

82. Garland, *Crumbling Idols*, 100.

83. Pizer, *Realism and Naturalism,* p. 141.

84. See Frederick J. Turner, *The Significance of the Frontier in American History,* March of America Facsimile Series, Number 100 (1894; Ann Arbor: University Microfilms, Inc., 1966), pp. 201, 220–222, 226–227.

85. Stocking, "Lamarckianism in American Social Science," 245; Wiebe, *Search for Order,* p. 66.

86. Pizer, *Realism and Naturalism,* pp. 127–132, 138–140.

87. Theodore Robinson, Diary, vol. 1, August 9, 1893. The Robinson Diaries are at the Frick Art Reference Library, New York.

88. For Robinson's biography, see E[liot]. C[lark]., "Robinson, Theodore," in *Dictionary of American Biography,* p. 54; John I. H. Baur, *Theodore Robinson, 1852–1896* (Brooklyn: Brooklyn Museum, 1946); Eliot Clark, *Theodore Robinson: His Life and Art* (Chicago: R. H. Love Galleries, 1979); and Sona Johnston, *Theodore Robinson, 1852–1896* (Baltimore: Baltimore Museum of Art, 1973).

89. Other Diary entries commenting on "Monet's desideratum" as the need to capture the mystery in nature include June 19, 1892; July 29, 1892; September 4, 1892; and February 23, 1893. On the necessity of hard observation, see the entries for November 21, 1892; January 23, 1893; and May 13, 1893.

90. Hamlin Garland, "Theodore Robinson," *Brush and Pencil* 4 (September 1899): 285.

91. Diary entry for June 3, 1892.

92. Diary entries for February 20, 1893; August 13, 1893; October 29, 1893; and December 2, 1893.

93. Diary entry for January 14, 1895.

94. Diary entries for October 3, 10, 23, and 24, 1894.

95. Diary entry for December 4, 1895.

96. Diary entries for June 16, 1895; September 20, 1895; October 2, 1895; and October 25, 1895.

97. On his literary and philosophical interests, see the Diary entries for April 22 and 24, 1892 (Flaubert); August 3, 1892 (Zola); May 19, 1894 (J. M. Barrie); October 3 and 4, 1894 (Huxley); undated entry from early November 1894 (Thackeray and Pope); March 10, 1895 (Renan); September 1, 1895 (Henry James); and November 6, 1895 (Wordsworth). Will H. Low, *A Chronicle of Friendships, 1873–1900* (New York: Charles Scribner's Sons, 1910), p. 285, notes that Robinson spent an extraordinary amount of time reading the poetry of Milton, Keats, and Swinburne, presumably in the early 1880s when Low's relationship to Robinson was closest.

98. Robinson's Diary entry for October 25, 1895, connects virility with American subjects.

99. Garland, "Theodore Robinson," 285.

100. Diary entry for August 10, 1892.

101. For Robinson's reference to nature as the "great mother," see his "Claude Monet," *The Century Magazine* 44 (September 1892): 699. On Monet's desideratum, see the Diary entries listed in note 89.

102. See, for example, his Diary entries for May 5 and 30, 1892; December 31, 1892; January 23, 1893; February 23 and 24, 1893; May 10 and 13, 1893; April 11, 1894; December 17, 1894; January 1, 1895; March 2, 9, and 16, 1896; also Robinson, "Claude Monet," 696.

103. Diary, February 24, 1893, and February 5, 1894.

104. Diary, March 19, 1896, notes his visit to the Metropolitan Museum of Art, where he perused Corot's *Ville d'Avray*, and his opinion: "One comes back to it with pleasure, to rest the eyes and spirit." Robinson's appraisal of Corot is found in his essay, "Jean-Baptiste-Camille Corot," in John C. Van Dyke, ed., *Modern French Masters: A Series of Biographical and Critical Reviews by American Artists* (New York: The Century Company, 1896), esp. pp. 11 and 113–116. Robinson, "Claude Monet," 1696, compares Corot with Monet.

105. Robinson, "Claude Monet," 698.

106. Diary entries, July 29, 1892; December 31, 1892; January 16, 27, and 29, 1893; January 2, 1894; February 17, 1894; April 8, 1894; July 13, 1894; and April 13, 1895. On Robinson's distrust of his sentimental streak, see Diaries, February 31, 1892; January 9, 1893; and December 23, 1893.

107. Diaries, February 4, 1893; January 8, 1893; December 16, 1894; April 21, 1895; July 25, 1895; and January 11, 1896.

108. In a few instances, for example, *Val d'Arconville* (1889, Art Institute of Chicago), Robinson tried to synthesize his two compositional types. On his taste in art, see Diaries, March 30, 1894, and March 26, 1896 (Homer); April 3, 1894, February 19, 1895, and March 19, 1896 (Corot); May 22, 1892, and June 3, 1892 (Puvis); February 2, 1895 (Vonnoh); and March 20, 1894 (Newman).

109. Clark, *Theodore Robinson*, pp. 27, 33, and 57. Robinson, Diary, December 8, 1893, seemed to be unaware of the Japanese sources of the high horizon line. On his preference for Monet's early work, see Diary, January 26, 1895.

110. Royal Cortissoz, *American Artists* (New York: Charles Scribner's Sons, 1923), pp. 131–133.

111. Diary, January 26, 1895.

112. Garland, "Theodore Robinson," 285; Diary, January 2, 1896.

113. On his admiration for Japanese design and Holbein's art, see his Diary, January 1, 1895, and February 8, 1896; on his dislike of using

photographs, January 1, 1895, and February 2, 1895. On Robinson's use of photography, see John I. H. Baur, "Photographic Studies by an Impressionist," *Gazette des Beaux-Arts* 30 (October–December 1946): 319–330.

114. Diary, August 12, 1895, and September 28, 1895.

115. Clark, *Theodore Robinson*, pp. 59 and 61.

116. Diary, July 21, 1892; on February 16, 1895, he noted the correlation between his moods and his physical condition.

117. Of the books of H. Emilie Cady, Robinson read *Finding the Christ in Ourselves* (1894). Robinson had first read Prentice Mulford's mind-cure pamphlets in March 1893. See Diary for April 19, 1892; March 4, 1893; July 13, 1894; January 13 and 23, 1895; February 5, 20, and 24, 1895; November 25, 27, 28, and 30, 1895; December 10, 21, and 30, 1895; January 13, 1896.

118. Pearl Howard Campbell, "Theodore Robinson, a Brief Historical Sketch," *Brush and Pencil* 4 (September 1899): 287.

119. J. Turner, *Without God, Without Creed*, pp. 248–259.

120. Garland, "Theodore Robinson," 286, appended an undated obituary from the *Brooklyn Eagle* in which Robinson was termed "a sane impressionist." *The Nation* (May 8, 1890), pp. 381–382, counted Robinson as "the best" of the American painters, who would "use . . . [Monet's] discoveries with a saner judgment"; quoted in Baur, *Theodore Robinson*, pp. 29–30.

121. *Boston Transcript* (1896); quoted in Dorothy Weir Young, *The Life and Letters of J. Alden Weir*, ed. with an introduction by Lawrence W. Chisolm (New Haven: Yale University Press, 1960), pp. 178 and 188.

122. *New York Times* (April 12, 1891): 12. Pyne, "John Twachtman and the Therapeutic Landscape," 50–51.

123. John Rewald, *The History of Impressionism* (New York: The Museum of Modern Art, 1973), pp. 423, 439, 449, notes, for example, that at the fourth, fifth, and sixth impressionist exhibitions of 1879, 1880, and 1881 Cassatt and Pissarro framed their works in complementary colors, while other painters used white or natural wood frames. Ulrich Hiesinger, *Impressionism in America*, p. 155.

124. "Ten American Painters," The *Sun* (March 22, 1907): 7. Hiesinger, *Impressionism in America*, pp. 24–26, 153, 155–156, 170, n. 12, and 240.

125. Tuan, "Thought and Landscape," 99.

126. Samuel Isham, *The History of American Painting* (1905; New York: The Macmillan Company, 1927), with supplemental chapters by Royal Cortissoz, p. 564.

127. *New York Times* (April 2, 1902): 8.

128. On their reasons for seceding from the SAA, see the public statements given by the Ten, quoted in Hiesinger, *Impressionism in America,* p. 18.

129. Many of the periodical writers on the Ten were careful to treat their paintings within the context of their Puritan heritage, often as the epitome of the New England ethos. See, for example, Caffin, "Art of Thomas W. Dewing," 714–724; Israel L. White, "Childe Hassam—a Puritan," *International Studio* 15 (December 1911): 29–33, who also includes Tarbell and Weir in this category; F. Newlin Price, "Childe Hassam—Puritan," *International Studio* 77 (April 1923): 3–7; John E. D. Trask, "About Tarbell," *American Magazine of Art* 9 (April 1918): 221; and Minna Smith, "The Work of Frank W. Benson," *International Studio* 35 (October 1908): 99. For biographies and ancestries of the Ten, see the *National Cyclopaedia of American Biography.*

130. Trachtenberg, *Incorporation of America,* pp. 101–103.

131. Strong, *Our Country,* pp. 55–56.

132. Hales, *Silver Cities,* pp. 193ff., 203–210; Alexander Alland Sr., *Jacob A. Riis, Photographer and Citizen* (New York: Aperture, 1974); Jacob A. Riis, *How the Other Half Lives: Studies among the Tenements of New York* (1890; New York: Dover Publications, 1971).

133. Hales, *Silver Cities,* pp. 183–185, 193–197.

134. George J. Lankevich and Howard B. Furer, *A Brief History of New York* (Port Washington, New York, New York, and London: Associated Faculty Press, 1984), pp. 174–182.

135. Wiebe, *Search for Order,* pp. 38–39, 77, 83, 91, and 96.

136. James, *American Scene,* pp. 131–135.

137. Hales, *Silver Cities,* ch. 2.

138. Jennifer A. Martin Bienenstock, "Childe Hassam's Early Boston Cityscapes," *Arts Magazine* 55 (November 1980): 168–171; Dianne H. Pilgrim, "The Revival of Pastels in Nineteenth-Century America: The Society of Painters in Pastel," *The American Art Journal* 10 (1978): 48; Gerdts, *American Impressionism,* pp. 48, 94–98.

139. A. E. Ives, "Talks with Artists: Mr. Childe Hassam on Painting Street Scenes," *The Art Amateur* 27 (October 1892): 117.

140. Schuyler, *New Urban Landscape,* p. 184; Charles Lockwood, *Manhattan Moves Uptown: An Illustrated History* (Boston: Houghton Mifflin Company, 1976), pp. 292–302. Marianna van Rensselaer, "Fifth Avenue," *The Century Illustrated Monthly Magazine* 47 (November 1893): 5–18; many of Hassam's paintings were engraved to illustrate this article.

141. Ives, "Talks with Artists," 116.

142. Van Rensselaer, "Fifth Avenue," 15.

143. Ives, "Talks with Artists," 116–117.

144. Hales, *Silver Cities,* pp. 90 and 101.

145. Schuyler, *New Urban Landscape,* pp. 185–193; Michele H. Bogart, *Public Sculpture and the Civic Ideal.*

146. Wanda M. Corn, "The New New York," *Art in America* 61 (July–August 1973): 58–65.

147. Trachtenberg, *Incorporation of America,* pp. 108–112; Roy Rosenzweig and Elizabeth Blackmar, *The Park and the People: A History of Central Park* (Ithaca: Cornell University Press, 1992), pp. 238ff; Henry Hope Reed and Sophia Duckworth, *Central Park: A History and a Guide* (New York: Clarkson N. Potter, Inc., 1967).

148. Rosenzweig and Blackmar, *Park and the People,* pp. 240–241.

149. Hales, *Silver Cities,* pp. 104–112.

150. James, *American Scene,* pp. 177–179.

151. Schuyler, *New Urban Landscape,* p. 191.

152. "Address of Mr. William M. Chase before the Buffalo Fine Arts Academy, January 28th, 1890," *Studio* 5 (March 1, 1890): 124; cited in William H. Gerdts, *Masterworks of American Impressionism* (Einsiedeln, Switzerland: Karl-Ulrich Majer, Eidolon AG, 1990), p. 94.

153. Evidence of Chase's study of Japanese prints and other objects is abundant, simply on the basis of his admiration for Whistler and the many examples of Japanese objects pictured in his compositions such as *The Kimono* (c. 1895; Thyssen-Bornemisza Collection, Lugano).

154. "Some Questions of Art: Pictures by Mr. William M. Chase," New York *Sun* (March 1, 1891): 14; and Charles de Kay, "Mr. Chase and Central Park," *Harper's Weekly* 35 (May 1891): 327–328.

155. Hubert Beck, "Die Ikonographie der Stadt: Das Zögern vor der Stadt-Thematik," in *Bilder aus der Neuen Welt: Amerikanische Malerei des 18. und 19. Jahrhunderts,* ed. Thomas Gaehtgens (Munich: Prestel-Verlag, 1988), pp. 114–117.

156. For example, see John Twachtman's painting *Dredging in the East River* (c. 1879/80).

157. Hales, *Silver Cities,* ch. 3; Marc Simpson on Robinson's sources in Monet's work and Charles Dudley Arnold's panoramas in *American Paintings from the Manoogian Collection* (Washington, D.C.: National Gallery of Art, 1989), pp. 154–156. On the millennial rhetoric at the opening of the fair, see Burg, *Chicago's White City,* pp. 100–113.

158. Meinig, "Symbolic Landscapes," 164–167.

159. J. B. Jackson, "The Order of a Landscape: Reason and Religion in

Newtonian America," in Meinig, *Interpretation of Ordinary Landscapes,* pp. 158–161.

160. Charles Eliot Norton, "The Lack of Old Homes in America," *Scribner's Magazine* 5 (May 1889): 638ff.

161. Norton, "Lack of Old Homes," 637–638.

162. James, *American Scene,* pp. 119–125.

163. Higham, *Strangers in the Land,* p. 139; Thomas Bender, *Toward an Urban Vision: Ideas and Institutions in Nineteenth-Century America* (Lexington: University Press of Kentucky, 1975), pp. 105 and 197.

164. Maurice Halbwachs, *The Collective Memory,* trans. Francis J. Ditter Jr. and Vida Yazdi Ditter (New York: Harper Colophon Books, 1980), p. 133. Meinig, "Symbolic Landscapes," 173–174; and David Lowenthal, "Age and Artifact: Dilemmas of Appreciation," in Meinig, *Interpretation of Ordinary Landscapes,* pp. 110ff. For example, organizations to preserve the Anglo-American past were established between the Centennial of 1876 and World War I in the following towns of Massachusetts: Cape Ann (1876); Newbury (1877); Concord (1886); Ipswich (1890); Nantucket (1894); Marblehead (1898); Dartmouth (1903); Northampton (1905); and Sandwich (1907).

165. Meinig, "Symbolic Landscapes," 165.

166. Hiesinger, *Impressionism in American,* pp. 116 and 158ff., cites primarily the reactionary *Art Interchange* as hostile to the impressionist technique of some members of the Ten.

167. *Connecticut and American Impressionism* (Storrs, Conn.: The William Benton Museum of Art, University of Connecticut, 1980).

168. Kathleen M. Burnside, *Childe Hassam in Connecticut* (Greenwich, Conn.: Historical Society of the Town of Greenwich, 1987), p. 5.

169. See, for example, Elizabeth de Veer and Richard J. Boyle, *Sunlight and Shadow: The Life and Art of Willard L. Metcalf* (New York: Boston University/Abbeville Press, 1987), no. 165, *Buttercup Time,* 1920; no. 167, *November Mosaic,* 1922, or no. 171, *October Morning (No. 2),* 1920; no. 187, *Northcountry,* 1923, or no. 288 *New England Afternoon,* 1919. Metcalf had earlier also used this strategy in approaching the White City of 1893 and Central Park; see *Early Spring Afternoon, Central Park* (1911; Brooklyn Museum).

170. Meinig, "Symbolic Landscapes," 165.

171. On the nostalgia for New England in the period, see Van Wyck Brooks, *New England: Indian Summer, 1865–1915* (New York: E. P. Dutton, 1940).

172. Lawrence Buell, *New England Literary Culture: From Revolution*

Through Renaissance (Cambridge: Cambridge University Press, 1986), pp. 307–308; Burnside, *Childe Hassam*, p. 15.

173. Burnside, *Childe Hassam*, pp. 8–9.

174. See, for example, Catherine Beach Ely, "Willard Metcalf," *Art in America* 13 (1925): 332–336; and Cortissoz, *American Artists*, pp. 143–145.

175. Perry Miller, "From Edwards to Emerson," *Errand into the Wilderness* (Cambridge, Mass.: The Belknap Press of Harvard University Press, 1981), esp. pp. 189–197.

176. Eugene A. Clancy, "The Car and the Country Home," *Harper's Weekly* 55 (May 6, 1911): 30; and "Successful Houses," *House Beautiful* 5 (May 1899): 267; quoted in Schmitt, *Back to Nature*, pp. 4–5, 17–18.

177. Buell, *New England*, pp. 310–313.

178. James, *American Scene*, pp. 43 and 49.

179. Ibid., pp. 23–25.

180. Ibid., pp. 38–47.

181. Schmitt, *Back to Nature*, pp. 4 and 18.

182. Jay Appleton, "Prospects and Refuges Re-Visited," *The Landscape Journal* 3 (1984): 91–103; and *The Symbolism of Habitat: An Interpretation of Landscape in the Arts* (Seattle: University of Washington Press, 1990), pp. 47ff.

183. Pyne, "John Twachtman and the Therapeutic Landscape," 55–56 and 62.

184. See Merrill, *A Pot of Paint*, pp. 102–103 and 352, n. 22; and E. R. Pennell and J. Pennell, *Life*, p. 165.

185. Letters from Twachtman to J. Alden Weir, January 2, 1885, and April 6, 1885; cited in Pyne, "John Twachtman and the Therapeutic Landscape," 53. Typescripts of these letters are owned by Ira Spanierman, New York.

186. On Twachtman's affinities with Chinese or Japanese Buddhist landscapes and Monet, see Pyne, 61–64. On Monet's intentions in the *nymphéas*, see Roger Marx, "Les 'Nymphéas' de M. Claude Monet," *Gazette des Beaux-Arts* 1 (June 1909): 529.

187. Pyne, "John Twachtman and the Therapeutic Landscape," 56–57, 64.

188. *New York Evening Post* (March 9, 1891): 7, cited in Hiesinger, p. 170; Isham and Cortissoz, *History of American Painting*, p. 587, also refer to Twachtman's flower studies as "ghostly."

189. *Boston Transcript* (1896); cited in Young, *Life and Letters*, p. 188; and *New York Times* (April 12, 1891): 12.

190. I thank Mary Baskett of Cincinnati, Ohio, for bringing to my attention Twachtman's marriage certificate, signed by John Goddard of the New Jerusalem Church in Cincinnati on April 21, 1881, and the fact that his wife, Martha Scudder, and her father were members of the Swedenborgian church. Pyne, "John Twachtman and the Therapeutic Landscape," 57–59, develops the parallels between the contemporary viewer response to Twachtman's landscapes and the practice of mind cure. Alfred Henry Goodwin, "An Artist's Unspoiled Country Home," *Country Life in America* 8 (October 1905): 628, noted that Twachtman owned Max Müller's translations of the great books of the East.

191. On Weir, Twachtman, and Robinson's involvement with Japanese prints in New York and Boston, see Robinson's Diary entries for October 31, 1893; November 30, 1893; December 10, 1893; January 6, 1894; and February 11, 1894; and Pyne, "John Twachtman and the Therapeutic Landscape," 68, n. 34.

192. For this understanding of the Japanese sensibility, see Weir's statement to the *New York Times* (January 9, 1898): 12.

193. Gerdts, *Masterworks of American Impressionism*, pp. 114, 116, 159.

194. D. Scott Atkinson, "Shinnecock and the Shinnecock Landscapes," in D. Scott Atkinson and Nicolai Cikovsky Jr., *William Merritt Chase: Summers at Shinnecock, 1891–1902* (Washington, D.C.: National Gallery of Art, 1987), p. 16.

195. Nicolai Cikovsky Jr., "Impressionism and Expression in the Shinnecock Landscapes: A Note," in *William Merritt Chase,* pp. 31–38.

196. Gerdts, *Masterworks of American Impressionism,* p. 98, also suggested this correlation of Chase's pleinairism to Boudin.

197. Guy Pène du Bois, "The Idyllic Optimism of J. Alden Weir. Living American Painters—Eleventh Article," *Arts and Decoration* 2 (December 1911): 55–57 and 78; Isham, 587.

198. Isham and Cortissoz, *History of American Painting,* p. 453.

199. Elizabeth de Veer, "Willard Metcalf: The Peacemaker of Old Lyme," *Art & Antiques* 4 (November/December 1981): 93; Richard J. Boyle, "The Art," in *Sunlight and Shadow,* pp. 225ff.

200. A son of spiritualists and a devotée of Emerson, Metcalf himself converted to spiritualist beliefs sometime in the late 1890s. De Veer, "Willard Metcalf: The Peacemaker of Old Lyme," 93–97; and "The Life," in *Sunlight and Shadow,* pp. 60, 75, 77, 151, and 153. On Inness's Swedenborgian beliefs, see Nicolai Cikovsky Jr., *The Life and Work of George Inness* (New York: Garland, 1977); and *George Inness* (New York: Praeger, 1971).

201. *Collector and Art Critic* 2 (January 1, 1900): 85; and "Art Exhibitions," *New York Daily Tribune* (December 16, 1899): 6; cited in Gerdts, *Masterworks of American Impressionism,* p. 124.

CONCLUSION

1. Avrich, *Haymarket Tragedy*; Rena Neumann Coen, *Painting and Sculpture in Minnesota: 1820–1914* (Minneapolis: Art Gallery, University of Minnesota, 1976), pp. 108–109; Annette Blaugrund et al., *Paris 1889: American Artists at the Universal Exposition* (New York: Abrams, 1989), pp. 179–181; and Patricia Hills, *The Painters' America: Rural and Urban Life, 1810–1910* (New York: Praeger Publishers, 1974), p. 123.

2. John Higham, "The Reorientation of American Culture in the 1890s," *The Origins of Modern Consciousness,* ed. John Weiss (Detroit: Wayne State University, 1965), pp. 38–47.

3. Letter of July 14, 1898; quoted in Nichols, "Familiar Letters," *McClure's Magazine* 31: 615.

4. My concepts of Turner's West as linking interior/exterior states with social spheres and the West as a Darwinian world of "apocalyptic nightmare" draw respectively on the papers of Heinz Ickstadt, "Transforming the Frontier: The Reinvention of the West in Late Nineteenth-Century Literature and Painting"; and Martin Christadler, "'Heavenly Cities in the West': Cathedral Rocks, Mountains, and Ruins of Time—Allegorizing American Landscape," at "Reinterpreting the American West: A German and American Dialogue," a symposium organized by the New York Historical Society and the National Museum of American Art, March 6, 1992.

5. Higham, "Reorientation," 38–39.

SELECT BIBLIOGRAPHY

Adams, Adeline. "The Secret of Life." *Art and Progress* 4 (April 1913): 925–932.

Adams, Henry. [Frances Snow Compton]. *Esther.* Intro. Robert E. Spiller. 1884. New York: Scholars' Facsimiles and Reprints, 1976.

———. *Mont-Saint-Michel and Chartres.* 1904. Cambridge, Mass.: The Riverside Press; Boston: Houghton Mifflin and Company, 1930.

Adams, Henry. *John La Farge, 1830–1870: From Amateur to Artist.* Ph.D. Diss., Yale University. Ann Arbor: University Microfilms, Inc., 1980.

———. "John La Farge's Discovery of Japanese Art: A New Perspective on the Origins of *Japonisme.*" *Art Bulletin* 67 (September 1985): 449–485.

———. "William James, Henry James, John La Farge, and the Foundations of Radical Empiricism." *American Art Journal* 17 (Winter 1985): 60–67.

Adams, Henry, et al. *John La Farge: Essays.* Pittsburgh and Washington, D.C.: The Carnegie Museum of Art and National Museum of American Art, Smithsonian Institution, 1987.

Alland, Alexander, Sr. *Jacob A. Riis, Photographer and Citizen.* New York: Aperture, 1974.

Allen, Gay Wilson. *William James: A Biography.* New York: Viking Press, 1967.

Arnold, Matthew. *Civilization in the United States: First and Last Impressions of America.* 1888. Boston: De Wolfe, Fiske, and Co., 1900.

———. *Culture and Anarchy.* 1869. In *The Portable Matthew Arnold,* pp. 469–573. Ed. Lionel Trilling. Middlesex: Penguin Books, 1980.

Atkinson, D. Scott, and Nicolai Cikovsky Jr. *William Merritt Chase: Summers at Shinnecock, 1891–1902*. Washington, D.C.: National Gallery of Art, 1987.

Avrich, Paul. *The Haymarket Tragedy*. Princeton: Princeton University Press, 1984.

Axelrod, Alan, ed. *The Colonial Revival in America*. New York: W. W. Norton, 1985.

Bacon, Henry. "Glimpses of Parisian Art." *Scribner's Monthly* 21 (December 1880): 169–181; 21 (January 1881): 423–431; and 21 (March 1881): 734–743.

Baker, Paul R. *Stanny: The Gilded Life of Stanford White*. New York: The Free Press; London: Macmillan, 1989.

Baltz, Trudy. "Pageantry and Mural Painting: Community Rituals in Allegorical Form." *Winterthur Portfolio* 15 (Autumn 1980): 211–228.

Banner, Lois W. *American Beauty*. New York: Knopf, 1983.

Bannister, Robert C. *Social Darwinism: Science and Myth in Anglo-American Social Thought*. Philadelphia: Temple University Press, 1979.

Banta, Martha. *Imaging American Women: Ideas and Ideals in Cultural History*. New York: Columbia University Press, 1987.

Baur, John I. H. *Theodore Robinson, 1852–1896*. Brooklyn: The Brooklyn Museum, 1946.

Beard, George M. *American Nervousness: Its Causes and Consequences*. New York: G. P. Putnam's Sons, 1881.

Bederman, Gail. *Manliness and Civilization: American Debates about Race and Gender, 1880–1917*. Chicago: University of Chicago Press, 1995.

Beer, Gillian. *Darwin's Plots: Evolutionary Narrative in Darwin, George Eliot, and Nineteenth-Century Fiction*. London: Routledge and Kegan Paul, 1983.

Bellomy, Donald C. "'Social Darwinism' Revisited." *Perspectives in American History* 1 (1984): 1–29.

Bender, Thomas. *Toward an Urban Vision: Ideas and Institutions in Nineteenth-Century America*. Lexington: University Press of Kentucky, 1975.

Bénédite, Léonce. "Artistes Contemporain: Whistler." *Gazette des Beaux-Arts* 33 (1905): 403–410, 496–511; 34 (1905): 142–158, 231–246.

Bercovitch, Sacvan. *The American Jeremiad*. Madison: University of Wisconsin Press, 1978.

———. *The Puritan Origins of the American Self*. New Haven: Yale University Press, 1975.

Berman, Milton. *John Fiske: The Evolution of a Popularizer*. Cambridge, Mass.: Harvard University Press, 1961.

Bermingham, Peter. *American Art in the Barbizon Mood.* Washington, D.C.: National Collection of the Fine Arts, Smithsonian Institution Press, 1975.

Betts, John Rickards. "Darwinism, Evolution, and American Catholic Thought, 1860–1900." *The Catholic Historical Review* 45 (July 1959): 161–185.

Bienenstock, Jennifer A. Martin. "Portraits of Flowers: The Out-of-Door Still-Life Paintings of Maria Oakey Dewing." *American Art Review* 4 (December 1977): 48–55, 114–118.

———. "The Rediscovery of Maria Oakey Dewing." *The Feminist Art Journal* 5 (Summer 1976): 24–27, 44.

Binyon, Laurence. *Painting in the Far East: An Introduction to the History of Pictorial Art in Asia, Especially China and Japan.* London: Edward Arnold, 1913.

Bloch, Ruth H. "Untangling the Roots of Modern Sex Roles: A Survey of Four Centuries of Change." *Signs* 4 (Winter 1978): 237–252.

Bogart, Michele H. "In Search of a United Front: American Architectural Sculpture at the Turn of the Century." *Winterthur Portfolio* 19 (Summer/ Autumn 1984): 151–176.

———. *Public Sculpture and the Civic Ideal in New York City, 1890–1930.* Chicago: University of Chicago Press, 1989.

Boller, Paul F. *American Thought in Transition: The Impact of Evolutionary Naturalism, 1865–1900.* Chicago: Rand McNally, 1969.

Boris, Eileen. *Art and Labor: Ruskin, Morris, and the Craftsman Ideal in America.* Philadelphia: Temple University Press, 1986.

Bourdieu, Pierre. *Distinction: A Social Critique of the Judgment of Taste.* 1979. Cambridge, Mass.: Harvard University Press, 1984.

———. "The Production of Belief: Contribution to an Economy of Symbolic Goods"; and "The Aristocracy of Culture." In *Media, Culture, and Society: A Critical Reader,* ed. Richard Collins et al., pp. 131–193. London: SAGE Publications, 1986.

———. "Social Space and Symbolic Power." *Sociological Theory* 7 (Spring 1989): 14–25.

Boyer, Paul. *Urban Masses and Moral Order in America, 1820–1920.* Cambridge, Mass.: Harvard University Press, 1978.

Boyle, Richard J. *American Impressionism.* Boston: New York Graphic Society, 1974.

———. *John Twachtman.* New York: Watson-Guptill Publications, 1979.

Brooks, Van Wyck. *New England: Indian Summer, 1865–1915.* New York: E. P. Dutton, 1940.

Broun, Elizabeth. "Thoughts That Began with the Gods: The Context of Whistler's Art." *Arts Magazine* 62 (October 1987): 36–43.

Brownell, W[illiam]. C. *French Art: Classic and Contemporary Painting and Sculpture*. 1892. New York: Charles Scribner's Sons, 1901.

———. "Whistler in Painting and Etching." *Scribner's Monthly* 18 (August 1879): 481–495.

———. "The Younger Painters of America." *Scribner's Monthly*, parts I and II, 20 (May and July 1880): 1–15, 321–335; and part III, 22 (July 1881): 321–334.

Buci-Glucksmann, Christine. "Catastrophic Utopia: The Feminine as Allegory of the Modern." *Representations* 14 (Spring 1986): 220–229.

Buell, Lawrence. *Literary Transcendentalism: Style and Vision in the American Renaissance*. Ithaca: Cornell University Press, 1973.

———. *New England Literary Culture: From Revolution through Renaissance*. Cambridge: Cambridge University Press, 1986.

Burg, David F. *Chicago's White City of 1893*. Lexington: University Press of Kentucky, 1976.

Burke, Doreen Bolger et al. *In Pursuit of Beauty: Americans and the Aesthetic Movement*. New York: Metropolitan Museum of Art/Rizzoli, 1986.

Burns, Sarah Lea. "Old Maverick to Old Master: Whistler in the Public Eye in Turn-of-the-Century America." *American Art Journal* 22 (1990): 28–49.

———. *The Poetic Mode in American Painting: George Fuller and Thomas Dewing*. Ph.D. Diss., University of Illinois at Urbana-Champaign. Ann Arbor: University Microfilms, Inc., 1979.

Burnside, Kathleen M. *Childe Hassam in Connecticut*. Greenwich, Conn.: Historical Society of the Town of Greenwich, 1987.

Burroughs, John. *Wake-Robin*. 1871. Boston: Houghton Mifflin and Company, 1913.

Caffin, Charles H. *American Masters of Painting: Being Brief Appreciations of Some American Painters*. New York: Doubleday, Page, and Co., 1902.

———. *Art for Life's Sake: An Application of the Principles of Art to the Ideals and Conduct of Individual and Collective Life*. New York: The Prang Company, 1913.

———. "The Art of Thomas W. Dewing." *Harper's Monthly Magazine* 116 (April 1908): 714–724.

———. *The Story of American Painting: The Evolution of Painting in America from Colonial Times to the Present*. New York: Charles Scribner's Sons, 1907.

Campbell, Pearl Howard. "Theodore Robinson: A Brief Historical Sketch." *Brush and Pencil* 4 (September 1899): 287–289.

Carman, Bliss. *The Kinship of Nature.* Boston: L. C. Page and Company, 1903.

Catalogue of a Portion of the Library of John La Farge. Anderson Auction Company, New York. March 24 and 25, 1909.

Catalogue of Mr. John Lafarge's Library. George A. Leavitt & Co. [New York]. January 17 and 18 [1881].

Catalogue of the Private Library of John La Farge, Esq. Leavitt, Strebeigh & Co., New York. December 18 and 19, 1866.

Catalogue of the Private Library of the late John La Farge. Merwin-Clayton Sales Company, New York. February 20, 21, and 23, 1911.

Child, Lydia M. "Resemblances between the Buddhist and the Roman Catholic Religions." *Atlantic Monthly* 26 (December 1870): 660–665.

Child, Theodore. "American Artists at the Paris Exhibition." *Harper's New Monthly Magazine* 79 (September 1889): 489–521.

———. "Impressionist Painting." *Art and Criticism: Monographs and Studies.* New York: Harper and Brothers, 1892. Also published as "A Note on Impressionist Painting." *Harper's New Monthly Magazine* 74 (January 1887): 313–315.

———. "The King of the 'Impressionists.'" *The Art Amateur* 14 (April 1886): 101–102.

———. "Salon of the Champ de Mars." *The Art Amateur* 25 (1891): 25.

———. "Some Modern French Painters." *Harper's New Monthly Magazine* 80 (May 1890): 817–842.

Chisolm, Lawrence W. *Fenollosa: The Far East and American Culture.* New Haven: Yale University Press, 1963.

Chotner, Deborah, Lisa N. Peters, and Kathleen A. Pyne. *John Twachtman: Connecticut Landscapes.* Washington, D.C.: National Gallery of Art, 1989.

Christy, Arthur. *The Orient in American Transcendentalism.* New York: Columbia University Press, 1932.

Cikovsky, Nicolai, Jr. *George Inness.* New York: Praeger, 1971.

———. *The Life and Work of George Inness.* New York: Garland, 1977.

Cikovsky, Nicolai, Jr., and Michael Quick. *George Inness.* Los Angeles: Los Angeles County Museum of Art, 1985.

A Circle of Friends: Art Colonies of Cornish and Dublin. Durham, N.H.: University Art Galleries, University of New Hampshire, 1985.

Ciucci, Giorgio, Francesco Dal Co, Mario Manieri-Elia, and Manfredo

Tafuri. *The American City: From the Civil War to the New Deal.* Cambridge, Mass.: The MIT Press, 1979.

Clark, Eliot. "The Art of John Twachtman." *The International Studio* 72 (January 1921): 77–86.

———. *John Twachtman.* New York: Privately printed, 1924.

———. "Theodore Robinson: A Pioneer American Impressionist (The Field of Art)." *Scribner's Magazine* 70 (December 1921): 763–768.

———. *Theodore Robinson: His Life and Art.* Chicago: R. H. Love Galleries, Inc., 1979.

Clarke, James Freeman. *Self-Culture: Physical, Intellectual, Moral, and Spiritual.* New York: James R. Osgood and Company, 1880.

"Claude Monet." *The Collector* 2 (February 15, 1891): 91.

"Claude Monet (The Field of Art)." *Scribner's Magazine* 19 (January 1896): 125.

"Colored Shadows (The Field of Art)." *Scribner's Magazine* 19 (April 1896): 522.

Connecticut and American Impressionism. Storrs, Conn.: The William Benton Museum of Art, University of Connecticut, 1980.

Cook, Clarence. *Art and Artists of Our Time.* 3 vols. New York: Selmar Hess, 1888.

———. "The Impressionist Pictures; the Art-Association Galleries." *The Studio* 1 (April 17, 1886): 245–254.

Corn, Wanda M. *The Color of Mood: American Tonalism, 1880–1910.* San Francisco: M. H. DeYoung Memorial Museum and the California Palace of the Legion of Honor, 1972.

———. "The New New York." *Art in America* 61 (July–August 1973): 58–65.

Corn, Wanda, and John Wilmerding. "The United States." In *Post-Impressionism: Cross-Currents in European and American Painting, 1880–1906,* pp. 219–240. Washington, D.C.: National Gallery of Art, 1980.

Cortissoz, Royal. "An American Artist Canonized in the Freer Gallery." *Scribner's Magazine* 74 (July–December 1923): 539–546.

———. *American Artists.* New York: Charles Scribner's Sons, 1923.

———. "Egotism in Contemporary Art." *Atlantic Monthly* 73 (May 1894): 644–652.

———. *John La Farge: A Memoir and a Study.* Boston: Houghton Mifflin and Company, 1911.

———. Papers. Beinecke Rare Book and Manuscript Library, Yale University Library.

―――. "Some Imaginative Types in American Art." *Harper's New Monthly Magazine* 91 (July 1895): 165–179.

Cott, Nancy F. "Passionlessness: An Interpretation of Victorian Sexual Ideology, 1790–1850." *Signs* 4 (Winter 1978): 219–236.

Cournos, John. "John Twachtman." *The Forum* 52 (August 1914): 245–248.

Cox, Kenyon. *The Classic Point of View.* 1911. New York: W. W. Norton, 1980.

―――. [K. K.]. "An Out-Door Masque in New England." *The Nation* 80 (June 29, 1905): 519–520.

―――. "The Recent Work of Edmund C. Tarbell." *Burlington Magazine* 14 (January 1909): 254–260.

Craig, Anne Throop. "The Poetic Theme in the Modern Pageant." *Forum* 54 (September 1915): 349–355.

Craven, David. "Ruskin vs. Whistler: The Case Against Capitalist Art." *Art Journal* 37 (Winter 1977/78): 139–143.

Curry, David Park. *James McNeill Whistler at the Freer Gallery of Art.* New York: Freer Gallery of Art, Smithsonian Institution, in association with W. W. Norton, 1984.

Darwin, Charles. *The Descent of Man and Selection in Relation to Sex.* London: J. Murray, 1874.

―――. *On the Origin of Species.* 1859. Ed. J. W. Burrow. Middlesex: Penguin Books, 1970.

Degler, Carl N. *In Search of Human Nature: The Decline and Revival of Darwinism in American Social Thought.* New York: Oxford University Press, 1991.

De Kay, Charles. "The Ceiling of a Café." *Harper's Weekly* 36 (March 1892): 257–258.

―――. "French and American Impressionists." *New York Times* (January 31, 1904): 23.

―――. "John H. Twachtman." *Arts and Decoration* 9 (June 1918): 73–76, 112.

―――. "Mr. Chase and Central Park." *Harper's Weekly* 35 (May 1891): 327–328.

―――. "Whistler: The Head of the Impressionists." *The Art Review* 1 (November 1886): 1–3.

De Veer, Elizabeth. "Willard Metcalf: The Peacemaker of Old Lyme." *Art & Antiques* 4 (November/December 1981): 93.

De Veer, Elizabeth, and Richard J. Boyle. *Sunlight and Shadow: The Life and*

Art of Willard L. Metcalf. New York: Boston University/Abbeville, 1987.

Dewing, Maria Richards Oakey. "Abbott Thayer—A Portrait and an Appreciation." *International Studio* 74 (August 1921): 6–14.

———. *Beauty in Dress.* New York: Harper and Brothers, 1881.

———. *Beauty in the Household.* New York: Harper and Brothers, 1882.

Dewing, Thomas Wilmer. Letters to Charles Lang Freer. Freer Gallery of Art Archives, Smithsonian Institution.

Dewing, Thomas Wilmer, and Maria Oakey. Papers and photographs. Archives of American Art, Smithsonian Institution, microfilms D22, 1818, 2077, 2083, and 2803.

Dictionary of American Biography. Vols. 1–21. Ed. Allen Johnson and Dumas Malone. New York: Charles Scribner's Sons, 1928–1958.

DiMaggio, Paul. "Cultural Entrepreneurship in Nineteenth-Century Boston: The Creation of an Organizational Base for High Culture in America." In *Media, Culture, and Society: A Critical Reader,* ed. Richard Collins et al., pp. 194–211. London: SAGE Publications, 1986.

Dobriansky, Ley E. *Veblenism: A New Critique.* Washington, D.C.: Public Affairs Press, 1957.

Dodd, Anna Bowman. "John La Farge." *The Art Journal* (London) 47 (1886): 261–264.

Douglas, Ann. *The Feminization of American Culture.* New York: Knopf, 1977.

Downes, William Howe. "Boston Painters and Paintings." *Atlantic Monthly* 62 (December 1888): 777–786.

———. "Impressionism in Painting." *New England Magazine* 6 (July 1892): 600–603.

———. "Whistler and His Work." *National Magazine* 20 (April 1904): 15.

Dubofsky, Melvyn. *Industrialism and the American Worker, 1865–1920.* Arlington Heights, Ill.: Harlan Davidson, Inc., 1985.

Du Bois, Guy Pène. "The French Impressionists and Their Place in Art." *Arts and Decoration* 4 (January 1914): 101–105.

———. "The Idyllic Optimism of J. Alden Weir [Living American Painters—Eleventh Article]." *Arts and Decoration* 2 (December 1911): 55–57, 78.

Duncan, Frances. "An Artist's New Hampshire Garden." *Country Life in America* 11 (March 1907): 516–520, 554, and 556.

———. "The Gardens of Cornish." *The Century Magazine* 72 (May 1906): 3–19.

Dyos, H. J., and Michael Wolff, eds. *The Victorian City: Images and Realities.* Vol. 2. London and Boston: Routledge and Kegan Paul, 1973.

Eddy, Arthur J. *Recollections and Impressions of James A. McNeill Whistler.* Philadelphia: J. B. Lippincott Company, 1903.

Eldredge, Charles C. *American Imagination and Symbolist Painting.* New York: New York University, Grey Art Gallery and Study Center, 1979.

———. "Nature Symbolized: American Painting from Ryder to Hartley." In *The Spiritual in Art: Abstract Painting, 1890–1985,* by Maurice Tuchman, pp. 113–130. New York: Abbeville, 1986.

Eliot, Charles William. *American Contributions to Civilization and Other Essays and Addresses.* New York: The Century Company, 1897.

———. "Emerson as Seer." *Atlantic Monthly* 91 (June 1903): 844–855.

Elliott, Maud H. *John Elliott: The Story of an Artist.* Boston: Houghton Mifflin and Company; Cambridge, Mass.: The Riverside Press, 1930.

Ely, Catherine Beach. "Thomas W. Dewing." *Art in America* 10 (August 1922): 224–229.

———. "Willard Metcalf." *Art in America* 13 (1925): 332–336.

Farley, James L. "The Cornish Colony." *Dartmouth College Library Bulletin* 14 (November 1973): 6–17.

Fenollosa, Ernest. "Chinese and Japanese Traits." *Atlantic Monthly* 69 (June 1892): 769–774.

———. "The Collection of Mr. Charles L. Freer." *Pacific Era* 1 (November 1907): 57–66.

———. "The Coming Fusion of East and West." *Harper's New Monthly Magazine* 98 (December 1898): 115–122.

———. "Contemporary Japanese Art." *The Century Magazine* 46 (August 1893): 577–581.

———. *East and West: The Discovery of America and Other Poems.* New York: Thomas Y. Crowell, 1893.

———. "The Place in History of Mr. Whistler's Art." *Lotus: In Memoriam: James McNeill Whistler* (Special Holiday Number, December 1903): 14–17; and *Lotos* 9 (1896): 581.

———, "The Significance of Oriental Art." *The Knight Errant* 1 (1892): 65–70.

Finberg, A. J. "Mr. Whistler and Artistic Solipsism." *The Athenaeum* (August 8, 1903): 198.

Fink, Lois Marie. *American Art at the Nineteenth-Century Paris Salons.* Cambridge: Cambridge University Press, 1990.

———. "The Innovation of Tradition in Late Nineteenth-Century American Art." *American Art Journal* 10 (November 1978): 63–71.

———. "19th Century Evolutionary Art." *American Art Review* 4 (January 1978): 74–81, 105–109.

Fiske, John. "Manifest Destiny." *Harper's New Monthly Magazine* 70 (March 1885): 578–590.

———. *Studies in Religion, Being The Destiny of Man; The Idea of God; Through Nature to God; Life Everlasting.* Boston: Houghton Mifflin and Company, 1902.

FitzGerald, Desmond. "Claude Monet—Master of Impressionism." *Brush and Pencil* 15 (March 1905): 181–195.

Foster, Kathleen A. "The Still-Life Painting of John La Farge." *American Art Journal* 11 (July 1979): 5–37.

Freer Gallery of Art Archives, Smithsonian Institution, Charles Lang Freer. Correspondence, 1876; 1886–1920.

———. Charles Lang Freer. Diaries. 1889–1890; 1892–1898; 1900–1919.

———. Letter from James McNeill Whistler to Anna McNeill Whistler, c. 1880.

———. Letterpress Books. March of 1892 to March of 1910.

———. Press Cuttings Books.

"French and American Impressionists." *The Art Amateur* 29 (June 1893): 4.

"The French Impressionists (The Fine Arts)." *The Critic* 5 (April 7, 1886): 195–196.

Fried, Michael. *Absorption and Theatricality: Painting and Beholder in the Age of Diderot.* Berkeley: University of California Press, 1980.

———. *Courbet's Realism.* Chicago: University of Chicago Press, 1990.

Fuller, Lucia Fairchild. Papers. Archives of American Art, Smithsonian Institution, microfilm 3825.

Gaehtgens, Thomas, ed. *Bilder aus der neuen Welt: Amerikanische Malerei des 18. und 19. Jahrhunderts.* Munich: Prestel-Verlag, 1988.

Garczynski, Edward Rudolf. "Jugglery in Art." *The Forum* 1 (August 1886): 592–602.

Gardner, Isabella Stewart. Papers. Archives of American Art, Smithsonian Institution, microfilm 401.

Garland, Hamlin. *Crumbling Idols: Twelve Essays on Art Dealing Chiefly with Literature, Painting, and the Drama.* Ed. Jane Johnson. 1894. Cambridge, Mass.: The Belknap Press of Harvard University Press, 1960.

———. "Theodore Robinson." *Brush and Pencil* 4 (September 1899): 285–286.

Gerdts, William H. *American Impressionism.* Seattle: Henry Art Gallery, University of Washington, 1980.

———. *American Impressionism.* New York: Abbeville, 1984.

———. *Masterworks of American Impressionism.* Einsiedeln, Switzerland: Karl-Ulrich Majer, Eidolon AG, 1990.

Gilder, Richard Watson, and Helena de Kay. Papers. Archives of American Art, Smithsonian Institution, microfilm 285.

Gillespie, Neal C. *Charles Darwin and the Problem of Creation.* Chicago: University of Chicago Press, 1979.

Glassberg, David. *American Historical Pageantry: The Uses of Tradition in the Early Twentieth Century.* Chapel Hill: University of North Carolina Press, 1990.

Glick, Thomas F., ed. *The Comparative Reception of Darwinism.* Austin: University of Texas Press, 1974.

Goley, Mary Anne. *John White Alexander (1856–1915).* Washington, D.C.: National Collection of Fine Arts, Smithsonian Institution, 1976.

Goodwin, Alfred Henry. "An Artist's Unspoiled Country Home." *Country Life in America* 8 (October 1905): 625–630.

Gosling, F. G. *Before Freud: Neurasthenia and the American Medical Community, 1870–1910.* Urbana: University of Illinois Press, 1987.

Green, Harvey. "Popular Science and Political Thought Converge: Colonial Survival Becomes Colonial Revival, 1830–1910." *Journal of American Culture* 6 (Winter 1983): 3–24.

Greta. "Art in Boston: The Wave of Impressionism." *The Art Amateur* 24 (May 1891): 141.

Grieve, Alastair. "Whistler and the Pre-Raphaelites." *The Art Quarterly* 34 (1971): 219–228.

Grimes, Frances. "The Reminiscences of Frances Grimes." Papers of Augustus Saint-Gaudens. Dartmouth College Library, microfilm 3565r #36.

Habermas, Jürgen. "Modernity versus Postmodernity." *New German Critique* 22 (Winter 1981): 3–17.

Halbwachs, Maurice. *The Collective Memory.* Trans. Francis J. Ditter Jr. and Vida Yazdi Ditter. New York: Harper Colophon Books, 1980.

Hale, John Douglass. *The Life and Creative Development of John H. Twachtman.* Ph.D. Diss., Ohio State University. Ann Arbor: University Microfilms, Inc., 1957.

Hales, Peter B. *Silver Cities: The Photography of Urbanization, 1839–1915.* Philadelphia: Temple University Press, 1984.

Hamilton, Luther. "The Work of the Paris Impressionists in New York." *The Cosmopolitan* 1 (June 1886): 240–242.

Harrison, Birge. *Landscape Painting.* 1909. New York: Charles Scribner's Sons, 1911.

Harrison, Irving B. "On Freud's View of the Infant-Mother Relationship and of the Oceanic Feeling—Some Subjective Influences." *Journal of the*

American Psychoanalytic Association 27 (1979): 399–421.

———. "On the Maternal Origins of Awe." *The Psychoanalytic Study of the Child* 30 (1975): 181–195.

Hart, Albert Bushnell. "Is the Puritan Race Dying Out?" *Munsey's Magazine* 45 (1911): 252–255.

Hartmann, Sadakichi. "On the Elongation of Form." *Camera Work* 10 (April 1905): 27–35.

———. *A History of American Art.* 2 vols. Boston: L. C. Page and Company, 1902.

———. *My Theory of Soul-Atoms.* New York: The Stylus Publishing Company, 1910.

———. "Thomas W. Dewing." *The Art Critic* (Boston) 1 (January 1894): 34–36.

———. *The Valiant Knights of Daguerre.* Ed. Harry W. Lawton and George Knox. Berkeley: University of California Press, 1978.

Hayward, Mary Ellen. "The Influence of the Classical Oriental Tradition on American Painting." *Winterthur Portfolio* 14 (Summer 1979): 107–142.

Hearn, Lafcadio. *Gleanings in Buddha-Fields: Studies of Hand and Soul in the Far East.* Boston: Houghton Mifflin and Company, 1897.

———. *Glimpses of Unfamiliar Japan.* Boston: Houghton Mifflin and Company, 1894.

———. *Kokoro: Hints and Echoes of Japanese Inner Life.* Boston: Houghton Mifflin and Company, 1896.

Hewison, Robert. *John Ruskin: The Argument of the Eye.* London: Thames and Hudson, 1976.

Hiesinger, Ulrich W. *Impressionism in America: The Ten American Painters.* Munich: Prestel-Verlag, 1991.

Higham, John. "The Reorientation of American Culture in the 1890's." In *The Origins of Modern Consciousness,* ed. John Weiss, pp. 25–48. Detroit: Wayne State University Press, 1965.

———. *Strangers in the Land: Patterns of American Nativism, 1860–1925.* New York: Athenaeum, 1965.

Hills, Patricia. *Turn-of-the-Century America: Paintings, Graphics, and Photographs, 1890–1910.* New York: Whitney Museum of American Art, 1977.

Hobbs, Susan. "A Connoisseur's Vision: The American Collection of Charles Lang Freer." *American Art Review* 4 (August 1977): 76–101.

———. "Thomas Dewing in Cornish, 1885–1905." *American Art Journal* 17 (Spring 1985): 2–32.

———. "Thomas Wilmer Dewing: The Early Years, 1851–1885." *American Art Journal* 13 (Spring 1981): 4–35.

Hodge, Charles. *What Is Darwinism?* New York: Scribner, Armstrong & Co., 1874.

Hofstadter, Richard. *Social Darwinism in American Thought, 1860–1915.* Philadelphia: University of Pennsylvania Press, 1945.

Hollinger, David A. *In the American Province: Studies in the History and Historiography of Ideas.* Bloomington: Indiana University Press, 1985.

———. "What Is Darwinism? It Is Calvinism!" *Reviews in American History* 8 (March 1980): 80–85.

Homer, William Innes. *Alfred Stieglitz and the American Avant-Garde.* Boston: New York Graphics Society, 1977.

———. *Robert Henri and His Circle.* Ithaca: Cornell University Press, 1969.

Hooper, Lucy H. "Art-Notes from Paris." *The Art Journal* (New York) 6 (1880): 188–190.

Horsman, Reginald. *Race and Manifest Destiny: The Origins of American Racial Anglo-Saxonism.* Cambridge, Mass.: Harvard University Press, 1981.

Hudson, Thomson Jay. *The Evolution of the Soul and Other Essays.* Chicago: A. C. McClurg and Company, 1904.

———. *The Law of Psychic Phenomena: A Working Hypothesis for the Systematic Study of Hypnotism, Spiritism, Mental Therapeutics, Etc.* Chicago: A. C. McClurg and Company, 1893.

Hutchison, William R. *The Modernist Impulse in American Protestantism.* Cambridge, Mass.: Harvard University Press, 1976.

———. "To Heaven in a Swing: The Transcendentalism of Cyrus Bartol." *Harvard Theological Review* 56 (October 1963): 275–295.

Huth, Hans. "Impressionism Comes to America." *Gazette des Beaux-Arts* 29 (April 1946): 225–252.

"Impressionism and Impressions." *The Collector* 4 (May 15, 1893): 213–214.

"The Impressionist Exhibition." *The Art Amateur* 14 (May 1886): 121; 15 (June 1886): 4.

"The Impressionists." *The Art Age* 3 (April 1886): 165–166.

"The Impressionists." *The Art Amateur* 30 (March 1894): 99.

"The Impressionists." *The Art Interchange* 29 (July 1892): 1–7.

"The Impressionists' Exhibition at the American Art Galleries." *The Art Interchange* 16 (April 24, 1886): 130–131.

Isham, Samuel. *The History of American Painting.* New ed. with supplemental chapters by Royal Cortissoz. 1905. New York: The Macmillan Company, 1927.

Ives, A. E. "Talks with Artists: Mr. Childe Hassam on Painting Street Scenes." *The Art Amateur* 27 (October 1892): 117.

Jackson, Carl T. "The New Thought Movement and the Nineteenth-Century Discovery of Oriental Philosophy." *Journal of Popular Culture* 9 (Winter 1975): 523–548.

———. *The Oriental Religions and American Thought: Nineteenth-Century Explorations.* Westport, Conn.: Greenwood Press, 1981.

James, Henry. *The American Scene.* London: Chapman and Hall, 1907.

———. *The Painter's Eye: Notes and Essays on the Pictorial Arts.* Ed. with an introduction by John L. Sweeney. Cambridge, Mass.: Harvard University Press, 1956.

James McNeill Whistler: A Re-Examination. Center for Advanced Studies in the Visual Arts Symposium Papers VI. Studies in the History of Art 19. Washington, D.C.: National Gallery of Art, 1987.

James, William. "The Gospel of Relaxation." *Scribner's Monthly* 25 (April 1899): 499–507.

———. "The Hidden Self." *Scribner's Magazine* 7 (March 1890): 361–373.

———. *The Varieties of Religious Experience: A Study in Human Nature.* Intro. by Reinhold Niebuhr. New York: Collier Books, 1961.

———. *The Will to Believe and Other Essays in Popular Philosophy; Human Immortality: Two Supposed Objections to the Doctrine.* New York: Dover Publications, 1956.

Jameson, Fredric. *The Political Unconscious.* Ithaca: Cornell University Press, 1981.

Jarves, James Jackson. *The Art-Idea: Sculpture, Painting, and Architecture in America.* New York: Hurd and Houghton, 1865.

———. "Art of the Whistler Sort." *New York Times* (January 12, 1879): 10e–f.

Jenkyns, Richard. *The Victorians and Ancient Greece.* Cambridge, Mass.: Harvard University Press, 1980.

Jerrold, Blanchard. *London: A Pilgrimage.* London: Grant and Company, 1872.

Johnson, Lee McKay. *The Metaphor of Painting: Essays on Baudelaire, Ruskin, Proust, and Pater.* Ann Arbor: University Microfilms, Inc., 1980.

Johnson, Ronald W. "Whistler's Musical Modes: Symbolist Symphonies, Numinous Nocturnes." *Arts Magazine* 55 (April 1981): 164–176.

Johnston, Sona. *Theodore Robinson, 1852–1896.* Baltimore: The Baltimore Museum of Art, 1973.

Jones, Howard Mumford. *The Age of Energy: Varieties of American Experience, 1865–1915.* New York: Viking Press, 1971.

Jordanova, Ludmilla. *Sexual Visions: Images of Gender in Science and Medi-*

cine between the Eighteenth and Twentieth Centuries. Madison: University of Wisconsin Press, 1989.

Katz, Ruth Berenson. "John La Farge, Art Critic." *Art Bulletin* 33 (June 1951): 105–118.

Kermode, Frank. *The Romantic Image.* New York: The Macmillan Company, 1957.

Kimmel, Michael S. "The Contemporary 'Crisis' of Masculinity in Historical Perspective." In *The Making of Masculinities,* ed. Harry Brod, pp. 121–153. Boston: Allen & Unwin, 1989.

Kleinfield, H. L. "The Structure of Emerson's Death." In *Ralph Waldo Emerson: A Profile,* ed. Carl Bode, pp. 175–199. New York: Hill and Wang, 1969.

Koehler, Sylvester R. *American Art.* New York: Cassell and Company, Limited, 1886.

———. Papers. Archives of American Art, Smithsonian Institution, microfilm D184.

Kofman, Sarah. *The Enigma of Woman: Woman in Freud's Writings.* Trans. Katherine Porter. Ithaca: Cornell University Press, 1985.

Kuhn, Thomas S. *The Structure of Scientific Revolutions.* Chicago: University of Chicago Press, 1970.

Kuklick, Bruce. *The Rise of American Philosophy: Cambridge, Massachusetts, 1860–1930.* New Haven: Yale University Press, 1977.

La Farge, Henry. "John La Farge's Work in the Vanderbilt Houses." *American Art Journal* 16 (Autumn 1984): 30–70.

La Farge, John. *An Artist's Letters from Japan.* New York: The Century Company, 1897. First published in installments in *The Century Magazine* (February 1890–August 1893).

———. *Considerations on Painting: Lectures Given in the Year 1893 at the Metropolitan Museum of New York.* 1895. New York: The Macmillan Company, 1908.

———. *The Higher Life in Art.* New York: The McClure Company, 1908.

———. "Mr. La Farge on Useless Art." *Architectural Record* 17 (April 1905): 346.

La Farge, John, S. J. "The Mind of John La Farge." *Catholic World* 140 (March 1935): 701–710.

———. *The Manner Is Ordinary.* New York: Harcourt, Brace & Co., 1954.

Lamont, Michèle, and Annette Lareau. "Cultural Capital: Allusions, Gaps, and Glissandos in Recent Theoretical Developments." *Sociological Theory* 6 (Fall 1988): 153–168.

Lathrop, George Parsons. "John La Farge." *Scribner's Monthly* 21 (February 1881): 503–516.

Lawton, Thomas, and Linda Merrill, *Freer: A Legacy of Art.* Washington, D.C.: Freer Gallery of Art, Smithsonian Institution; New York: Abrams, 1993.

Leader, Bernice Kramer. "Antifeminism in the Paintings of the Boston School." *Arts Magazine* 56 (January 1982): 112–119.

Lears, T. J. Jackson. "The Concept of Cultural Hegemony: Problems and Possibilities." *American Historical Review* 90 (June 1985): 567–593.

———. *No Place of Grace: Antimodernism and the Transformation of American Culture, 1880–1920.* New York: Pantheon Books, 1981.

Le Conte, Joseph. *Evolution: Its Nature, Its Evidences, and Its Relation to Religious Thought.* 1888. Revised ed. New York: G. Appleton and Company, 1891.

Lejeune, L. "The Impressionist School of Painting." *Lippincott's Magazine of Popular Literature and Science* 24 (December 1879): 720–727.

Lightman, Bernard. *The Origins of Agnosticism: Victorian Unbelief and the Limits of Knowledge.* Baltimore: The Johns Hopkins University Press, 1987.

Lindberg, David C., and Ronald L. Numbers, eds. *God and Nature: Historical Essays on the Encounter between Christianity and Science.* Berkeley: University of California Press, 1986.

Littell, Philip. "A Look at Cornish." *The Independent* 74 (June 5, 1913): 1297–1298.

Lochnan, Katharine A. *The Etchings of James McNeill Whistler.* New Haven: Yale University Press, in association with the Art Gallery of Ontario, 1984.

Lockman, DeWitt McClellan. Papers. Archives of American Art, Smithsonian Institution, microfilms 502 and 504.

Loughery, John. "Charles Caffin and Willard Huntington Wright, Advocates of Modern Art." *Arts Magazine* 59 (January 1985): 103–109.

Lovejoy, A. O. *The Great Chain of Being: A Study of the History of an Idea.* New York: Harper and Row, 1960.

Low, Will H. *A Chronicle of Friendships, 1873–1900.* New York: Charles Scribner's Sons, 1910.

Lyczko, Judith Elizabeth. "Thomas Wilmer Dewing's Sources: Women in Interiors." *Arts Magazine* 54 (November 1979): 152–157.

Mabie, Hamilton Wright. *Essays on Nature and Culture.* New York: Dodd, Mead, and Company, 1896.

———. "Ralph Waldo Emerson in 1903." *Harper's New Monthly Magazine* 106 (May 1903): 903–908.

Macbeth Gallery. Papers. Archives of American Art, Smithsonian Institution, microfilm NMc 42.

Mac Cormack, Carol P., and Marilyn Strathern, eds. *Nature, Culture, and Gender.* Cambridge: Cambridge University Press, 1980.

MacDonald, Greville. *George MacDonald and His Wife.* London: George Allen and Unwin, Limited, 1924.

MacDonald, Margaret F. "Whistler: The Painting of the 'Mother.'" *Gazette des Beaux-Arts* 85 (February 1975): 73–88.

MacKaye, Percy. "American Pageants and Their Promise." *Scribner's Magazine* 46 (July 1909): 28–35.

———. *The Civic Theatre in Relation to the Redemption of Leisure: A Book of Suggestions.* New York: Mitchell Kennerly, 1912.

Marsh, Margaret. "Suburban Men and Masculine Domesticity, 1870–1915." *American Quarterly* 40 (June 1988): 165–186.

Mase, Carolyn C. "John H. Twachtman." *The International Studio* 72 (January 1921): 71–75.

Mathews, F. Schuyler. *Field Book of Wild Birds and Their Music: A Description of the Character and Music of Birds, Intended to Assist in the Identification of Species Common in the United States East of the Rocky Mountains.* 1904. New York: G. P. Putnam's Sons, 1921.

Mattick, Paul, Jr. "The Beautiful and Sublime: Gender Totemism in the Constitution of Art." *Journal of Aesthetics and Art Criticism* 48 (Fall 1990): 293–303.

Mauclair, Camille. [Camille L. C. Fausti]. "James Whistler et le Mystère dans la peinture." *Revue Politique et Littéraire: Revue Bleue* 20 (October 3, 1903): 440–444.

May, Henry F. *The End of American Innocence: A Study of the First Years of Our Own Time, 1912–1917.* Chicago: Quadrangle Paperbacks, 1964.

Mayhew, Henry. *Mayhew's London: Being Selections from "London and the London Poor."* 1851; London: Spring Books, 1951.

Meinig, D. W. "Symbolic Landscapes: Models of American Community." In *The Interpretation of Ordinary Landscapes: Geographical Essays,* ed. D. W. Meinig, pp. 164–194. New York: Oxford University Press, 1979.

———, ed. *The Interpretation of Ordinary Landscapes: Geographical Essays.* New York: Oxford University Press, 1979.

Meixner, Laura. *An International Episode: Millet, Monet, and Their North American Counterparts.* Memphis, Tenn.: The Dixon Gallery and Gardens, 1982.

Merrill, Linda. *An Ideal Country: Paintings by Dwight William Tryon in the Freer Gallery of Art.* Washington, D.C.: Freer Gallery of Art, Smithsonian Institution, 1990.

———. *A Pot of Paint: Aesthetics on Trial in Whistler v Ruskin.* Washington: Smithsonian Institution Press, 1992.

Meyer, Agnes E. *Charles Lang Freer and His Gallery.* Washington, D.C.: Freer Gallery of Art, 1970.

———. "The Charles L. Freer Collection." *The Arts* 12 (August 1927): 65–82.

Meyer, D. H. "American Intellectuals and the Victorian Crisis of Faith." *American Quarterly* 27 (December 1975): 584–603.

Meyer, Donald. *The Positive Thinkers: Religion as Pop Psychology from Mary Baker Eddy to Oral Roberts.* New York: Pantheon Books, 1980.

Michael, Helen Abbott. [Celen Sabbrin]. *Science and Philosophy in Art.* Philadelphia: William F. Fell, 1886.

———. *Studies in Plant and Organic Chemistry and Literary Papers.* Cambridge, Mass.: The Riverside Press, 1907.

Monroe, Lucy. "Chicago Letter." *The Critic* 22 (May 27, 1893): 351.

Moore, George. *Modern Painting.* 1893. New York: Carra, 1923.

Moore, James R. *The Post-Darwinian Controversies: A Study of the Protestant Struggle to Come to Terms with Darwin in Great Britain and America, 1870–1900.* Cambridge: Cambridge University Press, 1979.

Moore, R. Laurence. *In Search of White Crows: Spiritualism, Parapsychology, and American Culture.* New York: Oxford University Press, 1977.

Morgan, Keith N. *Charles A. Platt: The Artist as Architect.* Cambridge, Mass.: The MIT Press; New York: The Architectural History Foundation, 1985.

———. "Charles A. Platt's Houses and Gardens in Cornish, New Hampshire." *Antiques* 112 (July 1982): 117–129.

Mulford, Prentice. *Your Forces, and How to Use Them.* New York: Red Cross Knight Library, c. 1889–1891.

Mumford, Lewis. *The Brown Decades: A Study of the Arts in America, 1865–1895.* 1931. New York: Dover Publications, 1955.

Mussulman, Joseph A. *Music in the Cultured Generation: A Social History of Music in America, 1870–1900.* Evanston, Ill.: Northwestern University Press, 1971.

Muther, Richard. *The History of Modern Painting.* 3 vols. London: Henry and Company, 1895–1896.

Nadel, Ira Bruce, and F. S. Schwarzbach. *Victorian Artists and the City: A Collection of Critical Essays.* New York: Pergamon Press, 1980.

National Cyclopaedia of American Biography. New York: James T. White and Company, 1897–1956.

Nead, Lynn. "Representation, Sexuality, and the Female Nude." *Art History* 6 (1983): 227–236.

Neumann, Erich. *The Great Mother: An Analysis of the Archetype.* Trans. Ralph Manheim. New York: Pantheon Books; Bollingen Series XLVII, 1963.

Newton, Joy, and Margaret F. MacDonald. "Whistler: Search for a European Reputation." *Zeitschrift für Kunstgeschichte* 41 (1978): 148–159.

Nichols, Rose Standish. "Familiar Letters of Augustus Saint-Gaudens." *McClure's Magazine* 31 (October 1908): 603–616; 32 (November 1908): 1–16.

Nochlin, Linda. "Seeing Through Women." *Woman.* Evanston, Ill.: Terra Museum of American Art, 1984.

Norton, Charles Eliot. "The Lack of Old Homes in America." *Scribner's Magazine* 5 (May 1889): 636–640.

O'Brien, Maureen C. *In Support of Liberty: European Paintings at the 1883 Pedestal Fund Art Loan Exhibition.* Southampton, N.Y.: The Parrish Art Museum, 1986.

O'Neill, William L. *Everyone Was Brave: A History of Feminism in America.* New York: Quadrangle—The New York Times Book Co., 1976.

O'Toole, Patricia. *The Five of Hearts: An Intimate Portrait of Henry Adams and His Friends, 1880–1918.* New York: Clarkson Potter Publishers, 1990.

Oakey, Alexander F. *The Art of Life and the Life of Art.* Harper's Franklin Square Library, no. 408, 1881. New York: Harper and Brothers, 1884.

———. "A Trial Balance of Decoration." *Harper's New Monthly Magazine* 64 (April 1882): 734–740.

Okakura, Kakuzo. *The Book of Tea.* 1906. New York: Duffield and Green, 1932.

———. *The Ideals of the East, with Special Reference to the Art of Japan.* London: John Murray, 1903.

———. *Okakura Kakuzo: Collected English Writings.* Tokyo: Heibonsha Limited, Publishers, 1984.

Olmstead, John Charles, ed. *Victorian Painting: Essays and Reviews; Vol. Three: 1861–1880.* New York: Garland, 1985.

Oppenheim, Janet. *The Other World: Spiritualism and Psychical Research in England, 1850–1914.* Cambridge: Cambridge University Press, 1985.

Parker, Gail Thain. *Mind Cure in New England from the Civil War to World War I.* Hanover, N.H.: University Presses of New England, 1973.

Parry, Albert. *Whistler's Father.* Indianapolis: The Bobbs-Merrill Company, Inc., 1939.

Pater, Walter. *The Renaissance: Studies in Art and Poetry. The 1893 Text.* Ed. Donald L. Hill. Berkeley: University of California Press, 1980.

Peel, J. D. Y. *Herbert Spencer: The Evolution of a Sociologist.* New York: Basic Books, 1971.

Pennell, E. R., and J. Pennell. *The Life of James McNeill Whistler.* Rev. 6th ed. Philadelphia: J. B. Lippincott Company, 1919.

———. *The Whistler Journal.* Philadelphia: J. B. Lippincott Company, 1921.

———. The Pennell-Whistler Collection of the Papers of Joseph Pennell, Elizabeth Robins Pennell, and James A. McNeill Whistler, Manuscripts Division, Library of Congress.

Pennell, Joseph. *The Graphic Arts: Modern Men and Modern Methods.* Chicago: University of Chicago Press, 1921.

Peters, Alfred H. "The Extinction of Leisure." *The Forum* 7 (August 1889): 683–693.

Phillips, Duncan. "Twachtman—An Appreciation." *The International Studio* 66 (February 1919): 106–107.

———. "What Is Impressionism." *Art and Progress* 3 (September 1912): 702–707.

Pizer, Donald. *Realism and Naturalism in Nineteenth-Century American Literature.* Carbondale and Edwardsville, Ill.: Southern Illinois University Press, 1984.

Poovey, Mary. *Uneven Developments: The Ideological Work of Gender in Mid-Victorian England.* Chicago: University of Chicago Press, 1988.

Pottier, Edmond. "Les Salons de 1892: La Peinture." *Gazette des Beaux-Arts* 7 (June 1892): 440–467.

Potts, Alex. "Picturing the Modern Metropolis: Images of London in the Nineteenth Century." *History Workshop* 26 (Autumn 1988): 32–43.

Price, F. Newlin. "Childe Hassam—Puritan." *International Studio* 77 (April 1923): 3–7.

Pyne, Kathleen. "*Classical Figures,* a Folding Screen by Thomas Dewing." *Bulletin of the Detroit Institute of Arts* 59 (Spring 1981): 4–15.

———. "Evolutionary Typology and the American Woman in the Work of Thomas Dewing." *American Art* 7 (Winter 1993): 12–29.

———. "Resisting Modernism: American Painting in the Culture of Conflict." In *American Icons: Transatlantic Perspectives on Eighteenth- and Nineteenth-Century American Art,* ed. Thomas W. Gaehtgens and Heinz Ickstadt, pp. 288–318. Santa Monica, Calif.: The Getty Center for the History of Art and the Humanities, 1992.

————. "Whistler and the Politics of the Urban Picturesque." *American Art* 8 (Summer/Fall 1994): 61–77.

Qualey, Carlton C., ed. *Thorstein Veblen: The Carleton College Veblen Seminar Essays.* New York: Columbia University Press, 1968.

The Quest for Unity: American Art Between World's Fairs, 1876–1893. Essay by David C. Huntington. Cat. entries by Michele Bogart, David A. Hanks, Kathleen A. Pyne, Nancy R. Shaw, Deborah Fenton Shepherd. Detroit: The Detroit Institute of Arts, 1983.

Reed, Henry Hope, and Sophia Duckworth, *Central Park: A History and a Guide.* New York: Clarkson N. Potter, Inc., 1967.

Revisiting the White City: American Art at the 1893 World's Fair. Washington, D.C.: National Museum of American Art and National Portrait Gallery, 1993.

Rewald, John. *The History of Impressionism.* New York: The Museum of Modern Art, 1973.

R[iordan]., R[oger]. "From Another Point of View." *The Art Amateur* 27 (December 1892): 5.

————. "Second Notice: The Impressionist Exhibition." *The Art Amateur* 14 (June 1886): 4.

Riis, Jacob A. *How the Other Half Lives: Studies among the Tenements of New York.* 1890. New York: Dover Publications, 1971.

Robinson, Theodore. "Claude Monet." *The Century Magazine* 44 (September 1892): 696–701.

————. Diaries. 1892–1896. Frick Art Reference Library, New York.

Rosenberg, Charles E. "The Place of George M. Beard in Nineteenth-Century Psychiatry." *Bulletin of the History of Medicine* 36 (1962): 245–259.

————. "Sexuality, Class, and Role in 19th-Century America." *American Quarterly* 25 (May 1973): 131–153.

Rosenblum, Robert, and H. W. Janson. *19th-Century Art.* New York: Abrams; Englewood Cliffs, N.J.: Prentice-Hall, Inc. 1984.

Rosenzweig, Roy, and Elizabeth Blackmar. *The Park and the People: A History of Central Park.* Ithaca: Cornell University Press, 1992.

Rydell, Robert. *All the World's a Fair: Visions of Empire at American International Expositions, 1876–1916.* Chicago: University of Chicago Press, 1984.

Russett, Cynthia Eagle. *Darwin in America: The Intellectual Response, 1865–1912.* San Francisco: W. H. Freeman and Co., 1976.

————. *Sexual Science: The Victorian Construction of Womanhood.* Cambridge, Mass.: Harvard University Press, 1989.

Saarinen, Aline B. *The Proud Possessors: The Lives, Times, and Tastes of Some Adventurous American Art Collectors.* New York: Random House, 1958.

Saint-Gaudens, Homer. *The Reminiscences of Augustus Saint-Gaudens.* 2 vols. New York: The Century Company, 1913.

Sandberg, John. "'Japonisme' and Whistler." *Burlington Magazine* 106 (November 1964): 500–507.

———. "Whistler Studies." *Art Bulletin* 50 (March 1968): 59–64.

Saveth, Edward N. *American Historians and European Immigrants, 1875–1925.* New York: Columbia University Press, 1948.

Schmitt, Peter J. *Back to Nature: The Arcadian Myth in Urban America.* New York: Oxford University Press, 1969.

Schorske, Carl E. *Fin-de-Siècle Vienna: Politics and Culture.* New York: Knopf, 1980.

———. "The Quest for the Grail: Wagner and Morris." In *The Critical Spirit: Essays in Honor of Herbert Marcuse,* ed. Kurt H. Wolff and Barrington Moore Jr., pp. 216–232. Boston: Beacon Press, 1967.

———. "Revolt in Vienna." *New York Review of Books* 33 (May 29, 1986): 24–29.

Schuyler, David. *The New Urban Landscape: The Redefinition of City Form in Nineteenth-Century America.* Baltimore: The Johns Hopkins University Press, 1986.

Seaton-Schmidt, Anna. "Frank W. Benson." *American Magazine of Art* 12 (November 1921): 365–372.

Shapiro, Laura. *Perfection Salad: Women and Cooking at the Turn of the Century.* New York: Farrar, Straus, and Giroux, 1986.

Sherwood, M. E. W. "New England Women." *Atlantic Monthly* 42 (August 1878): 230–237.

Showalter, Elaine. *Sexual Anarchy: Gender and Culture at the Fin de Siècle.* New York: Viking Press, 1990.

Sicherman, Barbara. "The Paradox of Prudence: Mental Health in the Gilded Age." *Journal of American History* 62 (March 1976): 890–912.

Sloan, Julie L., and James L. Yarnall. "Art of an Opaline Mind: The Stained Glass of John La Farge." *American Art Journal* 24 (Winter and Spring/Summer 1994): 5–43.

Smith-Rosenberg, Caroll. *Disorderly Conduct: Visions of Gender in Victorian America.* New York: Knopf, 1985.

Smith, Minna. "The Work of Frank W. Benson." *International Studio* 35 (October 1908): 99–106.

Solomon, Barbara Miller. *Ancestors and Immigrants: A Changing New England Tradition.* Cambridge, Mass.: Harvard University Press, 1956.

"Some Questions of Art: Pictures by Mr. William M. Chase." New York *Sun* (March 1, 1891): 14.

Spencer, Harold, Susan G. Larkin, and Jeffery W. Andersen. *Connecticut and American Impressionism.* Storrs, Conn.: William Benton Museum of Art, University of Connecticut, 1980.

Spencer, Herbert. *A System of Synthetic Philosophy.* London: Williams and Norgate, 1862–1896.

———.*Social Statics; or, the Conditions Essential to Human Happiness Specified, and the First of Them Developed.* 1865. New York: D. Appleton and Company, 1884.

Spencer, Robin, ed. *Whistler: A Retrospective.* New York: Hugh Lauter Levin Associates, Inc., 1989.

———. "Whistler and Japan: Work in Progress." In *Japonisme in Art: An International Symposium,* pp. 57–82. Tokyo: Society for the Study of Japonisme, 1980.

Stark, Otto. "The Evolution of Impressionism." *Modern Art* 3 (Spring 1895): 53–56.

Stedman, E. C. "Emerson." *The Century Magazine* 25 (April 1883): 886.

Steele, T[heodore]. C. "Impressionalism." *Modern Art* 1 (Winter 1893). unpag.

Stein, Richard L. *The Ritual of Interpretation: The Fine Arts as Literature in Ruskin, Rossetti, and Pater.* Cambridge, Mass.: Harvard University Press, 1975.

Stein, Roger B. *John Ruskin and Aesthetic Thought in America, 1840–1900.* Cambridge, Mass.: Harvard University Press, 1967.

Stephens, Henry G. "'Impressionism:' The Nineteenth Century's Distinctive Contribution to Art." *Brush and Pencil* 11 (January 1903): 279–297.

Stephens, Kate. "The New England Woman." *Atlantic Monthly* 88 (July 1901): 60–66.

Stocking, George W., Jr., *Race, Culture, and Evolution: Essays in the History of Anthropology.* Chicago: University of Chicago Press, 1982.

Strong, Josiah. *Our Country: Its Possible Future and Its Present Crisis.* Ed. Jurgen Herbst. 1886. Cambridge, Mass.: The Belknap Press of Harvard University Press, 1963.

Sutton, Denys. *James McNeill Whistler: Paintings, Etchings, Pastels, and Watercolours.* London: Phaidon, 1966.

———. *Nocturne: The Art of James McNeill Whistler.* London: Country Life Limited, 1963.

Swinburne, Algernon. *Essays and Studies.* 2d ed. London: Chatto and

Windus, Piccadilly, 1876.

Tachiki, Satoko Fujita. *Okakura Kakuzo (1862–1913) and Boston Brahmins.* Ph.D. Diss., University of Michigan. Ann Arbor: University Microfilms, Inc., 1986.

Tharp, Ezra. "T. W. Dewing." *Art and Progress* 5 (March 1914): 155–161.

Tharp, Louise Hall. *Saint-Gaudens and the Gilded Era.* Boston: Little, Brown and Co., 1969.

Thomas, John L. *Alternative America: Henry George, Edward Bellamy, Henry Demarest Lloyd, and the Adversary Tradition.* Cambridge, Mass.: The Belknap Press of Harvard University Press, 1983.

Tomlinson, Helen Nebeker. *Charles Lang Freer: Pioneer Collector of Oriental Art.* Ph.D. Diss., Case Western Reserve University. Ann Arbor: University Microfilms, Inc., 1979.

Trachtenberg, Alan. *The Incorporation of America: Culture and Society in the Gilded Age.* New York: Hill and Wang, 1982.

Trask, John E. D. "About Tarbell." *American Magazine of Art* 9 (April 1918): 217–228.

Trine, Ralph Waldo. *In Tune with the Infinite.* 1896. In *The Best of Ralph Waldo Trine.* Indianapolis: The Bobbs-Merrill Company, Inc., 1957.

Tuan, Yi-Fu. "Thought and Landscape: The Eye and the Mind's Eye." In *The Interpretation of Ordinary Landscapes: Geographical Essays,* ed. D. W. Meinig, pp. 89–102. New York: Oxford University Press, 1979.

Tucker, Allen. *John H. Twachtman.* New York: Whitney Museum of American Art, 1931.

Tuckerman, Henry T. *Book of the Artists: American Artist Life.* New York: G. P. Putnam & Son, 1867.

Turner, Frank M. *The Greek Heritage in Victorian Britain.* New Haven: Yale University Press, 1981.

Turner, Frederick J. *The Significance of the Frontier in American History.* March of America Facsimile Series, Number 100. 1894. Ann Arbor: University Microfilms, Inc., 1966.

Turner, James. *Without God, Without Creed: The Origins of Unbelief in America.* Baltimore: The Johns Hopkins University Press, 1985.

Twachtman, John. Typescripts of sixteen letters to J. Alden Weir. 1880–1892. Ira Spanierman, New York.

Underwood, Sarah Lee. *Charles H. Caffin: A Voice for Modernism, 1897–1918.* Ann Arbor: Univerity Microfilms, Inc., 1983.

Van Buren, Deborah Elizabeth. *The Cornish Colony: Expressions of Attachment to Place, 1885–1915.* Ph.D. Diss., George Washington University. Ann Arbor: University Microfilms, Inc., 1987.

Van Dyke, John C. *Art for Art's Sake: Seven University Lectures on the Technical Beauty of Painting.* New York: Charles Scribner's Sons, 1893.

―――. "The Bartholdi Loan Collection." *The Studio* 2 (December 8, 1883): 262–263.

―――, ed. *Modern French Masters: A Series of Biographical and Critical Reviews by American Artists.* New York: The Century Company, 1896.

―――. "What Is All This Talk about Whistler?" *Ladies' Home Journal* 21 (March 1904): 10.

Van Rensselaer, M. G. *Book of American Figure Painters.* Philadelphia: J. B. Lippincott, 1886.

―――. "The Waste of Women's Intellectual Force." *Forum* 13 (July 1892): 616–628.

Veblen, Thorstein. *The Theory of the Leisure Class: An Economic Study of Institutions.* 1899. New York: The Modern Library, 1934.

Venturi, Lionello, ed. *Les Archives de l'Impressionisme.* New York: Durand-Ruel, 1939.

Vicinus, Martha, ed. *A Widening Sphere: Changing Roles of Victorian Women.* Bloomington: Indiana University Press, 1977.

W., W. H. "What Is Impressionism? Part I." *The Art Amateur* 27 (November 1892): 140–141; "Part II." (December 1892): 5.

Waern, Cecilia. *John La Farge, Artist and Writer.* London: Seeley and Company, Limited, 1896.

―――. "Notes on French Impressionism." *Atlantic Monthly* 69 (April 1892): 535–541.

Warner, Eric, and Graham Hough, eds. *Strangeness and Beauty: An Anthology of Aesthetic Criticism, 1840–1910; Vol. I: Ruskin to Swinburne.* Cambridge: Cambridge University Press, 1983.

Watson, Forbes. Papers. Archives of American Art, Smithsonian Institution, microfilm D47–D57.

Weaver, Jane Calhoun, ed. *Sadakichi Hartmann: Critical Modernist; Collected Art Writings.* Berkeley: University of California Press, 1991.

Weeks, Jeffrey. *Sex, Politics, and Society: The Regulation of Sexuality Since 1800.* London: Longman Group Limited, 1981.

Weinberg, H. Barbara. "American Impressionism in a Cosmopolitan Context." *Arts Magazine* 55 (November 1980): 160–165.

―――. *The Decorative Work of John La Farge.* New York: Garland, 1977.

―――. "John La Farge, the Relation of His Illustrations to His Ideal Art." *American Art Journal* 5 (May 1973): 54–73.

―――. *The Lure of Paris: Nineteenth-Century American Painters and Their French Teachers.* New York: Abbeville, 1991.

—————. "Renaissance and Renascences in American Art." *Arts Magazine* 54 (November 1979): 172–176.

Weinberg, H. Barbara, Doreen Bolger, and David Park Curry. *American Impressionism and Realism: The Painting of Modern Life, 1885–1915*. New York: Metropolitan Museum of Art; New York: Abrams, 1994.

Weinberg, Louis. "Current Impressionism." *The New Republic* 2 (March 6, 1915): 124–125.

Weintraub, Stanley. *Whistler*. New York: Weybright and Talley, 1974.

Weitzenhoffer, Frances. "The Earliest American Collectors of Monet." In *Aspects of Monet: A Symposium on the Artist's Life and Times*, ed. John Rewald and Frances Weitzenhoffer, pp. 72–91. New York: Abrams, 1984.

Welbon, Guy Richard. *The Buddhist Nirvana and Its Western Interpreters*. Chicago: University of Chicago Press, 1968.

Wells, Kate Gannett. "Transitional American Woman." *Atlantic Monthly* 46 (December 1880): 817–823.

Whistler, James McNeill. *The Gentle Art of Making Enemies*. London: William Heinemann, 1890.

White, Henry C. *The Life and Art of Dwight William Tryon*. Cambridge, Mass.: The Riverside Press, 1930.

White, Israel L. "Childe Hassam–a Puritan." *International Studio* 15 (December 1911): 29–33.

White, Nelson C. "The Art of Thomas W. Dewing." *Art and Archaeology* 27 (June 1929): 253–261.

—————. Introduction. *A Loan Exhibition: Thomas W. Dewing, 1851–1938*. New York: Durlacher Brothers, 1963.

—————. Papers. Archives of American Art, Smithsonian Institution, microfilms D199–D202.

White, Stanford. Papers. Avery Library, Columbia University.

—————. Papers. New York Historical Society; also Archives of American Art, Smithsonian Institution, microfilm 505.

Wiebe, Robert H. *The Search for Order, 1877–1920*. New York: Hill and Wang, 1967.

Wilkinson, Burke. *Uncommon Clay: The Life and Works of Augustus Saint-Gaudens*. San Diego: Harcourt Brace Jovanovich, 1985.

Williams, Raymond. *The Country and the City*. New York: Oxford University Press, 1973.

Wilson, Richard Guy, Diane H. Pilgrim, and Richard R. Murray. *The American Renaissance, 1876–1917*. Brooklyn: The Brooklyn Museum, 1979.

Works in Oil and Pastel by the Impressionists of Paris. New York: The American Art Association, 1886.

Wright, Frank Lloyd. *The Natural House.* New York: Mentor Book; New American Library, 1963.

Wright, Gwendolyn. *Moralism and the Model Home.* Chicago: University of Chicago Press, 1981.

Wyllie, Irvin G. "Social Darwinism and the Businessman." *Proceedings of the American Philosophical Society* 103 (October 1959): 629–635.

Yarnall, James L. *John La Farge: Watercolors and Drawings.* Westchester, N.Y.: Hudson River Museum, 1990.

————. "John La Farge's 'Paradise Valley Period.'" *Newport History* 55 (Winter 1982): 6–25.

————. "John La Farge's Portrait of the Painter and the Use of Photography in His Work." *American Art Journal* 18 (Winter 1986): 4–20.

————. "New Insights on John La Farge and Photography." *American Art Journal* 19 (Fall 1987): 52–79.

Youmans, Edward Livingston, ed. *Herbert Spencer on the Americans and the Americans on Herbert Spencer: Being a Full Report of His Interview and of the Proceedings of the Farewell Banquet of November 9, 1882.* 1882. Reprint ed. New York: D. Appleton and Company, 1887.

Young, Andrew McLaren, Robin Spencer, and Margaret MacDonald, with the assistance of Hamish Miles. *The Paintings of James McNeill Whistler.* New Haven: Yale University Press, 1980.

Young, Dorothy Weir. *The Life and Letters of Julian Alden Weir.* Ed. with an introduction by Lawrence W. Chisolm. New Haven: Yale University Press, 1960.

Zahm, J[ohn]. A[ugustine]. *Evolution and Dogma.* Intro. Thomas J. Schlereth. 1896. New York: Arno Press, 1978.

Zurier, Rebecca. *Art for "The Masses": A Radical Magazine and Its Graphics, 1911–1917.* Philadelphia: Temple University Press, 1988.

INDEX

Page numbers in boldface indicate illustrations. Works of art are listed at the end of entries on individual artists.

use of art, 158–163, 174, 182,
204–205; types of women
portrayed by, 180; and Wagner's
opera, 155, 159–160; women in
interiors of, 177, 179, 183–188,
189, 195, 207, 269; women in
landscapes of, 147–148, 154–155,
157, 158–161, 163, 176, 195, 273,
286; women's reactions to works
of, 188; *After Sunset (Summer
Evening),* **153,** 153–154, 158, 164,
340n62; *The Angel of Sleep,* 149–
150, 151; *Beauty in the Household,*
145–146, **146,** 165, **167;** *Classical
Figures,* **198;** *The Days,* 136, **137;**
*Design for a Painted Arras for
Music Room: Classic Landscape and
Figures,* **167;** *Figure of a Girl in
Blue (Portrait of Minnie Clark),*
190; *The Fortune Teller,* 180, **181;**
*The Four Sylvan Sounds (The Four
Forest Notes): The Wind through
the Pine Trees, the Woodpecker, the
Sound of Falling Water, and the
Hermit Thrush,* 171–173, **172;** *Girl
with a Lute,* 184, **187;** *The Hermit
Thrush,* 147, 147–148, 153, 154,
159, 160, 161, 340n62; *In the
Garden,* **193;** *The Letter,* **178,** 179–
180, 344n113; *The Mirror,*
344n113; *The Necklace,* 211; *A
Painted Arras for Small Hall,* **146;**
The Piano, 169; *A Reading,* 177,
178, 179, 194, 211; *The Recitation,*
159; *Reclining Nude Figure of a
Girl,* 186, **187;** *The Seasons
Triptych* (with Tryon), 161, **162,**
163; *The Song,* 150, **150;** *The
Spinet,* 184, **185,** 194, 344n113;
Study of a Woman Seated, 184,
185; *Summer,* 159, **162,** 163,
340n62; *Tobias and the Angel
(Tobit's Walk with the Angel),* 150–
151, **151,** 153, 154. *See also*
Cornish art colony
Doré, Gustave: cityscapes of,

117–118; *Dudley Street, Seven
Dials,* 118, **118**
Downes, William Howe, 229
Du Mond, Frank: *Christ and the
Fishermen,* **288,** 290
Dublin, Vermont, 139
Duncan, Frances, 335n7

East-West synthesis, 172, 175–176
education of women, 188–189, 191,
192
The Eight, 203, 211
Elliott, Maud Howe, 144–45
Emerson, Ralph Waldo: Maria
Dewing's study of, 163; divinity in
evolution, 22; evolution of the
soul, 27–28; humanism in
religion, 21–22; nature poetry of,
172; on oceanic experience, 156–
157; "Woodnotes I," 172
energy: and mind cure, 156; of nature
and oceanic feeling, 154–155; of
talismanic objects, 171; woman as
conduit for nature's energy, 160.
See also nature; the spiritual
environment: evolutionary adapta-
tion to, 27; as factor in develop-
ment, 3, 33. *See also* designed
environments; evolution
(Spencerian/social)
Episcopalianism, 61
the erotic. *See* sexuality
the essential self. *See* internal life
euthenics. *See* the art of life
evolution: art's role in, 205, 206; as
cultural, 63, 65–66; environmen-
tal adaptation, 18; as teleological,
3; toward the spiritual, 86. *See
also* cultural evolution
evolution (Darwinian/biological):
American response to, 14–17;
challenges to Christianity, 3;
challenges to human place in
nature, 3; and crisis of faith, 148;
and cultural conflict, 222; issues
for Anglo-Americans, 17; and the